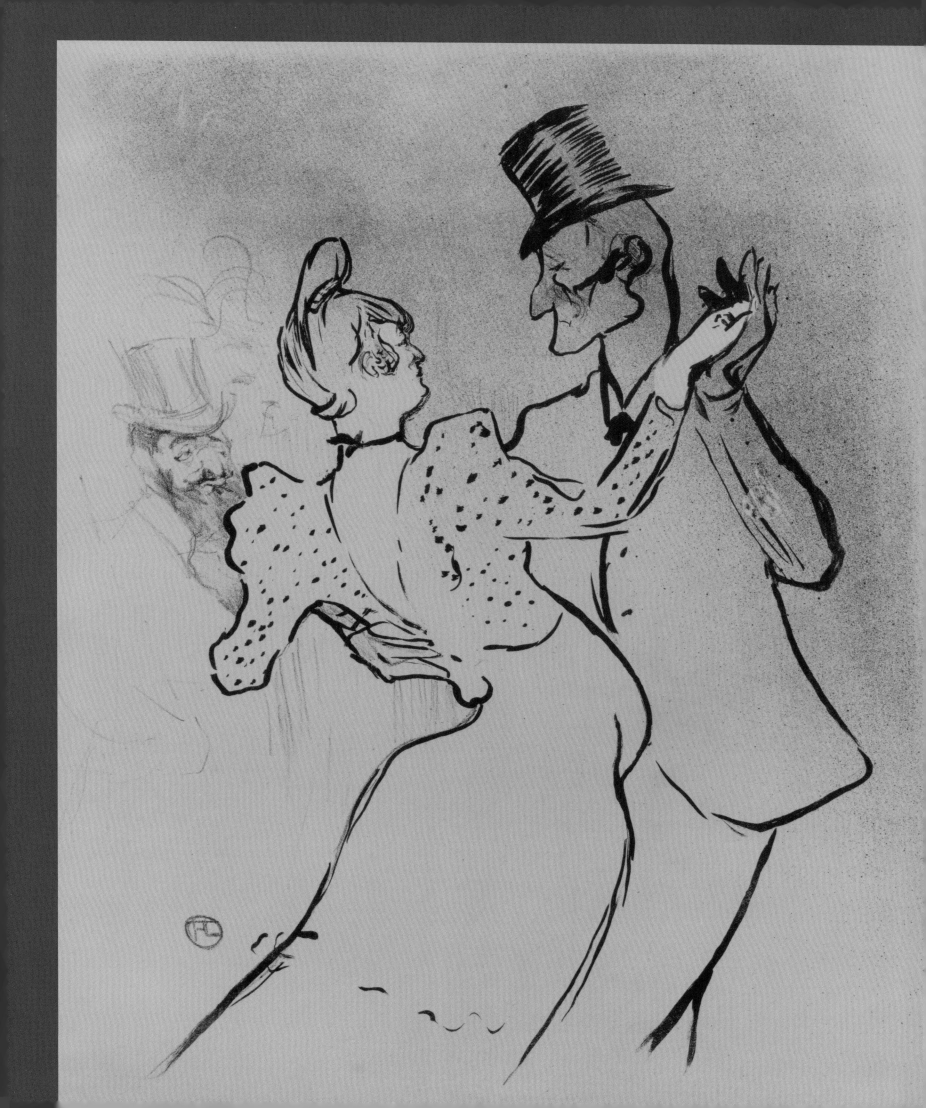

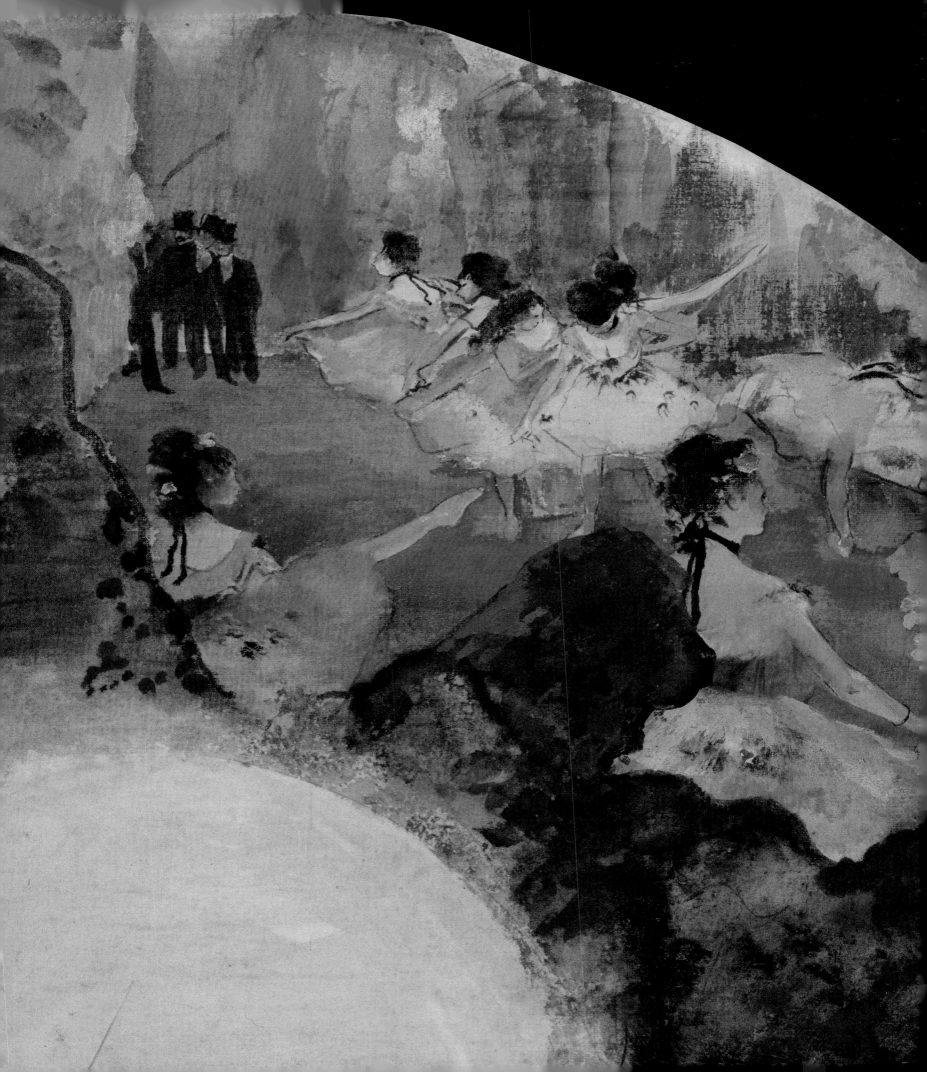

ANNETTE DIXON

with

MARY WEAVER CHAPIN

JILL DEVONYAR

RICHARD KENDALL

FLORENCE VALDÈS-FORAIN

The Dancer

DEGAS

FORAIN

TOULOUSE-LAUTREC

PORTLAND ART MUSEUM
OREGON

This publication was made possible through a gift of
Janet and Richard Geary,
with additional support provided by Mary and Pete Mark.

Published on the occasion of the exhibition *The Dancer: Degas, Forain, and Toulouse-Lautrec,* organized by Annette Dixon, Portland Art Museum, February 2–May 11, 2008.

The exhibition has been made possible by the generous support of Laura Meier, Dr. Alton and Celia Wiebe, Mary Hoyt Stevenson Foundation, Andrée Stevens, Roger and Mary Beth Burpee, Mrs. Graham J. Barbey, Schnitzer Novack Foundation, Pat and Trudy Ritz, NW Natural, KeyBank, The Boeing Company, Ruth Kainen, Nancie S. McGraw, Marge Riley, Ernest C. Swigert, The Acorn Fund of The Oregon Community Foundation, and an anonymous donor.

Library of Congress Cataloging-in-Publication Data
Dixon, Annette.
 The dancer : Degas, Forain, and Toulouse-Lautrec / Annette Dixon ; with Mary Weaver Chapin . . . [et al.].
 p. cm.
 Issued in connection with an exhibition held Feb. 2–May 11, 2008, Portland Art Museum.
 Includes bibliographical references.
 ISBN 978-1-883124-27-4 (hardcover : alk. paper)
 1. Dance in art—Exhibitions. 2. Dancers in art—Exhibitions. 3. Art and society—France—Paris—History—19th century—Exhibitions. 4. Art and society—France—Paris—History—20th century—Exhibitions. 5. Art, French—France—Paris—19th century—Exhibitions. 6. Art, French—France—Paris—20th century—Exhibitions. I. Chapin, Mary Weaver. II. Portland Art Museum (Or.). III. Title.
 N8217.D3D59 2008
 704.9'4979280944—dc22 2007042694

Published by
Portland Art Museum
1219 SW Park Avenue
Portland, OR 97205
www.pam.org

Distributed by
University of Washington Press
P.O. Box 50096
Seattle, WA 98145-5096
www.washington.edu/uwpress

Page 1: Henri de Toulouse-Lautrec, *La Goulue,* 1894 (detail, plate 120)
Pages 2–3: Edgar Degas, *Dancers,* 1879 (detail, plate 57)
Page 4: Edgar Degas, *Dancers in the Wings,* 1879–80 (detail, plate 50)
Page 6: Edgar Degas, *Dancer Looking at the Sole of Her Right Foot,* 1890–1900 (cast posthumously, 1919–29) (plate 64)
Page 10: Jean-Louis Forain, *On Stage,* 1910–11, watercolor on paper, 20⅛ × 14 inches (51 × 35.5 cm), The Samuel Courtauld Trust, The Courtauld Gallery, London

Project manager for Portland Art Museum: Bruce Guenther
Copyedited by Michelle Piranio
Proofread by Laura Iwasaki
Designed by John Hubbard
Separations by iocolor, Seattle
Produced by Marquand Books, Inc., Seattle
 www.marquand.com
Printed and bound by CS Graphics Pte., Ltd., Singapore

Contents

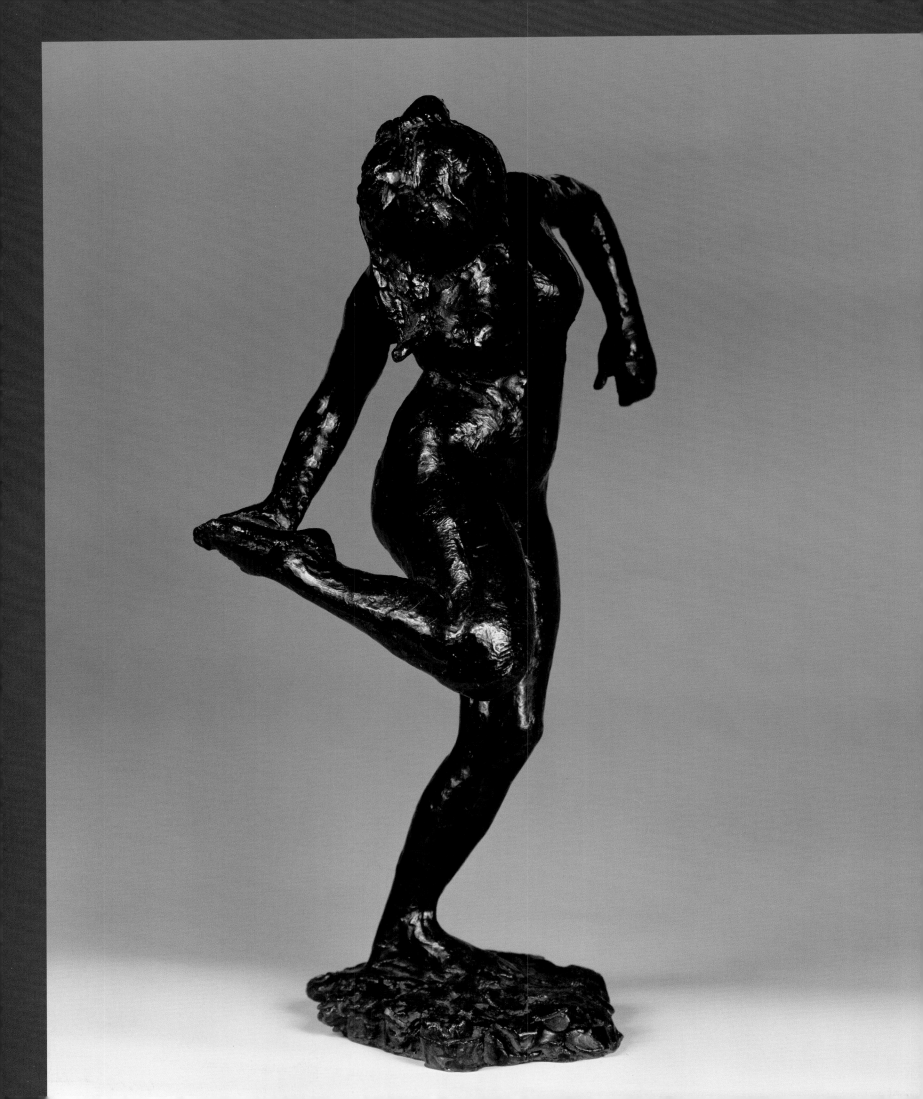

Director's Acknowledgments

ARTISTS IN LATE NINETEENTH-CENTURY FRANCE produced some
of Europe's most celebrated and revolutionary works of art. Among those
innovators are Edgar Degas, Jean-Louis Forain, and Henri de Toulouse-Lautrec,
who captured the renowned dancers of Paris in paintings, pastels, drawings,
prints, and sculptures, creating potent icons of a unique time, place, and
culture. Degas's images are perhaps the most widely recognized, significant
for their delicate as well as modern treatment of the performers. His follower
Forain expanded upon Degas's oeuvre with images that are distinguished
by their fine draftsmanship and biting satire. And Lautrec focused on balleri-
nas and cancan dancers in their social milieu, portraying them in arresting
compositions. The visual achievements of all three artists are readily evident
today. It is the underlying social commentary in their work, which would have
been appreciated by the audience of the time, that is not so obvious to us.
Upon learning more about the context in which these compelling works were
produced, we gain insight into why images of the dancer have become the
beloved representatives of the urban milieu of fin de siècle Paris.

I am extremely grateful to the exhibition's curator, Annette Dixon, whose
commitment to and passion for the project were evident upon my arrival as
the director of the Portland Art Museum in late 2006. Her comprehensive
investigation of the subject matter and her ability to bring together some
of the finest scholars on Degas, Forain, and Lautrec have given us and future
generations an expanded appreciation. Recognition must also be given to
Marnie P. Stark, assistant curator of prints and drawings, who made signi-
ficant intellectual contributions to the project, particularly to the catalogue,
during this three-year undertaking. Curatorial assistant Ingrid Berger was

the administrative mainstay of the project and also wrote for the catalogue. Chief curator Bruce Guenther has been a driving force behind this exhibition and publication, recognizing its significance, especially for our institution and community, which have a long and notable history of collecting and exhibiting French art. Director of collections and interim director of education Don Urquhart's oversight has allowed the Museum to transport priceless works of art from throughout the world to our city. The Museum's new director of development, J. S. May, has quickly helped to secure the resources for this vital and ambitious endeavor. Director of public relations and marketing Beth Heinrich has initiated a thoughtful plan to inspire our many audiences, who are welcomed at the Museum by our first-rate staff and volunteers, led by director of operations Rob Bearden.

I am grateful to Ed Marquand and John Hubbard at Marquand Books, whose dedication and hard work made this beautiful publication a reality, and to our distribution partner, the University of Washington Press, for making it widely available.

I join Annette in thanking the lenders to the exhibition for their willingness to share these remarkable works with the Museum's audience and with the world in this book.

Finally, the generosity of our funders is what ultimately makes all of this possible, and to them we are profoundly grateful. Janet and Richard Geary have provided major sponsorship of this beautiful publication and the scholarship herein, with additional support provided by Mary and Pete Mark. Once again, members of the Museum's Board of Trustees and volunteers have recognized the importance of this exhibition, providing the lead donations. Initial gifts by Dr. Alton and Celia Wiebe, Roger and Mary Beth Burpee, Pat and Trudy Ritz, Mrs. Graham J. Barbey, the Mary Hoyt Stevenson Foundation, and Nancie S. McGraw were especially meaningful, allowing the Museum to launch a successful funding drive. Of particular note, trustee Laura Meier's ongoing leadership and support of this exhibition, as well as her support of French art at the Museum, are an inspiration. Our thanks additionally go to Andrée Stevens, Schnitzer Novack Foundation, NW Natural, KeyBank, The Boeing Company, Ruth Kainen, Marge Riley, Ernest C. Swigert, The Acorn Fund of The Oregon Community Foundation, and an anonymous donor for their generous support of the exhibition and this important publication.

Brian J. Ferriso
The Marilyn H. and Dr. Robert B. Pamplin Director

Curator's Acknowledgments

I AM GRATEFUL to Brian J. Ferriso, executive director of the Portland Art Museum, for giving me the opportunity to realize this ambitious exhibition. I extend my profound thanks to my colleague Bruce Guenther, chief curator and curator of modern and contemporary art, for his expert guidance of the project and helpful advice on matters large and small. I am also deeply grateful to Marnie P. Stark, assistant curator of prints and drawings, and Ingrid Berger, curatorial assistant, for their thoughtful contributions to the catalogue and crucial assistance in all aspects of the project. Our many discussions during the planning phases of the exhibition were of great value to me. I would also like to acknowledge Amanda Kohn, associate registrar, for overseeing the loans to the exhibition and arranging for shipping and transportation, and Karly Schubothe, registrar's assistant, for managing orders for photography for the catalogue.

I congratulate the authors—Mary Weaver Chapin, Jill DeVonyar, Richard Kendall, and Florence Valdès-Forain—for their superb research and insightful essays. I offer thanks as well to Michelle Piranio, who edited the texts in the catalogue; Meghan C. Ducey, who translated Madame Valdès-Forain's essay; and Larissa Berry, Jeremy Linden, Keryn Means, Marissa Meyer, and Marie Weiler at Marquand Books for overseeing the production of the book.

I am sincerely grateful to the following individuals who have offered valuable advice, information, or assistance: Sylvie Brame, Galerie Brame & Lorenceau, Paris; Richard R. Brettell, University of Texas at Dallas; Sara Campbell, Norton Simon Museum; Jean-François Heim, Galerie Jean-François Heim, Paris; Waring Hopkins, Galerie Hopkins-Custot, Paris; Pierre Vidal and Mathias Auclair, Bibliothèque-Musée de l'Opéra, Paris; and Ruth Ziegler, Ruth Ziegler Fine Arts, New York.

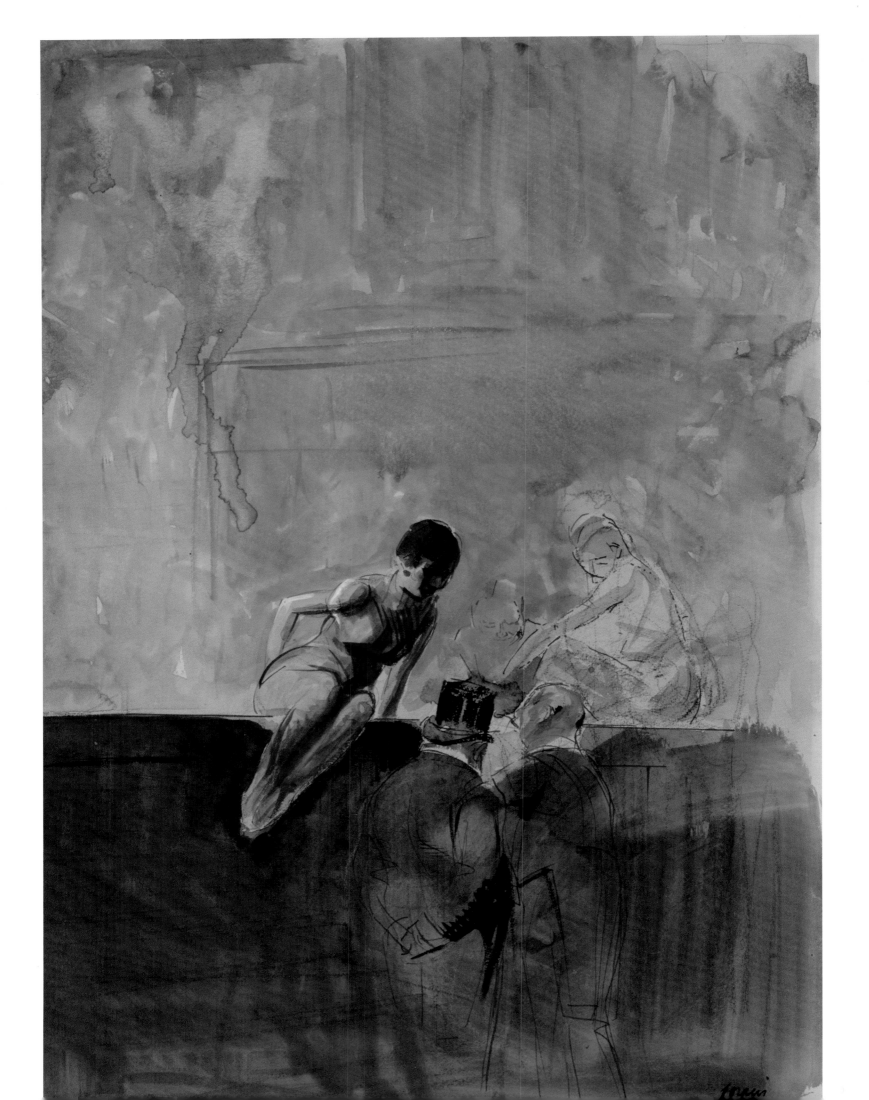

The exhibition would not have been possible without the generous participation of the lenders, who are listed on page 254, and I gratefully acknowledge the efforts of those individuals who have assisted with the loans: Louis Grachos and Douglas Dreishpoon, Albright-Knox Art Gallery; Ellen Plummer and Anne Gochenour, Arkansas Arts Center; Doreen Bolger and Jay M. Fisher, The Baltimore Museum of Art; Susan G. Glover and Karen Shafts, Boston Public Library; Arnold L. Lehman, Brooklyn Museum; Guillermo Solana, Carmen Thyssen-Bornemisza Collection, on loan to the Museo Thyssen-Bornemisza; Aaron Betsky and Kristin L. Spangenberg, Cincinnati Art Museum; Timothy Rub, Charles Venable, and Jane Glaubinger, The Cleveland Museum of Art; Deborah Swallow, The Courtauld Institute Gallery; Lewis I. Sharp and Timothy J. Standring, Denver Art Museum; Kevin Sharp and Marilyn Cheeseman, The Dixon Gallery and Gardens; John E. Buchanan Jr. and Robert Flynn Johnson, Fine Arts Museums of San Francisco; Manuel Schmit, Galerie Schmit, Paris; LuLen Walker, Georgetown University Library; Ann Philbin and Cynthia Burlingham, Hammer Museum; Michael E. Shapiro and David Brenneman, High Museum of Art; Malcolm Warner, Kimbell Art Museum; Kathleen Harleman, Krannert Art Museum; Virginia Tandy, Manchester City Galleries; William J. Chiego and Lyle W. Williams, McNay Art Museum; Philippe de Montebello, George R. Goldner, and Laurence B. Kanter, The Metropolitan Museum of Art; David Gordon, Joseph Ketner II, and Mary Weaver Chapin, Milwaukee Art Museum; William M. Griswold, Dennis Michael Jon, and Lisa Dickinson Michaux, The Minneapolis Institute of Arts; Marianne Doezema and Wendy M. Watson, Mount Holyoke College Art Museum; Serge Lemoine and Marie-Pierre Salé, Musée d'Orsay; Glenn Lowry and Deborah Wye, The Museum of Modern Art, New York; Earl A. Powell III and my colleagues in Old Master Prints, Old Master Drawings, and French Paintings, National Gallery of Art; Roberta Waddell, The New York Public Library; Gilles Chazal, Jose de Los Llanos, and Charles Villeneuve de Janti, Petit Palais, Musée des Beaux-Arts de la Ville de Paris; Anne d'Harnoncourt and Joseph J. Rishel, Philadelphia Museum of Art; Derrick R. Cartwright and D. Scott Atkinson, San Diego Museum of Art; Jessica F. Nicoll, Linda Muehlig, and Aprile Gallant, Smith College Museum of Art; Michael Conforti, Kathleen Morris, and my colleagues in Paintings and Sculpture and in Prints, Drawings, and Photographs, Sterling and Francine Clark Art Institute; Stephanie A. Stebich and Rock Hushka, Tacoma Art Museum; Charles E. Pierce Jr., Rhoda Eitel-Porter, and Cara Dufour Denison, Thaw Collection, The Pierpont Morgan Library; Alexander L. Nyerges and Mitchell Merling, Virginia Museum of Fine Arts; and Willard Holmes and Eric M. Zafran, Wadsworth Atheneum Museum of Art. I also wish to thank the private collectors who have graciously lent works to the exhibition: Mr. and Mrs. Michael Weston, Diane B. Wilsey, and others who wish to remain anonymous.

Annette Dixon, PhD
Curator of Prints and Drawings

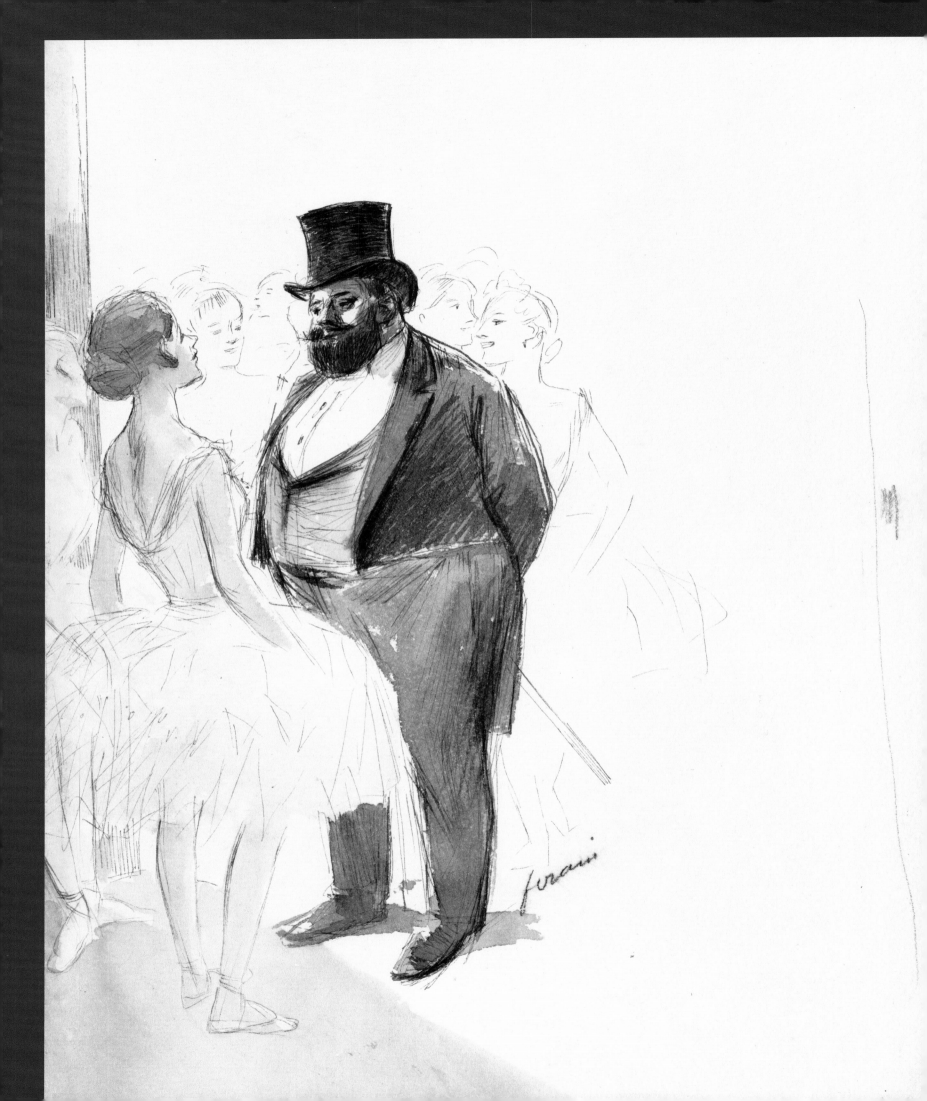

Annette Dixon

Investigations of *Modernity*

The Dancer in the Work of Degas, Forain, and Toulouse-Lautrec

THE PARIS OPÉRA, where traditional ballets were performed during
operatic interludes or staged independently, attracted members of the
elevated social classes as well as those with more modest means. The most
prominent spectators were the annual subscribers, or *abonnés*—members of
the upper class, political leaders, titans of industry, and financiers. There was
a profound difference socially between the rich spectators in the audience
and the performers onstage. Many of the dancers were drawn from the lower
classes, though this would change toward the latter part of the century.[1]
Rising through the ranks of the ballet was seen as a way for the dancers to
better their station in life and contribute money to their struggling families.
The wealthy male *abonnés* got the most expensive seats, with the best views,
and were given the privilege of going backstage during intermissions or
during and after performances. This afforded them the opportunity to consort
with the dancers, whose often precarious financial situations put pressure on
them to succumb to the advances of men who would become their supporters
or protectors. To be sure, there were those who remained aloof from this barter
of amorous favors for money, but in general, the ballet dancer was associated
in the public mind with the demimonde.

At the more popular cafés-concerts, cabarets, and dance halls, performers
executed the rowdy cancan or its racier version, the *chahut,* all the rage in fin
de siècle Paris. These venues attracted an array of social classes; some were
frequented by workers, while others drew a broader social mix, including the
bourgeoisie and even the aristocracy. The frisson of mixing with the lower
classes was wed to the whiff of disreputability at these chic establishments,
as predominantly male audiences came not only to savor the often salacious

performances but also to make assignations with the *cocottes* who frequented these places.[2]

As social types, both the ballet dancer and the *chahuteuse* came to evoke conflicting or ambivalent attitudes.[3] The ballerina was supposed to be graceful and elegant, chaste yet voluptuous, and able to charm her audience. While she should not embarrass the female spectators, she should coquettishly entice the males in the audience and the orchestra. In a period when Victorian modes of dress prevailed for respectable women, with the body mostly covered, the revealing of the dancer's form by the ballet costume exerted a strong attraction for the spectators. The dance-hall performers in their long street-length garments presented a more decorous appearance, yet they danced more provocatively, lifting their skirts to reveal their frilly undergarments. With their high kicks and choreographed contortions, the *chahuteuses* were considered variously to be vulgar, lewd, and loose or energetic, modern, and sophisticated.

This exhibition deals with the complex image of the dancer in the work of three artists for whom dance in its various manifestations was of intense interest: Edgar Degas, Jean-Louis Forain, and Henri de Toulouse-Lautrec. Each sought to portray rapidly changing urban life, concentrating on the human figure in its social context. The dancer proved to be a fruitful subject for their investigations of modernity.

Degas, Forain, and Lautrec each took a different approach to depicting the social tensions and contradictions in arenas that bought and sold women as embodied, on the one hand, in the ballet, idealized as art and beauty, and on the other, in the explicitly sexual *chahut.* Degas's dance subjects come out of the class-inflected social situations associated with the ballet. Yet, with rare exceptions,[4] he chose not to emphasize the reality of the sexual commerce at the Opéra, focusing instead on the artifice of the performance and the harsh daily life of the dancer.[5] His treatment of his subjects is deeply informed by the way we perceive figure/ground relationships and gesture as form. As art historian Gary Tinterow has observed, Degas's formal concerns "[diffuse] the sexuality of the sensational imagery to render it barely perceptible."[6] Whereas Degas saw his subject through the eyes of an artist, studying the gesture as a slice through space, Forain observed as a caricaturist and illustrator first, with a view toward social critique. He studied the way a gesture reads as part of a story. Drawing on his background as a newspaper illustrator, Forain developed concise and focused vignettes that insist on the narrative possibilities of backstage flirtations between social unequals, especially their exploitative aspects. By contrast, Lautrec's paintings, collectors' prints, and posters of celebrity dancers reveal his uncritical acceptance of the sexual commerce that was part of the popular entertainment scene of Montmartre and the *grands boulevards.* For him, the potent sexuality of these performers was a reflection of their humanity and an aspect of their distinctive individuality.

Degas: Privileged Viewpoints and Formal Pursuits

Degas's images of ballet performances convey both the spectacle and the sheer artifice of the theater and at the same time reference the spectator's physical or social position and conditions of viewing. His depictions of ballerinas performing onstage emerge about 1870, in his paintings of members of the orchestra at the Opéra. Dancers are first shown as equal in importance to the musicians in the 1872 painting *Musicians of the Orchestra* (fig. 1). In the upper register of the canvas, the prima ballerina, lit by the stage lights, curtsies while her companions look on; the musicians in the dark zone below are depicted only from the shoulders up and from behind. The authentic immediacy of this viewpoint creates a snapshot of the moment and suggests a privileged position—the first row of seats directly behind the orchestra, traditionally occupied by the wealthiest *abonnés*. This compositional formula will recur in Degas's graphic work, indicating his ongoing fascination with the motif (see fig. 2, plate 1).

In other works, we see the dancers from another privileged vantage point, namely, a loge close to the stage, as in *Dancer on Pointe* (plate 4) and *Theater Box* (plate 3). In the latter pastel, which shows the head and shoulders of an expensively dressed woman in a loge, we watch the scene through the eyes of her male companion, who is seated or standing behind her. The contrast between the darkness of the theater box and the brightness of the stage directly below emphasizes the experience of being an audience member sitting close to the stage, of having that privileged immediacy to the spectacle that class and money provided.

The majority of Degas's dance works focus on subjects behind the scenes. In the early 1870s, he gained access, probably through acquaintances or friends, to the backstage areas at the Opéra when it was located on the rue Le Peletier, before that building burned down in 1873.[7] His great dance

Fig. 1
Edgar DEGAS
Musicians of the Orchestra
1872
Oil on canvas
27⅛ × 19¼ in. (69 × 49 cm)
Städtische Galerie in Städel
Museum, Frankfurt am Main

Fig. 2
Edgar DEGAS
Ballet at the Paris Opéra
1877
Pastel over monotype on
cream laid paper
13⅞ × 27¾ in.
(35.2 × 70.6 cm)
The Art Institute of Chicago,
Gift of Mary and Leigh Block,
1981.12

classroom paintings, which emerged at this time, arise from numerous drawings that record his observations of the dancers in their daily routines. Among these studies is a group of loosely brushed drawings in essence, oil paint from which the oil has been removed and thinned with turpentine, creating a medium that is easy to manipulate and dries quickly. These drawings show him working out ways to suggest convincingly a volumetric body in space through tonal modeling, exploring various positions and gestures, and capturing the fall of light on the figure (plate 2).

The earliest of the classroom paintings, *The Dancing Class* (page 42, fig. 1) and *The Opéra Dance Studio on the Rue Le Peletier* (fig. 3), exude a calm order, with the dancers artfully arranged in a highly structured setting.[8] Both pictures depict a corner of a room, with mirrors reflecting dancers elsewhere in the space, where the viewer, too, is situated.[9] In both images, a dancer in a preparatory position awaits an instruction to proceed. In *The Opéra Dance Studio on the Rue Le Peletier,* the empty space between the instructor, Louis Mérante, and the dancer is particularly energized by the teacher's raised hand. In his classroom and rehearsal paintings, Degas would continue to experiment with the placement of figures and the use of the space between them to bring an acute modernity to the scenes. In *The Ballet Class* (plate 5), the artist places two groups of figures in opposite corners: in the upper left, three dancing ballerinas (amplified by their reflection in a mirror, in which one also sees the window in the viewer's space), and in the lower right, various dancers, an instructor, and an anchoring seated figure, who is reading. The empty area of floor separating the groups creates a certain spatial tension and lends a strange and accidental quality to the composition, suggesting a moment captured from life.

Opposite, top left to right:
Plate 1
Edgar DEGAS
On Stage III
1876–77
Etching on paper
3⅞ × 4⅞ in. (10 × 12.4 cm)
Fine Arts Museums of San Francisco, Museum Purchase, Achenbach Foundation for Graphic Arts Endowment Fund, 1964.142.14

Plate 2
Edgar DEGAS
Standing Dancer, Seen from the Back, Hands on Her Waist
c. 1873
Essence heightened with white on pink paper
14½ × 10⅛ in. (36.8 × 25.7 cm)
Musée d'Orsay, Paris, département des Arts graphiques du Musée du Louvre, legs du comte Isaac de Camondo, 1911 (RF 4038)

Opposite, bottom left to right:
Plate 3
Edgar DEGAS
Theater Box
1885
Pastel on paper
35½ × 29½ in. (90.2 × 74.9 cm)
The Armand Hammer Collection, Gift of the Armand Hammer Foundation, Hammer Museum, Los Angeles

Plate 4
Edgar DEGAS
Dancer on Pointe
c. 1877
Oil on canvas
19¾ × 23⅜ in. (50 × 60 cm)
Collection of Diane B. Wilsey

Below, left to right:
Fig. 3
Edgar DEGAS
The Opéra Dance Studio on the Rue Le Peletier
1872
Oil on canvas
12⅝ × 18⅛ in. (32.1 × 46 cm)
Musée d'Orsay, Paris (RF 1977)

Plate 5
Edgar DEGAS
The Ballet Class
c. 1880
Oil on canvas
32⅜ × 30¼ in. (82.2 × 76.8 cm)
Philadelphia Museum of Art, Purchased with the W. P. Wilstach Fund, W1937-2-1

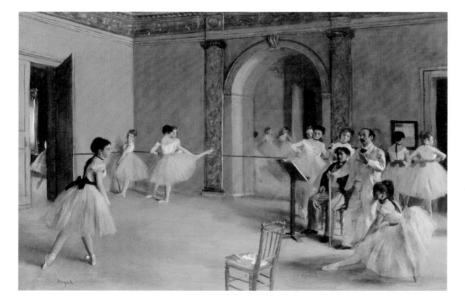

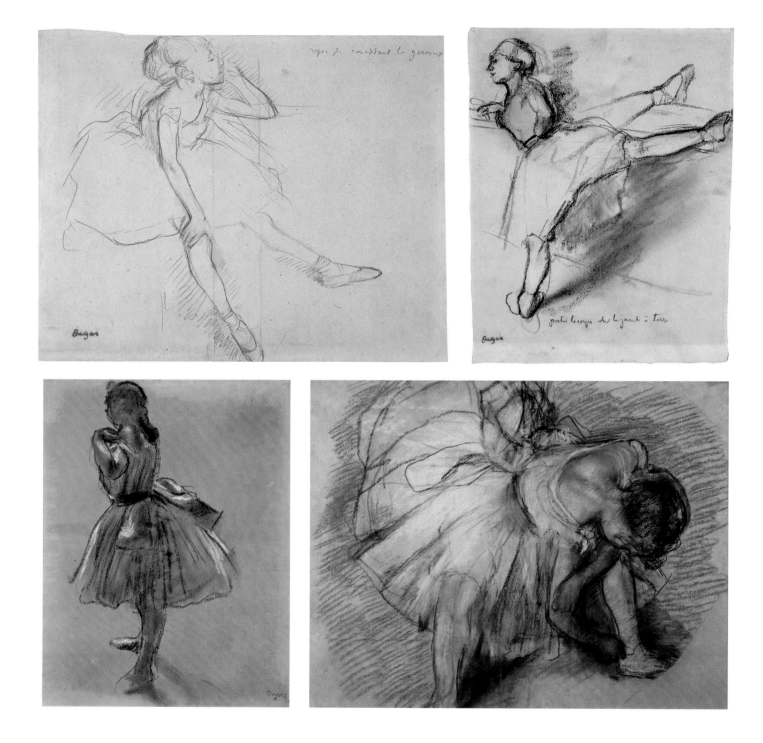

Degas's studies of dancers backstage record them at moments of exercise, practice, and rest. His drawings amount to an arsenal of poses and movements that he could amalgamate and reinterpret in more formal works. He depicted dancers at all levels, from the young pupils who began their training at ages seven to ten, commonly known as "little rats" (plate 6), all through the ranks from the corps de ballet to the *étoile*.[10] Some drawings capture dancers making casual or habitual gestures, such as adjusting a shoulder strap or a shoe (plates 8, 9). Others stress the physicality and exertion of the dancer's movements and show the artist working quickly as he repeatedly redraws limbs and contours in an effort to catch the immediacy of a body in motion (plate 7). Still other drawings depict moments of exhaustion and often convey an emotional component through the dancer's facial expression and gestures. In *Dancer Stretching,* for example, strong tonal modeling and touches of color give the figure a physical presence that matches her apparent pain (plate 10). Degas's works in this vein bring out the arduous aspects of the dancer's métier and unmask the illusion of effortlessness in his performance scenes.

Degas extended his study of the notations he made in the classroom with drawings created in the studio from memory or from a live model.[11] Beginning in the mid-1870s, when he was about forty, he complemented his two-dimensional explorations with a series of small-scale wax sculptures, which he used to study poses after the model had gone home (plates 11, 12). He continued to make wax sculptures, including many of horses, late into his life; as his eyesight failed, he would work exclusively in this medium, until the age of seventy-eight.[12] Of the roughly 150 wax sculptures found in Degas's studio after his death, in 1917, only about half of them were salvageable. The bronze founder A. A. Hébrard bought these and had them cast in bronze, with the approval of the artist's heirs. Degas's sculpture was known only through this posthumous casting until 1955, when the delicate wax maquettes, assumed to have been lost during the casting process, were rediscovered.[13] The surviving wax maquettes are now in the National Gallery of Art, Washington, DC, and the Musée d'Orsay, Paris.

Degas's sculptures of human subjects are typically of nude figures, dancers, and bathers. With the dancers in particular, he explored the balance and counterbalance of weight in difficult-to-hold positions. Working in three dimensions allowed him to examine the figure from multiple angles and served as an aid to his image making. His groundbreaking wax sculpture *Little Dancer, Aged Fourteen* (plate 13) is inconceivable without the series of drawings he made of the model, Marie van Goethem (fig. 4),[14] and the small wax maquette of a nude figure that directly preceded the sculpture (plate 14).[15] Degas often fashioned more than one sculpture in a given position. His many sculptures of ballerinas executing an arabesque amount to a sequential display of the stages of positions in this dance movement (plates 11, 12).[16]

A similar exploration of successive variations can be found in Degas's late charcoal drawings on translucent tracing paper, which allowed him to make multiple alterations to a given composition and innumerable changes from

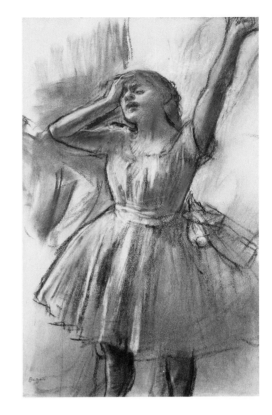

Opposite, top left to right:
Plate 6
Edgar DEGAS
Ballet Dancer in Repose
c. 1880–82
Charcoal on paper
9 9/16 × 11 7/16 in. (24.3 × 29.1 cm)
The Minneapolis Institute of
Arts, Gift of Julius Boehler

Plate 7
Edgar DEGAS
Dancer at the Barre
c. 1885
Black chalk with touches
of pink and white on paper
12 3/8 × 9 3/8 in. (31.2 × 23.7 cm)
Cincinnati Art Museum,
Annual Membership Fund

Opposite, bottom left to right:
Plate 8
Edgar DEGAS
Dancer Adjusting Her Dress
c. 1885
Pastel on paper
24 1/4 × 18 1/4 in. (61.6 × 46.4 cm)
Portland Art Museum, Bequest
of Winslow B. Ayer, 35.42

Plate 9
Edgar DEGAS
Dancer Adjusting Her Shoe
1885
Pastel on paper
19 7/16 × 23 3/4 in. (49.4 × 60.3 cm)
The Dixon Gallery and Gardens,
Memphis, Tennessee, Bequest
of Mr. and Mrs. Hugo N. Dixon,
1975.6

Above:
Plate 10
Edgar DEGAS
Dancer Stretching
c. 1882–85
Pastel on gray paper
18 3/8 × 11 3/4 in. (46.7 × 29.7 cm)
Kimbell Art Museum, Fort
Worth, Texas

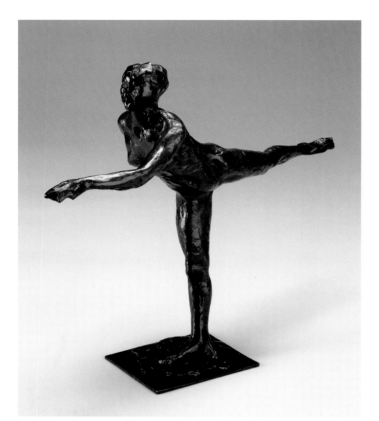

one drawing to another, spawning obsessive reworkings.[17] One drawing that provided the basis for a series of tracings is *Three Nude Dancers* (plate 15), in which powerful, weighty figures are shown resting on a banquette. The rightmost seated woman appears in only slightly different form in *Two Seated Dancers* (plate 16). Both figures in the latter charcoal drawing are worked up fully in the pastel drawing *Ballet Dancers in the Wings* (fig. 5). By placing traced drawings on easels in his studio, Degas was able to go from one to another, varying the coloration and other details of each—in effect creating sequences of drawings (see also fig. 6 and plate 17).[18]

Jill DeVonyar and Richard Kendall, in their essays in this book, eloquently discuss the role of the *abonné* in depictions by Degas. As they have noted elsewhere, dancers' backstage interactions with male patrons were never the subject of major paintings by Degas but exist only in sketchy oils and graphic

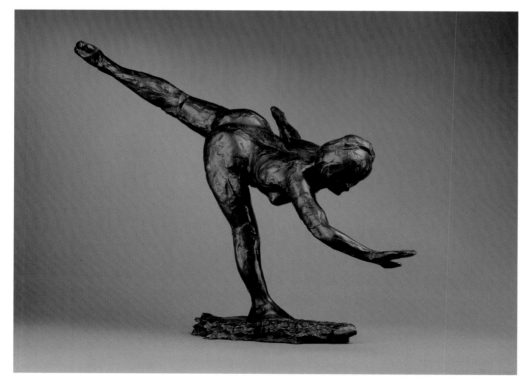

Plate 11
Edgar DEGAS
Arabesque over the Right Leg, Left Arm in Front
1882–95 (cast posthumously, 1919–21)
Bronze
11⅝ × 15¾ × 5½ in.
(29.5 × 40 × 14 cm)
The Baltimore Museum of Art, Nelson and Juanita Greif Gutman Collection BMA 1963.16.54

Plate 12
Edgar DEGAS
Grande Arabesque, Third Time
1882–95 (cast posthumously, 1919–37)
Bronze
17¼ × 22½ × 10⅜ in.
(43.8 × 57.2 × 26.4 cm)
Denver Art Museum Collection, Edward and Tullah Hanley Memorial Gift of the people of Denver and the area, 1974.354

Fig. 4
Edgar DEGAS
Four Studies of a Dancer
1878-79
Charcoal and white highlights
on imitation vellum
19¼ × 12⅜ in. (49 × 32.1 cm)
Musée d'Orsay, Paris,
département des Arts
graphiques du Musée du
Louvre (RF 4646)

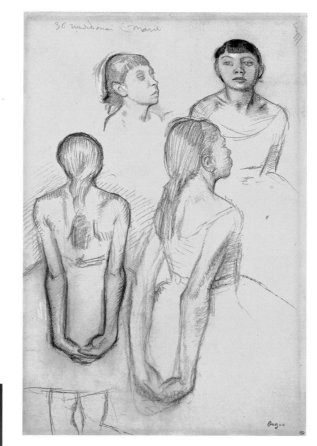

Plate 13
Edgar DEGAS
Little Dancer, Aged Fourteen
c. 1880-81 (cast posthumously,
c. 1919–32)
Bronze and fabric
38½ × 14½ × 14¼ in.
(98 × 36.8 × 36.2 cm)
Virginia Museum of Fine Arts,
Richmond, the State Operating
Fund and the Art Lovers'
Society

Plate 14
Edgar DEGAS
Study of a Nude Dancer
c. 1878–79 (cast posthumously,
1919–21)
Bronze
28¾ × 13 × 11 in.
(73.02 × 33.02 × 27.94 cm)
Albright-Knox Art Gallery,
Buffalo, New York, Friends of
Albright Art Gallery and Edwin
J. Weiss Funds, 1935, 1935:13

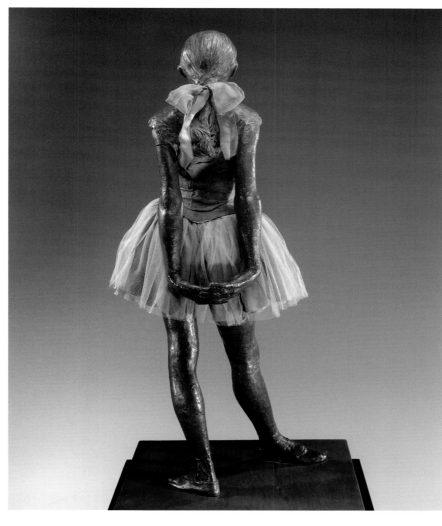

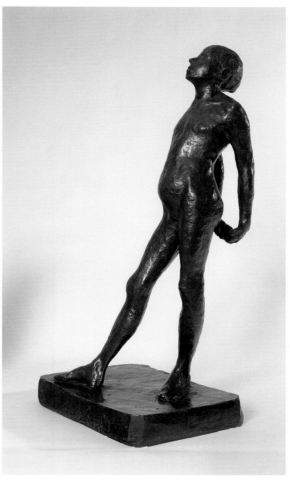

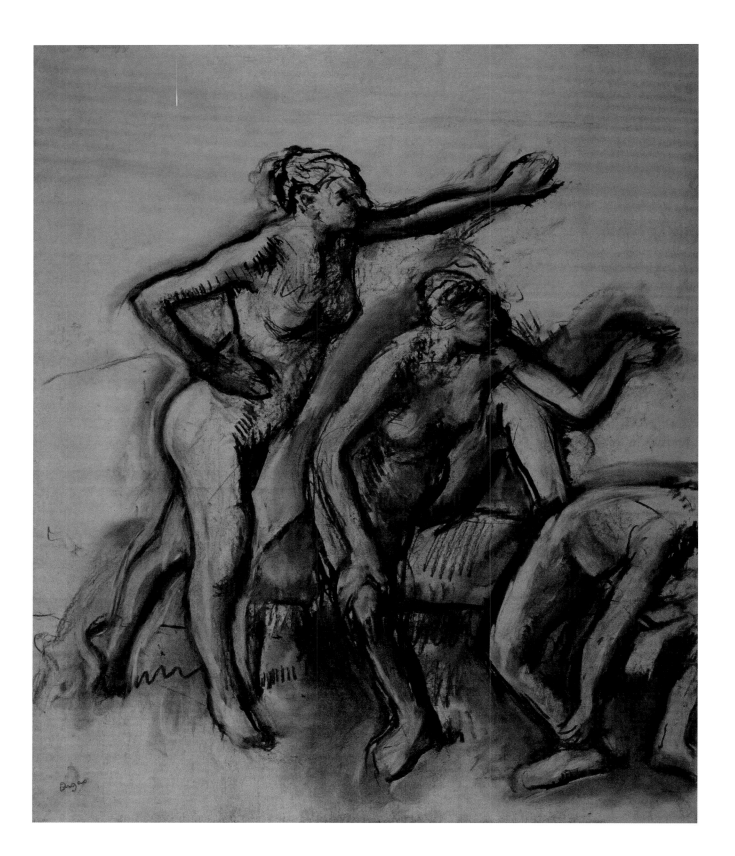

Plate 15
Edgar DEGAS
Three Nude Dancers
c. 1897–1901
Charcoal on paper
30⅜ × 24⅞ in. (77.2 × 63.2 cm)
Arkansas Arts Center
Foundation Collection,
Purchase, Fred W. Allsopp
Memorial Acquisition Fund,
1983.010.002

Plate 16
Edgar DEGAS
Two Seated Dancers
c. 1897–1901
Charcoal on tracing paper
24⅜ × 13¾ in. (62.9 × 34.9 cm)
The Samuel Courtauld Trust,
The Courtauld Gallery, London

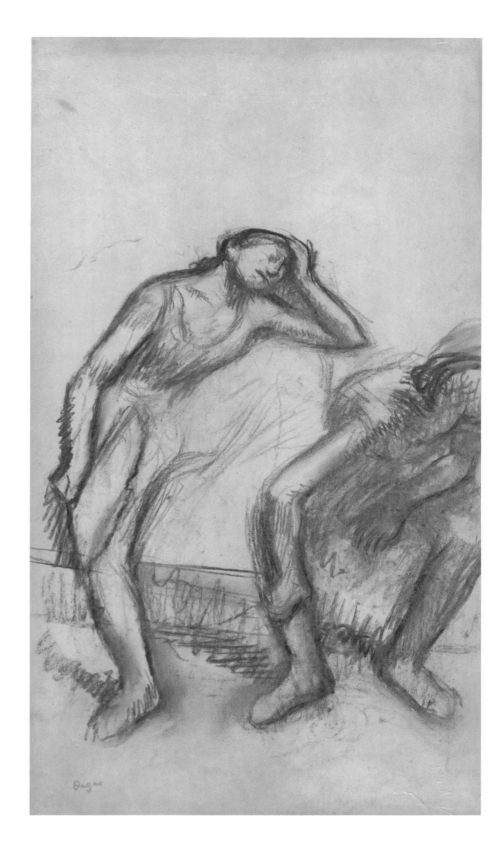

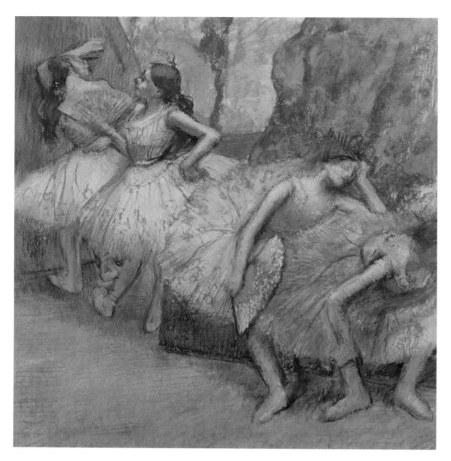

Fig. 5
Edgar DEGAS
Ballet Dancers in the Wings
1900
Pastel on tracing paper
28 × 26 in. (71.1 × 66 cm)
Saint Louis Art Museum,
Museum Purchase

Plate 17
Edgar DEGAS
Three Dancers in Yellow Skirts
c. 1900
Chalk and charcoal on tracing paper laid down on board
23⅝ × 19⅜ in. (60 × 49.8 cm)
Cincinnati Art Museum, Gift of Vladimir Horowitz

Fig. 6
Edgar DEGAS
Red Ballet Skirts
c. 1897–1901
Pastel on tracing paper
32 × 24½ in. (81.3 × 62.2 cm)
Glasgow City Council (Museums), The Burrell Collection, 35.243

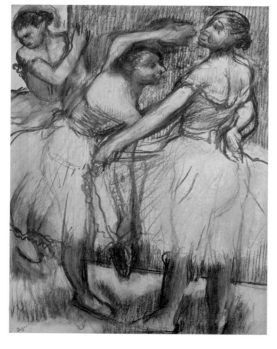

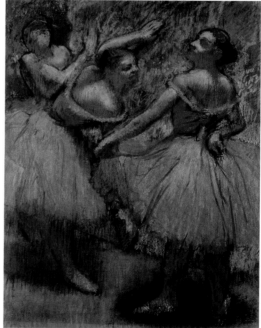

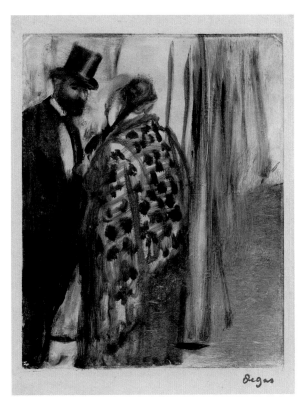

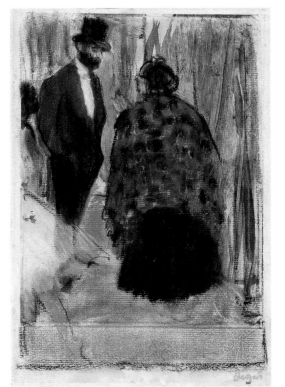

Plate 18
Edgar DEGAS
*Conversation: Ludovic
Halévy and Madame
Cardinal,* illustration for
La Famille Cardinal
1876–77
Monotype on paper
8⅜ × 6⅜ in. (21.3 × 16 cm)
The Cleveland Museum of Art,
Gift of the Print Club of
Cleveland in honor of Henry
Sayles Francis, 1967.167

Plate 19
Edgar DEGAS
*Conversation: Ludovic
Halévy Speaking with
Madame Cardinal,*
illustration for *La
Famille Cardinal*
1876–77
Monotype heightened
with pastel on paper
8½ × 6¼ in. (21.6 × 15.9 cm)
Private collection, Minnesota,
courtesy of Ruth Ziegler
Fine Arts, New York

works.[19] This was a theme that he dealt with particularly in the late 1870s.
His most extensive treatment of the theme of backstage flirtations consists
of a body of more than thirty monotypes he created to illustrate *La Famille
Cardinal,* a collection of satirical stories by his friend the librettist and *abonné*
Ludovic Halévy (plates 18, 19). The stories revolve around two young Opéra
dancers and their quest, abetted by their parents, for rich lovers. Though
Degas caricatures the male patrons, he does so with ironic humor. Perhaps his
recognition of his own upper-middle-class identity—as well as his friendship
with Halévy—was a factor in his nonjudgmental attitude toward the *abonné,*
an attitude quite different from that taken by Forain.

Forain: Narrative Meanings and Moral Implications

Like Degas, Forain made the offstage areas at the Opéra the main arena for his investigations of the ballet. However, rather than study the dancer's body or its motions, he pursued almost single-mindedly the interaction between dancers and their admirers in the wings, the corridors, and the dressing rooms. With this subject he created satirical narratives, eschewing Degas's formal vision. Forain explored the situational dilemma that the ballet dancer faced: to yield to the amorous advances of a wealthy patron or not survive economically. The artist mined this theme for decades for its rich social implications and approached it with a moralizing stance.[20]

Forain, who rose from an artisanal background to become a man-about-town,[21] perhaps felt a conflict between his working-class origins and his bourgeois aspirations. He sometimes portrays the *abonné* as a predator and the dancer as a victim, one who needed to master the art of flirtation in order to attract a protector and who benefited from the negotiatory skills of her mother. At other times, however, the dancer preys on the *abonné,* making a fool of him. Although Forain goes back and forth, assigning guilt to one party or the other, he always makes clear who is the user and who is the used. He ridiculed the triangle that developed between the dancer, her mother, and the *abonné,* and did so to expose the social structure that made this interrelationship necessary. And though he criticized all the players, he directed his most virulent barbs toward the *abonné,* who was often a married man. This was a patriarchal society that placed the man out in the world and the wife in the home; it was a social norm for husbands to have mistresses. In the fan *Evening at the Opéra* (plate 20), Forain depicts the *abonnés* negotiating the two worlds: on the left, they flirt with dancers onstage by the wings; on the right, they accompany their wives in a loge.

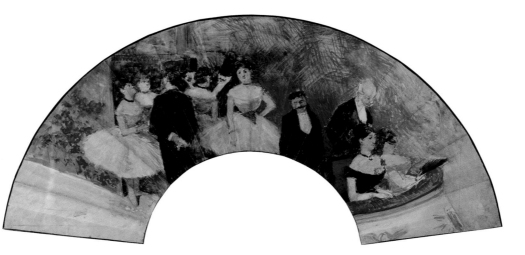

Plate 20
Jean-Louis FORAIN
Evening at the Opéra
c. 1879
Gouache, some graphite or chalk at left, on parchment (fan)
6⅜ (stick height) × 23¼ diam. in. (16.8 × 59 cm)
The Dixon Gallery and Gardens, Memphis, Tennessee, Museum Purchase, 1993.7.48

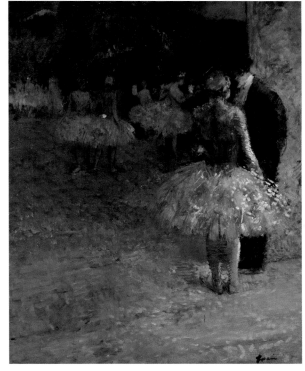

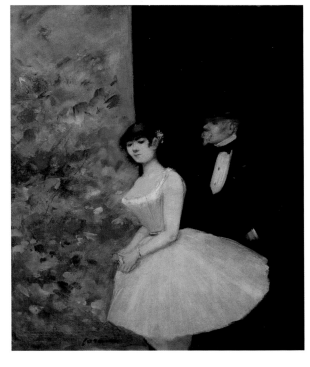

Forain brought a storyteller's art to his images. From the age of twenty-four, he worked as a newspaper illustrator as well as a painter and draftsman. The illustrator's narrative impulse carries over into his paintings and drawings. Unlike Degas, who modeled his forms with tone and color, Forain built his with line. His compositional devices focus the viewer's attention on a specific gesture or captured glance to suggest a critical narrative moment. Often this is the clandestine encounter between a dancer and an admirer in the wings, in which Forain suggests a hasty exchange of words or a furtive dalliance. He often places the pair near a stage flat or curtain, a bridge between the public stage and the backstage wings (plates 21–23). This is the point of contact between two zones: the stage with its bright lights, the dancers' realm; and the shadowy depths of the wings, a preserve lorded over by the *abonnés*. (He occasionally places the ballerina in shadow and the *abonné* in the brightly lit area, as in *In the Wings, No. 3,* plate 24.) Forain's didacticism is particularly clear in his use of this juncture as a site for the critical decision that the dancer must make.

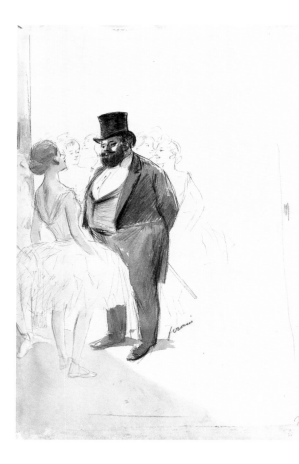

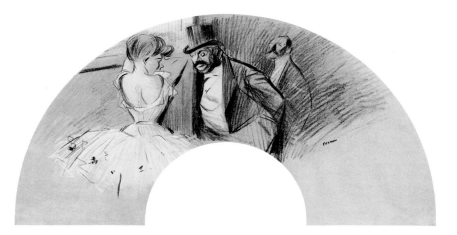

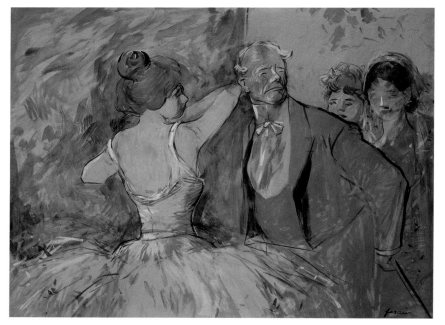

Plate 24
Jean-Louis FORAIN
In the Wings, No. 3
1890
Graphite, pen and ink, and ink
wash on paper
13¹³⁄₁₆ × 8¾ in. (33.5 × 22.2 cm)
Boston Public Library, Print
Department, Albert H. Wiggin
Collection

Plate 25
Jean-Louis FORAIN
Fan (For the Gavarni Ball)
1903
Color transfer lithograph
printed in chamois, red, and
black on imitation Japanese
paper
10¼ × 19½ in. (26 × 49.5 cm)
Boston Public Library, Print
Department, Albert H. Wiggin
Collection

Plate 26
Jean-Louis FORAIN
In the Wings
c. 1900
Gouache on paper
41½ × 55¾ in. (105.5 × 141.5 cm)
Petit Palais, Musée des
Beaux-Arts de la Ville de Paris,
Inv. PPP00855

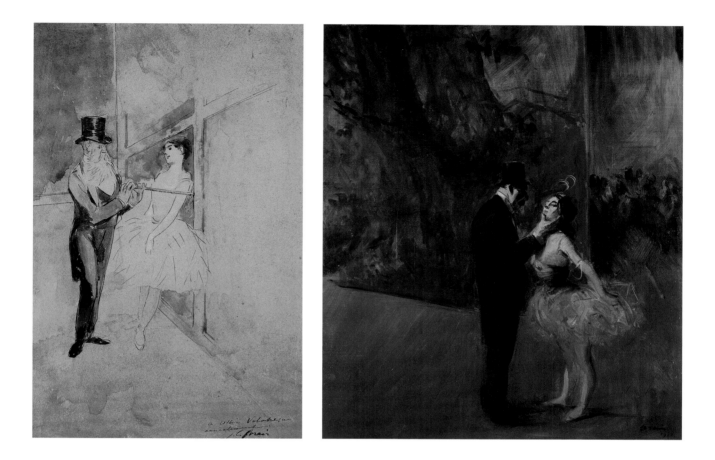

Forain charges these encounters with a variety of signals conveyed by gazes, facial expressions, and postures, but the moral implications prevail over the psychological ones. In *Fan (For the Gavarni Ball)* (plate 25), the *abonné* is clearly the aggressor, as he leans toward the dancer resting her elbows against a stage flat, his face jutting past the edge of the object into her space. By contrast, in *In the Wings* (plate 26), the dancer's bent right elbow, pointed toward the face of the *abonné,* may represent an attempt on her part to get him to notice her; his attentions have wandered, as he looks away from her. Forain frequently uses the trope of the *abonné*'s cane, a common accoutrement of upper-class men, to emphasize his role as an aggressor. In the drawing *Conversation with a Ballerina in the Wings* (plate 27), the gentleman uses his cane to bar a ballerina's way as she leans against a stage flat. In another instance, a gentleman holds his cane behind him, and it becomes an extension of his body, which itself literally invades the dancer's space as the curve of his heavy abdomen hangs over her delicate tutu (plate 24). This type of aggressive behavior is blatantly portrayed in *On the Stage* (plate 28), in which the *abonné* grasps the dancer's chin harshly as if to force her into submission; her rigid bearing, however, conveys pride and resistance.

Plate 27
Jean-Louis FORAIN
Conversation with a Ballerina in the Wings
c. 1885–90
Ink and ink wash on paper
mounted on board
13⅜ × 8½ in. (34 × 21.5 cm)
The Dixon Gallery and Gardens,
Memphis, Tennessee, Museum
Purchase, 1993.7.26

Plate 28
Jean-Louis FORAIN
On the Stage
1912
Oil on canvas
24 × 19¼ in. (61 × 49 cm)
Private collection

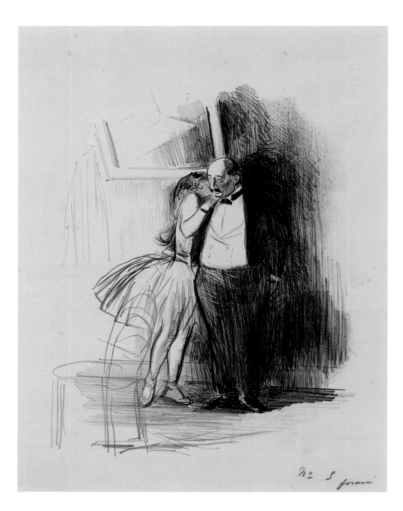

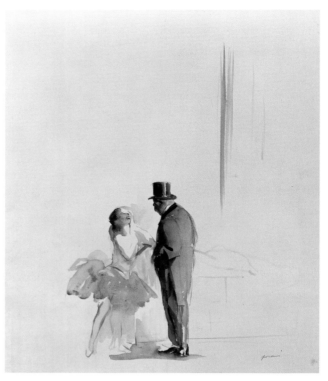

Plate 29
Jean-Louis FORAIN
The Consent
1892
Lithograph on dark cream
chine collé mounted on off-
white wove paper
10⅝ × 8⁵⁄₁₆ in. (27.1 × 21.1 cm)
Boston Public Library, Print
Department, Albert H. Wiggin
Collection

Plate 30
Jean-Louis FORAIN
*Dancer and Abonné at
the Opéra*
c. 1925
Watercolor on paper
21⅞ × 15 in. (55.5 × 38 cm)
Private collection

Forain was no less scathing in his judgment of the danc-
ers who made advances toward the *abonnés*. In *The Consent*
(plate 29), such a dancer whispers to a portly gentleman; his
look of surprise suggests that she may be taking the lead, or
perhaps acquiescing too quickly. In *Dancer and Abonné at
the Opéra* (plate 30), her bared teeth make her resemble a
carnivorous animal, suggesting that she will attempt to take
advantage of her suitor, as Florence Valdès-Forain notes in
her insightful essay in this book.[22] In some cases, a dancer's
facial expression or body language suggests that she is manip-
ulating the *abonné*. In *Behind the Scenes* (plate 23), the place-
ment of the dancer at the point where the stage flat vertically
divides the picture space emphasizes her awareness that she
has attracted an *abonné*'s attention. Her knowing look belies
her demure pose, which may be a strategy to entice him. Like-
wise, the dancer in the foreground of *Intermission. On Stage*
(plate 31) may be pretending not to notice the old gentleman
nearby who is ogling her as she bends to adjust her slipper,
allowing her shoulder straps to fall and revealing her breasts.

Plate 31
Jean-Louis FORAIN
Intermission. On Stage
1879
Watercolor, gouache, and India
ink, with graphite (traces) on
wove rag paper
13⅞ × 10¹¹⁄₁₆ in. (35.3 × 27.2 cm)
The Dixon Gallery and Gardens,
Memphis, Tennessee, Museum
Purchase, 1993.7.3

Plate 32
Jean-Louis FORAIN
The Abonné's Choice
c. 1896
Crayon, stumping, and
graphite on paper
16¼ × 11⅝ in. (41.5 × 29.5 cm)
Courtesy of Galerie Schmit,
Paris

Plate 33
Jean-Louis FORAIN
Habitués of the Wings
c. 1900
Black ink and brush on
wove paper
17⅝ × 22¾ in. (44.8 × 57.8 cm)
Boston Public Library, Print
Department, Albert H. Wiggin
Collection

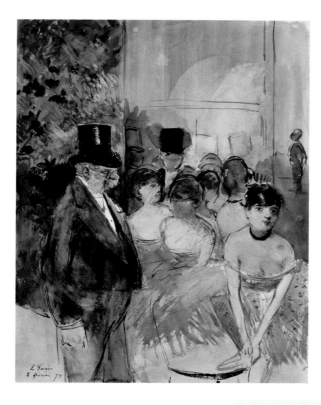

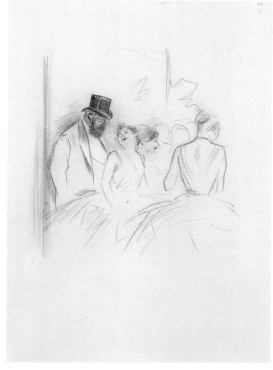

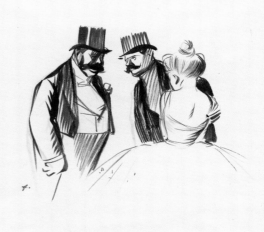

Through gesture and the tension suggested by the spaces
between figures, Forain asserts a narrative meaning. In *The
Abonné's Choice* (plate 32), among the dancers who show varying
degrees of interest in an *abonné*, one looks up at him with a
simpering expression on her face that signals her desire to be
chosen. In *Habitués of the Wings* (plate 33), a dancer recoils at
the advances of two top-hatted men who seem to appraise her
charms. In these two scenes, Forain's depiction of the figures
in three-quarter length evokes the fragments of a momentary
scene glimpsed and quickly captured by the artist, thus stress-
ing his role as a privileged observer. The rapid nature of much
of Forain's facture creates vignettes that focus on the specifics
of human interaction rather than the setting; he thus often
gives minimal indications of setting or forgoes such descrip-
tion altogether. In *The Dancer's Necklace* (plate 34), the dressing-
room environment is summarily indicated by the intersection
of two walls and partially sketched furnishings. In *The Abonné's
Choice,* he establishes the background with only a few vertical
lines and squiggles, allowing the sheet itself to suggest space,
whereas in *Habitués of the Wings,* he isolates the figures on
the paper.

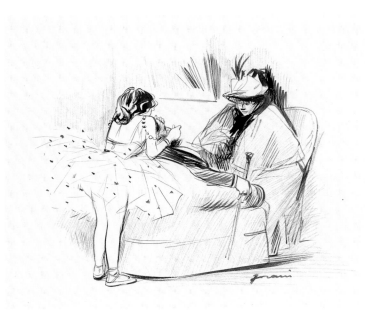

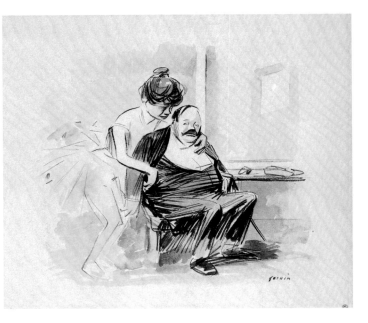

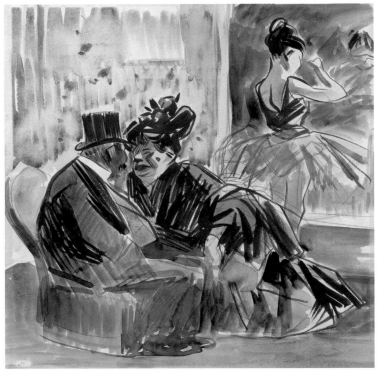

Clockwise from top left:
Plate 34
Jean-Louis FORAIN
The Dancer's Necklace
1896
India ink, blue colored pencil,
and graphite on paper
10⅞ × 13¼ in. (27.8 × 33.8 cm)
Courtesy of Galerie Schmit,
Paris

Plate 35
Jean-Louis FORAIN
The Dancer and Her Friend
c. 1900
Black crayon and watercolor
on paper
12½ × 14⅝ in. (31.7 × 37 cm)
Musée d'Orsay, Paris,
département des Arts
graphiques du Musée du
Louvre, legs du comte Isaac
de Camondo, 1911 (RF 4055)

Plate 36
Jean-Louis FORAIN
Negotiations in the Wings
c. 1898
Watercolor and India ink
on paper
12⅜ × 11¾ in. (31.5 × 30 cm)
Courtesy of Galerie Schmit,
Paris

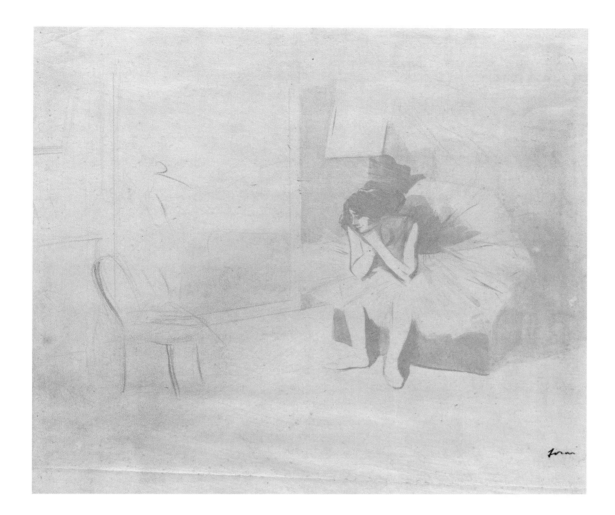

Plate 37
Jean-Louis FORAIN
*Dancer Seated in Her
Dressing Room*
c. 1895
Lithotint on china paper
13¼ × 14 in. (33.7 × 35.6 cm)
Boston Public Library, Print
Department, Albert H. Wiggin
Collection

It is in Forain's dressing-room scenes that venality often comes to the fore. In *The Dancer and Her Friend* (plate 35), the exchange of glances conveys nuances—stealthy on the part of a dancer who slips her hand into an *abonné*'s jacket, presumably to steal from him, and distrustful on his part. In *Dancer Seated in Her Dressing Room* (plate 37), the ballerina stares at an empty chair across from her: the *abonné* has apparently abandoned her, and she realizes that the source of her upkeep is gone.

The dancers' mothers played an important role in dancer-*abonné* relationships, and Forain exposes the often mercenary aspects of the triangle; these images, too, are often set in the dressing room. The mother seated before the *abonné* in *The Dancer's Necklace* (plate 34) smiles in approval of the trinket the man has just given her daughter. In *Negotiations in the Wings* (plate 36), the mother sits before an *abonné,* apparently bargaining or pleading. Forain makes her face into an ugly caricature, using class-based stereotypes—her coarse features, her heavy body past its prime, her frumpy clothing—to stress her lack of polish. The hideous face ties into Forain's own cynicism about a social structure, based on inequality, that encouraged sexual exploitation and its impact on dancers and their families. These images reveal Forain caught between his class of birth and aspirations to grandeur. He satirizes all parties, as he cannot comfortably claim either world for himself.

Lautrec: Erotic Subtexts and Individual Eccentricities

An aristocrat from an ancient family in southwestern France, Lautrec was captivated by the entertainment zones of the demimonde in bohemian Montmartre and later the Champs-Élysées. The mingling of social classes and the chic but seamy atmosphere of sensual excess and indulgence in the dance halls, cabarets, cafés-concerts, circuses, and brothels made these locales fertile ones for his investigations. Though his background of privilege set him apart from the lower-class per-formers here—the dancers, acrobats, singers, and clowns—his decadent and dissolute lifestyle, including alcoholism, made him fit into the nighttime world of these establishments. He came to know his proletarian subjects, studying them in their working environments. Drawing on his familiarity with these performers, he created arresting images, making his subjects readily recogniz-able to the audience of his day by capturing characteristic poses, telling ges-tures, and signature accoutrements.

Lautrec is of course best known for his large color lithographic posters advertising star performers at the entertainment establishments and his small editions of prints relating to celebrities of the era. He created his revolution-ary posters during a period in which many factors converged to make them possible.[23] An 1881 law recognizing freedom of the press facilitated the growth of a new industry of poster designers, printers, and *afficheurs*. An infrastruc-ture of print dealers and publishers embraced the revitalized medium. Posters were avidly collected (even torn, illegally, from the walls they covered), and in 1889, the first large exhibition of French posters was held at the Exposition Universelle in Paris. Jules Chéret, the father of the illustrated color poster, had taken advantage of larger lithographic machines to print in a bigger format. He had also developed a method that used three stones for three colors and *crachis,* or spattered ink, for modeling. Working with master printers such as Père Cotelle and Henri Stern, Lautrec similarly developed the ability to use more stones and more colors, increasing the subtlety of the pictorial effects he could obtain. He and other artists were inspired by the concurrent vogue for Japanese woodblock prints, adapting their design principles—pure colors, flat surfaces, decorative lines, cropped forms, and unusual vantage points—to the production of an exciting new art form.

Lautrec transformed the large lithographic poster as an advertising form with Charles Zidler's commission in 1891 to create a poster for the Moulin Rouge, featuring the star performer, La Goulue (Louise Weber). In the resulting print, *Moulin Rouge–La Goulue* (plate 38), Lautrec shows her doing the *chahut,* executing a high kick that reveals her ruffled pantaloons under-neath. Even though the dance itself connoted sexuality, the costume of the *chahuteuse* had recently become fashionable attire for women of the upper classes.[24] Lautrec's poster shrewdly assimilates these contradictions, making La Goulue seem naughty, but nice. And it contains still other sexual innuendos. As Mary Weaver Chapin notes in her perceptive essay on Lautrec in this book,

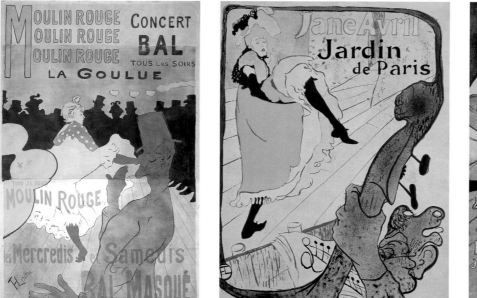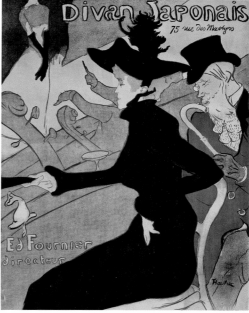

La Goulue's dancing partner, Jacques Renaudin, known as Valentin le Désossé (Valentin the Boneless), makes a lewd hand gesture with his thumb phallically extended toward the dancer's pubic area, while in the background the black silhouettes of top-hatted men and loose women with elaborate headdresses allude to sexual transactions and the mixing of classes. Legibility is enhanced by the arrangement of figures in parallel planes and the abstracting of the main subjects: Lautrec employs sinuous contours and flat color areas in his depiction of La Goulue, the focal point of the design, and he renders Valentin le Désossé as a boldly outlined shadowy form. By placing him in the fore-ground and cropping his figure, Lautrec makes him part of the viewer's space. With *Moulin Rouge—La Goulue,* Lautrec established the main features that would recur in his posters of celebrity dancers: fashionable dress, sexual refer-ences, simple design, and compositional devices that directly engage the viewer's position.

In other posters and prints for collectors of the time, Lautrec presents the human eccentricities of individual dancers, all the while maintaining an erotic subtext that speaks to the suggestive nature of their performances and the licentious pleasures available at these establishments. In the poster that Jane Avril commissioned for her performance at the Jardin de Paris, on the Champs-Élysées, which appeared in 1893, the star's emotionless face denies her inner life to the spectators, while the lifting of her black-stockinged legs against her underskirts with their undulating hems represents a public erotic display (plate 39).[25] Sexual connotations are pungently emphasized by the hairy hand that grasps the double bass enframing the composition. Lautrec makes overt

the subtle phallic reference in the rising double bass in works by Degas (see fig. 1). We view the dancer from below, as if we were seated behind the musician at the lower right; like Degas, Lautrec thus references a male spectator.

In the 1893 poster commissioned late the previous year by Édouard Fournier, the owner of the Divan Japonais, the singer Yvette Guilbert occupies the background, her head cropped at the edge of the image (plate 40). Our attention is riveted on Avril, shown as one of the cultured spectators who frequented that establishment. Seated just behind the orchestra and dressed entirely in black, she dominates the composition in the foreground with her emphatic silhouette and her elaborate signature hat. She appears to ignore the advances of the figure who accosts her from behind, the literary, music, and art critic Édouard Dujardin. Erotic symbols abound: her imperious flick of the wrist with her fan nicely balances the phallic suggestions of the contrabasses, Dujardin's cane, and Avril's own drooping purse. These two figures are cut off at knee length, a device that pulls us closer into the scene.

The top-hat-wearing Dujardin is one instance of Lautrec's inclusion of his own circle of pleasure-seeking male friends in his posters, collectors' prints, and paintings—the reality of the upper classes "slumming" in the entertainment establishments. By showing Avril as a spectator, aloof from aggressive sexual advances, Lautrec references changes occurring among women in Parisian society at that time, as they became more independent and self-actualized.

Lautrec depicted the female clown, acrobat, and dancer Cha-U-Kao several times, including in his sumptuous collectors' series *Elles,* depicting brothel life. In the enigmatic lithograph *The Seated Clowness* (*Mademoiselle Cha-U-Kao*) from this series (plate 41), her pose with forearms resting on her thighs

Plate 41
Henri de TOULOUSE-LAUTREC
The Seated Clowness (Mademoiselle Cha-U-Kao),
from the suite *Elles*
1896
Color lithograph on paper
20⅝ × 15⅞ in. (52.4 × 40.3 cm)
Portland Art Museum, Gift from the Collection of Laura and Roger Meier, 2004.122.3

Plate 42
Henri de TOULOUSE-LAUTREC
Dance at the Moulin Rouge
1897
Brush and spatter lithograph with scraper, printed in black and four colors on china paper, laid down on mat board
16⁵⁄₁₆ × 13⅝ in. (41.4 × 34.6 cm), trimmed
Milwaukee Art Museum, Gift of Mrs. Harry Lynde Bradley, M1964.57

Plate 43
Henri de TOULOUSE-LAUTREC
Cha-U-Kao at the Moulin Rouge
1897
Crayon, brush, and spatter lithograph printed in dark brown, gray-brown, orange-yellow, yellow, red, and blue on paper
15¹⁵⁄₁₆ × 12¹¹⁄₁₆ in. (40.5 × 32.2 cm)
Boston Public Library, Print Department, Albert H. Wiggin Collection

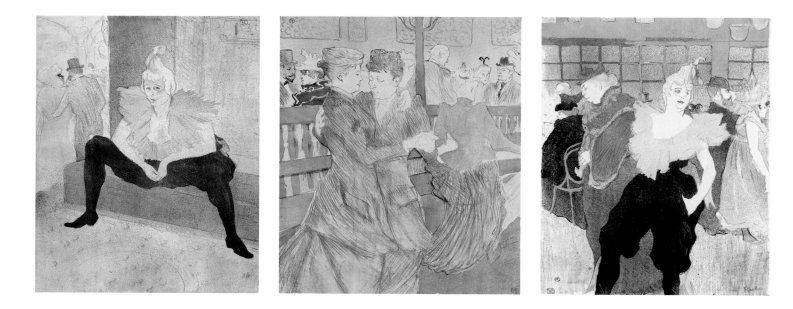

and silhouetted legs in black tights set brazenly apart is a more aggressive version of a pose Lautrec used a decade before in a painting of a seated dancer (page 143, fig. 5).[26] Cha-U-Kao's hands form a triangle suggestive of the pudendum, a crude gesture that may refer to the sexual commerce implied by the couple in the left background, or to the scenes from the lives of prostitutes depicted in *Elles*. Much of the force of this image lies in Cha-U-Kao's eyes—she looks at the viewer directly with a world-weary, ironic gaze.

In other images of Cha-U-Kao, the artist subtly alludes to her lesbian identity. Lesbians were prevalent in Paris during this period, particularly among dancers and other performers. In a lithograph of 1897, Lautrec shows Cha-U-Kao dancing with another woman in a tender embrace as they move to the music (plate 42). In another lithograph of the same year, she is shown arm in arm with the frumpy-looking Gabrielle-la-danseuse as she cruises the Moulin Rouge, hands thrust in her pockets (plate 43). Again, Lautrec stresses her humanity through her gaze, here a look of longing.

In his advertising posters designed to catch the eye on the street and in his prints meant for the delectation of the private viewer, Lautrec variously used innuendo to convey a sexual subtext in his images of dancers. Such allusions fit in with clichés about the sexual availability of dancers in fin de siècle Paris. Yet, with sensitivity to their gazes, gestures, and poses, the artist made their sexuality an integral part of their humanity. In focusing on performers who were considered to be on the margins of proper society, Lautrec brought to the fore these women's independence of choice and their alternative lifestyles outside the constraints of the bourgeoisie.

Representations of the dancer by Degas, Forain, and Lautrec are far more than explorations of form. Degas draws attention to the artifice of the spectacle and evokes the physical reality of the ballerina's life behind the scenes. Forain castigates the social inequities that made the exchange of money for sex a dilemma in the dancer's life. And Lautrec uses sexual references in his depictions of *chahuteuses* both to titillate and to stress the humanity of women whom society treated as commodities. Through these images, each artist in his own way investigated modernity in fin de siècle Paris, evoking issues of class, gender, and the urban milieu.

NOTES

1. On the dancer and *abonnés* as well as the social posi-
 tion of the ballet dancer, see Ivor Guest, *The Ballet of
 the Second Empire, 1847-1858* (London: A. and C. Black,
 1955), 14-23; Eunice Lipton, *Looking into Degas:
 Uneasy Images of Women and Modern Life* (Berkeley:
 University of California Press, 1986), 79-91; Robert L.
 Herbert, *Impressionism: Art, Leisure, and Parisian
 Society* (New Haven, CT: Yale University Press, 1988),
 103-7; and Jill DeVonyar and Richard Kendall, *Degas
 and the Dance* (New York: Harry N. Abrams, in asso-
 ciation with the American Federation of Arts, 2002),
 19-23, 35-36, 120-22.

2. On the popular establishments, see T. J. Clark, "A Bar
 at the Folies-Bergère," chap. 4 in *The Painting of
 Modern Life: Paris in the Art of Manet and His Follow-
 ers* (New York: Alfred A. Knopf, 1985), 205-58; Robert L.
 Herbert, "Café and Café-Concert," chap. 3 in *Impres-
 sionism: Art, Leisure, and Parisian Society*, 59-91; and
 Richard Thomson, "The Imagery of Toulouse-Lautrec's
 Prints," in Wolfgang Wittrock, *Toulouse-Lautrec: The
 Complete Prints*, 2 vols., ed. and trans. Catherine E.
 Kuehn (London: Philip Wilson Publishers for Sotheby's
 Publications, 1985), vol. I, 14-16.

3. See Alex Potts, "Dance, Politics and Sculpture," *Art
 History* 10, no. 1 (March 1987): 97-105.

4. See, for example, his pictures of the dancer and the
 abonné on pages 25 and 61.

5. Linda D. Muehlig, in *Degas and the Dance* (Northamp-
 ton, MA: Smith College Museum of Art, 1979), notes, in
 reference to Smith College's Degas painting *Dancer
 on Stage*, that "Degas does not destroy the illusion
 meant to be evoked by the performance, he instead
 shows the means by which the illusion was created"
 (p. 6).

6. Gary Tinterow, "The 1880s: Synthesis and Change,"
 in Jean Sutherland Boggs et al., *Degas* (New York:
 Metropolitan Museum of Art; Ottawa, National Gallery
 of Canada, 1988), 365-66. Tinterow is referring to
 Degas's work in the 1880s and beyond; however,
 I would argue there is relevancy to the work of the
 1870s as well.

7. On Degas's access backstage, see DeVonyar and
 Kendall, *Degas and the Dance*, 77-79.

8. See the extended analysis of the spatial structure of
 the paintings in Mari Kálmán Meller, "Exercises in and
 around Degas's Classrooms," pt. I, *Burlington Maga-
 zine*, March 1988, 208-12.

9. As noted by George Shackelford, *Degas: The Dancers* (Washington, DC: National Gallery of Art, 1984), 27–28; and Meller, "Exercises in and around Degas's Classrooms," 208–9.

10. On the dancer's training, see Guest, *The Ballet of the Second Empire,* 6–14; and DeVonyar and Kendall, *Degas and the Dance,* 129–33.

11. Another adjunct to Degas's image making was photography, a medium in which he experimented. He made photographs of models who posed in his studio for motifs he would then develop and repeat in his drawings and pastels. Though his photographs are not included in the current exhibition, see the discussions in Jean Sutherland Boggs, "The Dancer in the Amateur Photographer's Studio," in Boggs et al., *Degas,* cat. nos. 357–60, pp. 568–74; and Malcolm Daniel, *Edgar Degas: Photographer* (New York: Metropolitan Museum of Art, 1998), 43–46, 136–37, cat. nos. 42–44.

12. For the dating of the sculptures, see Charles Millard, "The Development of Degas's Sculptural Style," in Joseph S. Czestochowski and Anne Pingeot, *Degas Sculptures: Catalogue Raisonné of the Bronzes* (Memphis: Torch Press and International Arts, 2002), 67–73, revised version of the chapter of the same title first published in Charles Millard, *The Sculpture of Edgar Degas* (Princeton, NJ: Princeton University Press, 1976).

13. See John Rewald, "Edgar Degas—Original Wax Sculptures," in Czestochowski and Pingeot, *Degas Sculptures,* 280, reprint of Rewald's publication of the same title (New York: M. Knoedler, 1956); and Czestochowski, "Degas' Sculptures Re-examined: The Marketing of a Private Pursuit," in Czestochowski and Pingeot, *Degas Sculptures,* 11–25, esp. 13.

14. This drawing may have initiated the series; see Michael Pantazzi, catalogue entry in Boggs et al., *Degas,* cat. no. 223, pp. 346–47.

15. On the divergences in the position of the nude figure's proper right foot between the bronze cast and the wax original, see Arthur Beale, "*Little Dancer, Aged Fourteen:* The Search for the Lost *Modèle,*" in Czestochowski and Pingeot, *Degas Sculptures,* 90, reprint of Beale's essay of the same title in Richard Kendall, *Degas and the Little Dancer* (New Haven, CT: Yale University Press; Omaha: Joslyn Art Museum, 1998).

16. Richard Kendall, catalogue entry in Richard Kendall, Anthea Callen, and Dillian Gordon, *Degas: Images of Women* (Millbank, London: Tate Gallery Publications, 1989), cat. no. 27, p. 53.

17. See Richard Kendall, *Degas: Beyond Impressionism* (London: National Gallery Publications; Chicago: Art Institute of Chicago, 1996), 186–88.

18. Ibid., 187–88.

19. Noted by DeVonyar and Kendall, *Degas and the Dance,* 69–71.

20. On differences between Degas's and Forain's approaches to the ballet and other modern subjects, see Alicia Craig Faxon, *Jean-Louis Forain: A Catalogue Raisonné of the Prints* (New York: Garland Publishing, 1982), 9–10, 41–43; and Lillian Browse, *Forain the Painter, 1852–1931* (London: P. Elek, 1978), 27–28.

21. See Theodore Reff, "Le Petit Forain and Monsieur Degas," in Theodore Reff and Florence Valdès-Forain, *Jean-Louis Forain, the Impressionist Years: The Dixon Gallery and Gardens Collection* (Memphis: Dixon Gallery and Gardens, 1995), 13; and Florence Valdès-Forain, "A Portrait of Jean-Louis Forain," in ibid., 24–25.

22. See also Florence Valdès-Forain, catalogue entry in Theodore Reff and Florence Valdès-Forain, *Jean-Louis Forain: Les Années impressionnistes et post-impressionnistes* (Lausanne: Fondation de l'Hermitage; Paris, Bibliothèque des Arts, 1995), cat. no. 95, p. 153.

23. See Phillip Dennis Cate and Sinclair Hamilton Hitchings, *The Color Revolution: Color Lithography in France, 1890–1900* (Santa Barbara, CA: Peregrine Smith, 1978), 2–17.

24. Gale B. Murray, "The Theme of the Naturalist Quadrille in the Art of Toulouse-Lautrec: Its Origins, Meaning, Evolution, and Relationship to Later Realism," *Arts Magazine,* December 1980, 74.

25. On the public and private aspects of this depiction, see Mary Weaver Chapin's essay in this book and her essay "Stars of the Café-Concert," in Richard Thomson, Phillip Dennis Cate, and Mary Weaver Chapin, *Toulouse-Lautrec and Montmartre* (Washington, DC: National Gallery of Art and the Art Institute of Chicago, in association with Princeton University Press, 2005), 139.

26. This has been noted by Richard R. Brettell, catalogue entry in Richard R. Brettell, *Monet to Moore: The Millennium Gift of Sara Lee Corporation,* with Natalie H. Lee (New Haven, CT: Yale University Press, 1999), cat. no. 49, p. 191 n. 6. Brettell points out that Cha-U-Kao, shown frontally, is seated lower, with her feet more widely spread.

Opposite:
Plate 44
Jean-Louis FORAIN
Dancer at the Barre
c. 1885
Watercolor and ink on paper
10⁵⁄₁₆ × 6½ in. (26.2 × 16.5 cm)
The Dixon Gallery and Gardens, Memphis, Tennessee, Museum Purchase, 1993.7.25

Richard Kendall

Space and Narrative in Degas, Forain, and Toulouse-Lautrec

In the Wings

EDGAR DEGAS FIRST EMERGED as a specialist painter of the ballet in the early 1870s, as he approached the age of forty. By mid-decade, after an extraordinary burst of creativity, he had created a highly original repertoire of dance imagery that dominated perceptions of his achievement for more than a century. So successful was this new pictorial vocabulary that it was rapidly adopted by a number of younger painters and draftsmen, some of whom would exploit it for the rest of their careers. A major paradox of the period, however, lies in the fact that Degas himself soon moved on to revise and inflect, and ultimately to abandon, much of the visual language that had brought him fame as "the painter of dancers." Though he continued to choose ballet subjects for some of his most distinctive inventions in expressive color and form, the character of his later dance art changed profoundly. Topical allusions faded, along with the deep spaces and fastidious description of his novice years, in favor of an unprecedented monumentality. The result was a curious generation gap, as Degas's disciples and imitators—Jean-Louis Forain, Paul Renouard, Louis Legrand, Henri de Toulouse-Lautrec, and others— derived their manner from a Degas who had effectively ceased to exist.

 A little-studied feature of this story is the role of competing notions of realism within Degas's artistic milieu. At the beginning of this period, Degas openly associated with realist principles, while defining them broadly: in 1873, for example, he wrote to the painter James Tissot, urging him to join the group that would soon be known as the Impressionists, describing them as "a salon of realists."[1] Tissot's exquisitely detailed canvases of modern bourgeois life had already brought him financial success, and he declined Degas's invitation to exhibit. But a range of broadly "realist" styles was markedly on display at

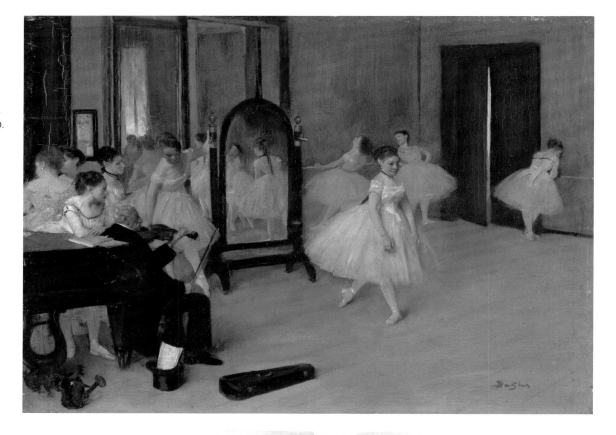

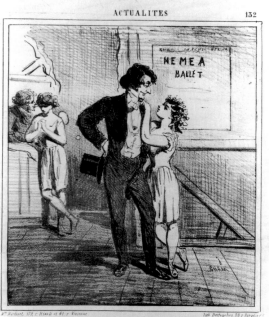

the first Impressionist exhibition, held in Paris in the spring of 1874, when Degas's highly refined *The Dancing Class* (fig. 1) formed part of his own submission. At the opposite extreme stylistically, Degas was openly engaged with a quite different kind of realist imagery during these same years, as represented by the lithographs of illustrators such as Honoré Daumier, Paul Gavarni, and Cham (fig. 2). Their vigorous, acerbic line drawings in black and white offered a clearly defined approach to narrative, as well as a ready-made iconography of theatrical motifs. In the absence of an established tradition of ballet painting, Degas brazenly appropriated certain of his compositions from this source, along with something of its graphic urgency and spatial inventiveness.[2]

The most authoritative account of Degas's artistic project in the early Impressionist period is probably that of Edmond Duranty, a novelist and critic who had long been associated with the promotion of realism in literature and the visual arts. Duranty's extended essay *The New Painting* was published in the spring of 1876 to coincide with the second exhibition of the Impressionist collective, when more than twenty new works by Degas were displayed.[3] Artist and writer were well acquainted, and Degas apparently collaborated on Duranty's text, which emphasized the potential of urban themes—Degas's preferred territory—rather than the rural landscape. Coyly omitting the names of the painters involved, Duranty announced that they had chosen "to eliminate the partition separating the artist's studio from everyday life, and to introduce the reality of the streets" into their pictures.[4] The Impressionists' models were located in plausible, carefully observed spaces, he explained: "in actuality, a person never appears against neutral or vague backgrounds."[5] With certain of Degas's exhibited works clearly in his mind, among them a study made in New Orleans, *Portraits in an Office,* and his *Yellow Dancers (In the Wings)* (fig. 3), Duranty continued: "the individual will be at a piano, examining a sample of cotton in an office, or waiting in the wings for the moment to go onstage."[6] This pictorial novelty,

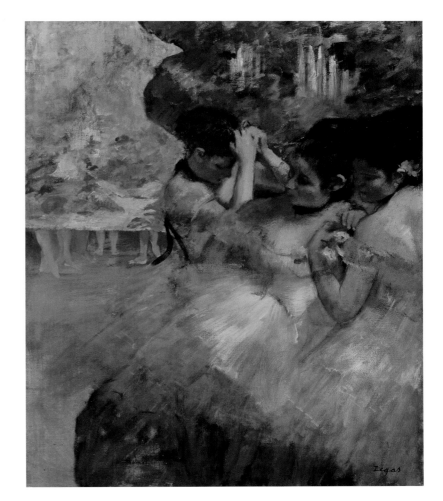

however, concerned not only subject matter but also "a new method of color, of drawing, and a gamut of original points of view." In the work of Degas and some of his colleagues, Duranty indicated, the spectator's visual experience might include "the large expanse of ground or floor in the immediate foreground. Sometimes our viewpoint is very high, sometimes very low; as a result we lose sight of the ceiling, and everything crowds into our immediate field of vision."[7]

"The individual . . . waiting in the wings" became an iconic image in the work of Degas and his successors, among them Forain and Lautrec. The *coulisses,* or theater wings, represented one of the unstable social sites of the age, where public

Fig. 3
Edgar DEGAS
Yellow Dancers (In the Wings)
1874–76
Oil on canvas
28⅞ × 23⅜ in. (73.5 × 59.5 cm)
The Art Institute of Chicago, Gift of Mr. and Mrs. Gordon Palmer, Mrs. Bertha P. Thorne, Mr. and Mrs. Arthur M. Wood, and Mrs. Rose M. Palmer, 1963.923

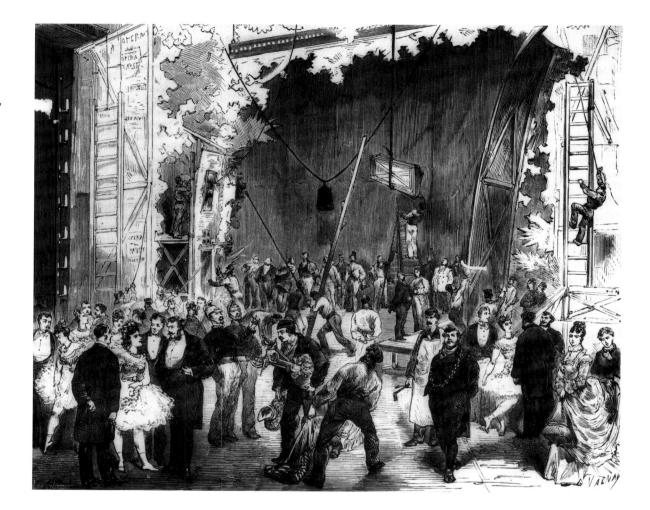

Fig. 4
VALNAY
The Wings at the Opéra,
illustrated in *Le Nouvel
Opéra* by Alphonse Royer
(Paris: Michel-Lévy frères,
1875)
Bibliothèque nationale de
France, Paris

fantasy met practical reality, and where norms of behavior could dissolve. This indeterminate region was legendary among social commentators, novelists and gossips, and the commonplace graphic chroniclers of Parisian life. Valnay's 1875 black-and-white drawing of backstage chaos at the newly opened Opéra, situated in the center of the city, encapsulated many aspects of the genre (fig. 4). Looking toward the lowered curtain in the background, we encounter stagehands and theater officials, the apparatus of illusion and the mundane sight of ropes and pulleys, ladders and scenery. Characteristic also are the ballerinas surrounded by their male retinue, all shown waiting in the wings for the performance to continue. Hard work and blatant flirtation coexist in this overcrowded panorama, where realism is predicated on encyclopedic inclusiveness. Typical of this journalistic-realist mode is the deep space between foreground characters and more distant activity,

which allows for multiple narratives to unfold in our imagination. Equally definitive is the hallucinatory detail in Valnay's image, pervading the entire scene without discrimination.

Contrasted in almost every other respect, Degas's oil painting *Yellow Dancers (In the Wings)* (fig. 3) is based essentially on the same physical context as Valnay's illustration. Again, we look across the Opéra stage while the set is being adjusted between acts, as a row of pink legs beneath a scenery panel at left indicates. Like Valnay, too, is the sense that this precisely described decor and the carefully characterized costumes relate to a specific production, such as those Degas is known to have witnessed—sometimes at close quarters—at the Paris Opéra during these years.[8] Yet Degas's language of realism is at the opposite extreme from that of Valnay. The wide, inclusive view in the published drawing is replaced by

a startling close-up of just three dancers, so adjacent to the viewer that their legs are cropped by the canvas edge. Even more drastically cut from our visual field are the backstage mechanics as well as the stage laborers and managers engaged with them that occupy so much of Valnay's design. Also rejected is the deep, lucid space in which such multitudinous functions can coexist and other scenarios can develop. In *Yellow Dancers (In the Wings),* we experience a more immediate confrontation, which surely corresponds with the "gamut of original points of view" described by Duranty. Almost a paradigm of what he saw as the visceral nature of Degas's early Impressionist oeuvre, this canvas combines the documentary function of real, carefully observed spaces with its opposite, a thoroughly modern moment when "everything crowds into our immediate field of vision."

As the irregular series of Impressionist exhibitions proceeded, Degas advanced in pictorial audacity and thematic originality, showing paintings of dance rehearsals and classrooms as well as variations on the subject of the wings. At the third exhibition, held in 1877, he listed nine ballet-based works in the catalogue, and in 1879, there were approximately eleven items of a similar kind.[9] More discreetly, Degas was extending his range in another direction, creating studies of *abonnés*—black-suited male subscribers to the Opéra—and scenes of ballerinas in their private dressing rooms. A virtuoso draftsman and printmaker, Degas now chose the graphic media to explore the profession's seamier side, most remarkably in a suite of black-and-white monotypes of backstage pursuit and seduction, such as *Pauline and Virginie Conversing with Admirers* (fig. 5). In making these monotypes between 1876 and 1877, Degas turned away from the prevalent manner of his own exhibited paintings and pastels. Working now in monochrome and on a smaller scale, he frankly adopted the syntax of his most distinguished forebears in the popular press. Comparable images of predatory *abonnés* behind the scenes at the Opéra were a staple of lithographs by Gavarni and Cham, who had mastered the subtle semaphores of the dancers' rejection of—and overtures toward— their male attendants. Degas's print openly embraces this world, with its simplified structures and lugubrious narratives, in a series of subtle acts of homage. It even has something in common with the stock-in-trade of Valnay, whose ambitious drawing also included a strikingly similar group of ballerinas and admirers at lower left.

By the end of this decade, Degas's paintings, pastels, and prints of various kinds had emphatically staked out the contemporary ballet as his artistic terrain while simultaneously defining a visual grammar that seemed inseparable from them. If much of this account is familiar to students of Degas today, its aftermath is less often noted. An examination of Degas's publicly presented work reveals that his professional tactics had already begun to shift in a decisive manner. At the fifth Impressionist exhibition, in 1880, for example, Degas presented just three dance images, and at his last two appearances in this sequence of exhibitions, in 1881 and 1886 respectively, not a single ballet picture by Degas was featured. For reasons that are undocumented,

Fig. 5
Edgar DEGAS
Pauline and Virginie Conversing with Admirers, illustration for
La Famille Cardinal
1876–77
Monotype
8⅞₁₆ × 6⅜₁₆ in. (21.5 × 16 cm)
Harvard University Art Museums, Fogg
Art Museum, Cambridge, Massachusetts,
Bequest of Meta and Paul J. Sachs, M14295

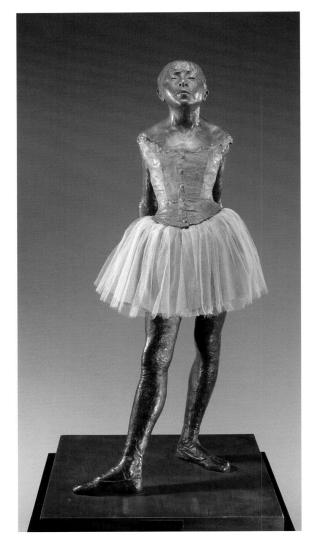

though apparently concerned with new technical preoccupations and a need to extend and reposition his art in midcareer, Degas no longer chose to define himself as an inveterate painter of the Paris Opéra. His growing influence on the younger generation may also have been a factor, as some of them—such as Forain and Federico Zandomeneghi—began to show work alongside the senior Impressionists, including images of dancers and the theater. At the 1881 exhibition, Degas signaled a broadening practice by unveiling his first large-scale sculpture, the wax figure of *Little Dancer, Aged Fourteen* (plate 45), which launched his reputation as a pioneer of three-dimensional realism. In 1886, at the final group display, he once again antagonized his critics and thrilled his supporters with a suite of pastels, this time concentrating specifically on nude women at their toilette.

Forain was twenty-three years old when Duranty's *The New Painting* appeared and Degas's *Yellow Dancers (In the Wings)* was originally shown. Born in Reims but a resident of Paris since his youth, Forain had recently begun to capitalize on his gifts as a draftsman to launch a career as an artist of the city's nightlife. A gregarious urbanite, he may well have visited the second Impressionist exhibition, where Degas's canvas hung, and soon befriended the artist himself. Degas is said to have invited the younger man to participate in the 1879 exhibition, in which Forain confidently displayed a large group of watercolors and a cluster of fan designs.[10] On this occasion, Forain's adulation for his mentor was barely concealed; like Degas, he submitted exactly two dozen works, among them Forain's own variations on the café scene, on ballet dancers and *abonnés,* and on actresses in their backstage quarters. While many of these pictures remain unidentified, a watercolor dated 1879, now known as *Intermission. On Stage* (plate 46), may have been among them. Drafted in his unmistakable linear hand, this work is surely Forain's own act of homage to Degas's *Yellow Dancers (In the Wings).* Here again, we encounter an offstage area busy with ballerinas, where "everything crowds into our field of vision," a location made explicit in brightly colored outfits and a painted scenery flat at left, and a sense of casual human events caught unawares. Even Forain's loose application of color, evident in the slashed green brushstrokes of the tutus, seems to echo the free handling in parts of Degas's composition.

Vivid and topical, Forain's *Intermission. On Stage* can be grouped loosely within the new aesthetic spelled out by Duranty and endorsed by Degas. The following year, Forain was hailed as a realist himself, when a cluster of similar works was admired for their "powerful reality": "Monsieur Forain is one of the most incisive painters of modern life that I know," wrote the novelist and art critic Joris-Karl Huysmans.[11] Conspicuous in Forain's painting, however, are a number of pictorial, narrative, and spatial elements that have no equivalent in Degas's *Yellow Dancers (In the Wings).* Most immediately, the intrusion of a large male figure at left in *Intermission. On Stage* is without precedent in Degas's painted oeuvre, in which *abonnés* are few and almost invariably appear as discrete, distant presences. When exceptions occur, as in the small canvas

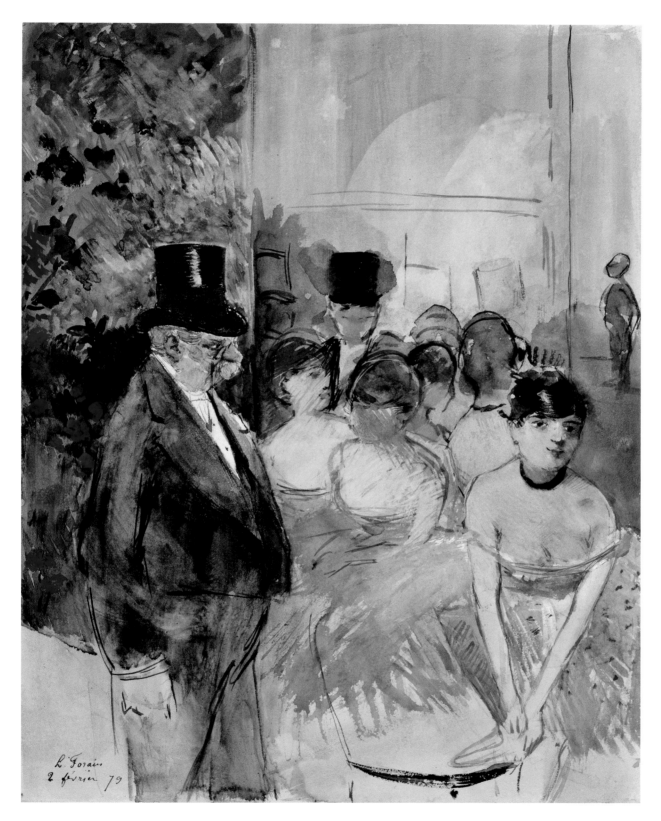

Plate 46
Jean-Louis FORAIN
Intermission. On Stage
1879
Watercolor, gouache, and India
ink, with graphite (traces) on
wove rag paper
13⅞ × 10¹¹⁄₁₆ in. (35.3 × 27.2 cm)
The Dixon Gallery and Gardens,
Memphis, Tennessee, Museum
Purchase, 1993.7.3

47

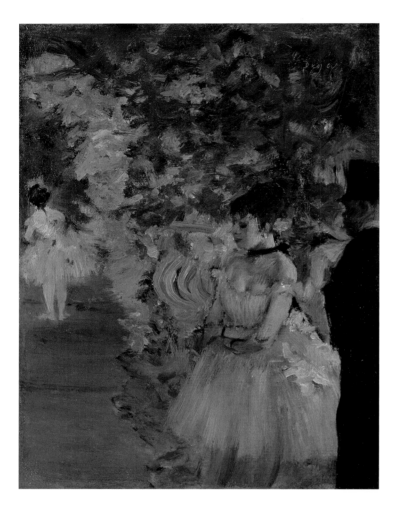

Plate 47
Edgar DEGAS
Dancers Backstage
1876 /1883
Oil on canvas
9½ × 7⅜ in. (24.2 × 18.8 cm)
National Gallery of Art,
Washington, DC, Ailsa Mellon
Bruce Collection 1970.17.25

Dancers Backstage (plate 47), the male character is cut off by the frame or absorbed in shadow, generating ambiguity rather than the frank display of lust in Forain's watercolor. Just as anomalous in any painting by Degas would have been the exaggerated, almost caricatural posture of the principal ballerina in *Intermission. On Stage,* who calmly displays her body to the enraptured man. Nothing is left to our imagination in the *abonné*'s intense leer or in the dancer's vacant expression, both of them comical and grotesque at the same time. Here, the sexual traffic of the theater world, a phenomenon extensively documented in the cartoons, cheap journalism, and popular literature of the time, is crudely set out in a painting for all to see.

The critical distinction between these pictures by Forain and Degas, however, is not a moral one but a question of visual language. As we have seen, the "reality" advocated by Duranty was concerned not with high ideals but with frank encounters in the public spaces and energized interiors of the contemporary world. Crowded corners and yawning voids were the essence of this mode, and in *Intermission. On Stage,* Forain has exploited their potential to good effect, thrusting the *abonné* toward us and echoing his figure in a tiny gray silhouette at right, across the expanse of the stage. Structurally, Forain's image is linked with Degas's *Pauline and Virginie Conversing with Admirers,* made two or three years earlier. In that monotype, another cluster of Opéra subscribers surrounds a pair of dancers, this time in a backstage corridor, while a distant blur—probably the girls' chaperone—reminds us that life continues elsewhere.

Crucial to the identity of Degas's print, however, is the fact that it was created as one of a series of projected illustrations for a book, a collection of short tales about the fictitious Cardinal family written by his friend Ludovic Halévy.[12] Set in the foyer and stairways of the Opéra building, these works by Degas were explicitly literary and descriptive, in ways that have very few counterparts in his paintings and pastels. An exception in his own oeuvre, they seem to point to a more general rule: anecdote and narrative were reserved by Degas for his graphic output, along with the pictorial conventions that sustained these devices. In this context, he turned naturally to work by his admired predecessors—in the *Famille Cardinal* series, certain of Daumier's lithographs are cited directly—in which economy of line and clarity of bodily expression were essential to their purposes. Deep, articulate spaces were also associated with this mode, whether in the ingenious hands of

Gavarni or the more predictable manner of Valnay. Judged in
these terms, the disjunction between Degas's small picture and
Forain's is fundamental. Whereas Degas has used the language
of illustration in the context for which it was perfected—in
essence, to tell a simple, rapidly assimilated story—Forain has
transposed it to the alien territory of painting. Instinctively, we
read Forain's characters and find amusement in his plausible,
localized drama as if it were a cartoon. Once enjoyed, our atten-
tion moves on.

Degas's continuing acquaintance in later years with Forain
and his family and his respect for the younger man's abilities are
matters of record.[13] According to Walter Sickert, a well-known
painter in the circle of Degas, Forain, and Lautrec, a special table
was kept in Degas's apartment in the 1890s for Forain's recent
satirical drawings, though it is perhaps significant that only
one of the latter's oil paintings featured in Degas's extensive art
collection.[14] Degas had no illusions about his acolyte's sources;
when he remarked that Forain "paints with his hands in my pock-
ets," he was surely thinking of more than Forain's eclecticism.[15]
Ideally placed to understand Forain's methods, Degas must have
realized that it was his own small-scale graphic artworks—such
as the monotypes and other prints—rather than his canvases
that were the real models for Forain's artistic achievement.
The visual boldness learned from such early pictures as *Yellow
Dancers (In the Wings),* combined with hints of stylized drawing
and caricature from the *Famille Cardinal* images, would surface
repeatedly in Forain's pictures—now enlarged and developed
in color—where they provided the foundation for much of his
mature ballet oeuvre.

The passing years brought a marked polarization between
the art of Degas and that of Forain, despite the two men's con-
tinued personal warmth.[16] By the late 1880s, Degas was steadily
shifting his interests from the wide spectacle of the Opéra stage
and its spacious classrooms toward the depiction of a few danc-
ers absorbed in their craft. *Abonnés* and their gross antics disap-
peared almost completely from his lexicon, as did scurrilous
incidents behind the scenery and much of the minutiae of the-
ater life. There were occasional throwbacks, often in the form
of repainted canvases or revisited motifs, where the occasional
male spectator might appear at the periphery.[17] But in a pastel
from the end of the century such as *Red Ballet Skirts* (fig. 6),
Degas definitively separated himself from the oeuvre that had
made his name two decades earlier. While these two dancers
might still be "waiting in the wings," they have little in common
with the aggressively crowded ballerinas in *Yellow Dancers*

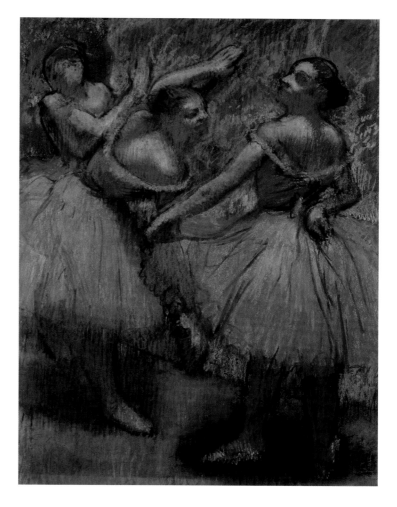

Fig. 6
Edgar DEGAS
Red Ballet Skirts
c. 1897–1901
Pastel on tracing paper
32 × 24½ in. (81.3 × 62.2 cm)
Glasgow City Council
(Museums), The Burrell
Collection, 35.243

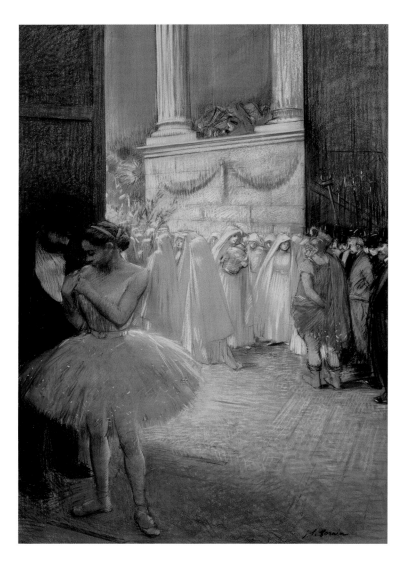

(In the Wings). No longer cropped by the frame, their limbs and gestures are comfortably contained within the picture rectangle, suggesting the wholeness and composure of a classical relief. With no narrative expectation, depth, too, is suppressed, here by a massive scenery element that is almost parallel to the picture plane, blocking the entire distant view. Most distinctive of all is a sense of uncertainty about the activities of these individuals, who could be performing, stretching themselves, or simply resting. Caught in a timeless, enigmatic envelope of color and texture, they are as far from characters in a work of illustration as Degas could take them.

A pastel by Forain of almost the same date, *Backstage at the Opéra during a Performance of "Aïda"* (plate 48), reveals both his undoubted progress in technical terms and his determined attachment to an overly familiar idiom. Yet again, we find ourselves at the periphery of the stage, a territory to which Forain turned obsessively and even monotonously as he grew older. In his pastel, Forain's solitary dancer awaits her moment in the spotlight, as Verdi's opera progresses in the vast spaces of the theater beyond. Any doubt about these events is dispelled by Forain's painstaking articulation of foreground, middle ground, and distance, within which the dramatis personae are clearly free to move. This is a narrative arena, deep and spectacular, but essentially frozen by the conventions of earlier decades, even generations. It is modern by virtue of its subject, yet ultimately rooted in the late academic tradition and echoed in the labored offshoots of that school as represented by Valnay. If the ballerina and her *abonné*-consort at left still pay distant homage to Degas's *La Famille Cardinal* scenes, any sense that this group "crowds into our immediate field of vision" in a stimulating or provocative fashion has long since evaporated.

Lautrec was both more limited in his interest in the ballet than Forain and more complex, imaginative, and alertly self-critical as an artist. Paradoxically, Degas never warmed to Lautrec as a person, perhaps sensing a rival in this talented, socially eccentric individual. As did Forain, Lautrec revered the older Impressionist, living close to Degas's apartment on the rue Victor Massé in lower Montmartre and sharing certain friends with him, such as the Opéra bassoonist Désiré Dihau.[18] Degas once told the English painter William Rothenstein that he was "interested" in Lautrec's work, and he certainly helped him at times. In September 1891, in a letter to his mother, Lautrec wrote: "Degas has encouraged me by saying my work this summer wasn't too bad. I'd like to believe it."[19] But Degas

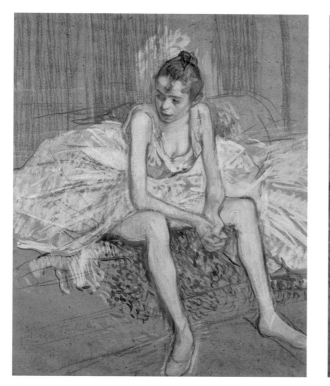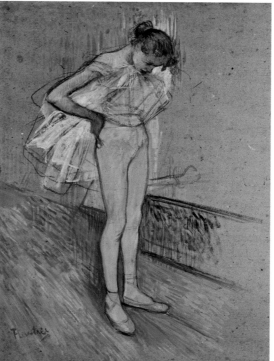

Fig. 7
**Henri de TOULOUSE-
LAUTREC**
*Seated Dancer with
Pink Tights*
1890
Oil and pastel on board
22¾ × 18½ in. (57.5 × 46.7 cm)
Private collection

Fig. 8
**Henri de TOULOUSE-
LAUTREC**
*Dancer Adjusting
Her Leotard*
1890
Oil on board
23¼ × 18⅛ in. (59 × 46 cm)
Private collection

stopped short of acquiring Lautrec's pictures for himself, owning neither paintings nor graphic work by his hand.

From his beginnings in this milieu, Lautrec tended to show his respect— and his good sense—by not challenging Degas on his painterly home ground. There seem to be few, if any, dance pictures by Lautrec, for example, that can be traced to the solemn precincts of the Opéra, despite his known acquaintance with that institution. But as with Forain, certain of his works appear to be overt gestures toward Degas's example: a study of Dihau playing his instrument, presumably in the Opéra orchestra; several *abonné*-like figures in backstage corridors; and miscellaneous dancers posturing offstage.[20] At his most humane, Lautrec applied a remarkable graphic mastery to the project of painting two superb pictures of dancers at rest, apparently in dressing rooms or the wings: *Seated Dancer with Pink Tights* (fig. 7) and *Dancer Adjusting Her Leotard* (fig. 8). Both are crisply observed and delicately conjured out of pastel and thinned paint on buff-colored cardboard, a mixture of media that inevitably recalls Degas. Even closer to his master is the choice of model, almost certainly a reminiscence of the long-limbed, youthful Marie van Goethem, who posed for *Little Dancer, Aged Fourteen.* But these are no glib attempts at pastiche; rather, Lautrec has honored his predecessor by acknowledging the debt and then moving on to tackle new, equally demanding challenges in his own progressive idiom.

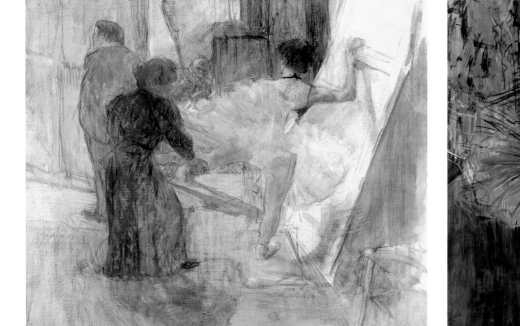

Plate 49
**Henri de TOULOUSE-
LAUTREC**
In the Wings
c. 1898–1900
Essence and colored crayons
over lithograph on paper
22 × 19¼ in. (56 × 49 cm)
Private collection, Minnesota,
courtesy of Ruth Ziegler Fine
Arts, New York

Fig. 9
**Henri de TOULOUSE-
LAUTREC**
Dancer
1895–96
Oil on canvas
79 × 28⅝ in. (200 × 72 cm)
Private collection, California

If these two young dancers are shown in dressing rooms, their more robust colleague in *In the Wings* (plate 49) is clearly positioned offstage, a location with an already long artistic history. This lithograph reveals Lautrec's subtle capabilities with line at its most exploratory, here seemingly frozen at the moment when his composition began to emerge from a tentative draft. None of the characters he depicts is a stock type: each has been chosen for its idiosyncratic form and each was freshly delineated as it was integrated into the ensemble. No paintings or pastels resulted directly from this inspired creation, but Lautrec's willingness to risk all on a hazardous conception is everywhere in evidence. A similar procedure no doubt lay behind the larger-than-life ballerina in *Dancer* (fig. 9), who is unequivocally and spectacularly present at the edge of some unknown theater's stage. Here again,

Lautrec nods with good humor toward his great predecessor, while creating an almost wild, asymmetric image that Degas never could have conceived. This tense ballerina does not coyly ask to be approached but leers back at the viewer, her distorted features and deeply unclassical physique expressive of a new, abrasive era. Created about the same time as Degas's *Red Ballet Skirts* and Forain's *Backstage at the Opéra during a Performance of "Aïda,"* she comes from a different world, that of the decadent fin de siècle. Acute as ever, Lautrec had realized that the notions of Duranty and his fellow realists were now threadbare, irrelevant to his novel aesthetic. An unprecedented visual argot was needed, in which improvised brushwork, fractured pictorial structures, and previously unimagined spaces would herald the twentieth century.

Plate 50
Edgar DEGAS
Dancers in the Wings
1879–80
Etching, aquatint, and drypoint
on paper
5½ × 4⅛ in. (14 × 10.5 cm)
The Baltimore Museum of Art,
the George A. Lucas Collection,
purchased with funds from the
State of Maryland, Laurence
and Stella Bendann Fund, and
contributions from individuals,
foundations, and corporations
throughout the Baltimore
community, BMA 1996.48.1045

NOTES

1. Herbert D. Schimmel, ed., *The Letters of Henri de Toulouse-Lautrec* (Oxford and New York: Oxford University Press, 1991), 152.

2. For the origins of some of Degas's dance imagery in caricature, see Jill DeVonyar and Richard Kendall, *Degas and the Dance* (New York: Harry N. Abrams, in association with the American Federation of Arts, 2002), esp. chaps. 1–3.

3. For Duranty's essay, see Charles S. Moffett, *The New Painting: Impressionism, 1874–1886* (Geneva, Switzerland: R. Burton, in association with the Fine Arts Museums of San Francisco and the National Gallery of Art, Washington, DC, 1986), 37–49.

4. Ibid., 44.

5. Ibid.

6. Ibid.

7. Ibid., 45.

8. Many such cases are described in DeVonyar and Kendall, *Degas and the Dance,* esp. chap. 6.

9. Degas's contributions to these exhibitions are listed in Ruth Berson, ed., *The New Painting: Impressionism, 1874–1886, Documentation,* 2 vols. (San Francisco: Fine Arts Museums of San Francisco, 1996). Uncertainty about the artist's submissions arose when works were listed in the catalogue but substituted or withdrawn from the exhibitions.

10. See ibid., vol. 2, 112–13.

11. Joris-Karl Huysmans, *Écrits sur l'art, 1867–1905,* ed. Patrice Locmant (Paris: Bartillat, 2006), 175–76.

12. Ludovic Halévy, *La Famille Cardinal* (Paris: Calmann Lévy, 1883). The individual stories had previously appeared in journals. Degas's monotypes were not used in this publication.

13. See, for example, Paul Valéry, "Degas, Dance, Drawing," reprinted in Paul Valéry, *Degas, Manet, Morisot,* trans. David Paul (Princeton, NJ: Princeton University Press, 1989), 73, 101.

14. Walter Sickert, "Degas," *Burlington Magazine,* November 1917, 184. For Degas's holdings of works by Forain, see Colta Ives, Susan Alyson Stein, and Julie A. Steiner, *The Private Collection of Edgar Degas: A Summary Catalogue* (New York: Metropolitan Museum of Art, 1997), 52–53.

15. Quoted in Jeanne Fevre, *Mon Oncle Degas* (Geneva, Switzerland: P. Cailler, 1949), 67.

16. For the later relationship between the two men, see Richard Kendall, *Degas: Beyond Impressionism* (London: National Gallery Publications; Chicago: Art Institute of Chicago, 1996), 161.

17. An example of this kind is Degas's painting *Dancers, Pink and Green,* c. 1885–95, The Metropolitan Museum of Art, New York.

18. For the geographical proximity and partly overlapping social world of the three men, see Kendall, *Degas: Beyond Impressionism,* chaps. 1 and 6.

19. Schimmel, *The Letters of Henri de Toulouse-Lautrec,* 152.

20. See M. G. Dortu, *Toulouse-Lautrec et son oeuvre,* 6 vols., Les Artistes et leurs oeuvres: Études et documents (New York: Collectors Editions, 1971), D. 3.383, P. 466, and P. 257.

Edgar Degas

Fig. 1
Edgar DEGAS
The Opéra Dance Studio
on the Rue Le Peletier
1872
Oil on canvas
12⅜ × 18⅛ in. (32.1 × 46 cm)
Musée d'Orsay, Paris (RF 1977)

Plate 51
Edgar DEGAS
Seated Dancer
1872
Essence over graphite on
pink paper
10¹⁵⁄₁₆ × 8¹¹⁄₁₆ in. (27.8 × 22.1 cm)
Thaw Collection, The Pierpont
Morgan Library, New York,
EVT 46

Seated Dancer, 1872

This drawing is one of several that Degas executed in essence or ink on colored papers for his great classroom paintings of the early 1870s. The sheet is a study for the seated figure that appears in the right foreground of *The Opéra Dance Studio on the Rue Le Peletier,* painted that same year (fig. 1). The dancer assumes a relaxed but alert seated pose, with her practice skirt draped across the back of the chair.

After Degas established in graphite the basic structure of the figure, her tutu, and the decorative edging of her bodice and her skirt hem, he brushed on essence in a gradation of tones to create volume. A network

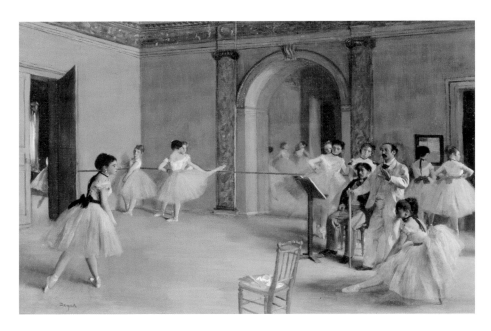

of loose brushstrokes suggests shadows on the floor and creates a background that intensifies the sense of relief. Here in the drawing, the figure is fully modeled and strongly three-dimensional, whereas in the painting, shadows are attenuated and tonalities of white and off-white abound, creating an effect of suffused light.[1]

The pink of the paper itself suggests the fall of light on the figure's upper back and shoulders and is visible through the strokes of essence delineating her tutu, making it seem light and billowy. With its dominant tones of gray, black, olive green, gold, and blue, the drawing focuses our attention on the almost iridescent touches of color, such as those on the purple ribbon at the figure's waist and the pink slippers with their green ribbons.

—Annette Dixon

NOTE

1. As noted by Mari Kálmán Meller, "Exercises in and around Degas's Classrooms,"
 pt. 1, *Burlington Magazine,* March 1988, 208–9 and n. 54.

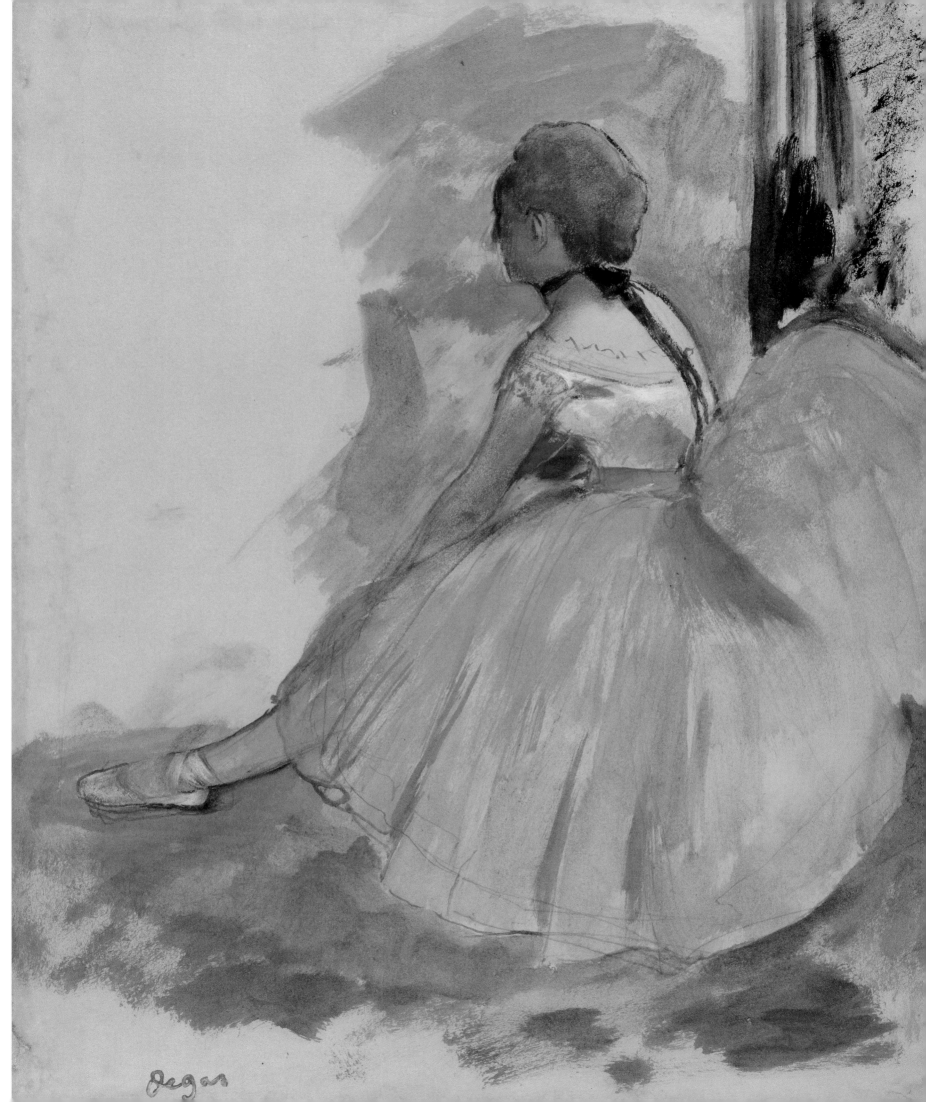

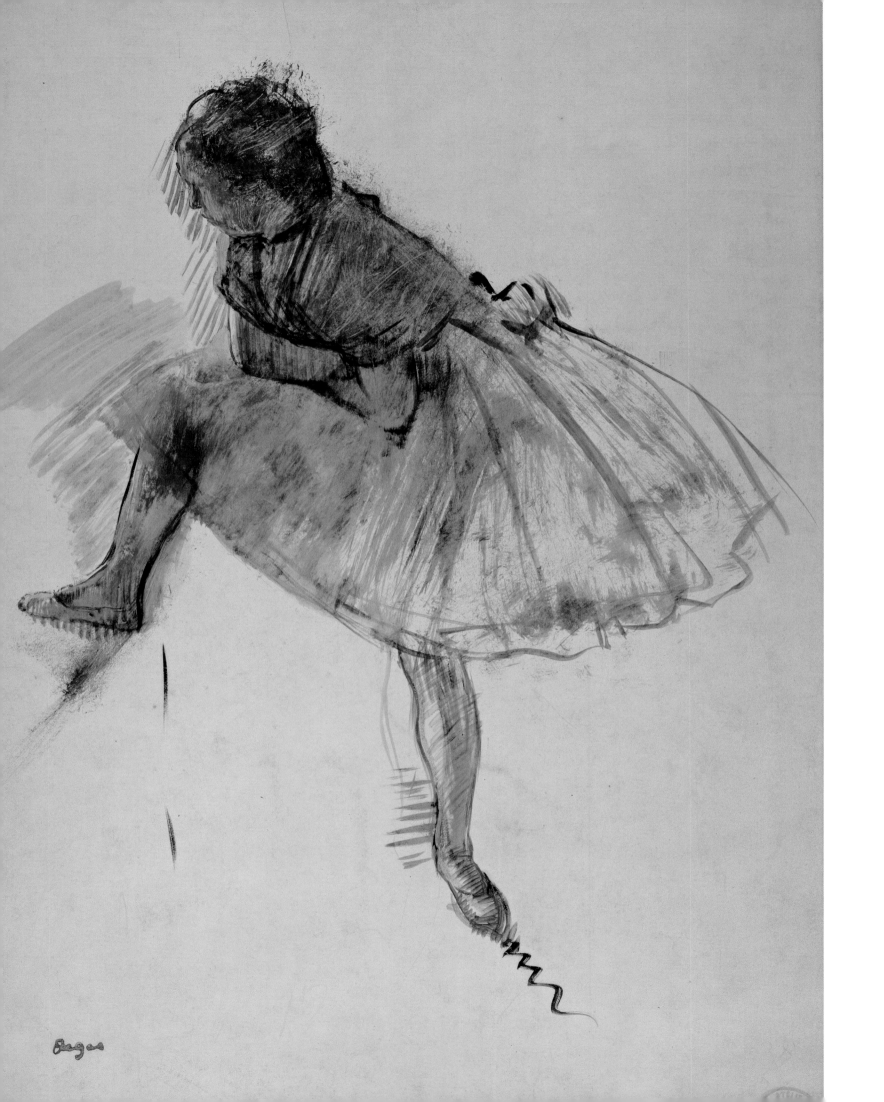

Study of a Ballet Dancer (recto), c. 1873

Study of a Ballet Dancer belongs to a group of essence and ink drawings that Degas executed on colored paper, most often pink, in the early 1870s. As art historian Richard R. Brettell has noted, although several of these sheets relate closely to figures in Degas's early classroom paintings, this particular drawing of a seated dancer seems to be a more general study.[1] Degas would have his models assume various positions so he could explore ways in which to depict the human form as well as to convey a sense of mental activity in the figure. Here, the dancer seems to attend to something beyond the confines of the sheet. The paper color itself plays a role in establishing the figure's volume and the space around it, imparting luminosity to the whole. Loose hatch marks and smudging along portions of her body's contour make her stand out as a volumetric entity. These closely spaced lines, along with the decorative flourish emanating from the dancer's proper left foot, activate the space. They are harbingers of the extraordinary mark making that would define the spaces around figures in Degas's late charcoal drawings of about 1900 (see, for example, plate 15).

—AD

NOTE

1. Richard R. Brettell et al., *Nineteenth- and Twentieth-Century European Drawings, The Robert Lehman Collection,* vol. 9 (New York: Metropolitan Museum of Art, in association with Princeton University Press, 2002), cat. no. 82, p. 166.

Plate 52
Edgar DEGAS
Study of a Ballet Dancer
(recto)
c. 1873
Oil paint heightened with body color on prepared pink paper
17½ × 12⅜ in. (44.5 × 31.4 cm)
The Metropolitan Museum of Art, New York, Robert Lehman Collection, 1975 (1975.1.611)

Conversation: Ludovic Halévy and Madame Cardinal, illustration for La Famille Cardinal, 1876–77

Conversation: Ludovic Halévy Speaking with Madame Cardinal, illustration for La Famille Cardinal, 1876–77

Plate 53
Edgar DEGAS
Conversation: Ludovic Halévy and Madame Cardinal, illustration for *La Famille Cardinal*
1876–77
Monotype on paper
8⅜ × 6⅜ in. (21.3 × 16 cm)
The Cleveland Museum of Art, Gift of the Print Club of Cleveland in honor of Henry Sayles Francis, 1967.167

Plate 54
Edgar DEGAS
Conversation: Ludovic Halévy Speaking with Madame Cardinal, illustration for *La Famille Cardinal*
1876–77
Monotype heightened with pastel on paper
8½ × 6¼ in. (21.6 × 15.9 cm)
Private collection, Minnesota, courtesy of Ruth Ziegler Fine Arts, New York

These two sheets are from a series of more than thirty monotypes that Degas planned as illustrations for *La Famille Cardinal,* by his friend the librettist Ludovic Halévy. These satirical stories revolve around Pauline and Virginie Cardinal, two young dancers at the Opéra, and their parents, particularly their procuress mother. Halévy, who was an Opéra *abonné,* also included himself in the stories. Between 1870 and 1880, a few of the tales appeared separately in the journal *La Vie parisienne,* and Halévy also issued volumes of Cardinal stories with unrelated material. The Cardinal stories were published definitively in 1883 as *La Famille Cardinal.*

As art historian Michael Pantazzi has argued, Degas seems to have begun these monotypes in 1876 and probably finished them by 1877, when he exhibited some of them in the third Impressionist exhibition.[1] For reasons unknown, Halévy rejected Degas's monotypes as illustrations for his book, choosing instead a more mundane treatment by another artist.

Degas created these monotypes during a period when he was experimenting intensely with the medium. These two are among five versions that Degas made for the opening scene, in which Halévy and Madame Cardinal meet in the corridors of the Opéra. As art historian Richard Thomson has pointed out, they represent Degas's habit of obsessively reworking the same motifs for different effects.[2] One version is a tour de force of manipulating the ink-covered plate to create tonal contrasts and textures (left). In another, he has enhanced the monotype with pastel to set off Madame Cardinal's form with her red tartan shawl (right). The cropping of the diaphanous ballet dancer by the left edge of the composition increases the sense of this being a moment captured.

—AD

NOTES
1. Michael Pantazzi, "Degas, Halévy and the Cardinals," in Jean Sutherland Boggs et al., *Degas* (New York: Metropolitan Museum of Art; Ottawa: National Gallery of Canada, 1988), 280.
2. Richard Thomson, *The Private Degas* (New York: Thames and Hudson, 1987), 67–69.

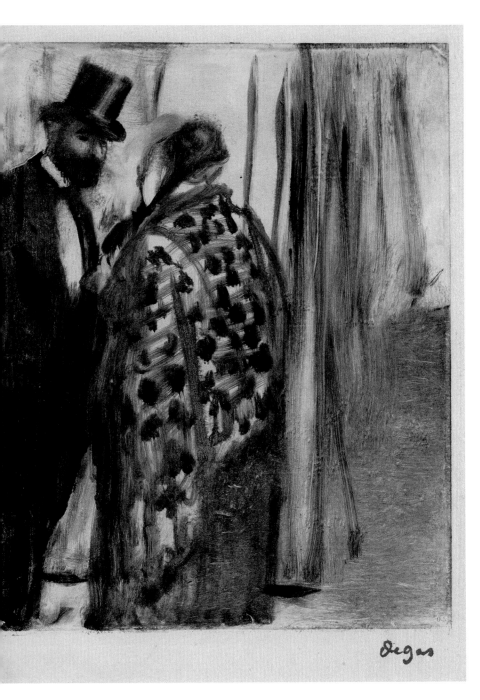 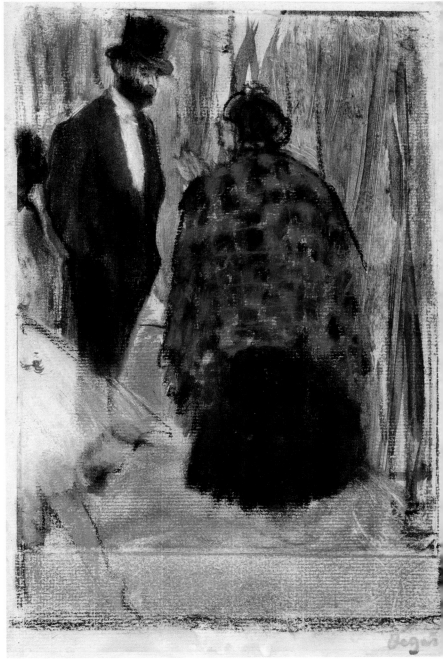

Plate 55
Edgar DEGAS
Dancers Backstage
1876/1883
Oil on canvas
9½ × 7⅜ in. (24.2 × 18.8 cm)
National Gallery of Art,
Washington, DC, Ailsa Mellon
Bruce Collection 1970.17.25

Dancers Backstage, 1876/1883

Dancers Backstage is a sketchy oil in which Degas addresses the interaction between the dancer and the *abonné,* a theme he rarely treated in his finished paintings. His placement of the ballerina in a pink tutu and a top-hatted gentleman dressed in black in the lower right foreground, pressed forward by the stage flat behind them, rivets our attention on them. There is an intriguing psychological tension between the two figures. Although the man's face is in shadow, we can clearly tell that the dancer is the object of his attention. Her downward look and crossed forearms reveal that she has noticed her admirer; she may be feigning lack of interest. Degas shows ambivalence toward the male onlooker, giving him a typically predatory role but reducing him to a mere silhouette cropped by the canvas's edge.

 —AD

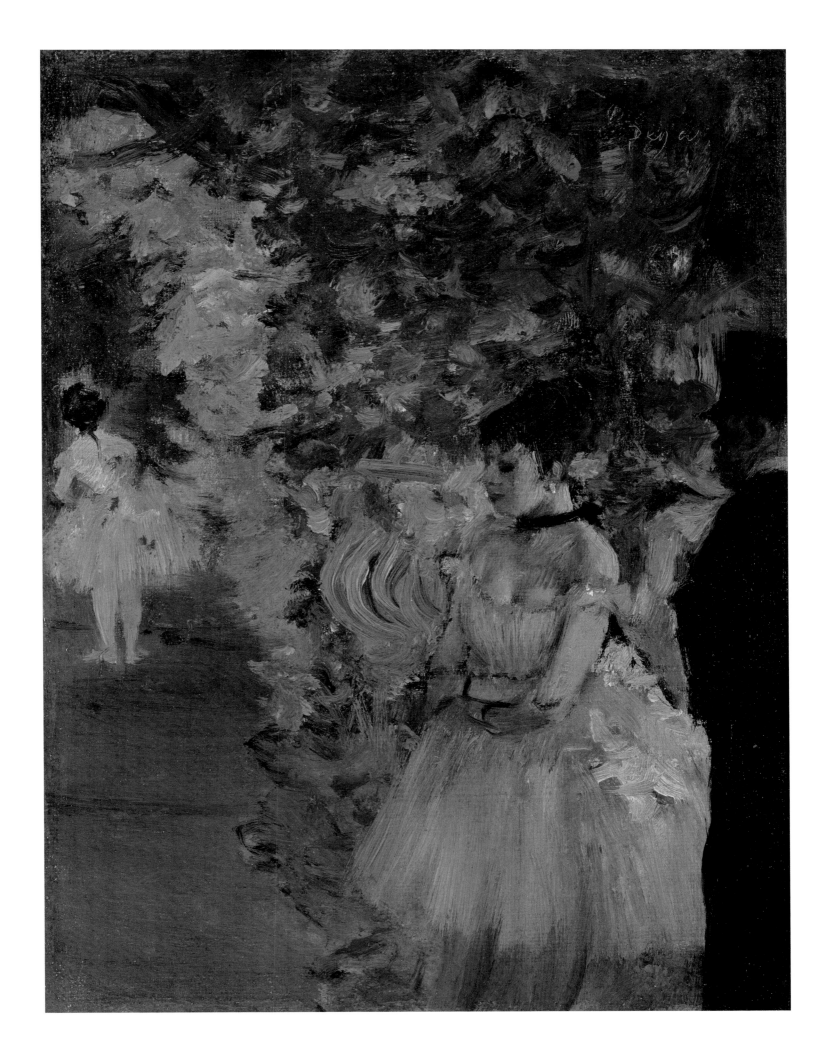

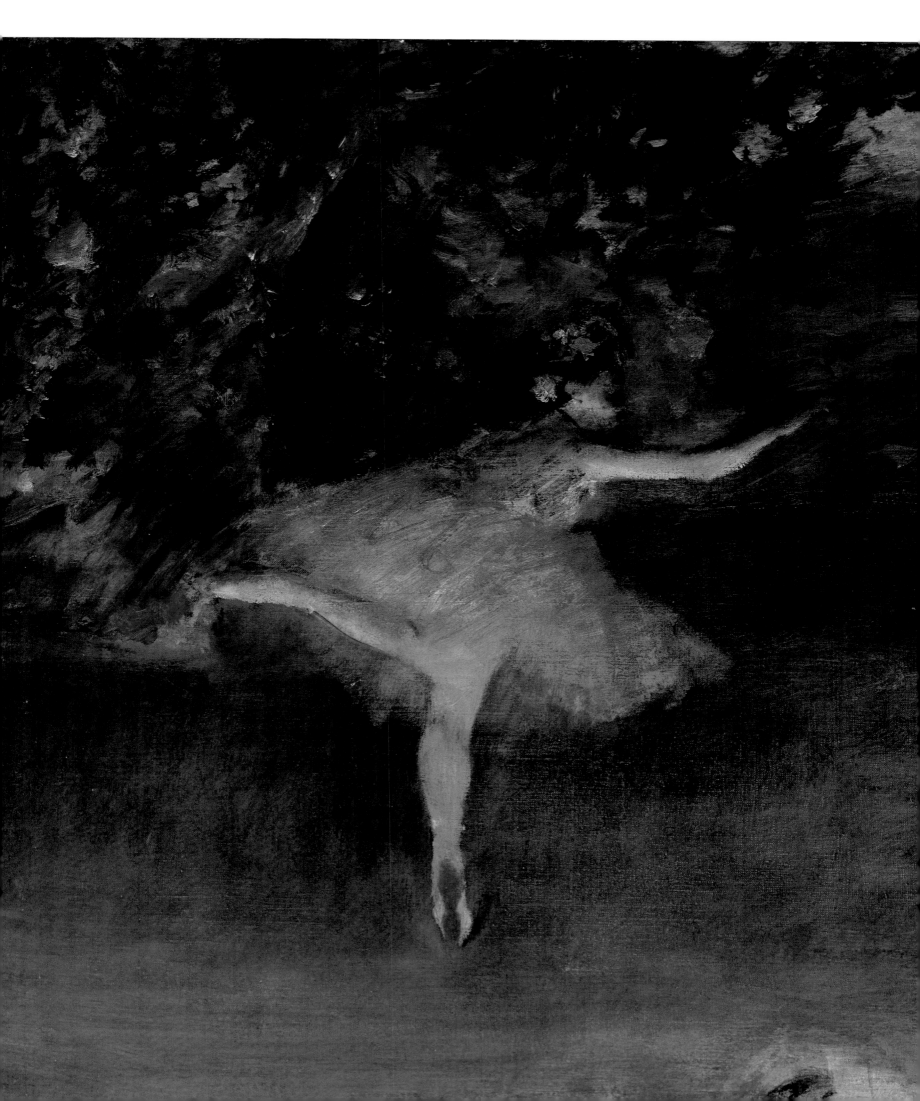

Dancer on Pointe, c. 1877 This painting shows a female dancer on pointe executing an *attitude.* With her right leg lifted behind and her right arm extended, she appears to be moving toward her partner in the background. This dancer is dressed as a male character, but it is unclear whether the figure represents a woman *en travesti.*[1] It was a common practice for female dancers to play male roles in the late nineteenth century. The number of male dancers had declined since earlier in the century owing to the importance accorded to the ballerina by technical advances stemming from the development of pointe work and the achievement of greater elevation in female dancing. The male dancer came to function merely as *porteur* for the virtuoso ballerina, with his roles eventually going to female dancers in male costume.[2]

The strong diagonal between the two dancers creates depth and activates the space between them. The figure of the ballerina is dazzling in the glare of stage lights, the source of which is outside the picture below and to the right, beyond which would be the audience. Our view of the main dancer is from slightly above, as if from a loge on the stage, a privileged position. The angled view of the stage flats reveals their two-dimensionality and calls attention to the artifice of the performance.

—AD

NOTES

1. I thank Jill DeVonyar for sharing information with me on the positions of the dancers and the difficulty of reading the gender of the background figure.
2. Ivor Guest, *The Ballet of the Second Empire, 1847–1858* (London: A. and C. Black, 1955), 2–3.

Plate 56
Edgar DEGAS
Dancer on Pointe
c. 1877
Oil on canvas
19¾ × 23⅝ in. (50 × 60 cm)
Collection of Diane B. Wilsey

Dancers, 1879 The mania for Japanese art and decorative objects that swept France in the late nineteenth century included an immense enthusiasm for Japanese fans, which were imported in great numbers in the 1870s and 1880s. Degas, who was an avid collector of Japanese art, and other Impressionist artists were inspired to create their own fans as wall decorations. He and his colleagues Forain, Marie Bracquemond, and Camille Pissarro showed fans in the fourth Impressionist exhibition in 1879.

Of the twenty-five fans that Degas is known to have created, twenty-one are on ballet subjects.[1] *Dancers,* with its view over a large scenery flat, depicts ballerinas during an intermission after the fall of the curtain. On the stage at right, dancers are warming up, while top-hatted *abonnés* watch them from the wings. The high vantage point is that of the privileged viewers in the highest tier of onstage loges.

As is typical of Degas's fans on dance themes, *Dancers* is asymmetrical in composition, with stage flats erupting from the center and from the edges, leaving a portion of the field bare of any representation—elements he derived from Japanese art. The artist created dazzling, iridescent effects with gouache and pastel, particularly in the scenery. Most of the ballerinas wear pink and purple tutus, but one of them, in the upper right, stands out from the rest of the cast: for her costume, Degas has economically relied on the dark cream color of the silk support itself.

—AD

NOTE

1. See the extensive discussion on Degas's fans in Marc Gerstein, "Degas's Fans," *Art Bulletin* 64, no. 1 (March 1982): 105–18.

Plate 57
Edgar DEGAS
Dancers
1879
Gouache, oil pastel, and oil paint on silk (fan)
12 1/16 × 23 15/16 in. (30.6 × 60.8 cm)
Tacoma Art Museum, Gift of Mr. and Mrs. W. Hilding Lindberg, 1983.1.8

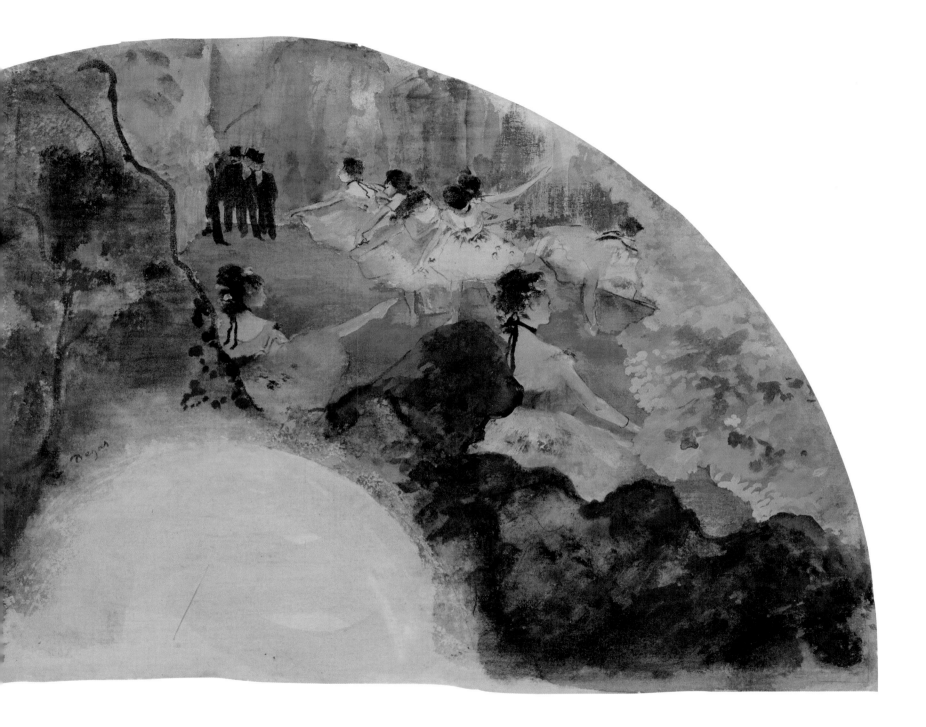

Plate 58
Edgar DEGAS
The Ballet Class
c. 1880
Oil on canvas
32⅜ × 30¼ in. (82.2 × 76.8 cm)
Philadelphia Museum of
Art, Purchased with the
W. P. Wilstach Fund, W1937-2-1

The Ballet Class, c. 1880

This painting of dancers in a rehearsal room is fascinating for its disquieting elements. The pared-down quality of the space heightens the impact of the strange division of the dancers into two groups at opposite corners. The yawning diagonal expanse of floor separating them increases the sense of contrast between the active dancers at upper left and those waiting at lower left. The mirror enframing and accentuating the dancing figures adds interest to the scene by reflecting the buildings visible through the rehearsal-room window; this serves to locate the scene in the urban milieu.

Alexander Cassatt, the brother of the artist Mary Cassatt, bought this painting from Galerie Durand-Ruel, to which Degas had sold it shortly after he finished it. Degas's extensive reworking of the painting caused a delay of several months before the artist was satisfied enough to deliver it to the dealer. Cassatt's correspondence with her friend the American collector of Impressionist art Louisine Havemeyer, describing the painting, and X-rays indicate that the seated woman reading a newspaper in the foreground covers over a seated dancer adjusting her shoe. Cassatt's correspondence also identifies the woman reading in the chair as Marie van Goethem, who was the model, around this same time, for Degas's *Little Dancer, Aged Fourteen* (plate 59). The figure of the ballet master, not part of the original design, covers pentimenti resulting from changes to the large dancer behind the seated woman.[1]

—AD

NOTE

1. On the history of this painting and Degas's reworking of it, see Michael Pantazzi, catalogue entry in Jean Sutherland Boggs et al., *Degas* (New York: Metropolitan Museum of Art; Ottawa: National Gallery of Canada, 1988), cat. no. 219, pp. 335–37.

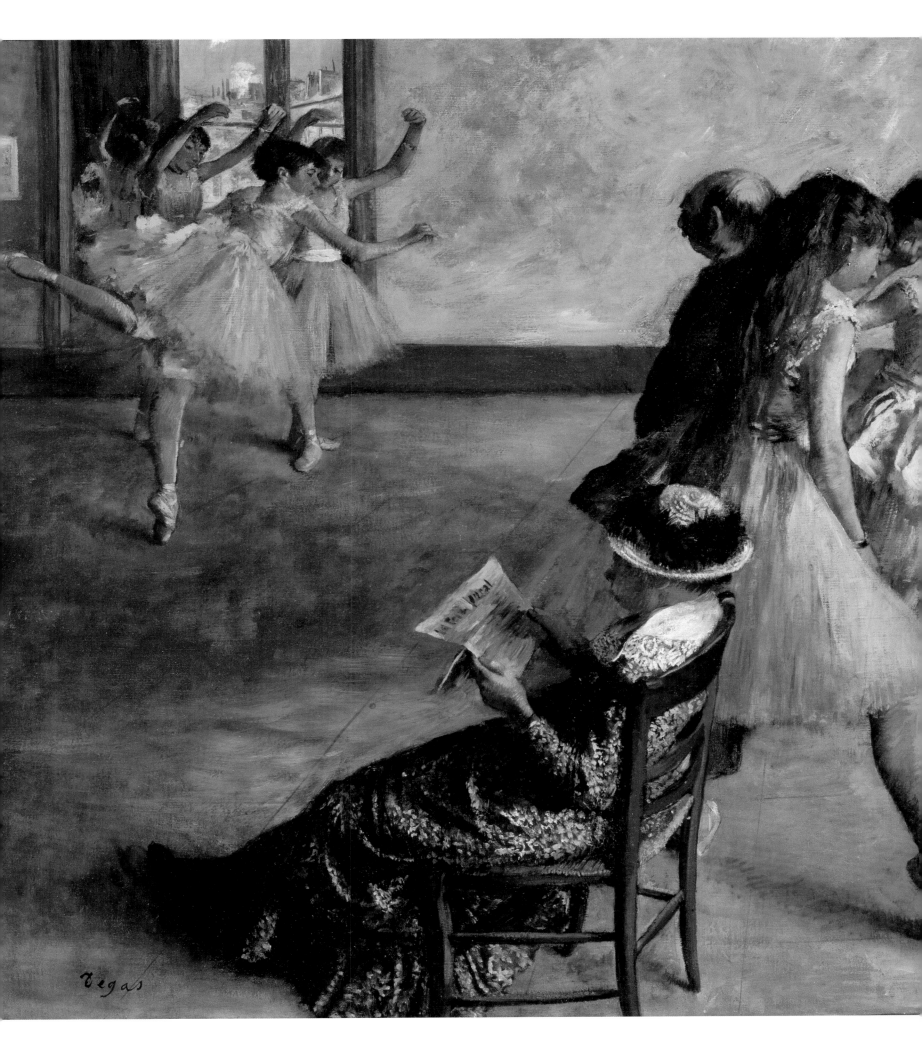

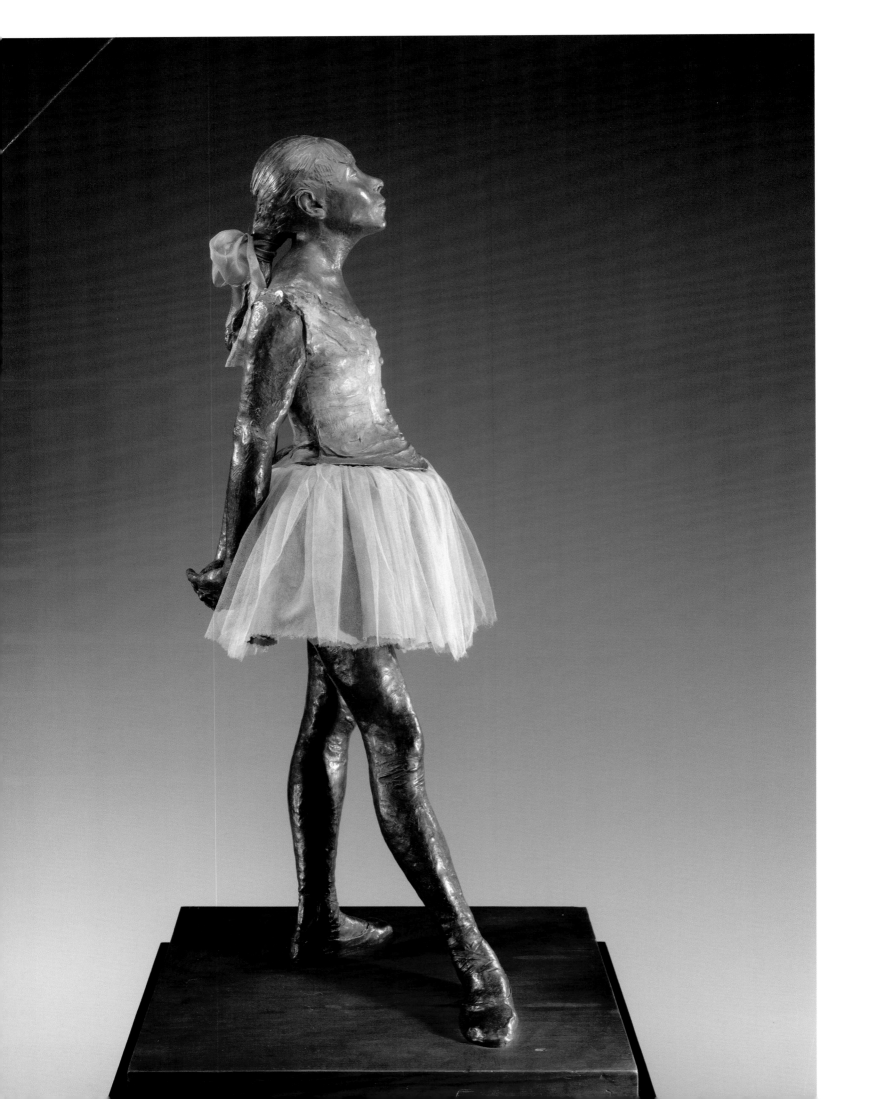

Little Dancer, Aged Fourteen,
c. 1880–81

Degas's *Little Dancer, Aged Fourteen* is the only sculpture that he exhibited publicly in his lifetime. Included in the sixth Impressionist exhibition in 1881, the work in its original wax form scandalized its audience with its extreme naturalism. Its bold mix of materials—tinted wax with real tutu and bodice, stockings, hair and neck ribbons, ballet slippers, and hair—represented a negation of the classical ideal of marble or bronze for sculpture. Degas's use of wax relates to a late nineteenth-century revival of interest in polychrome sculpture, which could incorporate wax, and a vogue for collecting sculpture in this material.[1] The combination of wax, clothing, and hair also brought to the work uncomfortable associations with the type of wax mannequins used in ethnographic displays or even in the exhibits of human pathology at the Musée Dupuytren, Paris.[2]

Degas's depiction of an adolescent dancer was controversial, as was the frank, unidealized quality of his representation. The subject drew upon the connection of young dancers with sexual looseness as well as prejudice against the lower classes, from which many of the ballet students came. In particular, contemporary thinking on evolution saw those at the bottom of the social scale as less evolved and morally corrupt. Degas also included some pastel drawings in the Impressionist exhibition depicting young lower-class males involved in a sensational recent murder trial, and this linking of criminality with socially inferior types carried over to *Little Dancer* as well.[3]

The model for *Little Dancer* was Marie van Goethem, a young ballet student, whom Degas depicted in several drawings as well as in a nude statue.[4] A sheet that shows her four times, in dance costume, in the same pose he adopted for the sculpture is inscribed with her name and address, and thus may have initiated the series of studies of her (fig. 1).[5]

The wax statue of *Little Dancer* was cast in bronze posthumously by the foundry of A. A. Hébrard.

—AD

Plate 59
Edgar DEGAS
Little Dancer, Aged Fourteen
c. 1880–81 (cast posthumously,
c. 1919–32)
Bronze and fabric
38½ × 14½ × 14¼ in.
(98 × 36.8 × 36.2 cm)
Virginia Museum of Fine
Arts, Richmond, the State
Operating Fund and the Art
Lovers' Society

Fig. 1
Edgar DEGAS
Four Studies of a Dancer
1878–79
Charcoal and white highlights
on imitation vellum
19¼ × 12⅝ in. (49 × 32.1 cm)
Musée d'Orsay, Paris,
département des Arts
graphiques du Musée du
Louvre (RF 4646)

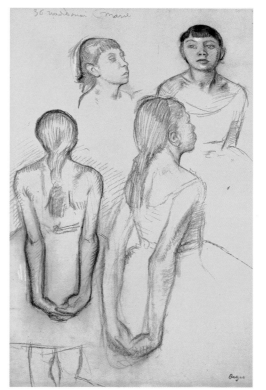

NOTES

1. As noted by Michael Pantazzi, "The Little Fourteen-Year-Old Dancer," in Jean Sutherland Boggs et al., *Degas* (New York: Metropolitan Museum of Art; Ottawa: National Gallery of Canada, 1988), 343.

2. See Douglas W. Druick and Peter Zegers, "Scientific Realism: 1873-1881," in ibid., 209-11; and Douglas W. Druick, "Framing the *Little Dancer Aged Fourteen*," in Richard Kendall, *Degas and the Little Dancer* (New Haven, CT: Yale University Press; Omaha: Joslyn Art Museum, 1998), 86.

3. Druick and Zegers, "Scientific Realism: 1873-1881," 205-11. See also Druick, "Framing the *Little Dancer Aged Fourteen*," 77-96.

4. On the circumstances of Marie van Goethem and her two sisters, all three of whom attended the Opéra ballet school, but only one of whom, Charlotte (who had a distinguished ballet career), resisted criminal influences, see Martine Kahane, "*Little Dancer, Aged Fourteen*—The Model," in Joseph S. Czestochowski and Anne Pingeot, *Degas Sculptures: Catalogue Raisonné of the Bronzes* (Memphis: Torch Press and International Arts, 2002), 101-7.

5. As noted by Michael Pantazzi, catalogue entry in Boggs et al., *Degas,* cat. no. 223, pp. 346-47.

Plate 60
Edgar DEGAS
Dancer Stretching
c. 1882–85
Pastel on gray paper
18⅜ × 11¾ in. (46.7 × 29.7 cm)
Kimbell Art Museum, Fort
Worth, Texas

Dancer Stretching, c. 1882–85 Degas's images of dancers exhausted to the point of agony reveal his intense empathy with their suffering through long hours of training and practice. In this pastel, the ballerina's gestures of pressing her right hand to her forehead and flinging her left arm upward emphasize her pain, which the artist makes even more palpable by placing her close to the viewer and having her figure fill the sheet, monumentalizing her form.

 Working quickly with bold strokes to capture the dancer's momentary attitude, Degas left evidence of his own process, with the preliminary lines and smudges suggesting the evolution of the image and the marks and smears around the figure setting her body off in relief. This is a bravura piece with scintillating passages of color, such as the vivid blue of the ballerina's bodice and the orange on her hair.

 —AD

Dancer Adjusting Her Dress, c. 1885 Degas observed dancers backstage at all moments of their day, capturing them in activity or at rest, often engaged in unconscious gestures. This pastel shows a dancer adjusting her shoulder strap, a motif that Degas treated in many variants. Seen in three-quarter view from the back, the dancer seems unaware of the onlooker. Degas established the contours and internal lines of the figure in black pastel, adding highlights in white to suggest the fall of light on her skin and costume. The placement of the highlights together with the diagonal smears of black below and to the right of her feet suggests the direction of the light source. The touches of white on her left arm and shoulder combine with smudging to create a strong sculptural effect in those areas.

 —AD

Plate 61
Edgar DEGAS
Dancer Adjusting Her Dress
c. 1885
Pastel on paper
24¼ × 18¼ in. (61.6 × 46.4 cm)
Portland Art Museum, Bequest
of Winslow B. Ayer, 35.42

Plate 62
Edgar DEGAS
Theater Box
1885
Pastel on paper
35½ × 29½ in. (90.2 × 74.9 cm)
The Armand Hammer
Collection, Gift of the Armand
Hammer Foundation, Hammer
Museum, Los Angeles

Theater Box, 1885

Degas's images of people in loges at the Opéra evoke the idea of spectatorship and what is taken in by the gaze. In this pastel, the foreground is occupied by the head and shoulders of an elegant woman holding a fan. The inclusion of two pairs of opera glasses reinforces the theme of looking. The vantage point is that of the woman's unseen male companion, who would be seated or standing behind her. The forms of the dancers, some partly hidden by the head of the seated woman and her neighbor to the left, are visible just beneath the box, which suggests that this is an expensive seat close to the stage. The physical proximity of the female spectator in the loge to the dancers below is underlined by the echoing shapes of the woman's fan and the tutu above her hand in the picture plane. This formal similarity serves both to gloss over and to call attention to the social and psychological differences that separated the spectators from the performers.[1]

The experience of attending a performance at the Opéra is also vividly suggested by the contrast between the darkness of the theater box and the brightly lit stage below, where the dancers' costumes sparkle. Degas's technique of building up layers of striations creates an effect of flickering light.

—AD

NOTE

1. I draw upon points made by Linda Nochlin, "A House Is Not a Home: Degas and the Subversion of the Family," in Richard Kendall and Griselda Pollock, eds., *Dealing with Degas: Representations of Women and the Politics of Vision* (New York: Universe, 1991), 60; though she is discussing the fan and the tutu in *The Dancer with a Bouquet* of 1878, I find her comments relevant to an understanding of *Theater Box.*

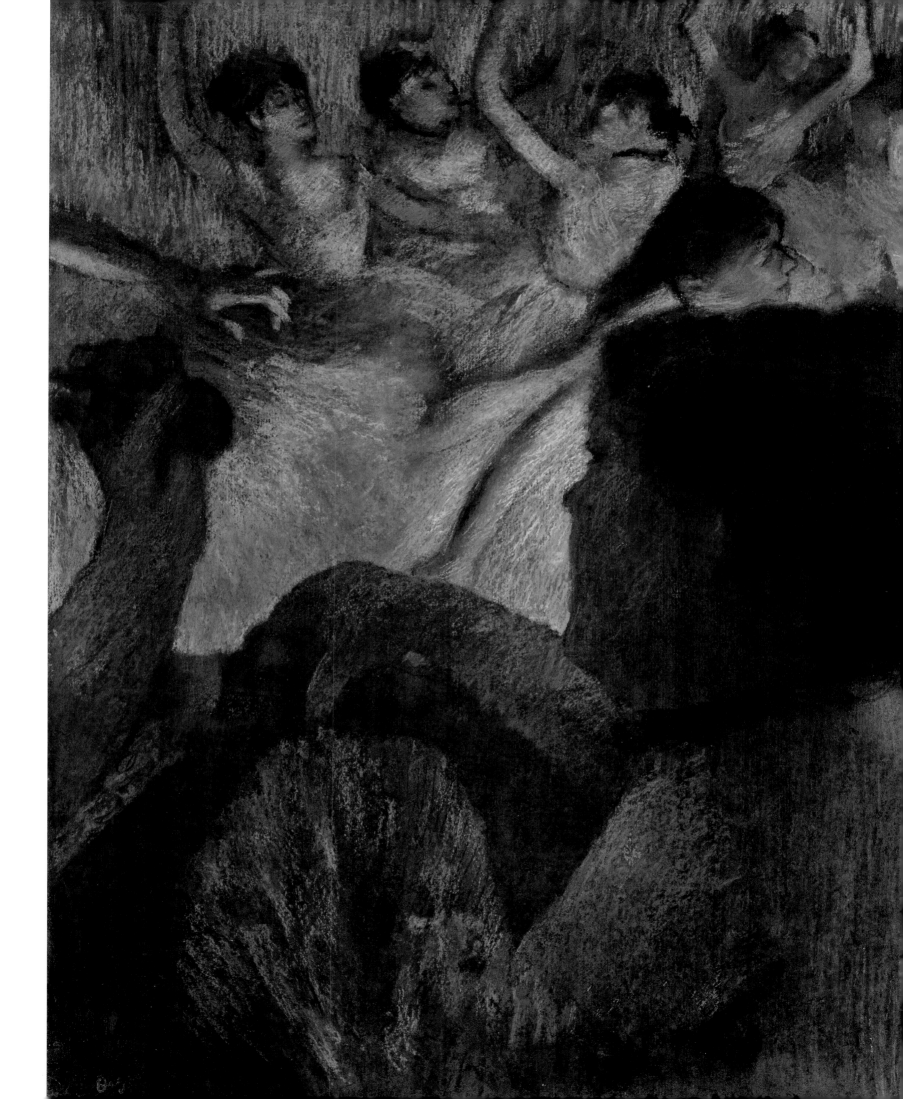

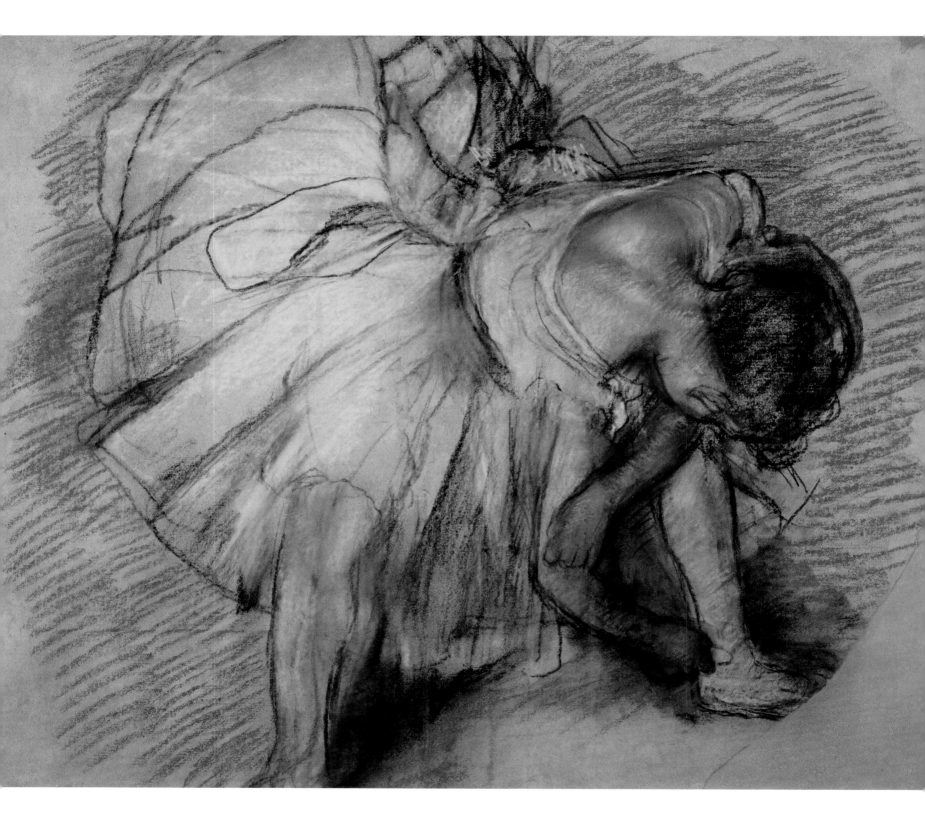

Dancer Adjusting Her Shoe, 1885

Degas was attracted both to the perfected elegance of the artificial poses of the ballet and to the relaxed casualness of the unguarded gestures of the dancer at rest. The latter include the often awkward motions associated with adjusting a costume. The motif of a seated dancer adjusting her shoe recurs in his oeuvre, particularly in the 1880s. This pastel represents a variant of the rightmost figure, in a related pose, in the painting *Ballet Rehearsal* (fig. 1).

Dancer Adjusting Her Shoe is also a superb example of Degas's mastery of the pastel technique to create three-dimensional form and scintillating chromatic effects, as in the blue and white passages in the figure's sash. Establishing the broad outlines of her body in black pastel, he built up the form using color pastel in lines of varying thickness and loose hatching.

—AD

Plate 63
Edgar DEGAS
Dancer Adjusting Her Shoe
1885
Pastel on paper
19 7/16 × 23 3/4 in. (49.4 × 60.3 cm)
The Dixon Gallery and Gardens, Memphis, Tennessee, Bequest of Mr. and Mrs. Hugo N. Dixon, 1975.6

Fig. 1
Edgar DEGAS
Ballet Rehearsal
c. 1885
Oil on canvas
18 7/8 × 34 5/8 in. (47.9 × 87.9 cm)
Yale University Art Gallery, New Haven, Connecticut, Gift of Duncan Phillips, B.A. 1908

Dancer Looking at the Sole of Her Right Foot, 1890–1900

After Degas's death, some 150 wax sculptures were found in his studio, only about half of which were salvageable. The bronze founder A. A. Hébrard, whom Degas had commissioned to cast three of his wax sculptures in plaster around 1900, bought those waxes that could be saved. (Although the artist had expressed interest to his friends in having the sculptures cast in bronze, he never did so.) With the approval of Degas's heirs, Hébrard had the founder Albino Palazzalo cast the waxes in bronze beginning in 1919, a process that was completed in 1932.

Degas created the wax sculptures as a way to study the human form in three dimensions from various viewpoints. He used them in his working process as a complement to his drawings. It appears that he created them directly from the live model and then made drawings from the wax model. Many of the sculptures, such as *Dancer Looking at the Sole of Her Right Foot,* show figures in positions that are difficult to hold and thus capture transient poses.

Except in the case of his *Little Dancer, Aged Fourteen* (plate 59), Degas did not give titles to his own sculptures. This sculpture of a nude woman looking at the sole of her right foot exists in four variants and has been traditionally identified as a dancer. However, one scholar has pointed out that the pose has affinities with some of Degas's late bather images,[1] and another has noted that the sculpture does not reflect a standard ballet position.[2] Nevertheless, this figure, like many of Degas's self-absorbed dancers, is preoccupied with her own body. The balance of limbs and head around the central mass of the torso as the woman twists to look at the sole of her foot induces the viewer to move around the form to understand it from multiple angles.

—AD

NOTES
1. Richard R. Brettell, catalogue entry in Richard R. Brettell and Suzanne Folds McCullagh, *Degas in the Art Institute of Chicago* (Chicago: Art Institute of Chicago; New York: Harry N. Abrams, 1984), cat. no. 76, p. 161.
2. Richard Kendall, catalogue entry in Richard Kendall, Anthea Callen, and Dillian Gordon, *Degas: Images of Women* (Millbank, London: Tate Gallery Publications, 1989), cat. no. 33, p. 58.

Florence Valdès-Forain

Forain at the Opéra
Fascinated Observer

"I WAS BORN IN REIMS IN 1852 AND I LOVE DANCE." The year was 1888, and this is the way Jean-Louis Forain introduced himself to the readers of *Le Courrier français,* a Parisian journal that brought him fame as a caricaturist. He was thirty-six years old and by that time had published his drawings in the satirical press for about twelve years. At the invitation of Edgar Degas, Forain participated in four Impressionist exhibitions between 1879 and 1886 as well as in the 1886 exhibition of Impressionist works organized by the art dealer Paul Durand-Ruel in New York.

Forain's elliptical proclamation attests to his passion for dance: for almost sixty years, from the middle of the 1870s until his death in 1931, he was a faithful follower of the Paris Opéra. Witness his many works devoted to the theme of the dancers there, which he produced in the wide range of media he held dear: oil, gouache, watercolor, pastel, pencil, ink, lithography, and etching.

Of course, it was Degas, eighteen years his senior, who introduced him to the theme of the dancer. Forain immortalized his mentor in a portrait sketch from around 1878 (fig. 1), which bears the inscription "On the Lookout for a Star." Yet despite Degas's influence, Forain's depictions of life at the Opéra tell us a different story and express his deep-seated propensity to satirize, revealing his utterly personal approach to the subject. In Forain's art, as in the works of Honoré Daumier, with whom he felt a kinship, painting and illustration form an inseparable whole.

Forain's representations of the dancer figure reveal the artist to be, first, a young Impressionist who had "the unlikely good fortune to resemble no one else"[1] and then, in his later works, a socially engaged artist who found serenity in his final years.

Fig. 1
Jean-Louis FORAIN
On the Lookout for a Star
c. 1878
Graphite on paper
4½ × 3⅜ in. (11.4 × 8.6 cm)
Private collection

Plate 65
Jean-Louis FORAIN
Ballet Dancer
1887
Pastel on blue wove paper,
laid down
22¼ × 16⅞ in. (56.5 × 43 cm)
National Gallery of Art,
Washington, DC, Gift of
Mrs. Lessing J. Rosenwald,
1989

à l'affût d'une étoile

IN 1874, WHEN THE SALON REJECTED his submissions, Forain enthusiastically joined the ranks of the Impressionist rebels. With Édouard Manet and Degas, he espoused the precepts hailed by the poet Charles Baudelaire, namely, to paint subjects that reflected modern urban life. He also championed the Naturalist writer Joris-Karl Huysmans's doctrine that "a writer, like a painter, should be of his time."[2] The Paris Opéra was emblematic of Parisian "modernity"; it was therefore fitting that during his Impressionist period (1876–95), Forain found great inspiration there.

Whereas Degas delved into multiple facets of life at the Opéra, Forain showed a marked predilection for life backstage. He portrayed some of his dancers as archetypally ethereal creatures, such as those on his painted fans, notably, *Dancer with a Rose* (plate 66) and *Dancer in a Colored Tutu* (plate 67). But as a rule, Forain did not portray them in the act of dancing. Sometimes they are standing alone in poses resembling those of Degas's dancers, as in *Ballet Dancer* (plate 65), in which we see the ballerina from behind. Most often they are shown in the company of *abonnés,* or subscribers—older, worldly men of means who paid them court.

At the time, it was deemed fashionable to subscribe to the Opéra in order to gain access to the *foyer de la danse,* where between acts one could consort with the dancers. Even more enviable was having an Opéra dancer or an actress as one's mistress—a woman akin to Émile Zola's character Nana, from his novel of the same name. The myth of the notorious "star"—a wanton, unattached woman devouring the fortunes of the wealthy elite—had already insinuated itself as a Romantic notion in the preceding decades. It must be said, however, that Forain beheld a harsh reality steeped in poverty, a condition that compelled the *petits rats*—or "little rats," as they were known—to seek a "protector," one who could provide them with decent living conditions.[3] Relatively few young girls could claim to be pursuing a true vocation. More frequently, it was their mothers who enrolled them in dance classes either hoping that their daughters might secure an improved lot in life or having their own designs on the material comforts that a rich admirer could bestow upon the family as a whole.

The caricaturist Paul Gavarni had already illustrated the character types of the dancer and the *abonné* in the mid-1800s, and Degas reintroduced them early in the 1870s. So, even though Forain did not invent these types, they figure so prominently in his repertoire that they are often associated with him. In fact, the young Henri de Toulouse-Lautrec made a pastiche of them in the 1890s.[4]

Forain's *Evening at the Opéra* (plate 68) is emblematic: it was not the magic of balletic performance that intrigued him, but what transpired behind the scenes—backstage—and beyond the stage, in the audience's loges. On this fan, the artist used red and green, complementary colors, to juxtapose and contrast these two worlds. In this way, he exposed the realities of modern life by emphasizing the underbelly of society. He zeros in on the Opéra's *foyer* as a den of debauchery, as if it were a promenade or gallery in a theater or at the

Plate 66
Jean-Louis FORAIN
Dancer with a Rose
c. 1885–90
Watercolor on linen (fan)
10⅝ (stick height) ×
20 diam. in. (27 × 51 cm)
The Dixon Gallery and Gardens,
Memphis, Tennessee, Museum
Purchase, 1993.7.47

Plate 67
Jean-Louis FORAIN
Dancer in a Colored Tutu
c. 1890
Black chalk, pastel, and
gouache on blue paper (fan)
12½ (stick height) ×
23⅞ diam. in. (31.7 × 60.7 cm)
The Dixon Gallery and Gardens,
Memphis, Tennessee, Museum
Purchase, 1993.7.49

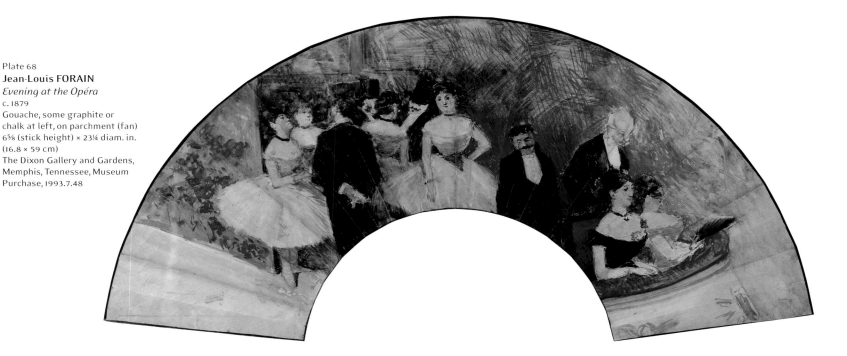

Plate 68
Jean-Louis FORAIN
Evening at the Opéra
c. 1879
Gouache, some graphite or
chalk at left, on parchment (fan)
6⅜ (stick height) × 23¼ diam. in.
(16.8 × 59 cm)
The Dixon Gallery and Gardens,
Memphis, Tennessee, Museum
Purchase, 1993.7.48

Folies-Bergère cabaret, where the *ambulantes,* or ladies of the night, would prowl. In 1883, the writer Paul Bourget praised Forain's striving for "new artistic means to express the ravages of mind and soul that dissolute Paris visited upon its captive denizens."[5]

Forain's earlier works are snapshotlike stills of contemporary Parisian life that equally convey an impression, which he achieved by using pictorial devices inherited from the Impressionists. According to the art historian Louis Gillet, Impressionism gave Forain "the freedom to paint as he wished, ... to communicate the sensations and feelings of a young man blithely set loose in the Paris of 1880.... What makes these paintings of Monsieur Forain so charming is that he does not hide the pleasure he finds in his quest: one can feel the vivid immediacy of the impressions upon his senses."[6] Of particular note, Forain's images of dancers incorporate Degas's innovations in composition, style, and technique.

First of all, Forain used a sophisticated composition inherited from Japanese woodblock prints. In *Intermission. On Stage* (plate 69) and *Behind the Scenes* (plate 70), the edge of the scene, the boundary between stage and backstage, abruptly bisects the overall composition. The figures are truncated, instilling a sense of immediacy. Sometimes, the dancer directs her gaze toward the spectator, as in *Intermission. On Stage,* establishing a bond and reinforcing the spontaneity of the scene.

Next, Forain was a keen observer of the effects of artificial lighting. In *Head of a Young Dancer* (plate 71) and *Intermission. On Stage,* for example, the lighting is milky, typical of the gas lighting used before the advent of electricity, dramatizing the whiteness of the dancers' skin. In the latter work, the light source is not shown, but its luminosity emanates from the right

Plate 69
Jean-Louis FORAIN
Intermission. On Stage
1879
Watercolor, gouache, and India
ink, with graphite (traces) on
wove rag paper
13⅞ × 10¹¹⁄₁₆ in. (35.3 × 27.2 cm)
The Dixon Gallery and Gardens,
Memphis, Tennessee, Museum
Purchase, 1993.7.3

Plate 70
Jean-Louis FORAIN
Behind the Scenes
c. 1880
Oil on canvas
18¼ × 15⅛ in. (46.4 × 38.4 cm)
National Gallery of Art,
Washington, DC, Rosenwald
Collection 1943.11.4

Plate 71
Jean-Louis FORAIN
Head of a Young Dancer
c. 1885–90
Oil on paper laid down on
canvas
16½ × 13⅜ in. (42 × 34 cm)
Private collection

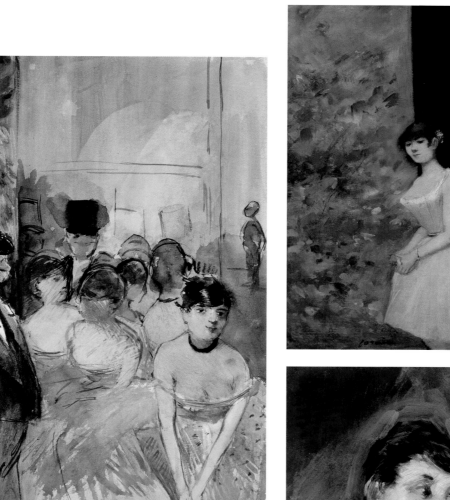

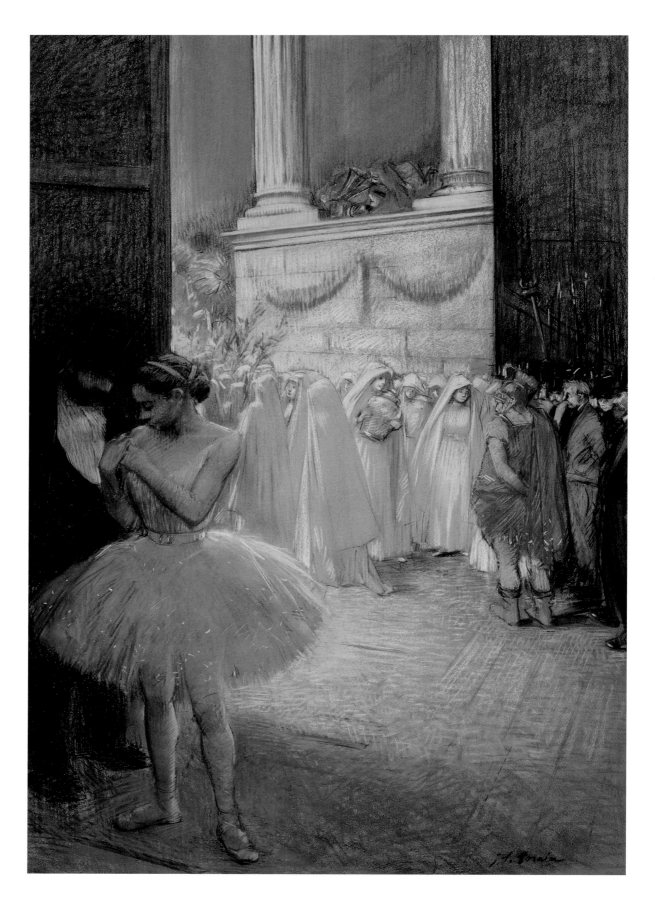

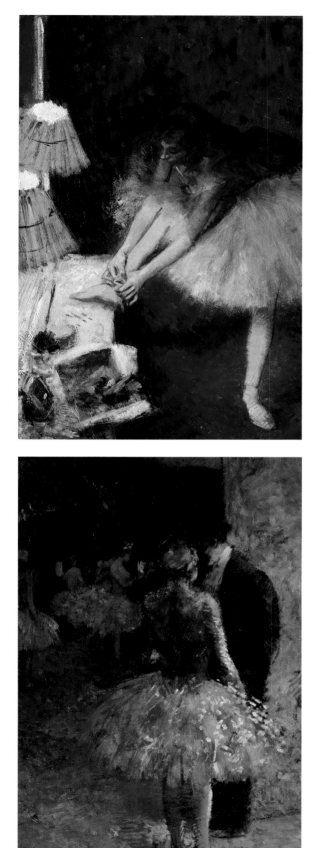

and falls on the dancers' torsos, whereas in *Backstage at the Opéra during a Performance of "Aïda"* (plate 72), the light source remains in the background. And in *Dancer in Her Dressing Room* (plate 73), to the contrary, the lighting, tempered by two pink lampshades, gently irradiates the intimacy of the scene. The absence or presence of a physical light source in Forain's paintings seems to reflect Degas's belief that it was important to "work a great deal on nocturnal effects, lamps, candles, etc. The titillation is not always to show light but rather its effect."[7]

Stylistically, Forain made use of a flickering touch. In *Behind the Scenes* and *Intermission. On Stage,* the vegetal motifs on the scenery backdrops are almost indistinguishable as they glow with multicolored brushstrokes. Forain, like Degas, contrasted abstract representations of the stage scenery with detailed renderings of the figures. In *Le Dialogue* (plate 74), the fluttering brushstrokes carry across the entire canvas.

Still following Degas's example, Forain sought to portray the realism of the bodies. He often cast the ballerina as a slender beauty, but as in Degas's sculpture *Little Dancer, Aged Fourteen* (plate 77), the anatomies of Forain's ballerinas are not idealized in the manner of the Salon's academic nudes, in which smooth skin prevailed. In *Intermission. On Stage,* he even portrays a *petit rat* with stooped shoulders and a sunken chest.

Finally, under Degas's influence, Forain turned to using both pastels and unusual supports such as fans. Forain used pastel for scenes exalting femininity, as in *Dancer with a Mirror* (plate 75). Encouraged by Degas, he explored the possibilities of composition that the fans' rounded edges afforded him to echo the curves of the dancers' tutus. Around 1885, he experimented with another novel support, the tambourine, whose vellum allowed him to emphasize transparencies. Forain painted *In the Wings* (plate 76) after Édouard Manet, who in 1879 had decorated some tambourines on the theme of Spanish dance.[8]

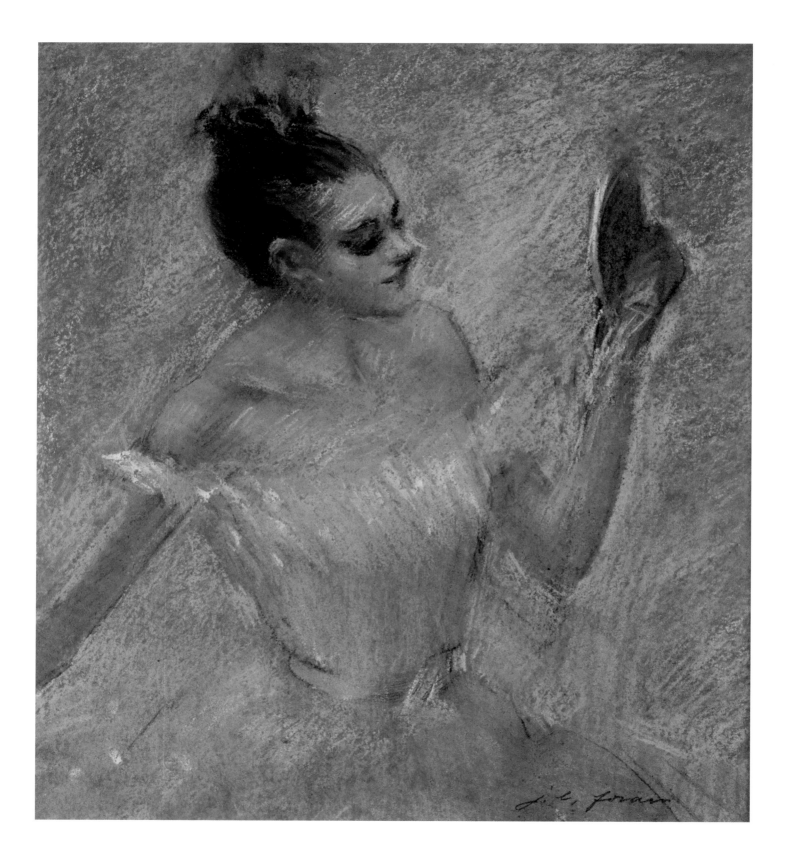

Plate 75
Jean-Louis FORAIN
Dancer with a Mirror
c. 1885
Pastel on gray/tan wove paper
with blue fibers
12⅜ × 11⅛ in. (31.4 × 28.3 cm)
The Dixon Gallery and Gardens,
Memphis, Tennessee, Museum
Purchase, 1993.7.27

Plate 76
Jean-Louis FORAIN
In the Wings
c. 1885
Oil on vellum
11¾ diam. in. (29.7 cm)
Private collection

Plate 77
Edgar DEGAS
Little Dancer, Aged Fourteen
c. 1880-81 (cast posthumously,
c. 1919-32)
Bronze and fabric
38½ × 14½ × 14¼ in.
(98 × 36.8 × 36.2 cm)
Virginia Museum of Fine Arts,
Richmond, the State Operating
Fund and the Art Lovers'
Society

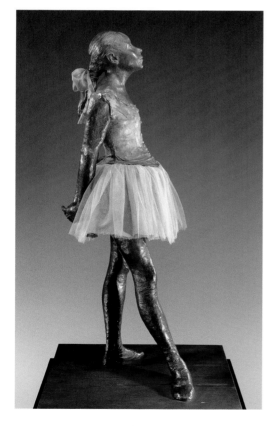

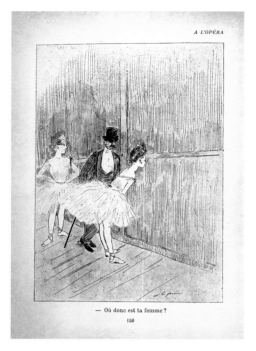

Fig. 2
"At the Opéra: Where is your wife then?"
Illustration in Jean-Louis Forain, *La Comédie parisienne,* second series (Paris: Librairie Plon, 1904), p. 150

Fig. 3
"Love in Paris: Morning—Evening."
Illustration by Jean-Louis Forain published in *Le Fifre,* no. 11 (May 4, 1889)

Fig. 4
"One more year to wait, General."
Illustration in Jean-Louis Forain, *La Comédie parisienne* (Paris: Ed. Charpentier et Fasquelle, 1892), p. 9

WHAT MOST DISTINGUISHES FORAIN from the other Indépendents is his satirical slant. In the words of the art critic Diego Martelli, "Forain, a young man, follows Degas with one foot and the caricaturist Grévin with the other."[9] Forain's insightful powers of observation and psychological analysis are exploited in both his press illustrations and his Opéra scenes.

In *Behind the Scenes* (plate 70), made about 1880, Forain depicts a ballerina standing in the wings, turning away from the gentleman beside her whom she appears to ignore or perhaps even shun. As art historian Theodore Reff has noted, Forain's juxtaposition of these two actors in contrasting roles reveals a subtle psychological analysis.[10] When, on the same theme, Degas painted *Dancers Backstage* (plate 55), he eluded the confrontation since the figures are partially eclipsed by a larger backstage scene in which another ballerina and several stage flats appear.

Of course, the captions that accompany Forain's legendary press illustrations demonstrate his psychological acumen and provide fertile ground for further interpreting his paintings (figs. 2–7). Some of his paintings take up identical themes of certain works he published in journals. This can be seen in his watercolor *The Visit* (plate 78), which stigmatizes poor families whose venality drives them to exploit their young daughters' charms. A version also appeared as a drawing published in *Le Fifre,* a satirical weekly magazine that Forain founded in 1889.[11]

In the first issue of *Le Fifre,* Forain explained that his illustrations were meant "to tell everyday life stories, to show the absurdity of certain sorrows,

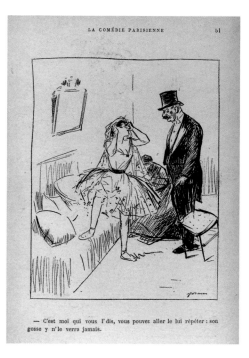

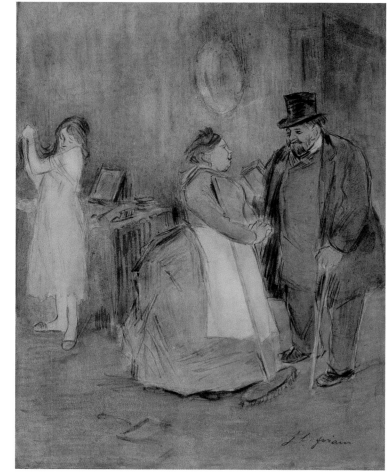

Fig. 5
"It is all agreed. We'll see our wives to the carriages and we'll be back."
Illustration in Jean-Louis Forain, *La Comédie parisienne* (Paris: Ed. Charpentier et Fasquelle, 1892), p. 71

Fig. 6
"So tell me André, as a man, what do you think of her?"
"She's perfect, Father!"
"You wouldn't believe the misery I have to endure at home because of her!"
Illustration in Jean-Louis Forain, *La Comédie parisienne* (Paris: Ed. Charpentier et Fasquelle, 1892), p. 210

Fig. 7
"I am telling you and you can tell him: He will never see his child."
Illustration in Jean-Louis Forain, *La Comédie parisienne* (Paris: Ed. Charpentier et Fasquelle, 1892), p. 51

Plate 78
Jean-Louis FORAIN
The Visit
c. 1889
Watercolor with graphite and gouache on wove paper
11¾ × 8⅞ in. (29.8 × 22.5 cm)
The Dixon Gallery and Gardens, Memphis, Tennessee, Museum Purchase, 1993.7.10

91

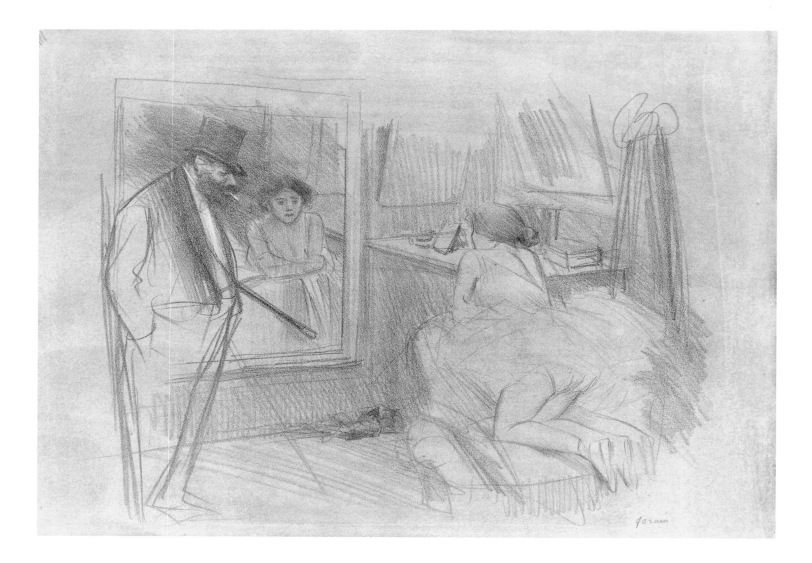

Plate 79
Jean-Louis FORAIN
*Dancer's Dressing Room,
Second Plate*
1894
Lithograph on off-white paper
mounted on a second sheet
11¾ × 16⅜ in. (29.8 × 42.1 cm)
Boston Public Library, Print
Department, Albert H. Wiggin
Collection

Plate 80
Jean-Louis FORAIN
In the Wings
c. 1885
Pen, brush, and ink on paper
17 × 11½ in. (43.3 × 29.1 cm)
Petit Palais, Musée des
Beaux-Arts de la Ville de
Paris, Inv. PPD00995

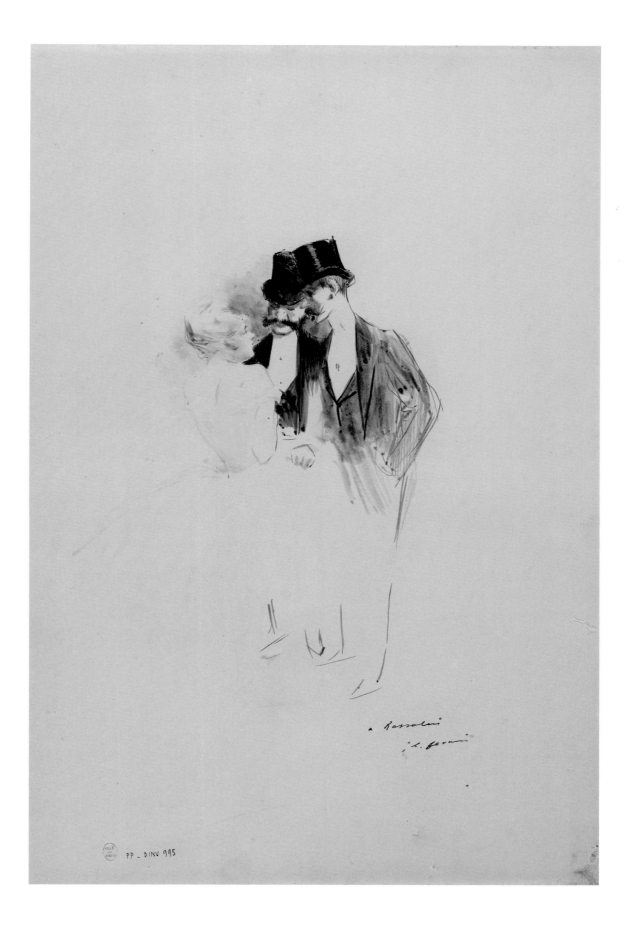

Fig. 8
Jean-Louis FORAIN
The Star Dressing
c. 1876
Ink wash and watercolor
on paper
11¹³⁄₁₆ × 7⅜ in. (30 × 20 cm)
Private collection

Fig. 9
Jean-Louis FORAIN
The Admirer
c. 1877–79
Oil on canvas mounted
on wood
8 × 6 in. (20.3 × 15.2 cm)
Museum of Fine Arts, Houston;
Gift of Audrey Jones Beck

the sadness in many joys.... Always upbeat, often ironic, these contributions scrutinize the failings and shortcomings of contemporaries, without attacking them per se.... To be interesting and inquisitive, an artist merely has to study the world of his own time."[12]

Forain's trenchant eye, in both his paintings and his press illustrations, was trained especially on the figure of the Opéra subscriber. Early in his career, from 1876 to 1880, Forain often portrayed these earnest admirers as pretentious wimps, transfixed in adulation before their divas, as we can see in a watercolor from about 1876 inscribed *The Star Dressing* (fig. 8) and an oil painting from about 1877–79 titled *The Admirer* (fig. 9). In later works, such as the 1892 lithograph *The Consent* (plate 81), the *petit rat* appears quite fragile compared to the stout, blackened mass of her suitor.[13] Forain systematically lampooned this bourgeois type by overstating his physical deformities and highlighting the contrast between feminine fragility and masculine brutality, between grace and ugliness.

This satirical slant is particularly evident in *Intermission. On Stage,* in which Forain's critique of the *abonné* is clearly expressed by his inclusion of pretentious accoutrements—a

lorgnette and the venerable Légion d'Honneur red ribbon on the man's lapel.[14]

Forain's hand, which in his earliest press illustrations was spindly and thin, became more assertive and concise around 1890. According to Huysmans, "[Forain's] drawing is deliberate, rapid, summarizing the whole."[15] The apparent facility with which he dashed out the figures in *Dancer Refastening Her Shoulder Strap* (plate 82), a preparatory work for the marvelous pastel *Backstage at the Opéra during a Performance of "Aïda,"* is illusory. In fact, he achieved this easy flow of line by virtue of daily practice, "the patient accumulation of notes and the fearful memory of precise observations," in the words of writer Jean Richepin.[16] Jean-Auguste-Dominique Ingres had advised Degas on the primary importance of developing a drawing practice, and one senses that Forain followed the great painter's recommendations to the letter: "Draw lines, young man, draw, either from memory or from life, and you will be a good artist."[17]

Plate 81
Jean-Louis FORAIN
The Consent
1892
Lithograph on dark cream
chine collé mounted on
off-white wove paper
10⅝ × 8⅚ in. (27.1 × 21.1 cm)
Boston Public Library, Print
Department, Albert H. Wiggin
Collection

Plate 82
Jean-Louis FORAIN
*Dancer Refastening Her
Shoulder Strap*
c. 1890–95
Colored pencil on paper
20⅛ × 15¾ in. (51 × 40 cm)
Private collection

Plate 83
Jean-Louis FORAIN
Ballerina in Repose
c. 1890–95
Red chalk on paper
20⅛ × 15¾ in. (51 × 40 cm)
Private collection

Plate 84
Jean-Louis FORAIN
*Ballet Dancer Seen from
the Back*
c. 1895
Red, black, and white chalk
on light brown paper
18¹⁵⁄₁₆ × 12¹⁵⁄₁₆ in. (48.1 × 32.9 cm)
Sterling and Francine Clark
Art Institute, Williamstown,
Massachusetts

forain

17 - 42

Plate 85
Jean-Louis FORAIN
In Front of the Set
c. 1895–1900
Pastel on paper
19½ × 23¾ in. (49.5 × 60.5 cm)
The Dixon Gallery and Gardens,
Memphis, Tennessee, Museum
Purchase, 1993.7.30

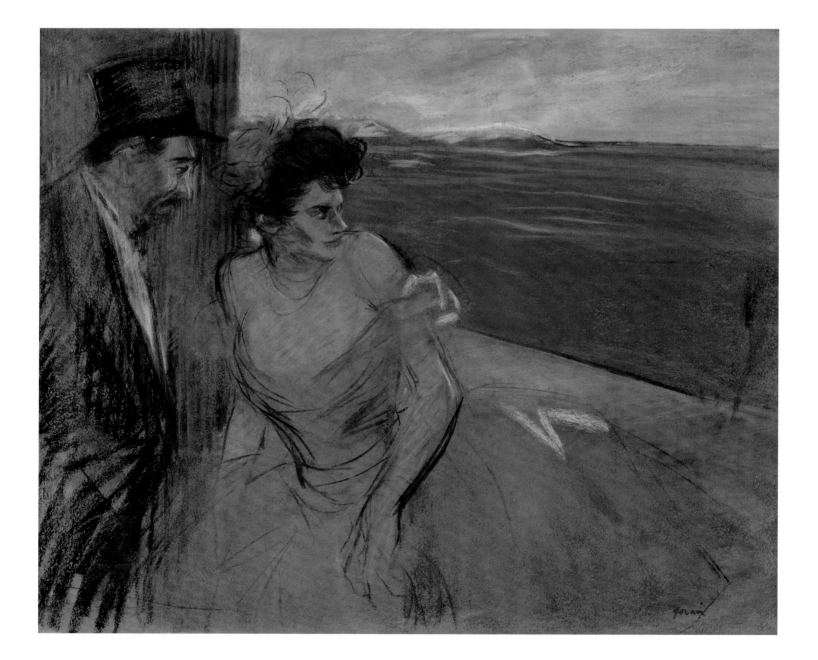

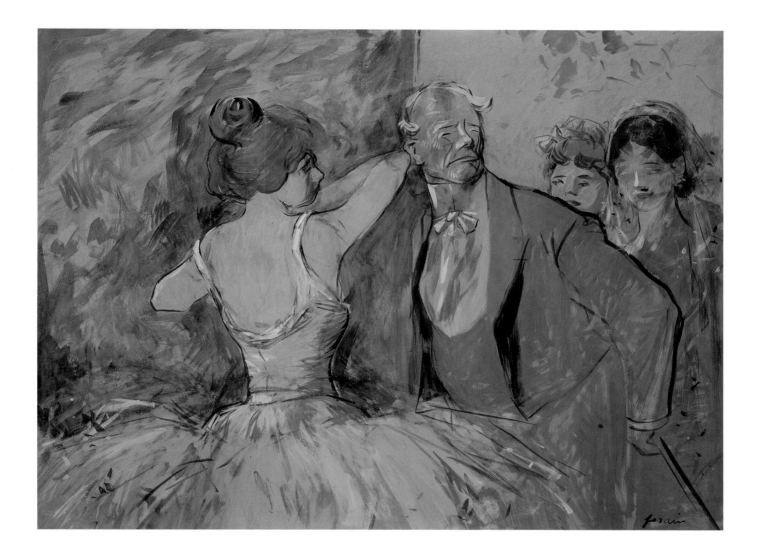

FORAIN'S WORK FROM 1895 TO 1900 shows that he was embarking on a period of transition. His pastel *In Front of the Set* (plate 85) and the gouache *In the Wings* (plate 86) demonstrate an evolution in his style. The lively and pure colors are taken from the Impressionists' palette, and they in no way prefigure the subdued tones he tended to prefer in the subsequent two decades. In addition, Forain has modeled his figures' faces with brutal gashes. The draftsmanship that structures these two works is fully realized in an incisive, elliptical, and above all very personal style. Art historian Richard Thomson noted rightly that when Lautrec painted *Dancer* (fig. 10), he used very broad strokes to obtain the effect of rapid brushwork so characteristic of Forain's paintings of ballerinas.[18]

Plate 86
Jean-Louis FORAIN
In the Wings
c. 1900
Gouache on paper
41½ × 55¾ in. (105.5 × 141.5 cm)
Petit Palais, Musée des
Beaux-Arts de la Ville de Paris,
Inv. PPP00855

Opposite:
Plate 87
Jean-Louis FORAIN
On the Stage
1912
Oil on canvas
24 × 19¼ in. (61 × 49 cm)
Private collection

Fig. 10
Henri de TOULOUSE-LAUTREC
Dancer
1895–96
Oil on canvas
79 × 28⅝ in. (200 × 72 cm)
Private collection, California

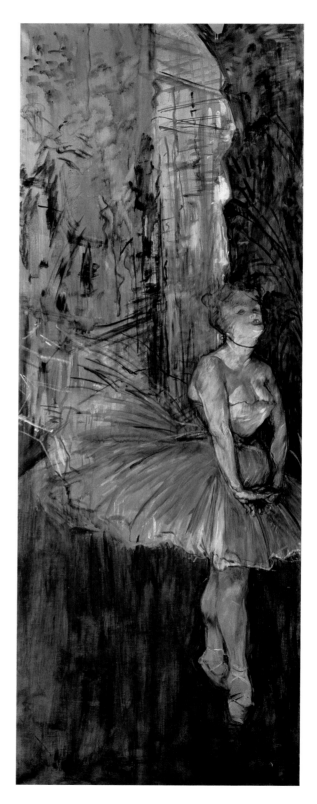

Forain became more engaged in and responsive to political life in the 1890s and thus produced various satirical works on sociopolitical themes in his later years (1900–1914), relinquishing his focus on Parisian society life. Dancers all but vanished from his caricatures and press illustrations; they were replaced by judges, parliamentarians, financiers, lawyers, and politicians. At the same time, Forain painted courtroom scenes in all their pathos, with indifferent judges, impervious to the plights of the deprived and disinherited. And at the Opéra, Forain was no longer the shrewd and amused observer of his youth. He now unleashed a heartfelt fury over the indignities a dancer was forced to endure in accepting the advances of the proverbial subscriber. He expressed his burning indignation through new artistic means.

First of all, his brushwork became very rapid. The writer Marie de Régnier called him the "Lion of Drawing,"[19] and Forain really let out his claws when he depicted the *vieux beau* in the 1912 oil painting *On the Stage* (plate 87), in which the much older man examines a young ballerina, holding her by the chin. This treatment of the dancer as property deeply shocked Forain, and he communicates his disgust by focusing on the facial expressions and body language, paying little or no heed to background detail, composition, or even the figures' clothing. The sophisticated spatial divisions of the Impressionist era give way to a sparer composition, with figures placed somewhat asymmetrically on the canvas. The dancer's tutu is but vaguely suggested. Forain represents his figures with confidence, using brusque, assertive, and quick brushstrokes. It is with the same furious energy that he traced his vitriolic political caricatures, to the extent that one can imagine the pen shattering under the rage propelling it, as it drew hatched, broad lines.

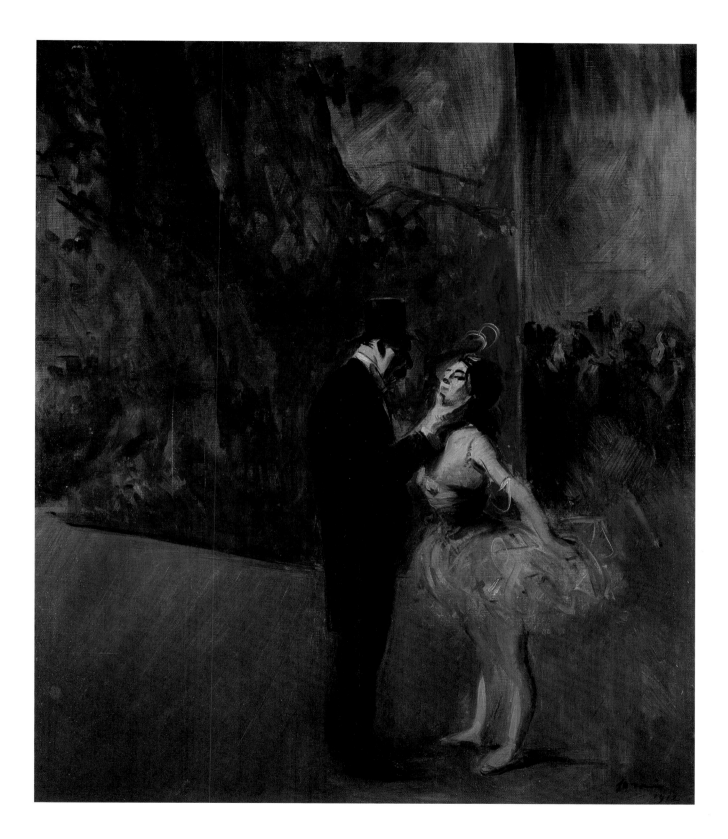

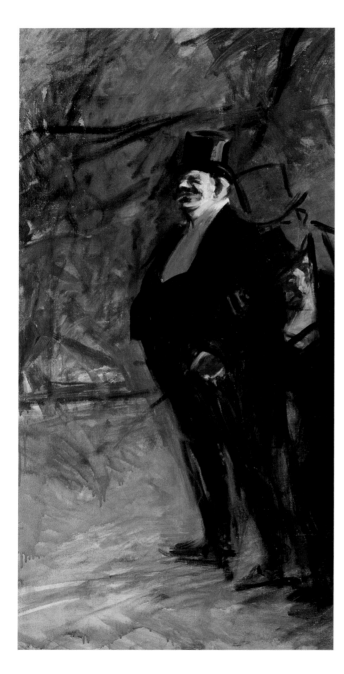

Plate 88
Jean-Louis FORAIN
Abonnés in the Wings
c. 1905
Oil on canvas
35⅜ × 17¾ in. (90 × 45 cm)
Private collection

Plate 89
Jean-Louis FORAIN
Negotiations in the Wings
c. 1898
Watercolor and India ink
on paper
12⅜ × 11¾ in. (31.5 × 30 cm)
Courtesy of Galerie Schmit,
Paris

Forain's brushstroke is also incisive in his execution of facial expressions in *Abonnés in the Wings* (plate 88), in which subscribers hover in anticipation of receiving dancers' favors, and this despite their physical corpulence deformed by age or excess. In *Negotiations in the Wings* (plate 89), one can guess just how sordid their transactions may have been. The dancer is shown from behind and in the background; the round-shouldered suitor confers with the dancer's mother, who leans her ghastly face toward his. And as for the *abonné*'s prurient leer in Forain's 1903 lithograph *Fan (For the Gavarni Ball)* (plate 90), it is explicit on his craggy, rugged face.[20]

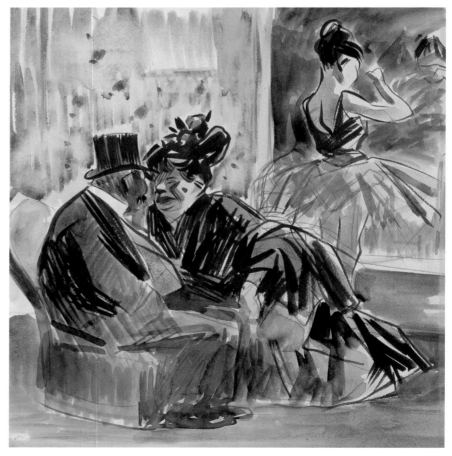

Again, taking pen to paper with economy and concision, this "Lion of Drawing" likewise leaves his imprint on the silhouettes of the two figures in *The Ballet Master and the Dancer* (plate 91), in which the ballerina is viewed from behind. The extreme synthesis of the character types and situations Forain knew so well is encapsulated here: in both mass and shape, the figures are reduced to a minimum, culminating in an abstraction of imagery. There is no decor for this "rehearsal." The dancer's graceful, slender neck is pitted against the grotesque, sagging corpulence of her teacher, giving the viewer an inkling of the authority he wielded over his protégée. This elliptical image shocked viewers.

Plate 90
Jean-Louis FORAIN
Fan (For the Gavarni Ball)
1903
Color transfer lithograph
printed in chamois, red, and
black on imitation Japanese
paper
10¼ × 19½ in. (26 × 49.5 cm)
Boston Public Library, Print
Department, Albert H. Wiggin
Collection

Plate 91
Jean-Louis FORAIN
*The Ballet Master and
the Dancer*
c. 1910
Watercolor and India ink on
paper
11 × 15⅞ in. (28 × 40.5 cm)
Private collection

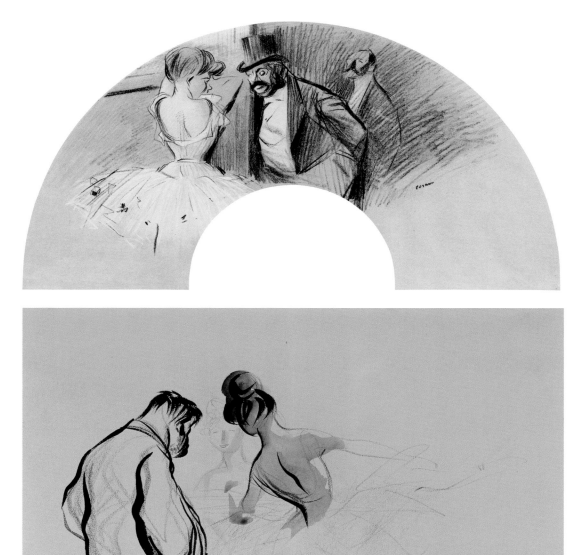

Plate 92
Jean-Louis FORAIN
Dancer against Stage Decor
1905
Oil on canvas
25⅜ × 31⅞ in. (65 × 81 cm)
Private collection

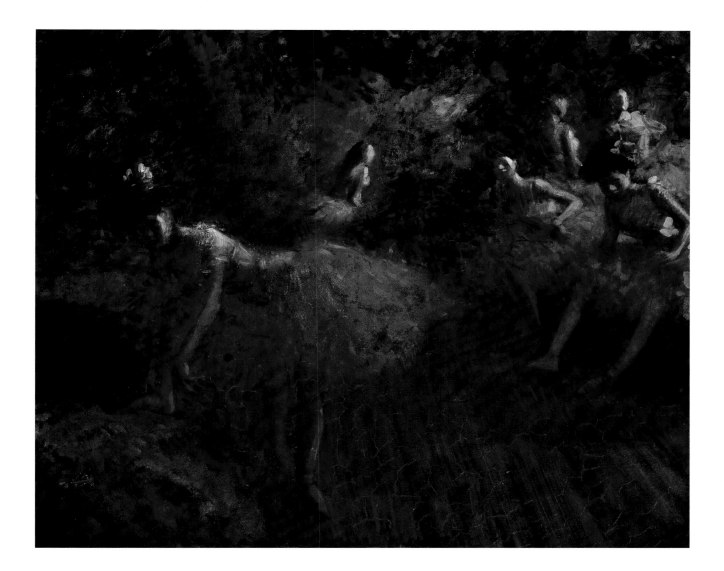

One also notes around this time Forain's increasing use of muted tones. In *On the Stage* (plate 87), Forain brings out the light emanating from the projectors that rains upon the face and bust of the dancer as well as on the *abonné*'s neck. Only the flowers in the dancer's hair stand out amidst the otherwise subdued palette in *Dancer against Stage Decor* (plate 92). By contrast, in *Dancers in Pink* (plate 93), the lighting delicately highlights and caresses their bodies and costumes, ensconcing them in a gauzy rose-colored symphony, bringing a feminine note to the entire ensemble. As Gillet wrote in 1913: "[Forain's] work, fed by immense study, softened by daily practice, driven by renewed indignations and concerns, has fully blossomed. He has made great drawings, but only now does he include, as Ingres would have had it, anger and rage."[21]

Plate 93
Jean-Louis FORAIN
Dancers in Pink
c. 1905
Oil on canvas
23¾ × 29 in. (60.3 × 73.6 cm)
Carmen Thyssen-Bornemisza
Collection, on loan to the
Museo Thyssen-Bornemisza,
Madrid

DURING THE WAR YEARS (1914–18), Forain supported the nationalistic fervor of his compatriots in the press, and the image of the dancer was absent from his repertoire. Dancers reappeared, however, in his later works (1920–31) and manifest Forain's talent at the peak of his artistic development as well as the new social status of the dancer.

The socioeconomic realities of the ballerina's life had changed: dance was recognized as a more laudable career, and working dancers earned decent salaries, thereby rendering the "protectors" of former times superfluous. The world of the *foyer de la danse* had fallen into decline.

In *The Dancers' Repose* (fig. 11), the ballerinas' admirers are the secondary figures, relegated to the background, and their physical appearances are not as hideous as before. Forain became less severe, perhaps because independent women of this profession no longer needed to be defended. Furthermore, the carnivorous little face of the ballerina in *Dancer and Abonné at the Opéra* (plate 94) shows us that she will reach her goal—the "old man" will pay. She is nothing like the fragile victim featured in *Conversation with a Ballerina in the Wings* (plate 95), drawn forty years earlier.

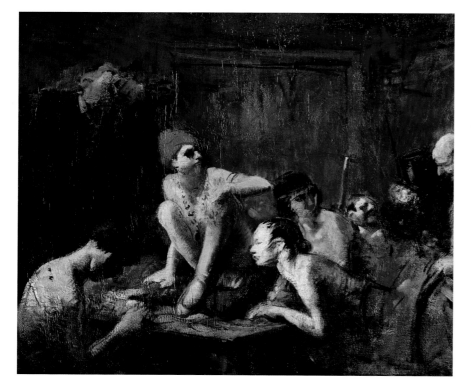

Fig. 11
Jean-Louis FORAIN
The Dancers' Repose
1924
Oil on canvas
20½ × 24¾ in. (52 × 63 cm)
Private collection

Plate 94
Jean-Louis FORAIN
*Dancer and Abonné at
the Opéra*
c. 1925
Watercolor on paper
21⅞ × 15 in. (55.5 × 38 cm)
Private collection

Plate 95
Jean-Louis FORAIN
*Conversation with a
Ballerina in the Wings*
c. 1885–90
Ink and ink wash on paper
mounted on board
13⅜ × 8½ in. (34 × 21.5 cm)
The Dixon Gallery and Gardens,
Memphis, Tennessee, Museum
Purchase, 1993.7.26

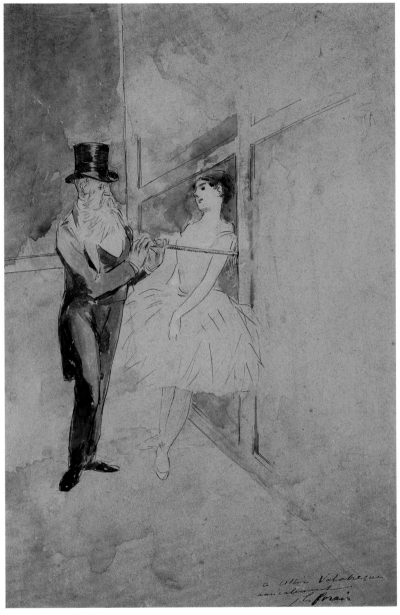

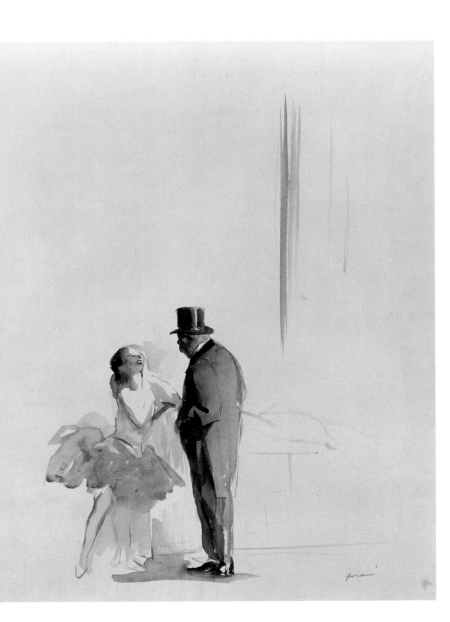

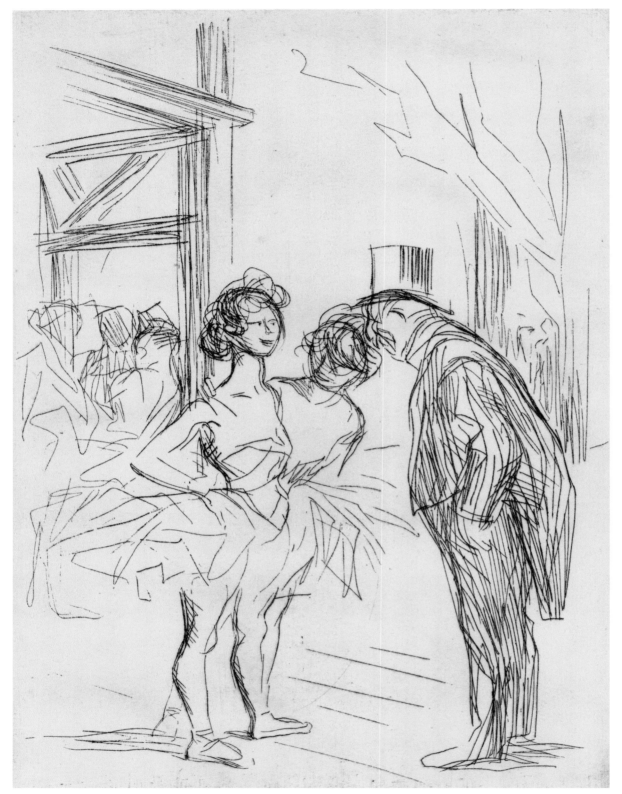

Plate 96
Jean-Louis FORAIN
In the Wings
c. 1909
Etching on beige laid paper
10½ × 8⅝ in. (26.7 × 21.9 cm)
Boston Public Library, Print
Department, Albert H. Wiggin
Collection

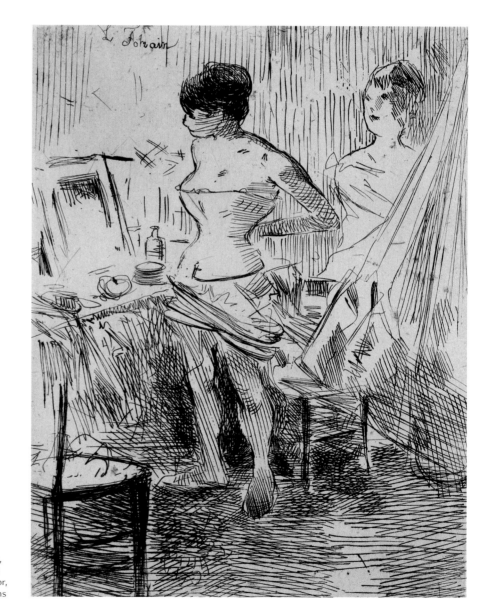

Plate 97
Jean-Louis FORAIN
Dancers in Their
Dressing Room
c. 1876
Etching on paper
6¼ × 4⅝ in. (15.8 × 11.7 cm)
Print Collection, Miriam and
Ira D. Wallach Division of Art,
Prints and Photographs, The
New York Public Library, Astor,
Lenox, and Tilden Foundations

Plate 98
Jean-Louis FORAIN
Dancer in a Tutu
c. 1925
Watercolor on paper
12 × 8⅞ in. (30.5 × 22.5 cm)
Private collection

The triumphant ballerina in *Dancer in a Tutu* (plate 98) sweeps toward the viewer, brightly captured in a *pas de dégagé.* Her tutu is modern—very short. To the right, the gauze of the tutu blends in with the set, which is treated in a fluid manner.

Forain progressively decreased his contributions to the press and stopped publishing in them definitively in 1925, when he was seventy-three years old. Judging from the bright colors he returned to in the 1920s, for example in *Two Dancers at Intermission* (plate 99) and *The Dancers' Repose,* one might conclude that the artist in him seemed to be at peace.

AS REFF HAS KEENLY OBSERVED, "It was this notion of the incisiveness of drawing, its capacity to cut through appearances to expose the deeper truth beneath . . . that Forain and Degas shared. . . . So it was appropriate that the aged Degas should have wished for no other eulogy at his funeral than the brief one he wanted his fellow draftsman to deliver: 'You, Forain, will say, "He greatly loved drawing: so do I,"' and you will go home."[22]

It may well be this commitment to the incisive potential of drawing that elicited Lautrec's admiration as well. In 1891, he said, "I belong to no school. I admire Degas and Forain."[23]

Through his renderings of the dancer, traditionally deemed a subject with lighter connotations, we can see how perceptive Forain was and grasp his position as a socially committed artist. The image of the dancer in his work conveys a message of capital social importance, at once generous and humane.

As Paul Léon so justly put it: "This humorist was soft at heart. . . . It was out of pity for the victims, those of humble extraction, those whom fate had been cruel to, that he was moved to be brutal to the others, the possessors, the self-satisfied. . . . Forain tells us about ourselves: he penetrates to our inner selves more deeply than we dare."[24]

The *abonnés* of days gone by have deserted the wings and the backstage at the Opéra, but doesn't Forain's message of compassion and rebellion remain pertinent today?

Translated from the French by Meghan C. Ducey

Plate 99
Jean-Louis FORAIN
Two Dancers at Intermission
1919
Watercolor on paper
12⅝ × 8¾ in. (32 × 22 cm)
Private collection

Plate 100
Jean-Louis FORAIN
The Presentation: A Dancer, Her Mother, and a Gentleman
c. 1895
Black crayon and gray ink wash on paper
16⅜ × 10¾ in. (41.6 × 27.4 cm)
Musée d'Orsay, Paris, département des Arts graphiques du Musée du Louvre, legs du comte Isaac de Camondo, 1911 (RF 4054 recto)

NOTES

1. Joris-Karl Huysmans, *Certains* (Paris: Tresse et Stock, 1889; repr. with *L'Art moderne,* Paris: Union Générale d'éditions, 1975), 272. Huysmans was an avowed champion of the Impressionists; he brought Forain's talents to light in 1879. The two men were friends who shared many interests. Forain illustrated two of Huysmans's novels, *Marthe* (1879) and *Croquis parisiens* (1880); he also painted Huysmans's portrait around 1878 (Musée d'Orsay, Paris). Unless otherwise noted, translations of quoted material are by Meghan Ducey.

2. Joris-Karl Huysmans, "Sur Émile Zola et *L'Assommoir,*" *L'Actualité de Bruxelles,* March 18, 1877.

3. These *petits rats* were typically young dancers, students in the dance class, who were often used as extras.

4. See Henri de Toulouse-Lautrec's drawing *Pastiche of Forain,* c. 1890–95, private collection, D. 3.998 in M. G. Dortu, *Toulouse-Lautrec et son oeuvre,* 6 vols. Les Artistes et leurs oeuvres: Études et documents (New York: Collectors Editions, 1971) and in Richard Thomson et al., *Toulouse-Lautrec* (New Haven, CT: Yale University Press, 1991), 184.

5. Paul Bourget, *Essais de psychologie contemporaine* (Paris: A. Lemerre, 1883).

6. Louis Gillet, "Forain, son exposition aux Arts Décoratifs," *La Revue hebdomadaire,* January 25, 1913, 486–87. Gillet was curator at the Musée de Chantilly.

7. Theodore Reff, *The Notebooks of Edgar Degas,* 2 vols. (London: Clarendon Press, 1976; repr., New York: Hacker Art Books, 1985), Notebook 23 (Bibliothèque Nationale, Carnet 21, p. 45), cited by Henri Loyrette in Jean Sutherland Boggs et al., *Degas* (New York: Metropolitan Museum of Art; Ottawa: National Gallery of Canada, 1988), 46.

8. See, for example, Édouard Manet, *Couple of Spanish Dancers,* oil on parchment, 1879, J. W. Fosburgh Collection, New York, cat. no. 345 in Paul Jamot, Georges Wildenstein, and Marie-Laure Bataille, *Manet,* 2 vols. (Paris: Ed. d'études et de documents, G. Van Oest, 1932), and cat. no. 300 in Sandra Orienti, *Tout l'oeuvre peint d'Édouard Manet* (Milan: Rizzoli Editore; Paris: Flammarion, 1967/1970); Édouard Manet, *Couple of Spanish Dancers,* oil on parchment, 1879, Mrs. H. H. Rogers Collection, New York, cat. no. 344 in Jamot et al., *Manet,* and cat. no. 300 in Orienti, *Tout l'oeuvre*; and Édouard Manet, *Bust of Spanish Dancer,* oil on parchment, 1879, private collection, Paris, cat. no. 416 in Jamot et al., *Manet,* and cat. no. 302 in Orienti, *Tout l'oeuvre.*

9. Diego Martelli, "Gli impressionisti, mostra del 1879," *Roma Artistica,* June 27 and July 5, 1879, cited in Charles S. Moffett, *The New Painting: Impressionism, 1874–1886* (Geneva, Switzerland: R. Burton, in association with the Fine Arts Museums of San Francisco and the National Gallery of Art, Washington, DC, 1986), 282.

10. Theodore Reff, *Manet and Modern Paris* (Washington, DC: National Gallery of Art, 1982), 120.

11. *Le Fifre,* no. 1 (February 23, 1889). Forain's drawing appeared with the caption: "Ah Monsieur le comte, jusqu'à quelle heure avez-vous gâté notre Nini? La voilà qui rate encore son conservatoire!" ("Ah, Monsieur the Count, until what time did you indulge our little Nini? Here she is again missing her classes [at the conservatory]!").

12. Ibid.

13. Cat. no. 5 in Marcel Guérin, *J.-L. Forain, lithographe. Catalogue raisonné de l'oeuvre lithographié de l'artiste* (Paris: H. Floury, 1910), and cat. no. 184 in Alicia Craig Faxon, *Jean-Louis Forain: A Catalogue Raisonné of the Prints* (New York: Garland Publishing, 1982).

14. The national order of the French Legion of Honor is the most prestigious honorary decoration bestowed in the country.

15. Huysmans, *Certains,* 273.

16. *Le Fifre,* no. 1 (February 23, 1889).

17. Daniel Halévy, *Degas parle* (Paris: La Palatine, 1960), 57.

18. Thomson et al., *Toulouse-Lautrec,* 184.

19. Marie de Régnier was the daughter of the poet José Maria de Heredia and was married to the poet Henri de Régnier.

20. Cat. no. 17 in Guérin, *J.-L. Forain, lithographe,* and cat. no. 254 in Faxon, *Catalogue Raisonné of the Prints.*

21. Gillet, "Forain, son exposition aux Arts Décoratifs," 489.

22. Theodore Reff and Florence Valdès-Forain, *Jean-Louis Forain, the Impressionist Years: The Dixon Gallery and Gardens Collection* (Memphis: Dixon Gallery and Gardens, 1995), 20; and Theodore Reff and Florence Valdès-Forain, *Jean-Louis Forain: Les Années impressionnistes et post-impressionnistes* (Lausanne: Fondation de l'Hermitage; Paris: Bibliothèque des Arts, 1995), 117.

23. John Rewald, *Post-Impressionism: From Van Gogh to Gauguin* (New York: Museum of Modern Art, 1956; repr., Paris: Albin Michel, 1961), 313.

24. Paul Léon, "Forain 1852–1931," *L'Art,* no. 16 (November–December 1931): 117–18. Léon was director of the Musées de France and a member of the Académie Française.

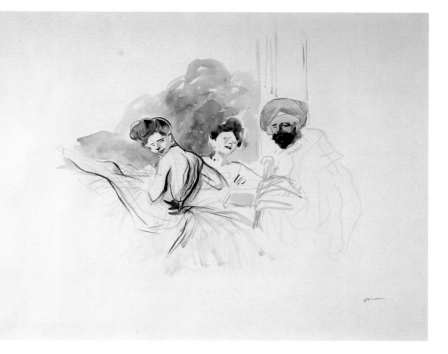

Plate 101
Jean-Louis FORAIN
Dancers at the Barre
c. 1895
Watercolor on paper
16.7 × 22 in. (42.5 × 56 cm)
Private collection

Jean-Louis *Forain*

Evening at the Opéra, c. 1879 The veritable craze for all things Japanese and Chinese in late nineteenth-century France was part of a greater trend marking the growing impact of Asian art on the Western canon. One particular development was the adoption of fan painting, very much in vogue at the time of this work's execution. Camille Pissarro, Degas, and Forain were among several artists to exhibit fans in the fourth Impressionist exhibition of 1879.

The format of the fan presents a unique challenge in terms of composition. In *Evening at the Opéra,* making clever use of the arched shape of the parchment, Forain bridges the realms of the theater box, shown on the right, and the backstage wings, which occupy the left half of the fan. The complementary colors of green and red help to differentiate the two zones. Form interacts playfully with subject matter, as the curved shape of the fan is echoed by the rounded edge of the spectator's loge and the plumage of the dancers' tutus, in addition to the fan held by one of the female patrons.

The fan was a popular fashion accessory at formal occasions such as balls and operas. For the affluent patrons of establishments such as the Paris Opéra, much of the evening's excitement derived from people watching in the halls and foyers, often eclipsing interest in the onstage performance itself. Forain was acutely aware of this and preferred to depict the offstage dramas, particularly those taking place backstage, where the male subscribers would assemble between and after performances to mingle with the dancers. Using the particular compositional conceits of the fan format, Forain was able to display, with some irony, the incongruity between the women who accompanied the male patrons to the Opéra and the ballerinas who received them in the wings and dressing rooms.

Two other fans in the exhibition, *Dancer with a Rose* (plate 66) and *Dancer in a Colored Tutu* (plate 67), depict ballerinas in the act of performance, a rarity in Forain's oeuvre. In both cases, a single dancer is positioned off to the side, creating an asymmetry typical of traditional Asian fan decoration.

—Ingrid Berger

Plate 102
Jean-Louis FORAIN
Evening at the Opéra
c. 1879
Gouache, some graphite or chalk
at left, on parchment (fan)
6⅝ (stick height) × 23¼ diam. in.
(16.8 × 59 cm)
The Dixon Gallery and Gardens,
Memphis, Tennessee, Museum
Purchase, 1993.7.48

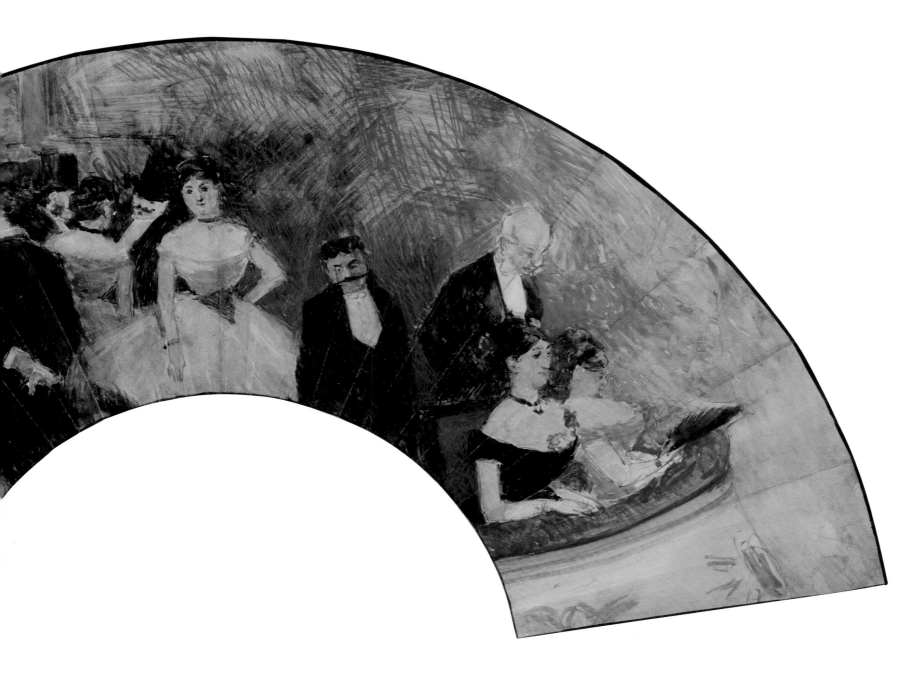

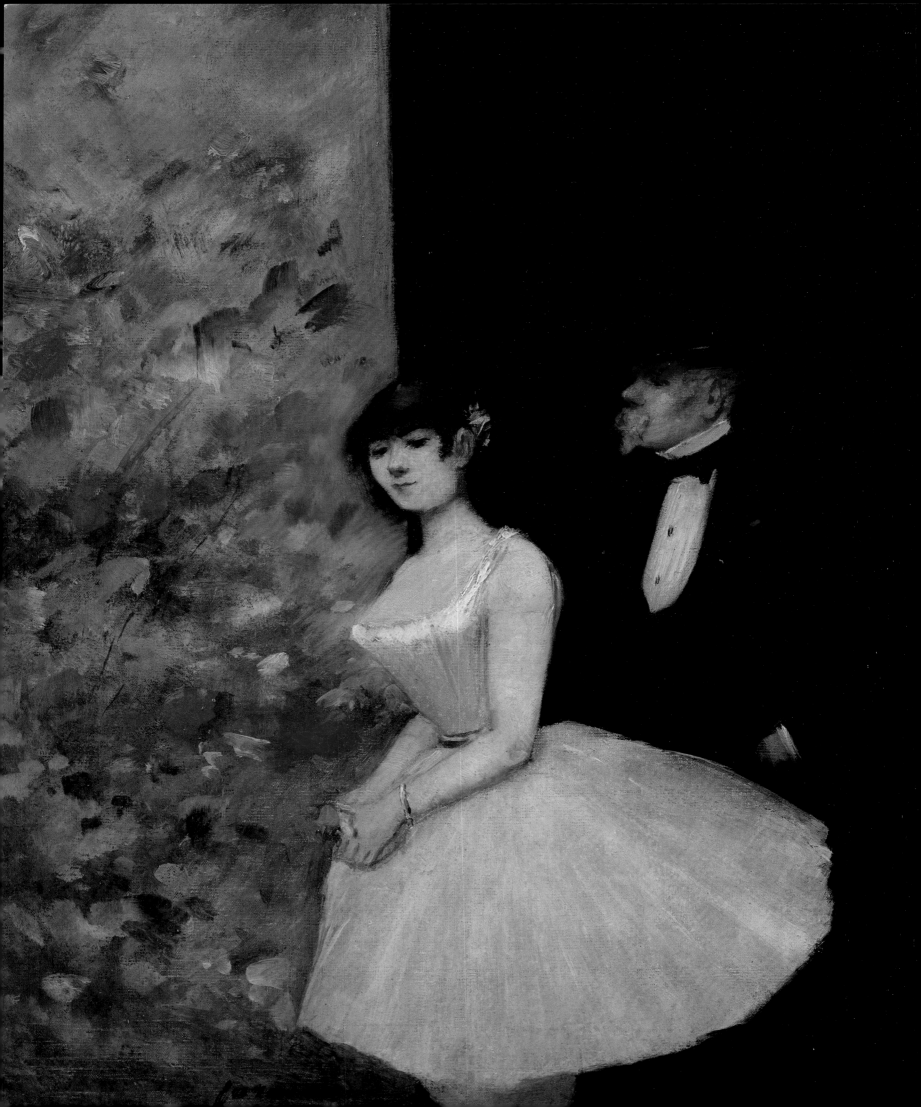

Behind the Scenes, c. 1880

Behind the Scenes successfully employs a common motif in Forain's oeuvre: the juxtaposition of light and dark, female and male, on- and offstage. Dividing the composition just off vertical center, Forain contrasts with stark clarity the bright lights and vivid floral set design of the stage with the black depths of the wings. This device establishes a larger dichotomy, between the young, graceful ballerina and her aging admirer, relating each figure to the opposing worlds of light and dark. The dancer's pristine white tutu absorbs the glow of the stage lights even as it projects behind her, and its placement against the backdrop of shadow makes it all the more luminous. The dancer's youth and beauty echo the lush floral decor of the stage flat and are underscored by the flower tucked behind her ear and the blossom shape of her tutu. Her male suitor emerges directly from the shadows of the wings, his black suit blending seamlessly into the opaque background and linking him with the dark world behind the scenes of the ballet.

Forain is at his most engaging when exploring the impact of a singular, relationally charged interaction. The ballerina's furtive smile belies the feigned aloofness of her pose, betraying an acute awareness of her admirer's focused attention. Forain's views of the particular social structure surrounding the dancer and the male subscriber were far from neutral. Throughout his career, he continued to illustrate his disdain for the ubiquitous presence of the licentious *abonnés* and their patronage, which was nonetheless essential to a dancer's survival. The theme of contrasts here also suggests this darker truth behind the surface splendor of the ballet.

—IB

Plate 103
Jean-Louis FORAIN
Behind the Scenes
c. 1880
Oil on canvas
18¼ × 15⅛ in. (46.4 × 38.4 cm)
National Gallery of Art,
Washington, DC, Rosenwald
Collection 1943.11.4

Plate 104
Jean-Louis FORAIN
Ballet Dancer
1887
Pastel on blue wove paper,
laid down
22¼ × 16⅞ in. (56.5 × 43 cm)
National Gallery of Art,
Washington, DC, Gift of
Mrs. Lessing J. Rosenwald
1989

Ballet Dancer, 1887　In *Ballet Dancer,* Forain observes a single dancer in a decontextualized setting. Chest lifted, her hands pressed into the small of her back and her arms akimbo, she stands in three-quarter profile. The long braid trailing down the length of her back accentuates the verticality of her posture. Like Degas, Forain used studies of single figures to investigate the comportment of dancers. However, in this particular sketch, he seems equally interested in the effects of luminosity. The easily blended pastel medium lends itself to the representation of the glow of the stage lights, suggested by the light blue smudging at the left of the sheet. The chalklike substance is also highly effective in evoking the ephemeral effects of the delicate tutu.

Admirers of Forain and his distinctive style have always extolled the dexterity with which he wielded his pencil and brush. Even at his most economical, he communicates maximum information by placing his marks with shrewd precision and allowing the negative space of the blank page to serve as a compositional element. This excellence of draftsmanship drew the attention of the young Lautrec, whose father was a friend of Forain's. Note the similarity between this dancer and Lautrec's *The Dancer* of 1890 (plate 136). Forain and Lautrec shared more than a propensity for representations of the dancer; during the 1890s, both artists were frequent contributors to the same Parisian periodicals.[1] Forain's satirizing contempt for high society and his incisive drawing style were traits much admired by the slightly younger Lautrec.

—IB

NOTE
1. Lillian Browse, *Forain the Painter, 1852–1931* (London: P. Elek, 1978), 25.

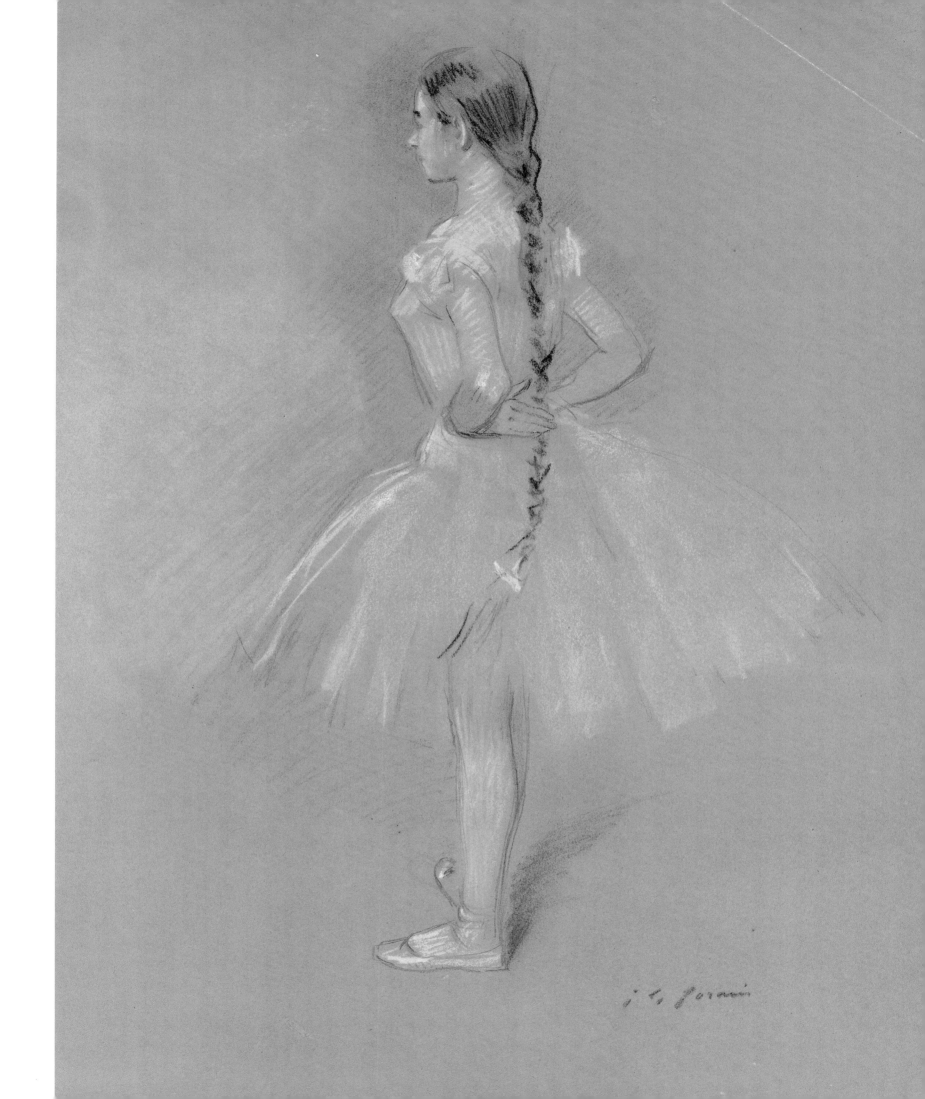

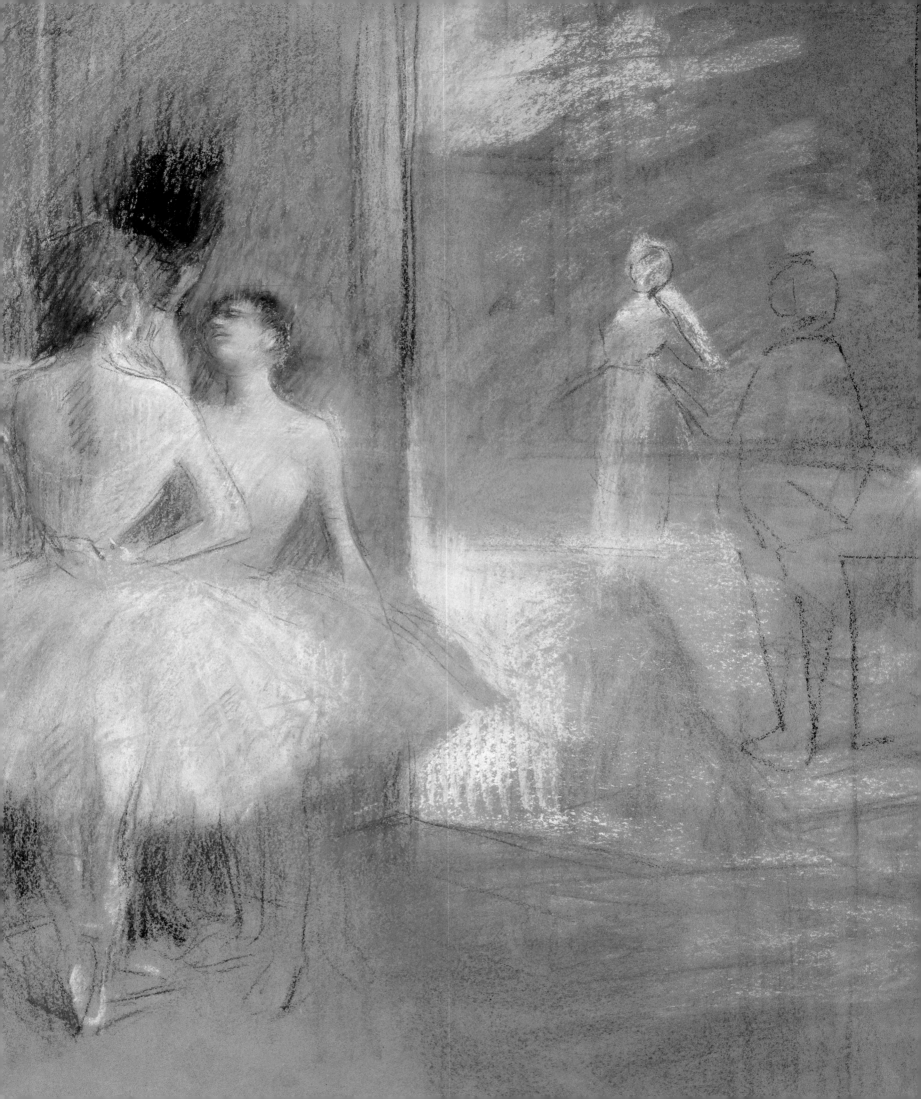

In the Wings, c. 1888

In the Wings is marked by a rudimentary sketchlike quality, evoked through the loose application of chalk and pastel on brown paper, much of which is left exposed, becoming itself an aesthetic element. The striated marks, notable in the more fully developed figures on the left, and the gestural blue streaks of the stage lights draw attention to the artist's swift and energetic application of the medium. Forain was widely admired by his contemporaries for his judicious yet powerful use of line to capture the essential nature of a scene. His highly personal style was developed through years of executing rapid sketches on the streets of Paris and honed by his prolific career as a political cartoonist. In fact, until recently, Forain's legacy centered on his role not as a painter but as a frequent contributor of illustrations to popular periodicals such as *Le Courrier français* and *Le Fifre.*

Forain returned repeatedly to the theme of the dancer and her admirer conversing in the wings. Here, he suggests the shadow of a stage flat, which serves as a backdrop to the conversation between two ballerinas and their admirer. With a minimum of strokes, he depicts an additional male figure and a dancer onstage, to the right. The white and pale blue pastel highlights indicate the glare of the stage lights. It is possible that Forain intentionally left this work unfinished, as even with the utmost economy of line, the full impact of the scene is realized. Forain's compositional eye, especially his strategic use of light, has been compared to that of a stage director's,[1] an observation that is also applicable to his concentration of detail on the critical moment in the scene. A flirtatious backstage interaction is the primary plot of this narrative, and thus is the most fully developed region of the work, drawing our eye straight to the point of interface, as one ballerina tilts her face up with rapt attention. In Forain's view, the performance required of the dancers for their backstage suitors equaled, if not outweighed, their execution of choreography onstage. These young women's reliance on the financial support of their wealthy patrons was a subject that Forain continued to address with both a critical and a satirically humorous eye for the duration of his career.

—IB

NOTE

1. Yves Brayer, "Forain, the Painter I Knew," preface to Alicia Craig Faxon, *Jean-Louis Forain: Artist, Realist, Humanist* (Washington, DC: International Exhibitions Foundation, 1982), 9.

Plate 105
Jean-Louis FORAIN
In the Wings
c. 1888
Pastel and black chalk
on paper
28 × 23 in. (71 × 58.5 cm)
Private collection

Plate 106
Jean-Louis FORAIN
Le Dialogue
c. 1890
Oil on canvas
27½ × 21¾ in. (69.9 × 55.2 cm)
Courtesy of Mr. and
Mrs. Michael Weston

Le Dialogue, c. 1890

Le Dialogue exemplifies the scintillating brushwork typical of Forain's Impressionist style. Treating one of his favorite themes, namely, the encounter of a male patron and a ballerina in the wings, he illuminates the foremost pair with the glow of the stage lights emanating from the right. In the gauzy, decorative material of the dancer's tutu and the areas where the light strikes her arm, Forain uses a dappled brushstroke indicative of the influence of Degas. Like his mentor, Forain preferred the study of artificial light, such as that found in the theater, over the plein air nature scenes filled with sunlight that dominate the Impressionist canon. Urban spaces and the people inhabiting them are what captivated Forain, whose polemical temperament drew him toward themes with sociopolitical undercurrents. In the late years of the nineteenth century, the wings and dressing rooms of the Paris Opéra were the primary platform for his visual analysis of Parisian society.

Most of the canvas, illustrating the vast area of the wings, is bathed in shadow. Additional white-shirted male patrons move among the dancers in the background, indicating the thorough penetration of the backstage domain by these affluent men. Forain masterfully suggests the ample spaces and covert inner workings of this behind-the-scenes world, using the effects of shadow and strategic lighting to heighten the intrigue of the conversations occurring here. Though Forain was greatly influenced by the Impressionists' concern with capturing the effects of light, he maintained a focus on the social implications embedded in his subjects' interactions. As one contemporary critic wrote, "[Forain] is the poet of corruption in evening clothes ... of high life masking empty hearts."[1]

—IB

NOTE

1. Octave Maus, writing in *L'Art moderne* (Brussels), June 27, 1879; quoted in Charles S. Moffett, *The New Painting: Impressionism, 1874–1886* (Geneva, Switzerland: R. Burton, in association with the Fine Arts Museums of San Francisco and the National Gallery of Art, Washington, DC, 1986), 455.

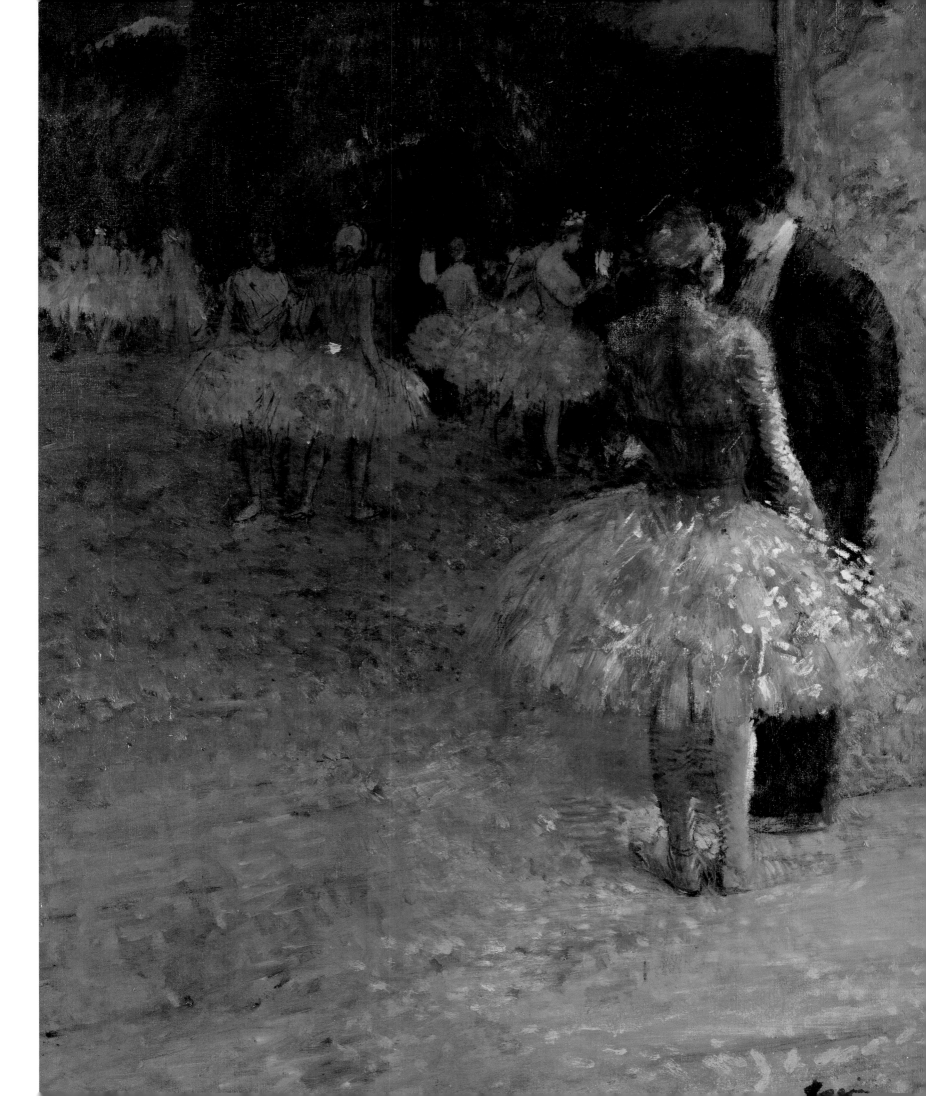

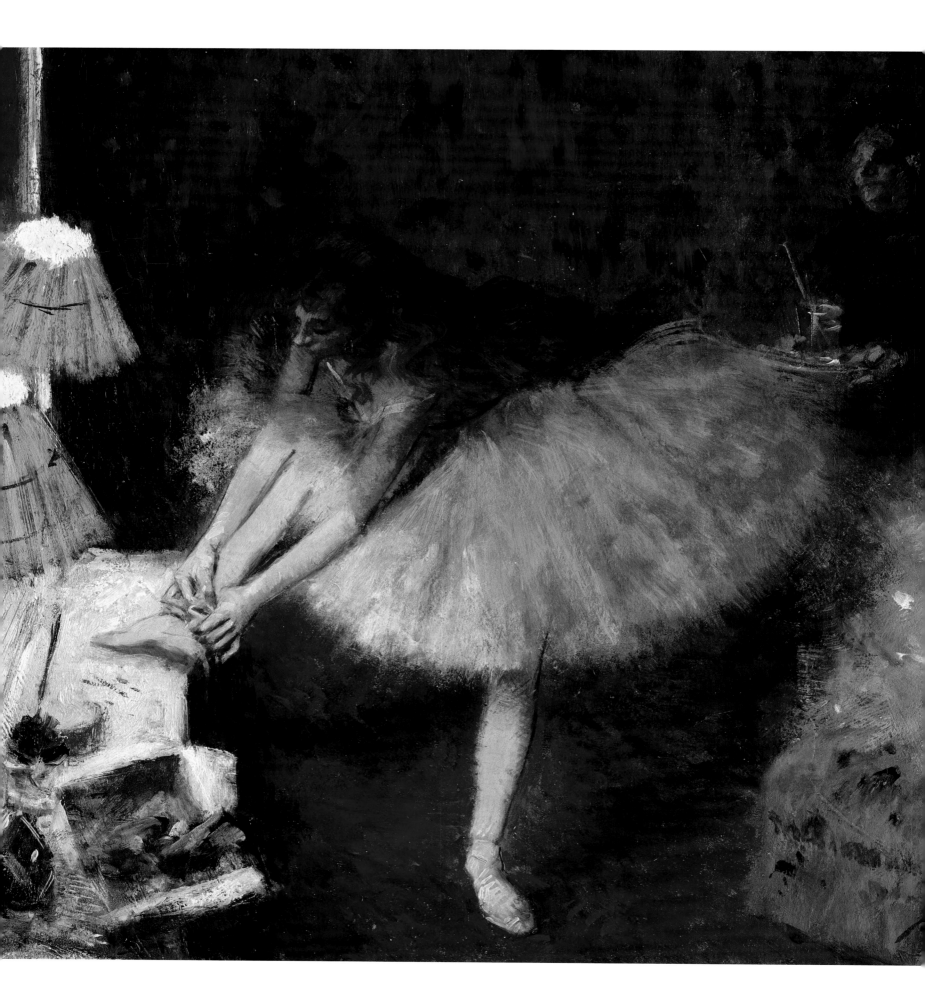

Dancer in Her Dressing Room, c. 1890

Dancer in Her Dressing Room embodies the height of Forain's formal Impressionism, characterized by textural brushwork, the rendering of large fields of mottled colors in place of a strongly delineated background, and a focus on the representation of artificial light. It reveals both his skill in depicting a variety of surfaces and his masterful use of light as a compositional device. In making this painting, Forain applied layers of wet paint one over another to achieve the soft, blurred appearance,[1] which is especially effective in communicating the luminosity of the glowing lampshade and the tactile layers of the dancer's gauzy tutu.

Forain has brought us here into the private space of the dancer's dressing room. This anecdotal scene has a gentle air of trespass, as if we are glimpsing this moment of preparation through the keyhole of the dressing-room door. Forain underscores this effect by concentrating the light source in the lower left corner, eschewing the frontal perspective found in a print of the same theme, *Dancer Tying Her Slipper* (plate 176). Although the elements of the two works are nearly identical, the compositional staging of *Dancer in Her Dressing Room* creates a much more atmospheric effect. Here, a figure, most likely the girl's mother, bears a tray with a glass of water; in the upper right corner, a dresser spills undergarments from its drawers; and the dancer ties her slipper on her vanity, which is strewn with the various accoutrements of beautification. A spare tutu, rendered ethereal through Forain's brushwork, sparkles on a chair. The scene is portrayed with the exactitude of an artist well acquainted with the situational details of the world of ballet.

—IB

NOTE

1. Information courtesy the Sterling and Francine Clark Art Institute object file: conservation examination by Sandra Webber, December 15, 2003.

Plate 107
Jean-Louis FORAIN
*Dancer in Her Dressing
Room*
c. 1890
Oil on panel
10½ × 13¹³⁄₁₆ in. (26.6 × 35 cm)
Sterling and Francine Clark
Art Institute, Williamstown,
Massachusetts

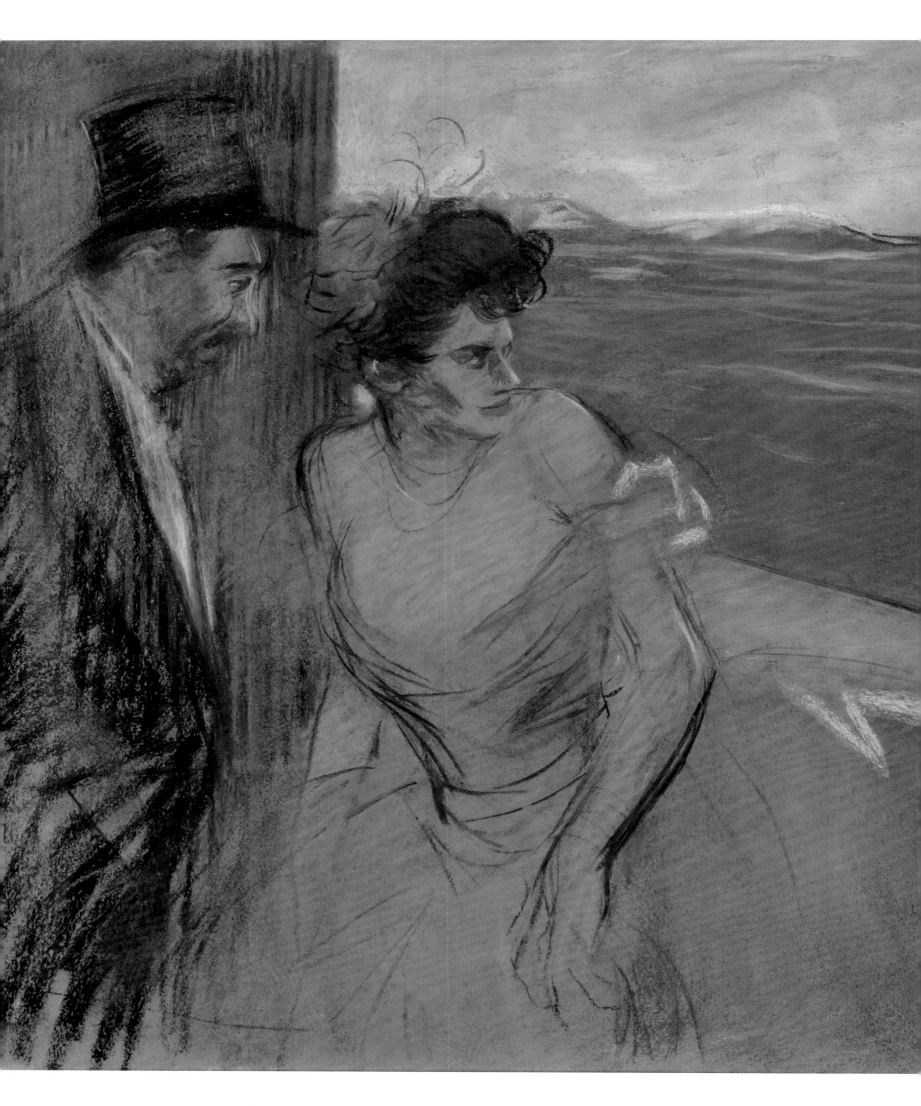

In Front of the Set, c. 1895–1900

Here, Forain isolates a dancer and her male admirer against a seascape backdrop, focusing our attention exclusively on their dramatic interaction. Her tense body language and apprehensive facial expression clearly communicate her discomfort, though we cannot be sure whether it is the looming presence of the top-hatted patron or an event outside the picture plane that elicits her wary reaction.

In this pastel, Forain displays his distinctive, swiftly executed sketching method, manipulating the medium with great success to accentuate the mood of the scene. The patron's tuxedo is drawn with thick lines that fortify his weighty presence, echoed in the emphatic vertical line of the stage flat. Furthermore, he has been sequestered by the dark stage wing behind him, a device Forain frequently used to visually associate the figure of the *abonné* with the backstage realm. The dancer's anxiety is mirrored in the hasty treatment of the lines shaping her torso and the nervous markings highlighting her hair and its ornament, which contrast with the smooth expanse of blue on the stage flat behind her.

Forain has been described as a "story teller in paint,"[1] and although the medium used here is pastel, the sentiment still rings true. His knack for characterization enables the energy and personality of his figures to shine through with an immediacy conveyed by the confidence and economy of his line. For Forain, who had a prolific career as an illustrator for popular magazines, the Opéra was a platform from which to gather fodder for his social satire. In fact, his fine arts oeuvre is matched, if not outstripped, by his bitingly critical journalistic cartoons, and the intrigue of the present scene almost begs for a caption imparting the artist's notorious wit.

—IB

NOTE

1. Lillian Browse, *Forain the Painter, 1852–1931* (London: P. Elek, 1978), 24.

Plate 108
Jean-Louis FORAIN
In Front of the Set
c. 1895–1900
Pastel on paper
19½ × 23¾ in. (49.5 × 60.5 cm)
The Dixon Gallery and Gardens,
Memphis, Tennessee, Museum
Purchase, 1993.7.30

Plate 109
Jean-Louis FORAIN
The Dancer's Necklace
1896
India ink, blue colored pencil,
and graphite on paper
10⅞ × 13¼ in. (27.8 × 33.8 cm)
Courtesy of Galerie Schmit,
Paris

The Dancer's Necklace, 1896

The history of this drawing's various incarnations reveals the avid sociopolitical undertones of Forain's career. The composition, in which a young ballerina playfully dangles her necklace across her patron's face, hovering over the back of his armchair as he faces her serenely seated mother, is indicative of the dressing-room dealings so prevalent in late nineteenth-century Paris. Often coming from homes of near destitution, many young dancers relied on the financial support of these wealthy men, who delighted in spoiling their coveted favorites with token gifts and vital monetary patronage. The dancer, for her part, was reduced to a distinct class of courtesan. As the consenting countenance of the girl's mother in this work reveals, dancers were encouraged, if not duty bound, to participate in this type of exploitative liaison. The mothers often brokered these untoward deals, dispensing with pretense for the sake of securing their daughters' lesson fees.

Forain was outspoken in his disapproval of these circumstances. In addition to exhibiting his work in salons and galleries, he was a renowned contributor to numerous popular publications. It was for his role as a political satirist and draftsman that Forain was most highly regarded by his contemporaries, and he identified himself most strongly with that aspect of his career. The image of *The Dancer's Necklace* first appeared in the April 12, 1896, issue of *Le Courrier français,* and again in 1904, in *La Comédie parisienne.* In this second publication, he added a caption to the image, being equally admired for his sharpness of tongue. Imagining the inner sentiments of the dancer as she panders to a gentleman clearly old enough to be her father, the caption expresses both her distaste for his appearance and her desperation to retain his interest: "He would have to be loaded to be able to cheat on me with a face like that!"[1]

Forain was hailed for the virtuosity of his rapid drawing technique, and his deft treatment of India ink here enabled him to render an effective narrative scene with minimal line and hatching. Of particular note is the way he uses negative space to evoke the voluminous tulle of the tutu. Lauded as the greatest cartoonist since Francisco de Goya and Honoré Daumier, Forain later in his life eschewed his early affiliations with Degas and other leading artists of the day, preferring to steep himself firmly in the tradition of these satirical illustrators.

—IB

NOTE

1. The image appeared in *La Comédie parisienne,* 2nd series (1904), p. 169, with the title *L'École des michets* and the legend "—faut-il qu'il en ait un'galette pour pouvoir me tromper avec cte [*sic*] gueule-là!" This information and the translation above were kindly supplied by Florence Valdès-Forain.

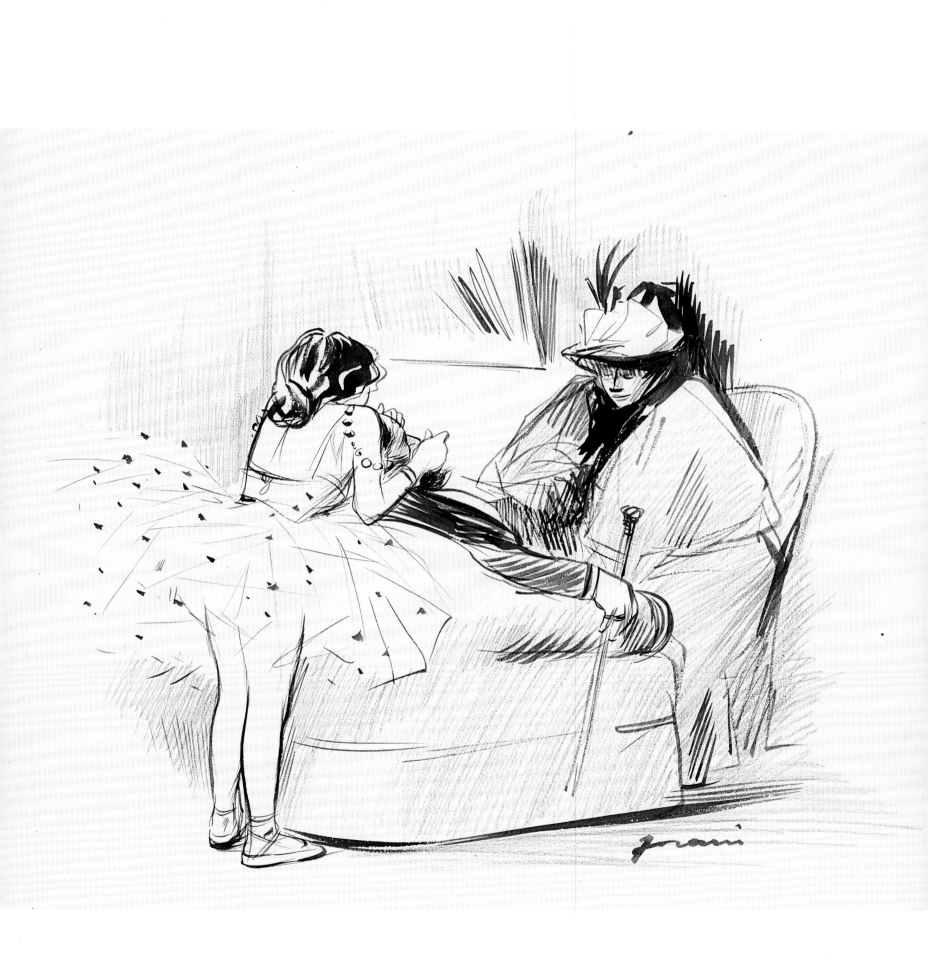

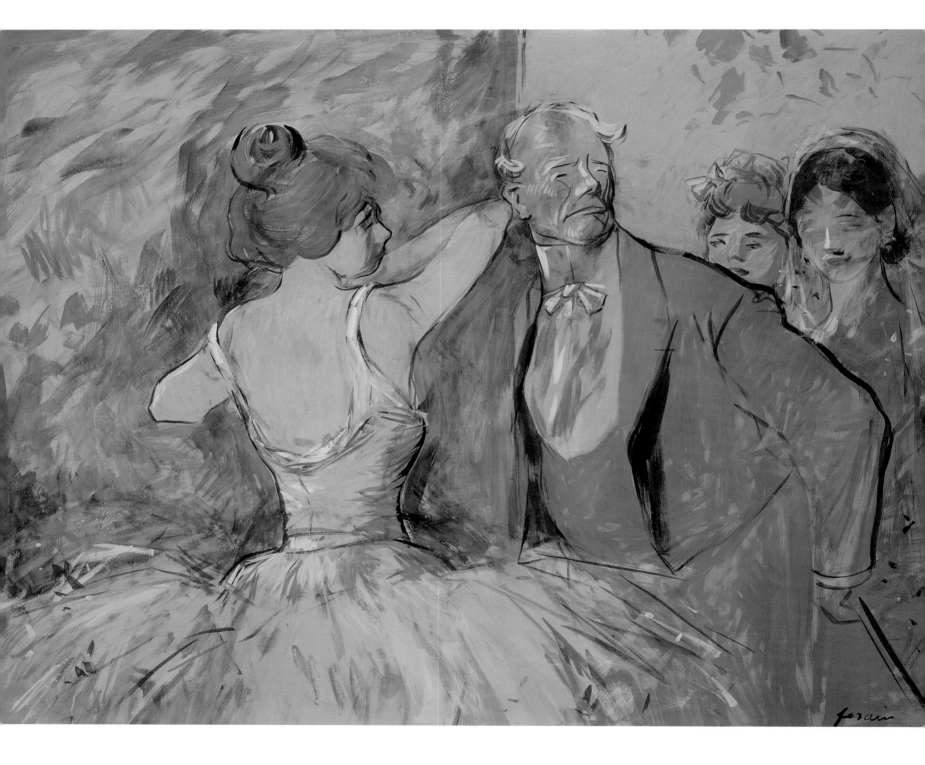

In the Wings, c. 1900

The provenance of this work is enough to distinguish it from its many thematic counterparts. *In the Wings* was donated to the Petit Palais, Musée des Beaux-Arts de la Ville de Paris, in 1930, by Ambroise Vollard.[1] Arguably the most influential French art dealer at the turn of the twentieth century, Vollard played a prominent role in shaping the careers of such monumental figures as Paul Cézanne, Paul Gauguin, Pablo Picasso, and Vincent van Gogh. Forain's ties to Vollard are noteworthy: the young dealer made his first professional sale with a drawing by the artist, and the two men continued to be friends throughout their illustrious careers.

Utilizing his recurrent device of dividing the composition with a vertical stage flat, Forain heightens the spatial dynamics with the unusual positioning of his two central figures. Though she may simply be stretching, the dancer's coy adjustment of her bodice suggests that she is preening before an audience of one. However, her spectator is distracted, perhaps having caught sight of another ballerina who has captured his attention. The angle of the dancer's arms counterbalances the loosely triangular shape created by the two figures, in such close proximity that her elbow practically brushes the man's ear. Yet there is a sense of disconnect in the pair, each seemingly oblivious to the other despite their near collision.

Forain was fond of juxtaposing the on- and offstage worlds, and was especially fascinated by the peripheral point where the stage ends and the backstage begins. The dancer occupies the front area and the *abonné* the back, with the edge of the scenery serving as a boundary between the two sectors. Her tutu extends beyond the edge of the stage flat to protrude across the man's lower body, while he leans just over the margin of the set onto the stage. The calculated division of space emphasizes these subtle transgressions.

—IB

NOTE

1. This information was kindly supplied by Florence Valdès-Forain.

Plate 110
Jean-Louis FORAIN
In the Wings
c. 1900
Gouache on paper
41½ × 55¾ in. (105.5 × 141.5 cm)
Petit Palais, Musée des
Beaux-Arts de la Ville de Paris,
Inv. PPP00855

Plate III
Jean-Louis FORAIN
Dancers in the Wings
c. 1904
Oil on canvas
27⅝ × 21¾ in. (70 × 55.4 cm)
Manchester City Galleries,
1938.366

Dancers in the Wings, c. 1904

Rarely do Forain's dancers possess such a commanding presence as the central figure of this painting, whose pose and expression convey an almost haughty imperiousness. The Spanish-style shawl and headdress have yet to be identified in relation to a specific production, though their exotic flair accentuates the grandeur of the dancer's comportment. The hint of a tree to the right and the indistinct shadow at the upper left suggest that the dancers are waiting just off the curtained stage. The somber palette, rich in browns and grays, is indicative of Forain's more mature style as well as the early influence of Édouard Manet, whom the artist met through his association with Degas.[1]

Also of note in these darkened wings is the lack of the male presence. Forain has been criticized for his disregard of the dancer's onstage presence, so often do his works center on the ballerinas mingling backstage with the lurking *abonnés.*[2] In this regard, he differs from his mentor Degas, whose profuse investigations of the dancer in rehearsal and performance indicate his fascination with the study of the body in motion, with the dancer providing a means to this end. Forain was drawn more to the social, not physical, aspects of the dancer's reality. In *Dancers in the Wings,* however, the cluster of three women at the left more closely resembles the figural groupings favored by Degas, in whose works similar arrangements of ballerinas are shown readying for performance, adjusting their costumes, and stretching. Both artists often imported such figures from sketches or studies to lend an air of spontaneous temporality to the finished paintings.

In his more illustrative works, such as *Negotiations in the Wings* (plate 89), Forain presents his protagonists, the dancer and the *abonné,* as archetypal caricatures. But in a painting such as *Dancers in the Wings,* the archetype gives way to a more individualized representation. Here, the realistic rendering of the central dancer—especially the details of her expression—lends a greater impact to her countenance. Without emphasis on a moral undertone dictating the composition, Forain brings the psychological dimension of the individual dancer to the forefront.

—IB

NOTES

1. Lillian Browse, *Forain the Painter, 1852–1931* (London: P. Elek, 1978), 21.
2. See ibid., 36.

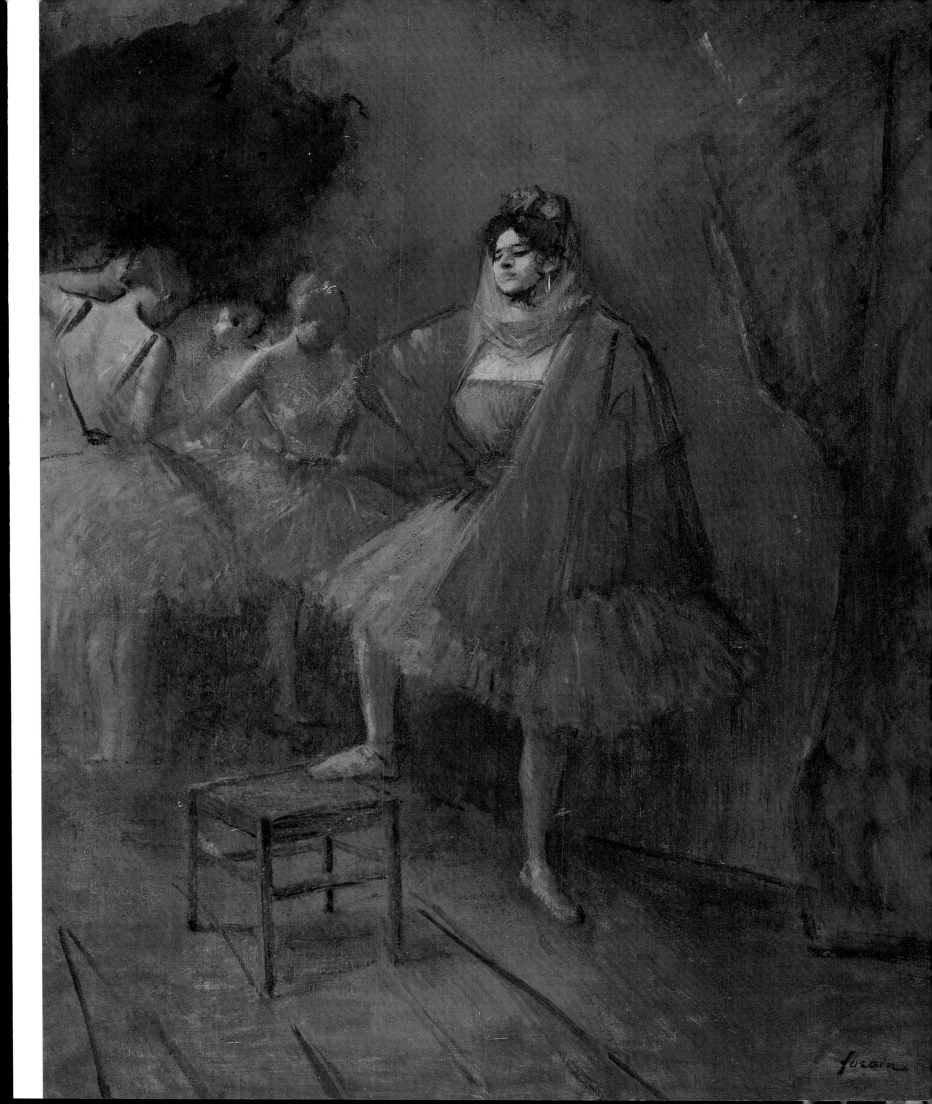

Dancers in Pink, c. 1905

Dancers in Pink is a striking example of Forain's skill in rendering the full spectrum of opera-house lighting, from highlight to shadow. He employs mottled brushwork typical of the Impressionist style to create a lush yet indistinct backdrop and captures the glow of the stage lights on the shoulders and tutus of the weary dancers.

Like Degas before him, who portrayed exhausted dancers and illustrated the harsh physical reality behind the effortless appearance of performance, Forain recognized the physically taxing nature of the dancer's profession. Here, the women regroup during an intermission. The attention to detail in the fatigued dancers' splayed legs and bent elbows indicates firsthand observation by the artist. However, the figure at the left, relacing her slipper on a piece of stage decor, closely resembles the ballerina from Forain's *Dancer in Her Dressing Room* (plate 107) and *Dancer Tying Her Slipper* (plate 176), both made more than a decade earlier. Forain spent a lot of time observing and sketching dancers at the Opéra both onstage and off, and like Degas had a certain repertoire of figures, which often originated in a study and could later be found in more fully realized compositions. Though *Dancers in Pink* appears to be a spontaneously observed moment, it is probably in fact a deliberate compositional arrangement, whose sense of authenticity—deceptive or not—owes much to Forain's practice of assembling images of the dancer from myriad studies.

Forain always prioritized the unstructured moments of the ballet over the actual performance. Even in a composition such as this, in which the dancers occupy the stage, the artist selects a scene that emphasizes the reality, and not the spectacle, of the dance. The *abonné* is almost conspicuous in his absence, given Forain's preoccupation with the role of those male "protectors" in the lives of the dancers. Considering the overtly derisive tone of the majority of Forain's ballet-themed works, this canvas seems divested of the moralizing to which he was prone. However, it is important to remember Forain's profound interest in the human condition, manifested here in his recognition of the arduous nature of the dancer's life, which demanded both physical and social stamina.

—IB

Plate 112
Jean-Louis FORAIN
Dancers in Pink
c. 1905
Oil on canvas
23¾ × 29 in. (60.3 × 73.6 cm)
Carmen Thyssen-Bornemisza
Collection, on loan to the
Museo Thyssen-Bornemisza,
Madrid

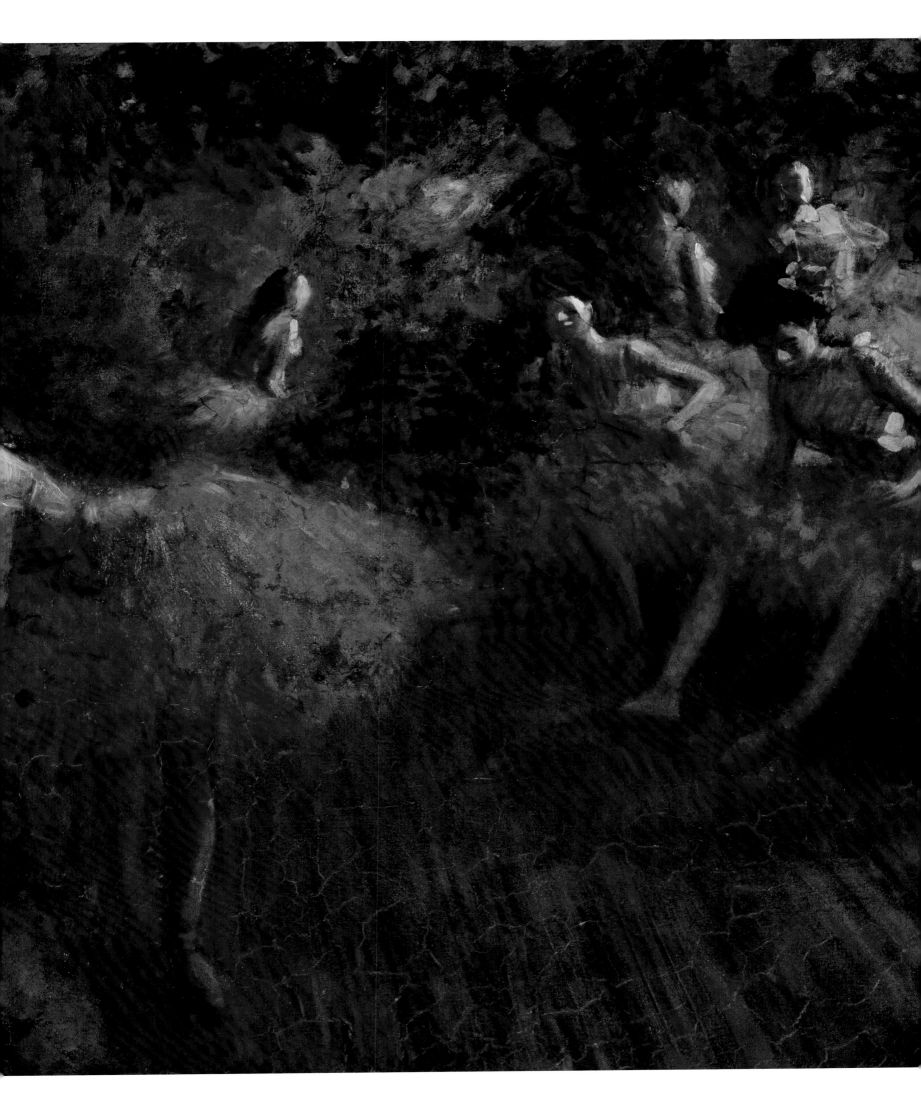

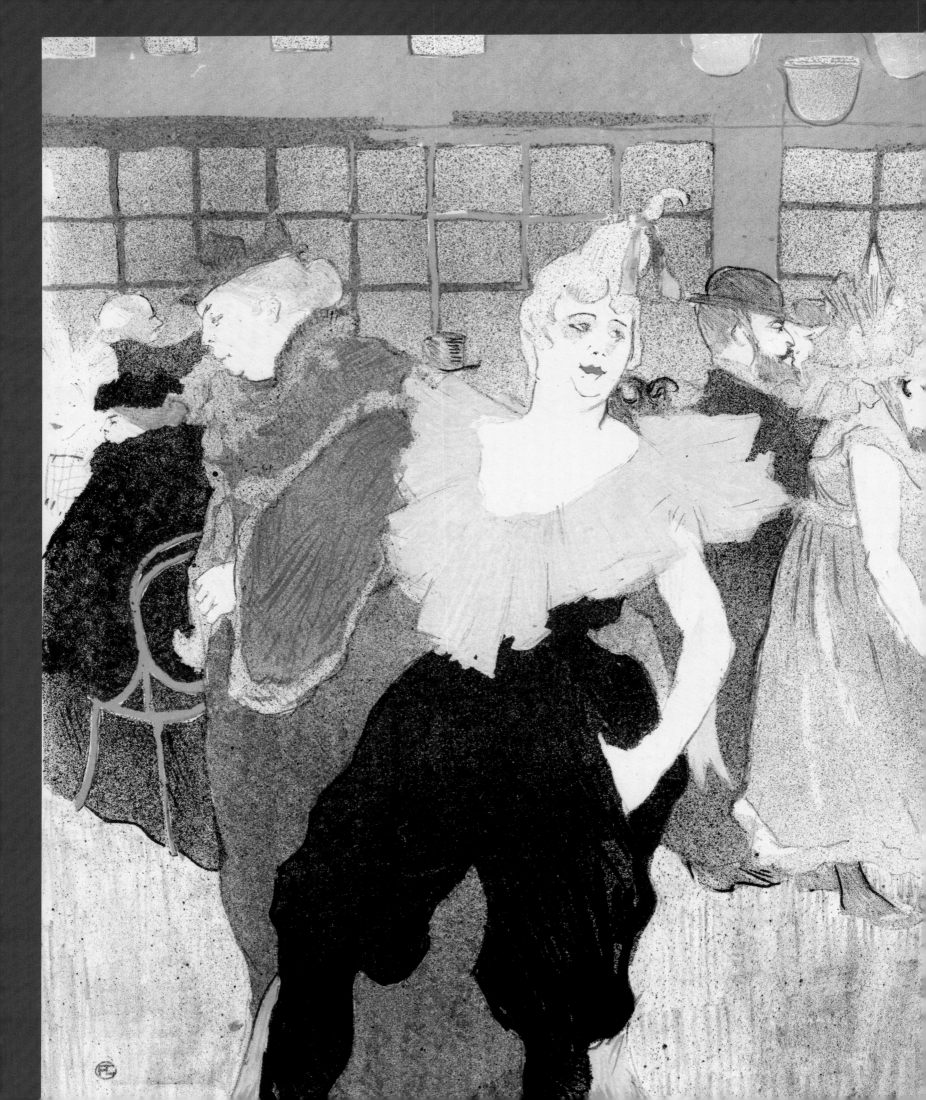

Mary Weaver Chapin

Public Lives and Private Performances The Dancers of Toulouse-Lautrec

THROUGHOUT HIS SHORT BUT PROLIFIC artistic life, Henri de Toulouse-Lautrec was deeply engaged with the art of dance. Crippled as a child, he was unable to dance or even walk with ease, but he was thoroughly fascinated by movement, first of the horses at his family's country estate, and then of the dancers and performers who populated the Opéra, cafés-concerts, dance halls, and circuses of Paris. Lautrec initially drew on the examples of Edgar Degas and Jean-Louis Forain, but he soon developed his own visual language and inimitable approach to depicting the dancers and their patrons. Unlike his predecessors, who closely observed their subjects while maintaining a certain emotional distance, Lautrec was well acquainted with the dancers he painted. This intimacy allowed him access both onstage and off. He especially relished the indeterminate areas—between a dancer's celebrity identity as a performer and her private life, between candor and pose—and explored this territory in many of his finest images. Moreover, Lautrec examined the difference between the public sexuality required of cancan dancers performing for a predominantly male clientele and their own private pleasure, frequently taken with other women, as many of the dancers of the time were lesbians.[1] He also toyed with the social mobility of the dancer, playing with the highly permeable boundaries between ballerina, *chahut* dancer, and acrobat. His unique vision and interpretation captured the fascinating realm of dance in all its variety at the end of the century. This essay introduces these themes by focusing on Lautrec's depiction of select dancers and venues, ranging from ballerinas at the Paris Opéra to the stars of the Moulin Rouge and dancers performing on the *grands boulevards.*

Lautrec's Ballerinas

The only surviving son of a consanguineous marriage, between first cousins, Henri-Marie-Raymond de Toulouse-Lautrec-Montfa hailed from an aristocratic family that had once ruled much of southern France.[2] By the time of Lautrec's birth, their fortunes were much diminished, but the patrician attitudes of the once-prominent family were still in force. Lautrec was expected to follow in his father's footsteps and lead a life of hunting, horsemanship, and idle pastimes—including amateur painting and drawing—befitting his station in life, and Lautrec took up drawing at an early age. When, in 1878, he fell and fractured his left femur and was restricted to bed rest, Lautrec's artistic activity increased, as it did the following year when he broke his right femur and was forced to undergo painful and futile treatments to spur his bones back to health. Ultimately, Lautrec's growth was permanently stunted, giving him the appearance of having an adult head and torso balanced on a child's legs (fig. 1).

Although it would be reductive to insist that his injuries caused him to become an artist, it is fair to say that these circumstances led him deeper into his art as a youth and helped persuade his parents to allow him to pursue formal artistic training in Paris. Lautrec first studied with René Princeteau,

Fig. 1
Henri de Toulouse-Lautrec

Fig. 2
**Henri de TOULOUSE-
LAUTREC**
Ballet Dancers
1885
Oil on plaster transferred
to canvas
60⅜ × 60 in. (153.5 × 152.5 cm)
The Art Institute of Chicago,
Helen Birch Bartlett Memo-
rial Collection, 1931.571
post-treatment

an *animalier* painter, and then with the academicians Léon Bonnat and
Fernand Cormon.[3] At Cormon's studio, Lautrec followed a traditional aca-
demic course of study but also experimented, on his own time, with the
prevailing avant-garde painting styles of Impressionism and Realism (also
called Naturalism) practiced by Degas and his followers such as Forain.
Lautrec's enthusiasm for these masters was seemingly limitless, but Degas
held his highest esteem.[4]

The influence of both Degas and Forain is most obvious in Lautrec's first
paintings of dancers. Around 1885 or 1886, he painted four murals directly on
the walls and a wooden door at the Auberge Ancelin, a small country inn in
the village of Villiers-sur-Morin, east of Paris. In *Ballet Dancers* (fig. 2), Lautrec
adopted not only one of Degas's favored subjects, ballerinas at the Opéra, but
also his compositional conventions of strong diagonal movement, unusual
cropping at the margins, and the pronounced intrusion in the lower right cor-
ner of an object just outside the frame of the canvas.[5] In another image from
the series, in which a dancer in her dressing room has her costume adjusted
while attended by an *abonné,* Lautrec borrowed the iconography directly from
Forain.[6] It is clear that in his Auberge Ancelin paintings he was relying on the

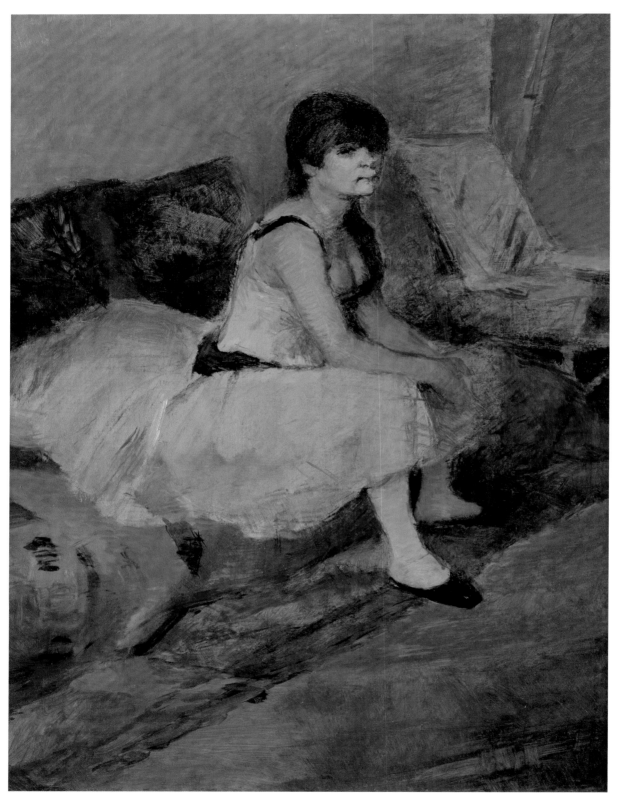

Plate 113
Henri de TOULOUSE-LAUTREC
Dancer Seated on a Pink Divan
c. 1885–86
Oil on canvas
18¾ × 14¼ in. (47.6 × 36.2 cm)
The Dixon Gallery and Gardens, Memphis, Tennessee, Gift of the Sara Lee Corporation, 2000.3

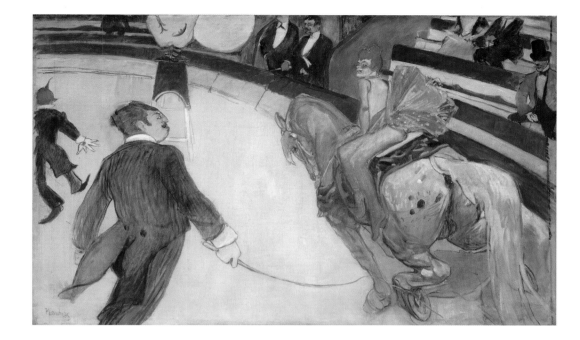

models and precedents set by his artistic idols, perhaps as a tribute to their
genius or because he was still relatively inexperienced at this point and had to
depend on the older artists' compositions as he made his first ventures into
more avant-garde styles.

Lautrec may have painted the portrait *Dancer Seated on a Pink Divan*
about the same time (plate 113). He again looked to Degas and Forain for sub-
ject matter and guidance on the composition, but the strong individuality of
the dancer sets this work apart. The model openly engages with the viewer,
gazing out under a fringe of chestnut brown hair. Her heavily powdered face
is punctuated by the thin red line of her lips, set in an expression of weariness,
or protracted patience. She is posed casually, seated on the divan with her feet
parted and her forearms resting on her knees, and without the elegance or
formal posture one would expect from a trained ballet dancer of the Opéra.
In fact, it is possible that this is not a ballet dancer at all—she is depicted not
onstage, in the wings, or in a rehearsal studio but in the artist's atelier: a can-
vas leaning against the wall in the upper right part of the composition and
the low divan and its distinctive cover are found in other portraits Lautrec did
of friends and models in his studio.[7] She could simply be a girl Lautrec picked
up from the model market in the Place Pigalle or a circus performer. Circus
performers often dressed in tutus, as seen in Lautrec's painting *Equestrienne
(At the Circus Fernando)* (fig. 3) and his series of circus drawings executed in
1899.[8] In fin de siècle Paris, the boundaries between model, dancer, and circus
acrobat were fluid, and women frequently moved between venues as their
fortunes and reputations rose or fell.

Plate 114
Henri de TOULOUSE-LAUTREC
The Dancer
1890
Oil on board
26¾ × 20¼ in. (68 × 51.5 cm)
Private collection

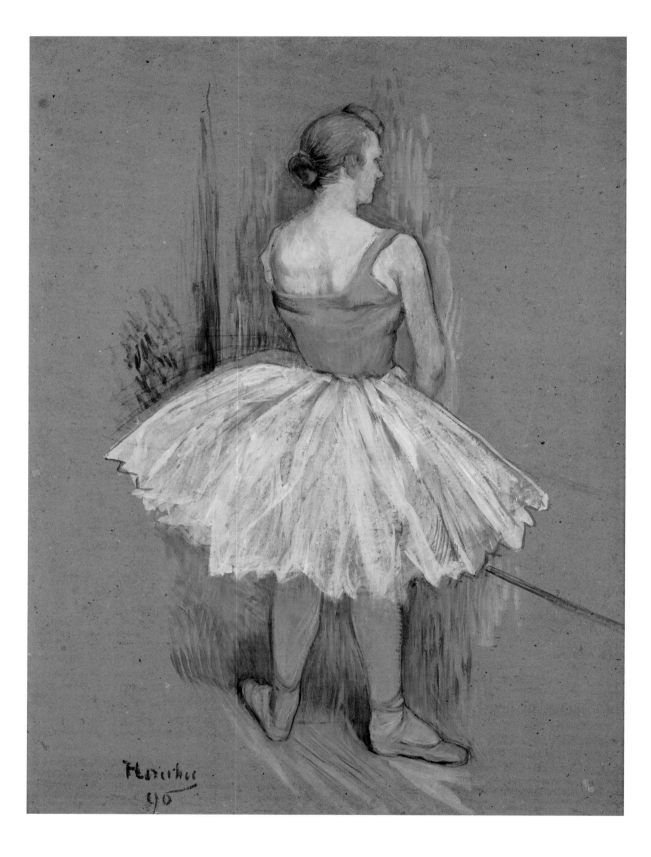

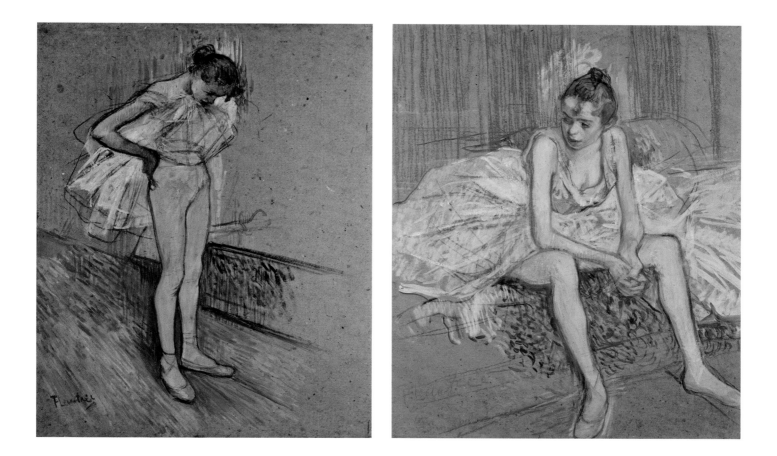

Ambiguity also prevails in three of the ballet pictures he created in 1890. In *The Dancer* (plate 114), the woman stands in a confident pose, her feet firmly planted, her back to the viewer. Lautrec emphasizes her broad, masculine shoulders and the strong musculature of her back and calves but gives little indication of her environment.[9] Nor is the setting clear for *Dancer Adjusting Her Leotard,* in which a young woman, unaware of the viewer, tucks the hem of her tutu under her chin to better access her leotard (fig. 4). Lautrec used a fluid, graphic line to describe the figure and merely sketched in the background. The same girl is the model for *Seated Dancer with Pink Tights,* set either in the artist's studio or in another private locale (fig. 5). By showing her seated heavily on a low divan, her frail arms resting on her spread legs, Lautrec emphasizes her corporality. At the same time, he accentuates her sexuality by outlining her pink tights with crimson red, which contrasts with her powdered cleavage and echoes her heavily rouged lips. The fact that she is sitting on a bed or divan, rather than on a chair in a rehearsal room or in the wings of the stage, suggests sexual availability. Furthermore, as one art historian has pointed out, the short, dark brushstrokes beneath the young woman's spread legs suggest "a kind of displaced pubis."[10]

Fig. 4
Henri de TOULOUSE-LAUTREC
Dancer Adjusting Her Leotard
1890
Oil on board
23¼ × 18⅛ in. (59 × 46 cm)
Private collection

Fig. 5
Henri de TOULOUSE-LAUTREC
Seated Dancer with Pink Tights
1890
Oil and pastel on board
22¾ × 18½ in. (57.5 × 46.7 cm)
Private collection

These ballerina paintings can be seen as a bridge between Lautrec's reliance on the artistic models of Degas and Forain and the discovery of his own artistic voice, technique, and subject. His interest in the individual identity of each dancer, which would come to define his mature work—and which would help the stars in their quest for celebrity[11]—is already becoming evident: taking the conventional subject of the ballerina and placing her in equivocal surroundings and poses, he forces his viewers to question their initial assumptions—to look closer. He also introduces the sexual status of the dancer and the mobility between performer and prostitute. These elements would reach their greatest expression in his paintings and prints of dance performers in the 1890s, works that cemented his reputation and communicated a new vision of the dancer in fin de siècle Paris.

Lautrec at the Moulin Rouge

Lautrec's intense engagement with dance accelerated with the opening of the Moulin Rouge in 1889 (fig. 6). Lautrec had previously frequented other dance halls, cabarets, and cafés-concerts in Montmartre, such as the Élysée-Montmartre and the Moulin de la Galette, where he painted the dancers and denizens beginning around 1886. The Moulin Rouge, however, marked a new chapter in Lautrec's life and art and took the spectacle of dance (and the attendant atmosphere of sexuality) to a new level. The Moulin Rouge not only offered a hall where the public could dance to the accompaniment of an orchestra but boasted a stage for singers and performers, an outdoor garden with an additional stage, and a gigantic papier-mâché elephant left over from the Exposition Universelle of 1889. The highlight of the establishment was the performance of the rowdy *chahut* (also known as the *quadrille naturaliste* or *quadrille réaliste*), a precursor to the cancan of the Second Empire that was revived in Lautrec's day.[12]

The undisputed star of the *chahut* was Louise Weber, known as La Goulue (The Glutton) (fig. 7). She began dancing at the Moulin de la Galette and the Élysée-Montmartre in 1885–86 as a teenager, and Lautrec had made a few rather tentative paintings of her at that time.[13] When the Moulin Rouge opened just a few years later, she was already known as the "queen of the quadrille,"[14] and the proprietors of the Moulin Rouge quickly hired her to star at their new enterprise. She was a figure of enormous fascination for the general public and had a formidable, vulgar charisma. One art critic, Gustave Coquiot, described her as "a strange girl with an ugly face, a rapacious look, a grim mouth and hard eyes,"[15] while another wrote that she had "the face of a strong-willed, dirty-minded baby and a brash provocative stare" (fig. 8).[16] It was that vulgarity and her reputation for voracious sexuality as well as her skillful dance performances that commanded the public's attention. According to one observer:

As the orchestra attacked the quadrille, the groups of dancers formed and were immediately surrounded by inquisitive spectators. That of

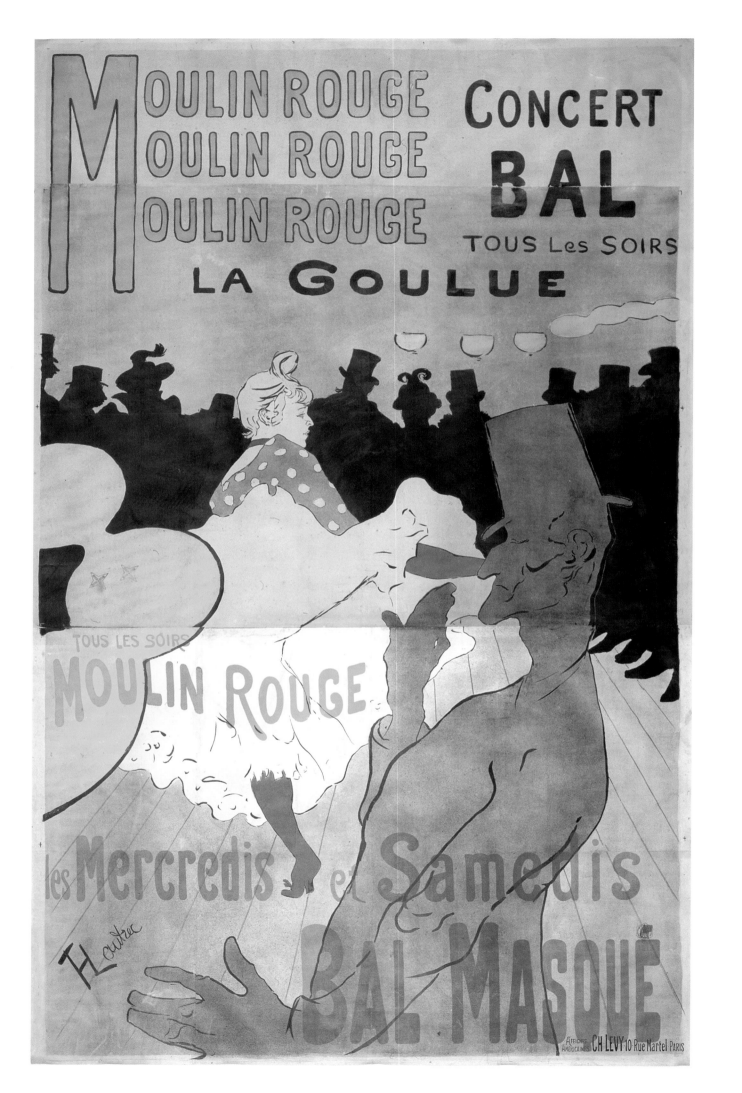

La Goulue . . . attracted the greatest number. Encased in her blonde hair, and décolleté down to the navel, she strode into the dance hall like a conqueror. She danced with a vulgar elegance and knew how to make the most of her legs by cunning *entrechats;* her skirts, raised waist-high, showed off her figure to perfection. Decency was safeguarded by bloomers made of transparent muslin that did not allow anyone to remain in ignorance of the blondness of her person. She gesticulated with her foot, which she held vertically above her head, and then brought the dance to a close by letting herself flop with legs apart, the upper half of her body erect, her arms raised to the sky in a sign of triumph.[17]

Lautrec wisely capitalized on La Goulue's reputation and celebrity in the poster he designed for the Moulin Rouge in 1891 (plate 115). The massive image—more than a meter wide and almost two meters high—features the famous dancer in the midst of one of her high kicks. Her voluminous petticoats create a frothy aureole around her spread legs, drawing attention to what one commentator delicately referred to as "the most symbolic part of her plump person."[18] In the foreground, Valentin le Désossé (Valentin the Boneless), her partner, points to this "symbolic part" with his right thumb while his left thumb suggests sexual arousal. In a frieze behind the dancers, silhouetted spectators press onto the dance floor to watch the exhibition of the *chahut.* Their head wear reveals the wide cross section of society—gentlemen in top hats, proletarian workers in bowler hats, *cocottes* in fancifully plumed bonnets—that flocked to the Moulin Rouge in search of adventure and sexual titillation.

This atmosphere of sexuality and spectacle permeates Lautrec's images of *chahuteuses,* both on- and offstage. Shortly after the appearance of his highly successful poster, he created a large-scale oil painting of the star cruising around the Moulin Rouge, arm in arm with her sister, Jeanne Weber, on the left of the composition, and another woman—perhaps her lover, the dancer known as La Môme Fromage—on the right (fig. 9).[19] La Goulue boldly steps into the scene, resplendent in her deeply plunging neckline, her translucent bodice, and orange topknot and bearing the confident, impudent stare that was her trademark. Lautrec emphasizes her individuality almost to the point of caricature, celebrating her squinty, slightly crossed eyes and the sexual confidence that made her a celebrity of Montmartre.

Plate 115
Henri de TOULOUSE-LAUTREC
Moulin Rouge—La Goulue
1891
Color lithograph on paper
75¼ × 45⅞ in. (191 × 116.5 cm)
Krannert Art Museum, Gift of William S. Kinkead, 1975-11-5

Fig. 9
Henri de TOULOUSE-LAUTREC
La Goulue at the Moulin Rouge
1891–92
Oil on board
31¼ × 23¼ in. (79.4 × 59.1 cm)
The Museum of Modern Art, New York, Gift of Mrs. David M. Levy (161.1957)

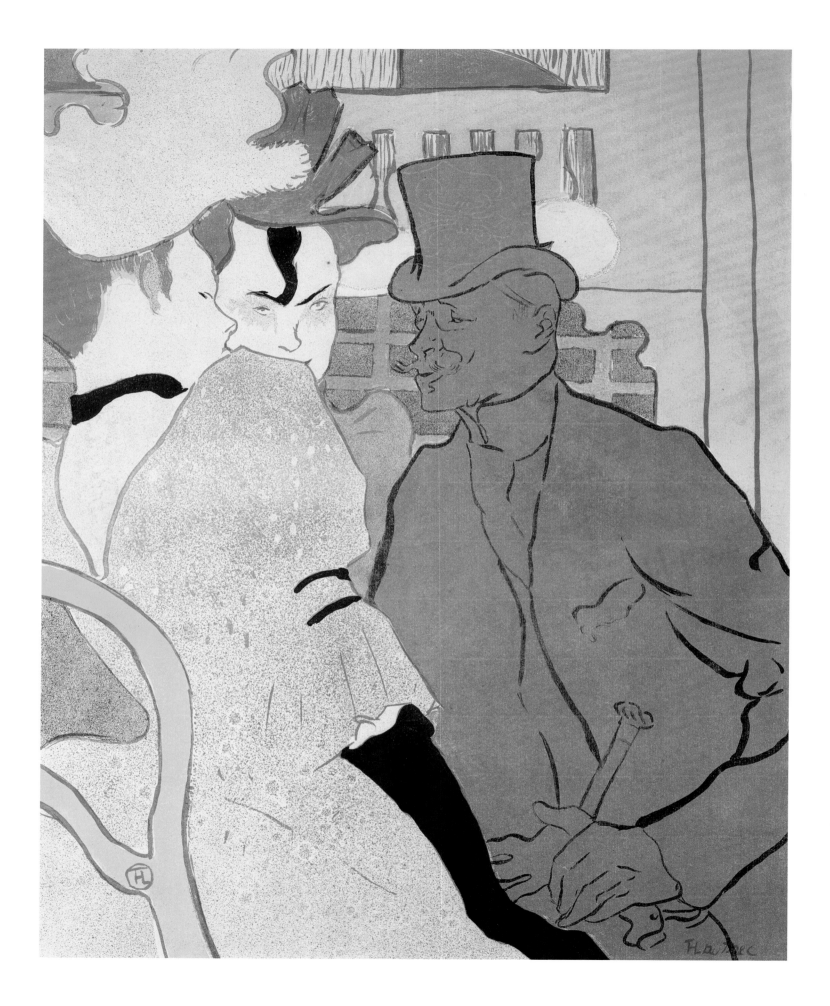

At the same time, Lautrec was creating prints that referenced the sexual
commerce that was part and parcel of the dance hall, as in *The Englishman at
the Moulin Rouge* (plate 116). In this lithograph, the shadowy figure leans close
to the two women, perhaps with a proposition. Although the individuals have
not been identified, one scholar suggests that they represent La Goulue and
La Môme Fromage.[20] If so, it would be in keeping with Lautrec's love of para-
dox: a gentleman solicits the star dancers of the sexually provocative *chahut*
who are, ironically, not interested in male attention.

Other performers at the Moulin Rouge held equal fascination for Lautrec.
Foremost among his favorites was Jane Avril, a quadrille dancer known as
La Mélinite (a type of dynamite) for her explosive and somewhat unexpected
style of dancing (fig. 10). Although she would perform in the quadrille or *cha-
hut* with other women, she preferred to dance alone, and it was her solo danc-
ing that garnered great praise. Avril had an appreciation for literature and
art, was the close acquaintance of several writers and critics, and was a fre-
quent visitor to artists' ateliers. It was perhaps the contrast between her more
refined lifestyle and her suggestive dancing that caused the greatest frisson
among the spectators, for although she was considered more elevated than
the gloriously vulgar La Goulue, she still played on her sexuality, enhancing it

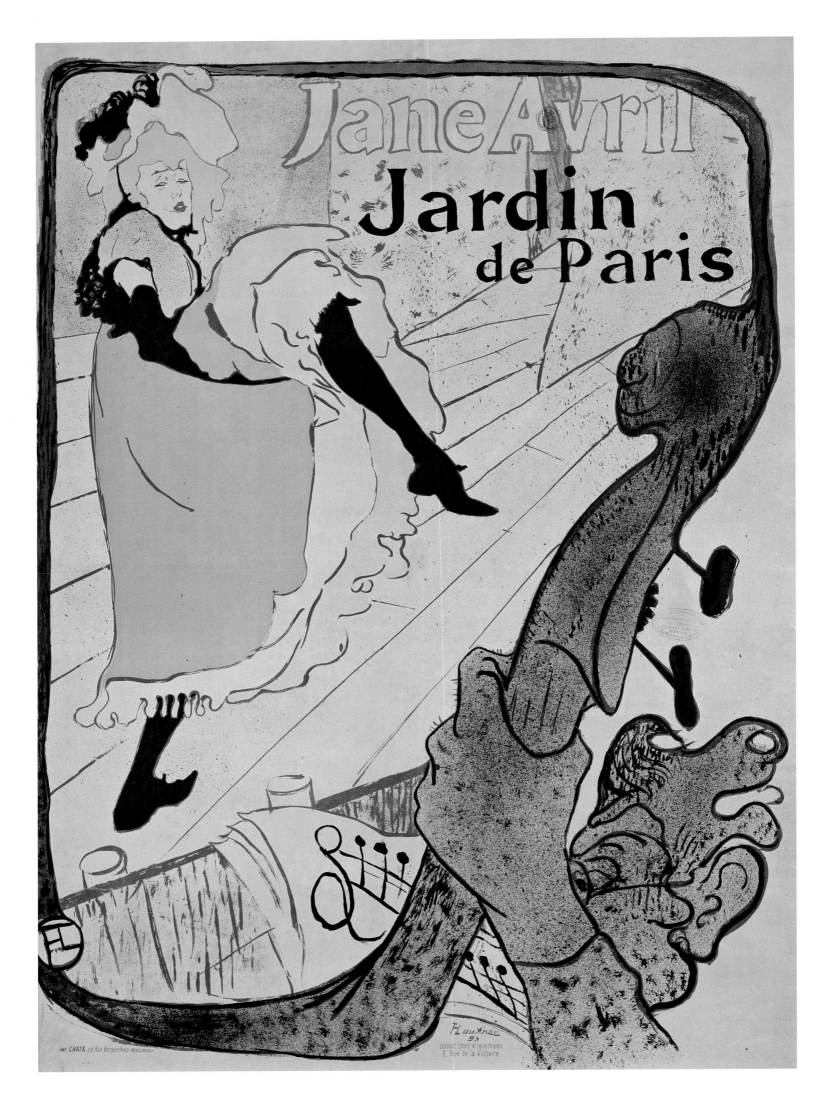

with "an assumed modesty," as poet and critic
Arthur Symons wrote, and projecting an air of
"depraved virginity."[21] Her personal story also
fascinated the public, including Lautrec: the
illegitimate daughter of an aristocratic Italian
father and a demimondaine mother, Avril was
institutionalized as a teenager at the Salpêtrière
sanatorium under the care of the famous expert
in hysteria Jean-Martin Charcot for treatment
for her fine nerves.[22]

Avril enthralled Lautrec, and she reciprocated
the admiration, commissioning posters from him
throughout her career. His first major work of the
dancer was his 1893 publicity poster advertising
her appearance at the Jardin de Paris, a café-
concert that attracted Moulin Rouge regulars
who would parade there at eleven o'clock every
night to continue the revelry when the Moulin
Rouge closed.[23] In the large lithograph (plate 117),
Avril dances alone, balancing on her left leg, her
right leg held aloft and pointed toward the gro-
tesquely rendered contrabassist who looms in the
foreground. His bug-eyed gaze and firm grasp on
his erect instrument powerfully convey the sexual
content of the dance, but Avril appears unaware
of the musician and his crude gesture, and of the
viewer as well; instead, she is deep in reverie, danc-
ing for herself as much as for the paying viewers.[24]
Her detachment is also evident in Lautrec's 1893
lithograph of her that appeared in the print port-
folio *Le Café-concert* (plate 118). Clad in a billowing
skirt, she stalks down the planks of the dance hall,
her pointy chin and slanted eyes giving her a preda-
tory appearance, yet she avoids eye contact with
the viewer.

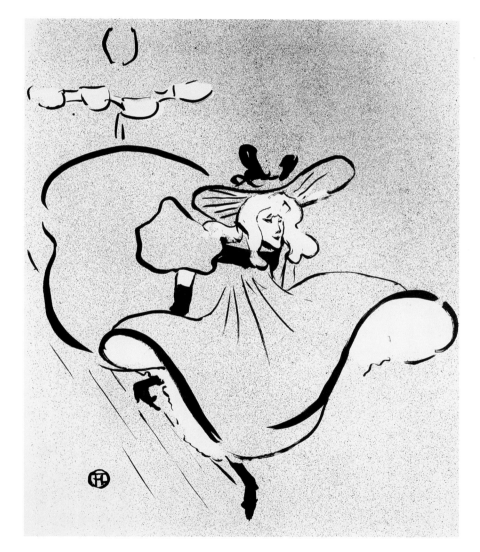

Plate 119
**Henri de TOULOUSE-
LAUTREC**
*Miss Ida Heath, English
Dancer*
1894
Lithograph printed in green
on paper
14¼ × 10⅝ in. (36.2 × 27 cm)
Fine Arts Museums of San
Francisco, Bequest of Bruno
Adriani, 1971.28.23

Plate 120
**Henri de TOULOUSE-
LAUTREC**
La Goulue
1894
Lithograph printed in black
on paper
11¹⁵⁄₁₆ × 9¹⁵⁄₁₆ in. (30.3 × 25.2 cm)
The Museum of Modern Art,
New York, Gift of Abby Aldrich
Rockefeller, 147.1946

Plate 121
Henri de TOULOUSE-
LAUTREC
Divan Japonais
1893
Color lithograph on paper
31½ × 24⅜ in. (79.9 × 61.9 cm)
Fine Arts Museums of San
Francisco, Gift of Bruno and
Sadie Adriani, 1958.88

Avril is similarly aloof in Lautrec's poster, made that same year, for the café-concert Divan Japonais (plate 121). Here, Avril is depicted as a member of the audience, a fashionable *parisienne* rather than a licentious *chahut* dancer. Nonetheless, Lautrec infuses the scene with some of the legendary sexual innuendo that marks his images of dancers: the gentleman seated behind her leans forward, grips his erect cane, and purses his lips, suggesting he is not immune to the dancer's charms, even when she is not performing. When showing the dancer in her private life, however, Lautrec envelops her in ordinariness; in three paintings of about 1892, *Jane Avril in the Entrance to the Moulin Rouge, Putting on Her Gloves* (fig. 11), *Jane Avril Leaving the Moulin Rouge,* and *Jane Avril, La Mélinite,* she appears as an anonymous woman, dressed in a proper hat and coat. Her gaze is turned inward, and there is no indication of her life as a star of the sexually charged *chahut.*

It was their personal relationship over the decade that kept Avril coming back to Lautrec for poster designs, even as his alcoholism accelerated and his devotion to the dance halls waned toward the end of the 1890s. Avril prevailed upon him to create two final posters for her. For the one announcing her tour of England with the troupe of Mademoiselle Églantine in 1896 (plate 122), Lautrec permits Avril a greater degree of individuality by depicting her on the far left, set slightly apart from her fellow dancers. Furthermore, rather than advertising the skilled synchronicity of the dancers, Lautrec depicts Avril as either a half step ahead of or behind the troupe, her foot not yet raised to the same angle as the others. In his final work for Avril (and his last lithograph of a dancer), she stands alone, her arms raised toward her fabulously plumed hat, her mouth agape in song—or, just as likely, from exertion (plate 123).

Fig. 11
Henri de TOULOUSE-LAUTREC
Jane Avril in the Entrance to the Moulin Rouge, Putting on Her Gloves
c. 1892
Oil and pastel on millboard, laid on panel
40⅛ × 21¾ in. (101.9 × 55.25 cm)
The Samuel Courtauld Trust, The Courtauld Gallery, London

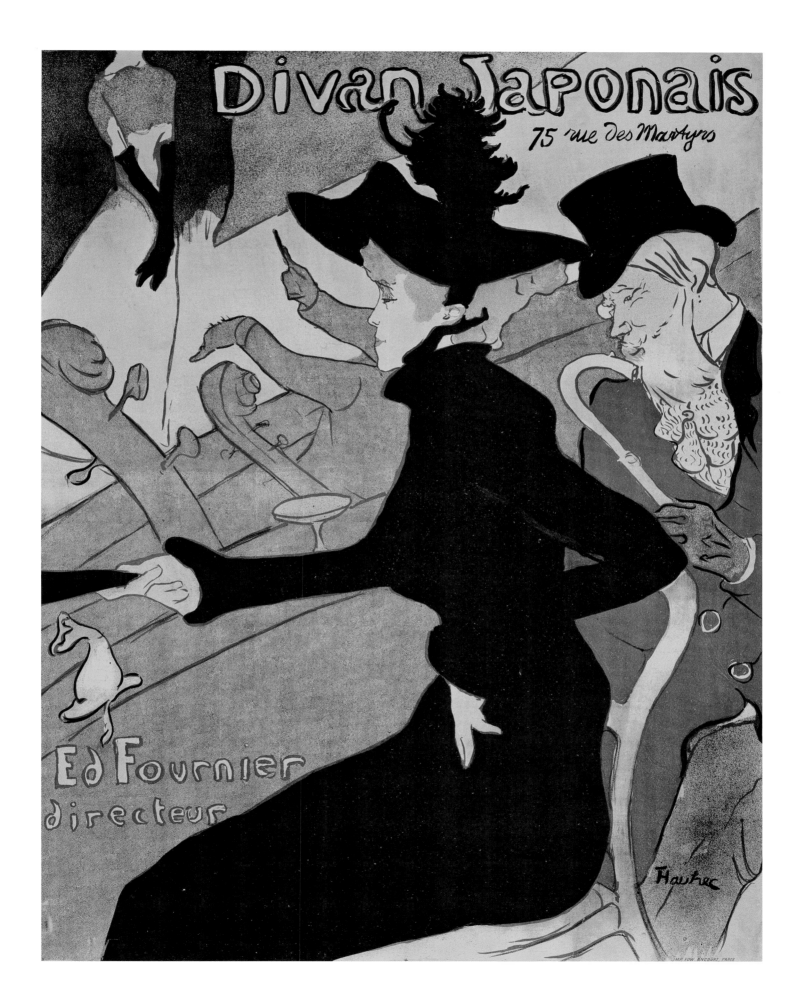

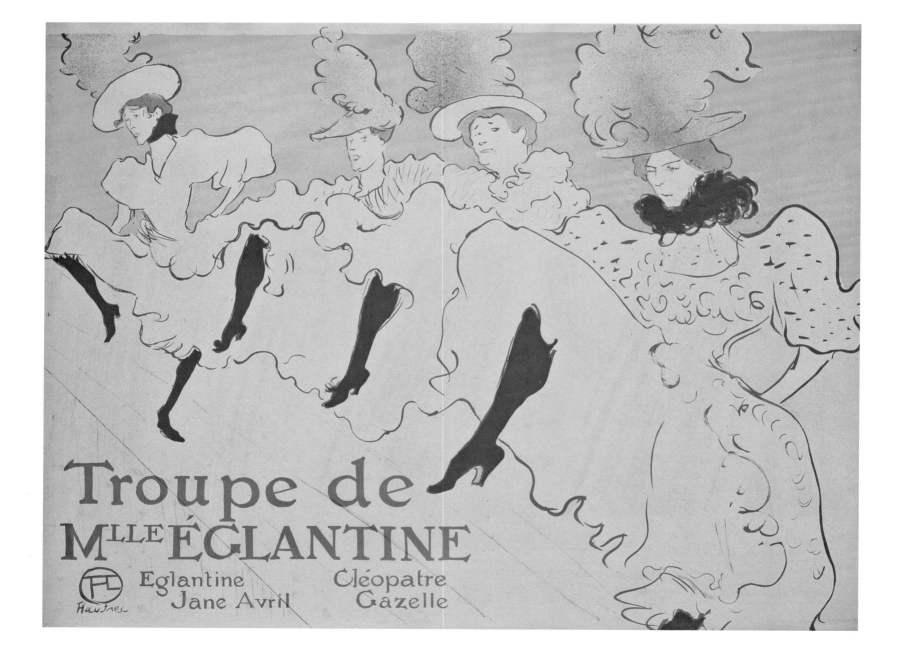

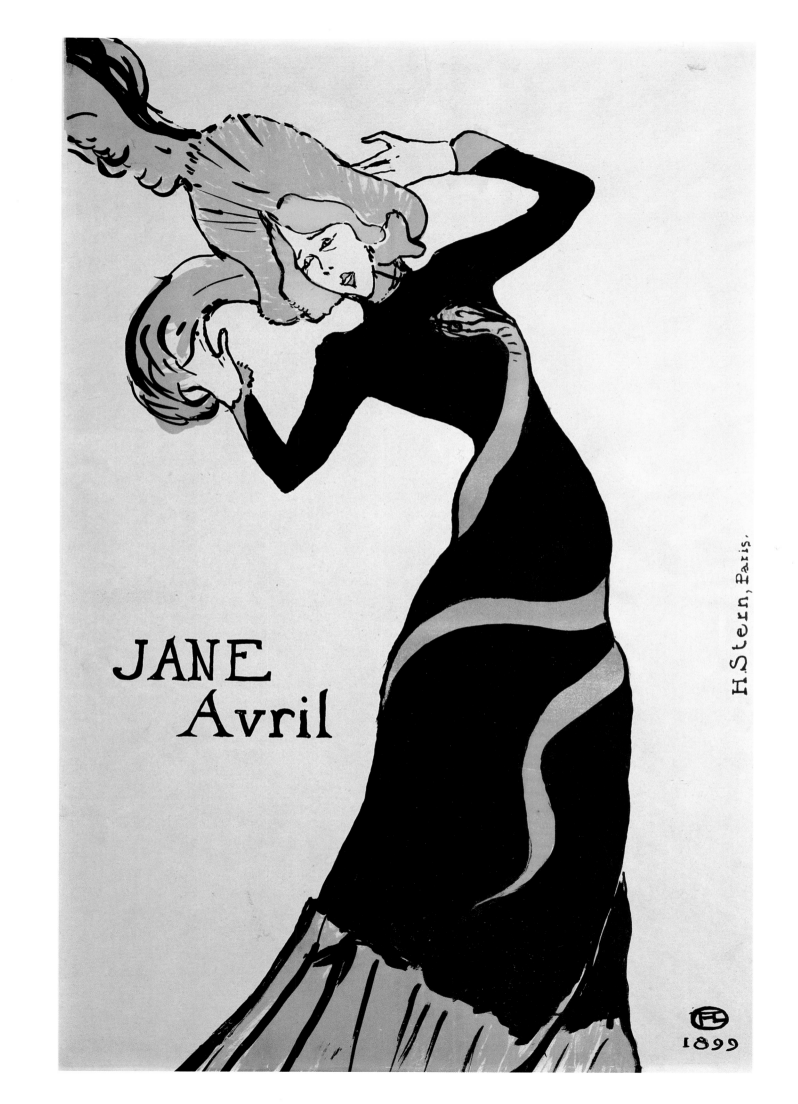

JANE
Avril

H.Stern, Paris.

1899

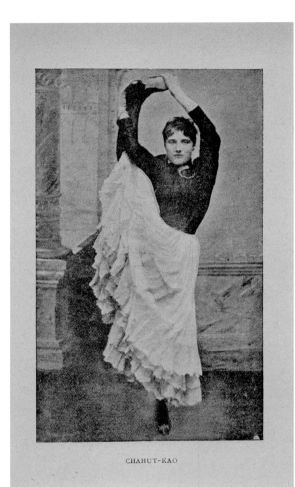

Fig. 12
Cha-U-Kao, photograph
reproduced in Maurice
Delsol, *Paris-Cythère: Étude
de moeurs parisiennes*,
c. 1891/1894, p. 101

LAUTREC IMMORTALIZED ANOTHER Moulin Rouge performer, Cha-U-Kao, in four major oil paintings and several dazzling prints that depict her at the Moulin Rouge (either working or simply enjoying the entertainment), in her private life, or in Lautrec's studio. Unlike other dancers whom Lautrec depicted, she is surrounded by mystery: her real name, her birth and death dates, her personal history, and even the exact nature of her performance have been lost to posterity. Her stage name is a play on *chahut-chaos,* which suggests her status as a dancer. Contemporaneous writers called her a *chahuteuse* or a *clownesse.*[25] Art historians have referred to her as an acrobat or as a dancer who habitually appeared in a clown costume.[26] Adding to the mystery is the fact that Lautrec never showed her in a dance or acrobatic performance; in all but two of his images of her, she is engaged in leisure activities in public spaces.[27] A recently discovered photograph of her in a guidebook by Maurice Delsol sheds a glimmer of light on this enigma (fig. 12). She is dressed plainly, in the long skirt and tight-fitting bodice of a *chahut* dancer, and is posed with her leg held aloft. In his commentary, the author identifies her as "one of the prettiest *chahut* dancers in Paris."[28] Yet Lautrec's depictions of her feature not the slim, supple woman with a fresh face and strong jaw we see in the photograph but a *clownesse* with an ample figure, thick makeup, and a ridiculous white wig tied up with a yellow bow. Lautrec, who loved the ambiguity of disguise, performance, and candor, and the nebulous areas between, was mesmerized by her.

Cha-U-Kao, like many of her fellow female dancers and performers in fin de siècle Paris, was a lesbian and during her free time would dance with her lover at the Moulin Rouge. Lautrec featured the couple in his 1892 painting *At the Moulin Rouge, Two Waltzing Women* (fig. 13). Using a dark palette of blacks, sickly greens, and accents of bright red in this densely painted composition, he conveys the dimly lit interior of the Moulin Rouge as the two women hold each other closely. Their black, mannish jackets and long skirts appear to merge, causing their pasty white hands and faces to emerge out of the darkness. Although the lovers do not make eye contact, Cha-U-Kao's closed lids and her partner's flushed cheeks, as well as their beautifully rendered hands and faces, suggest the tenderness between them.

Lautrec must have been highly satisfied with this large painting, since five years later he reprised the composition as a five-color lithograph titled *Dance at the Moulin Rouge* (plate 124). The fact that he transposed the composition almost exactly—although using lighter colors as well as a lighter, graphic rendering—is significant, since Lautrec almost never made copies of his work. The date of the lithograph—1897—is also significant, since by this time the Moulin Rouge had changed considerably; most of Lautrec's favorite performers had moved on, and he himself was more interested in the entertainments found on the *grands boulevards.* Perhaps *Dance at the Moulin Rouge* should be considered, then, a nostalgic look back for Lautrec, an interpretation that gains credence when one notes that both the painting and the print include several of Lautrec's personal friends (including Jane Avril,

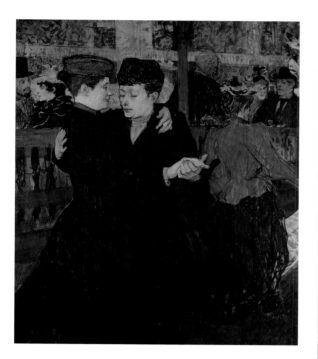

Fig. 13
Henri de TOULOUSE-LAUTREC
At the Moulin Rouge,
Two Waltzing Women
1892
Oil tempera on cardboard
36⅝ × 31½ in. (93 × 80 cm)
National Gallery in Prague,
O-3200

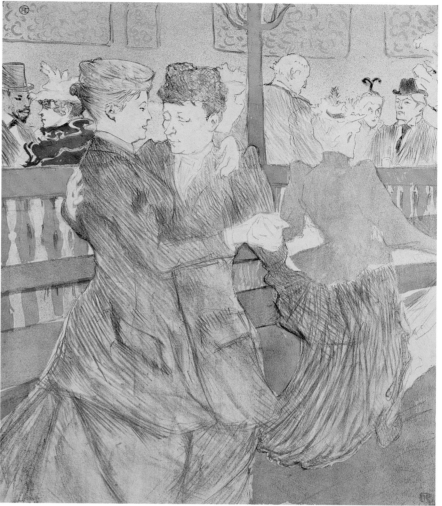

Plate 124
Henri de TOULOUSE-LAUTREC
Dance at the Moulin Rouge
1897
Brush and spatter lithograph
with scraper, printed in black
and four colors on china paper,
laid down on mat board
16⁵⁄₁₆ × 13⅝ in. (41.4 × 34.6 cm),
trimmed
Milwaukee Art Museum, Gift
of Mrs. Harry Lynde Bradley,
M1964.57

dancing alone in a red jacket).[29] This and the print that follows were his final Moulin Rouge images.

Also in 1897, Lautrec made another lithographic copy of a painting of Cha-U-Kao, from 1895, this time as she strides through the Moulin Rouge (plate 125).[30] She sports the baggy black trousers, wide yellow ruff, and odd white wig that Lautrec found so appealing and has her right arm linked with that of a woman known as Gabrielle-la-danseuse. As in his depictions of La Goulue promenading at the Moulin Rouge, Lautrec's interest here is in the character of the dancer in the in-between moments: she is not performing onstage, nor is she in her private life. Rather, she is enacting her public persona as a Moulin Rouge celebrity. Interestingly, Gabrielle-la-danseuse's identity is also blurred; here, the *chahuteuse* looks more like a bourgeois matron intent on finding the door. Perhaps Lautrec was playing with the tension between work and leisure, public performance and private life. He had toyed with imagery of Gabrielle-la-danseuse in displaced surroundings in the early 1890s when he painted her in the garden of Père Forest, where the nocturnal dancer looked decidedly ill at ease in the sun-dappled garden.[31]

Nowhere is this confusion between setting and identity more perplexing than in his masterful print *The Seated Clowness* (plate 126). The performer rests on a low red step, her legs spread wide and her pale forearms placed on her knees. Her magnificent yellow ruff frames her face and deeply plunging décolleté. She casts a wry, ironic smile at the viewer, while behind her, on the left, a top-hatted gentleman leans close to a woman clad in pink and wearing a small black mask. The setting is ambiguous—since the sitter is Cha-U-Kao, it would suggest that it is the Moulin Rouge, but the reference to a masked ball would point to the Opéra. To complicate the interpretation, this print was included in Lautrec's *Elles* album of 1896. This suite of images, consisting of ten lithographs plus a cover and frontispiece, has long been interpreted as a representation of daily life at a brothel on the rue des Moulins. More broadly, the series can be read as details of the intimate life of women in general, or more likely, of kept women. Some have even proposed that this series was Lautrec's take on the Japanese tradition of erotic prints of courtesans, and others have suggested that the entire suite is based on the life of Cha-U-Kao, yet none of these scenarios is fully satisfying.[32] It was, perhaps, his love of paradox that compelled Lautrec to include Cha-U-Kao in *Elles,* confounding the viewer's expectations.

Plate 125
Henri de TOULOUSE-LAUTREC
Cha-U-Kao at the Moulin Rouge
1897
Crayon, brush, and spatter lithograph printed in dark brown, gray-brown, orange-yellow, yellow, red, and blue on paper
15⅝⁄₁₆ × 12¹¹⁄₁₆ in. (40.5 × 32.2 cm)
Boston Public Library, Print Department, Albert H. Wiggin Collection

Plate 126
Henri de TOULOUSE-LAUTREC
The Seated Clowness (Mademoiselle Cha-U-Kao), from the suite *Elles*
1896
Color lithograph on paper
20⅝ × 15⅞ in. (52.4 × 40.3 cm)
Portland Art Museum, Gift from the Collection of Laura and Roger Meier, 2004.122.3

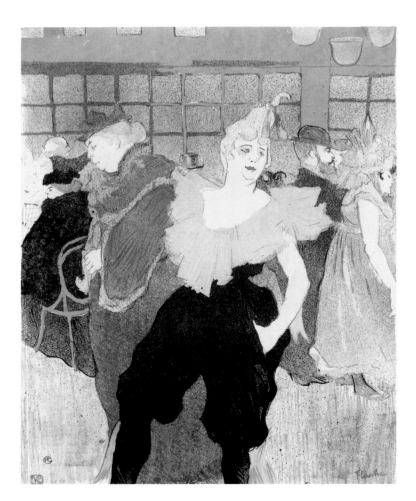

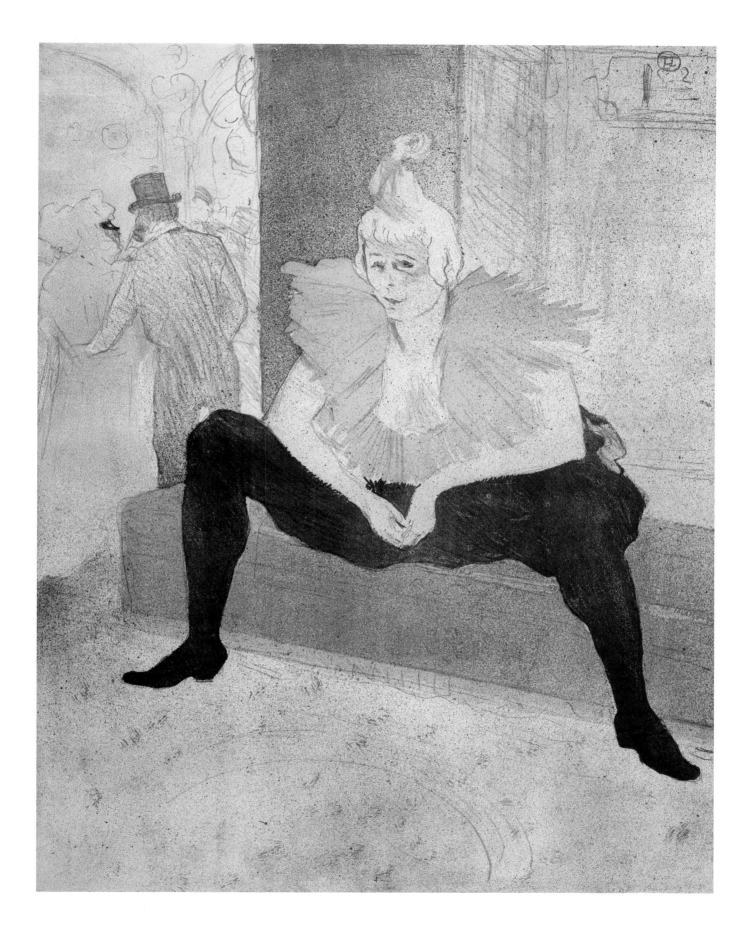

Plate 127
Henri de TOULOUSE-LAUTREC
Miss Loïe Fuller
1893
Brush and spatter lithograph
printed in black, brown, yellow,
red, and blue with gold powder
added by hand
14⅛ × 10 in. (35.9 × 25.4 cm)
Boston Public Library, Print
Department, Albert H. Wiggin
Collection

From the Moulin Rouge to the grands boulevards

Dance stars such as La Goulue, Jane Avril, and Cha-U-Kao were each the subject of one of Lautrec's intense obsessions or *furias*.[33] During the course of such a *furia,* which could last weeks or even years, he came to know his subject very well as he drew, painted, sketched, and made prints of her. Some of his best work is the result of this type of infatuation. Thus it is an anomaly that Lautrec's superb print *Miss Loïe Fuller* appears not as part of a larger series of images devoted to the dancer but as a single, brilliant statement (plates 127–130).

Fuller was an American performer who fashioned a new type of dance spectacle. Draped in voluminous gowns, she manipulated the fabric with the aid of large wands (fig. 14). The use of mirrors, electric lights, and colored filters added to the experience as she performed acts with titles such as "Serpentine" or "Butterfly." Writer and critic Edmond de Goncourt referred to her dancing as "a cyclone of veils and a swirl of skirts, illuminated now by the conflagration of a setting sun, now by the pallor of a sunrise."[34] Fuller's act was billed as "Symbolist" dance as a means of distinguishing it from "Naturalist" dance such as the *chahut* and the classical dance of the Opéra, and that distinction testifies to the wide range of dance entertainment available in the capital at the time. It is also significant that Fuller had originally approached the Opéra as her preferred venue, and only when it rejected her did she seek out a contract with the Folies-Bergère, pointing to the hierarchy of dance— Opéra, café-concert, dance hall—that still held sway.[35]

Lautrec attended Fuller's Parisian debut at the Folies-Bergère in 1892, and like innumerable artists, he was captivated by the combination of lights, dance, and music.[36] He began by producing a sketch, rapidly recording the motion of her swirling gowns and her seeming weightlessness as she balanced on tiny feet beneath the billowing fabric. He then used his study as the basis for one of his most complex prints, adding the suggestion of the orchestra box and the intruding neck of the contrabass into the right foreground, much in the manner of his poster for Jane Avril from the same year. Using at least five colors, and sometimes more than seven, Lautrec treated each of the sixty or so copies as individual impressions, altering the colors applied to the stone each time and dusting the completed print with a bag of metallic powder (either gold or silver) to produce a glimmering surface. Curry yellow, aubergine, blue, rosy reds, and rich browns and golds are fused in various combinations, resulting in a dazzling array of "unique multiples."

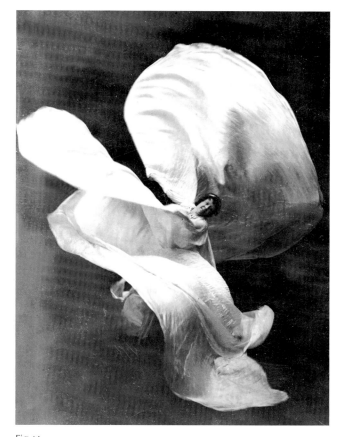

Fig. 14
Loïe Fuller in one of her dances

Plate 128
Henri de TOULOUSE-LAUTREC
Miss Loïe Fuller
1893
Brush and spatter lithograph
with keystone in olive green,
color stone in various colors,
and gold powder on beige wove
paper
14¹⁵⁄₁₆ × 10¼ in. (37.9 × 26 cm)
Smith College Museum of Art,
Northampton, Massachusetts,
Gift of Selma Erving, class of
1927

Plate 129
Henri de TOULOUSE-LAUTREC
Miss Loïe Fuller
1893
Brush and spatter lithograph
on paper
14⅜ × 10⅜ in. (36.7 × 26.8 cm)
McNay Art Museum, San
Antonio, Gift of Robert L. B.
Tobin, 1974.51

Plate 130
Henri de TOULOUSE-LAUTREC
Miss Loïe Fuller
1893
Lithograph on paper
14³⁄₁₆ × 10½ in. (37.0 × 26.6 cm)
Brooklyn Museum, Museum
Collection Fund 39.25

Marcelle Lender

In the mid to late 1890s, Lautrec turned away from the dance halls and immersed himself in the life of the brothel and the theater. He never lost his interest in movement and dance, but the subject of his next dance obsession—Marcelle Lender (Anne-Marie Marcelle Bastien)—was an actress at the Théâtre des Variétés. His first of more than a dozen lithographs of her dates from 1893; the bulk of his production, however, was done in 1895, when she was performing in Hervé's *Chilpéric.* Lender played Galswinthe, a Spanish princess, and the second act of the operetta called for her to dance a bolero.[37] Lautrec was so entranced with her performance that he returned dozens of times to watch the actress, always sitting in the front row, just to the left of center stage.[38] Drama critic Romain Coolus claimed that he accompanied Lautrec twenty times to the production. When Coolus quizzed his friend as to why he returned again and again, the artist said, "I only come so I can see Lender's back. . . . Look at it carefully. It's rare that you see anything so magnificent. Lender's back is sumptuous."[39]

Lautrec filled his notebooks with rapid sketches of her in motion (fig. 15) and eventually convinced her to pose for him in his studio, where he studied various aspects of her movement and features (plate 131).[40] He translated his sketches into nine lithographs of Lender performing in *Chilpéric,* dancing, turning, and bowing (plates 132, 133). The most magnificent of these is *Mademoiselle Marcelle Lender, Bust Length* (plate 134), a lithograph from 1895 rendered in eight colors with brush and spatter applications. This elaborate print was developed over the course of four states and is among the finest and most

Fig. 15
Henri de TOULOUSE-LAUTREC
Marcelle Lender Dancing the Bolero in "Chilpéric"
c. 1895–96
Black crayon on paper
6½ × 8½ in. (16.5 × 21.5 cm)
Musée d'Orsay, Paris, département des Arts graphiques du Musée du Louvre (RF 29583.BIS)

Plate 131
**Henri de TOULOUSE-
LAUTREC**
Mademoiselle Lender
1895
Black crayon, with touches of
blue pencil, on paper
12⁵⁄₁₆ × 7¾ in. (31.2 × 20 cm)
Thaw Collection, The Pierpont
Morgan Library, New York,
EVT 177

Plate 132
**Henri de TOULOUSE-
LAUTREC**
*Lender from the Back
Dancing the Bolero in
"Chilpéric"*
1895
Crayon and spatter lithograph
printed in olive green on wove
paper
14¹³⁄₁₆ × 10⁵⁄₁₆ in. (37.6 × 26.8 cm)
Boston Public Library, Print
Department, Albert H. Wiggin
Collection

Plate 133
**Henri de TOULOUSE-
LAUTREC**
*Lender Dancing the Bolero
Step in "Chilpéric"*
1895
Lithograph printed in olive
green on ivory wove paper
14½ × 11 in. (36.8 × 27.9 cm)
Mount Holyoke College Art
Museum, South Hadley,
Massachusetts, Gift of
Mrs. Myron Black

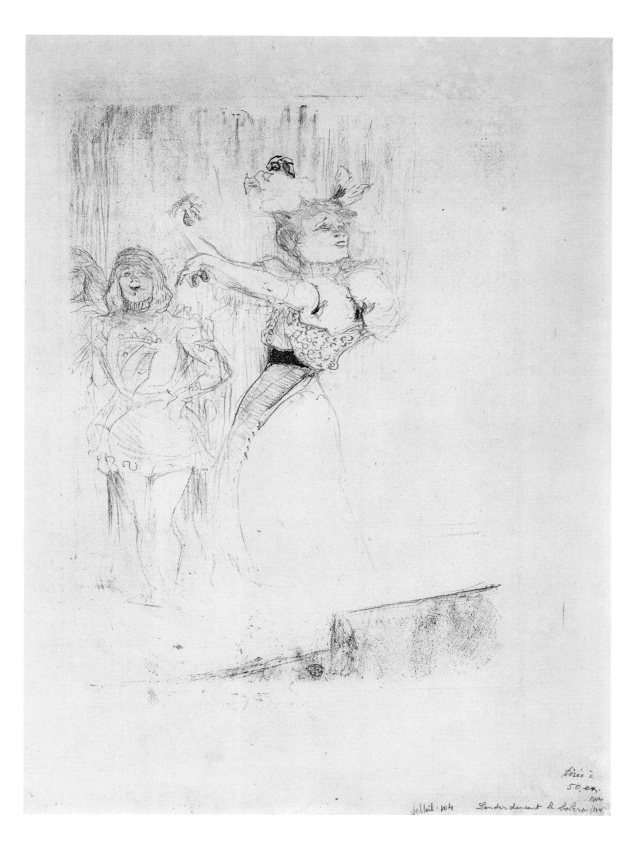

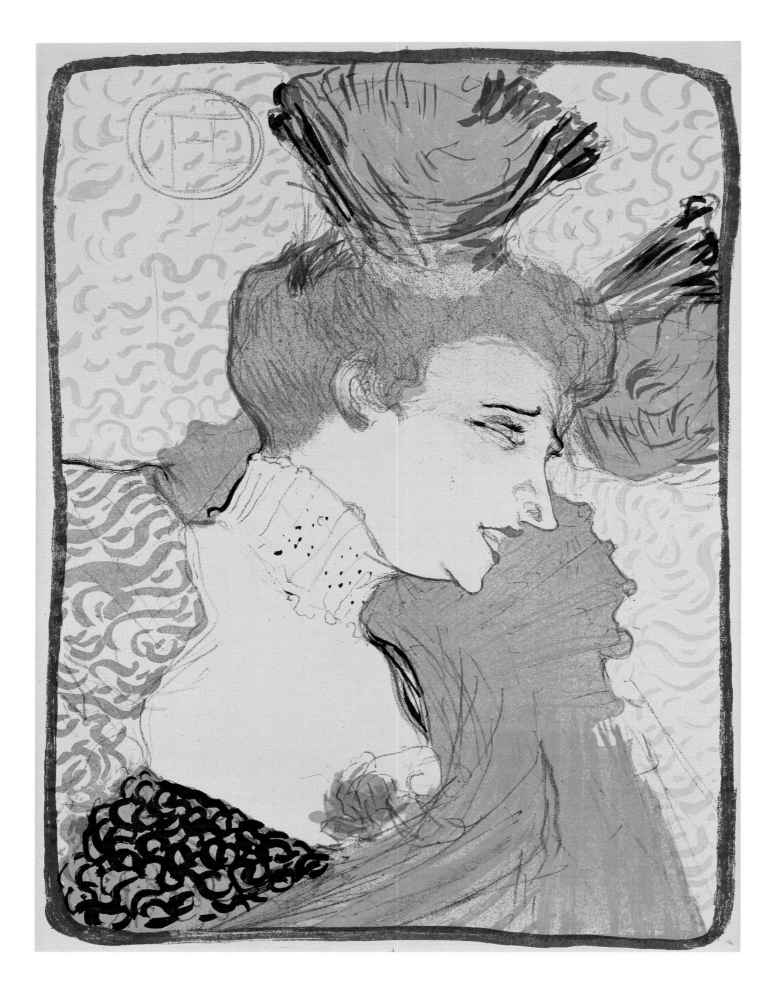

technically demanding in Lautrec's oeuvre. Lender's orange-red hair frames her like a corona and contrasts with the bright pink flowers she wears in her hair. The glaring footlights bleach out her décolleté and the lower portion of her face, but Lautrec outlines her distinctive profile with a fine line of crimson ink, setting her features off from the green shawl and yellow-patterned background. Julius Meier-Graefe, the influential German art critic and editor of the avant-garde periodical *Pan,* convinced his editorial board to include this luxurious print as an art supplement for *Pan* subscribers, and it was seen widely throughout Germany and France. In 1895–96, Lautrec completed his massive oil painting *Marcelle Lender Dancing the Bolero in "Chilpéric"* (fig. 16), a summation of his fascination with this actress and her explosive dance in which she kicks up her petticoats into a froth of color and motion.

Plate 134
**Henri de TOULOUSE-
LAUTREC**
*Mademoiselle Marcelle
Lender, Bust Length*
1895
Color lithograph on paper
12⅞ × 9⅝ in. (32.7 × 24.4 cm)
Portland Art Museum, The
Vivian and Gordon Gilkey
Graphic Arts Collection,
80.122.22

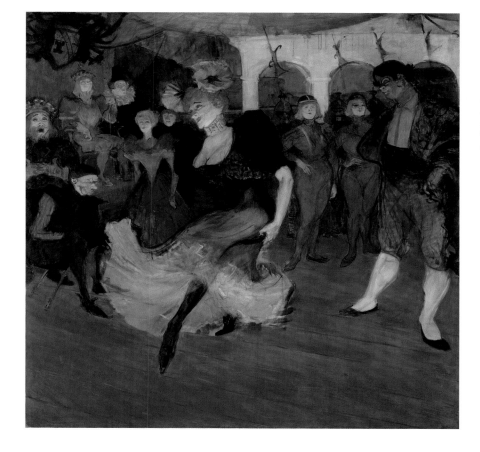

Fig. 16
**Henri de TOULOUSE-
LAUTREC**
*Marcelle Lender Dancing
the Bolero in "Chilpéric"*
1895–96
Oil on canvas
57⅛ × 59 in. (145 × 149 cm)
National Gallery of Art,
Washington, DC, Collection of
Mr. and Mrs. John Hay Whitney

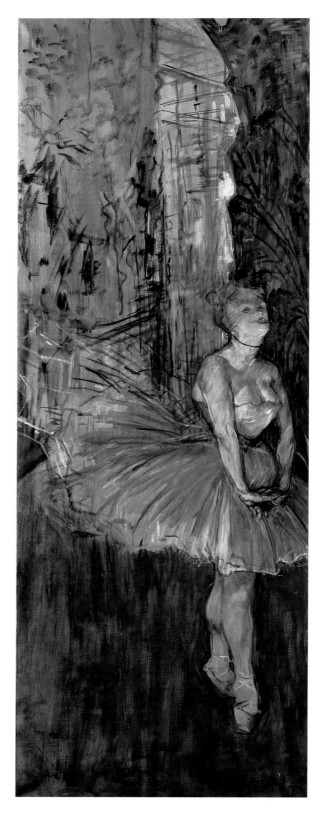

Fig. 17
**Henri de TOULOUSE-
LAUTREC**
Dancer
1895–96
Oil on canvas
79 × 28⅜ in. (200 × 72 cm)
Private collection, California

"The Buddha of the Quadrille" Lautrec's profound fascination with dance faded (but did not disappear) during the last five years of his brief life. His health was compromised by the effects of alcoholism and syphilis, and with some exceptions, his best work was behind him. Perhaps he suspected as much when he returned to the subjects that had made him famous earlier in his career, revisiting Degasesque figures in *Dancer* (fig. 17) and making lithographs of his earlier paintings of Cha-U-Kao. These reprises may also have been a means of solidifying his reputation and securing his status for posterity as the ultimate chronicler of dancers in the 1890s, which, in fact, happened quite rapidly. In the decades following his death in 1901, at the age of thirty-six, a host of personal reminiscences was published in which Lautrec was cast not only as the "official painter" of the Moulin Rouge but as the very essence of the dance. Art critic Thadée Natanson reported that Lautrec seemed to "reign" over the dancing mayhem, while Coquiot noted that "for everyone—both dancers and spectators—[Lautrec] soon became the indispensable figure in terms of the raison d'être of the dance. Seated at his table with friends, he was like the Buddha, the Buddha in a bowler hat, the Buddha of the quadrille and the waltz. But this was a Buddha who saw everything and observed everything and who registered the most complete collection of gestures and postures imaginable."[41] It was Lautrec's unique vision, and his personal interaction with the dancers, that allowed him to capture the exciting world of popular dance as well as the private lives of the dancers in fin de siècle Paris.

NOTES

1. Lautrec's fascination with lesbians in Paris's brothels is well documented by his many paintings of lovers in bed. Yet it is striking that so many of the dancers he portrayed were either avowed or rumored lesbians, namely, La Goulue, La Môme Fromage, Jane Avril, Cha-U-Kao, May Milton, May Belfort, and Loïe Fuller.

2. For an excellent biography of Lautrec, see Julia Frey, *Toulouse-Lautrec: A Life* (New York: Viking, 1994).

3. On Lautrec's early artistic training and production, see Gale B. Murray, *Toulouse-Lautrec: The Formative Years, 1878–1891* (Oxford: Clarendon Press; New York: Oxford University Press, 1991).

4. Lautrec's high regard for Degas has been well covered in the general literature on the former. The artist Édouard Vuillard recalls that Lautrec so admired Degas's work that he once took his friends to see a painting by Degas as their "dessert" after a lavish meal. Édouard Vuillard, "Lautrec raconté par Vuillard," *L'Amour de l'Art,* April 1931, 141.

 It is worth noting that at this stage of his career, Lautrec probably absorbed most of the lessons of Degas through the older artist's followers, such as Jean-Louis Forain, Federico Zandomeneghi, and Jean-François Raffaëlli. See Murray, *The Formative Years,* 87, 98.

5. On the history of these murals, see Charles F. Stuckey, *Toulouse-Lautrec: Paintings* (Chicago: Art Institute of Chicago, 1979), 96–99; Frey, *Toulouse-Lautrec: A Life,* 248–49; and Murray, *The Formative Years,* 96–98. On the recent conservation of *Ballet Dancers,* see Faye Wrubel and Francesca Casadio, "Conservation/Revelation: Henri de Toulouse-Lautrec's *Ballet Dancers* Finds Renewed Harmony," *Conservation at the Art Institute of Chicago* (Museum Studies/Art Institute of Chicago) 31, no. 2 (2005): 46–53.

6. Murray, *The Formative Years,* 98.

7. The divan appears in *Study of a Nude—Woman Sitting on a Divan* (1883), Albi, Musée Toulouse-Lautrec (Dortu P. 170); and *Gustave Lucien Dennery* (1883), Paris, Musée du Louvre (Dortu P. 223). For a discussion of this picture, see Richard R. Brettell, *Monet to Moore: The Millennium Gift of Sara Lee Corporation,* with Natalie H. Lee (New Haven, CT: Yale University Press, 1999), 188–91.

 Note: Dortu painting (P.) numbers refer to M. G. Dortu, *Toulouse-Lautrec et son oeuvre,* 6 vols., Les Artistes et leurs oeuvres: Études et documents (New York: Collectors Editions, 1971).

8. *Equestrienne (At the Circus Fernando)* is a particularly apt example of the mobility of the dancer/model/performer in Montmartre. The model is said to be Suzanne Valadon, who became a circus acrobat at the age of fifteen. When an accident ended her career the following year, she became an artists' model, posing for Pierre-Auguste Renoir, Pierre Puvis de Chavannes, and Lautrec, among others, and finally became an accomplished artist in her own right.

 For illustrations of Lautrec's circus drawings of 1899, see *Toulouse-Lautrec's "The Circus": Thirty-nine Crayon Drawings in Color* (Mineola, NY: Dover Publications, 2006).

9. Lautrec painted a similar dancer in another canvas, which he later turned 180 degrees and overpainted (Dortu P. 523). A palimpsest of the original dancer image can still be seen. See Götz Adriani, *Toulouse-Lautrec. Das gesamte graphische Werk. Bildstudien und Gemälde* (Cologne: Dumont, 2005), 270.

10. Unsigned essay in *The John and Frances L. Loeb Collection,* sales catalogue, New York, Christie's, May 12, 1997, lot 111, p. 52.

11. On Lautrec and celebrity culture, see Mary Weaver Chapin, "Henri de Toulouse-Lautrec and the Café-Concert: Printmaking, Publicity, and Celebrity in Fin-de-Siècle Paris" (Ph.D. diss., Institute of Fine Arts, New York University, 2002); and Richard Thomson, Phillip Dennis Cate, and Mary Weaver Chapin, *Toulouse-Lautrec and Montmartre* (Washington, DC: National Gallery of Art and the Art Institute of Chicago in association with Princeton University Press, 2005), 46–63.

12. On the history of the cancan and *chahut,* see Ivor Guest, "The Heyday of the *Cancan,*" in *Second Empire Medley,* ed. W. H. Holden (London: British Technical and General Press, 1952), 10–23; and David Price, *Cancan* (Cransbury, NJ: Fairleigh Dickinson University Press, 1998).

13. See, for example, *The Quadrille of the Louis XIII Chair at the Élysée-Montmartre* (1886), private collection (Dortu P. 261); and *At the Moulin de la Galette: La Goulue and Valentin le Désossé* (1887), Albi, Musée Toulouse-Lautrec (Dortu P. 282).

14. Abel Hamel, "Chronique parisienne," *La Vie moderne,* January 23, 1886, 903. Unless otherwise noted, translations of quoted materials are by the author.

15. Gustave Coquiot, *Des Peintres maudits* (Paris: André Delpeuch, 1924), 76.

16. André Warnod, quoted by Frey, *Toulouse-Lautrec: A Life,* 190.

17. François Gauzi, *Lautrec mon ami* (Paris: La Bibliothèque des Arts, 1992), 78–79. Translation based on that in Gauzi, *My Friend Toulouse-Lautrec,* trans. Paul Dinnage (London: Neville Spearman, 1957), 40.

18. Arsène Alexandre, "Chronique d'aujourd'hui: Henri de Toulouse-Lautrec," *Paris,* January 8, 1892, 2. As Richard Thomson has written, the emphasis on La Goulue's spread legs is even greater in the preparatory drawing for this poster. See Richard Thomson, *Toulouse-Lautrec* (London: Oresko Books, 1977), 59.

19. On La Goulue's affair with La Môme Fromage, see Yvette Guilbert, *La Chanson de ma vie: Mes Mémoires* (Paris: B. Grasset, 1927), 61–63; and Francesca Canadé Sautman, "Invisible Women: Lesbian Working-Class Culture in France, 1880–1930," in *Homosexuality in Modern France,* ed. Jeffrey Merrick and Bryant T. Ragan Jr. (New York: Oxford University Press, 1996), 184–85.

20. Frey, *Toulouse-Lautrec: A Life,* 314.

21. Arthur Symons, *From Toulouse-Lautrec to Rodin, with Some Personal Impressions* (New York: Alfred H. King, 1930), 22.

22. See Michel Bonduelle and Toby Gelfand, "Hysteria Behind the Scenes: Jane Avril at the Salpêtrière," *Journal of the History of the Neurosciences* 7, no. 1 (1998): 35–42. For recent scholarship on Avril, see François Caradec, *Jane Avril au Moulin Rouge avec Toulouse-Lautrec* (Paris: Fayard, 2001); and Catherine Pedley-Hindson, "Jane Avril and the Entertainment Lithograph: The Female Celebrity and *fin-de-siècle* Questions of Corporeality and Performance," *Theater Research International* 30, no. 2 (2005): 107–23.

23. Claire Frèches-Thory, catalogue entry in Richard Thomson et al., *Toulouse-Lautrec* (New Haven, CT: Yale University Press, 1991), 298.

24. Other commentators have interpreted Avril's expression as one of great weariness, noting that she "dances for our pleasure and not her own." See Ernest Maindron, *Les Affiches illustrés* (Paris: G. Boudet, 1896), 112.

25. For example, Maurice Joyant refers to her as a *danseuse* in *Henri de Toulouse-Lautrec, 1864–1901,* 2 vols. (Paris: H. Floury, 1927; repr., New York: Arno Press, 1968), vol. I, 196; Gauzi refers to her as a *clownesse* in *Lautrec mon ami,* 171. Both men were contemporaries (and friends) of Lautrec and patrons of the Moulin Rouge and were thus, presumably, familiar with Cha-U-Kao.

26. Frey, *Toulouse-Lautrec: A Life,* 193; Naomi E. Mauer, catalogue entry in Stuckey, *Toulouse-Lautrec: Paintings,* 256. Christina Freher posits that Cha-U-Kao was not a dancer at all; see her "Die Clownesse Cha-U-Kao," in *Sammlung Oskar Reinhart "Am Römerholz," Winterthur. Gesamtkatalog,* ed. Mariantonia Reinhard-Felice (Basel: Schwabe, 2003), 542–46.

27. One lithograph shows Cha-U-Kao on horseback in a procession at the Moulin Rouge with La Goulue, which was, perhaps, part of her paid performance. See Wolfgang Wittrock, *Toulouse-Lautrec: The Complete Prints,* 2 vols., ed. and trans. Catherine E. Kuehn (London: Philip Wilson Publishers for Sotheby's Publications, 1985), cat. no. 42, vol. I, pp. 142–43. A painting of 1895 depicts the *clownesse* in Lautrec's studio (Dortu P. 582, sold at Sotheby's New York, April 24, 1985).

28. Maurice Delsol, *Paris-Cythère: Étude de moeurs parisiennes* (Paris: Imprimerie de la France artistique et industrielle, n.d. [c. 1891/94?]), 101; I am aware of two other confirmed photographs of Cha-U-Kao, one in which she is topless and the other in which she strikes an acrobatic pose. For both, see Philippe Huisman and M. G. Dortu, *Lautrec par Lautrec* (Paris: La Bibliothèque des Arts, 1964), 83. To the best of my knowledge, the photograph reproduced here has never been discussed in the Lautrec literature.

29. Lautrec also included his friends François Gauzi, at the far left, and Charles Conder, at the right edge of the composition.

30. The painting *La Clownesse Cha-U-Kao* (1895) is now in the Oskar Reinhart "Am Römerholz" Collection, Winterthur, Switzerland (Dortu P. 583).

31. Musée Toulouse-Lautrec, Albi (Dortu P. 359).

32. For a brief overview of the competing interpretations, see Thomson, catalogue entry in Thomson, Cate, and Chapin, *Toulouse-Lautrec and Montmartre,* 436–37.

33. On Lautrec's *furias,* see Frey, *Toulouse-Lautrec: A Life,* 243.

34. Quoted in Thomson, Cate, and Chapin, *Toulouse-Lautrec and Montmartre,* 306.

35. Ibid., 304. The hierarchy between the "high" forms of dance at the Opéra and the vulgar cancan/*chahut* is apparent in the story of the ballerina Clara Pilvois, who dared to dance a few steps of the cancan at a ballet rehearsal. The *maître de ballet* was so horrified that he immediately ejected her from the rehearsal room. See Guest, "The Heyday of the Cancan," 12.

36. For a full treatment of Loïe Fuller in art, see, among others, Margaret Haile Harris, *Loïe Fuller: Magician of Light* (Richmond: Virginia Museum of Fine Arts, 1979); and Jo-Anne Birnie Danker, ed., *Loïe Fuller— Getanzter Jugendstil* (Munich: Museum Villa Stuck, 1995).

37. Florence E. Coman, *Toulouse-Lautrec: "Marcelle Lender in 'Chilpéric'"* (Washington, DC: National Gallery of Art, 1994), n.p.

38. Joyant, *Henri de Toulouse-Lautrec,* vol. I, 198–200.

39. Romain Coolus, "Souvenirs sur Toulouse-Lautrec," *L'Amour de l'Art* 12, no. 4 (April 1931): 139.

40. Coman, *Toulouse-Lautrec: "Marcelle Lender in 'Chilpéric,'"* n.p.

41. Thadée Natanson, *Un Henri de Toulouse-Lautrec* (Geneva, Switzerland: Pierre Cailler, 1951); Coquiot, *Des Peintres maudits,* 76.

Henri de Toulouse-Lautrec

Plate 135
Henri de TOULOUSE-LAUTREC
Dancer Seated on a Pink Divan
c. 1885–86
Oil on canvas
18¾ × 14¼ in. (47.6 × 36.2 cm)
The Dixon Gallery and Gardens, Memphis, Tennessee, Gift of the Sara Lee Corporation, 2000.3

Dancer Seated on a Pink Divan,

c. 1885–86 Lautrec was an art student at Fernand Cormon's studio in Montmartre when he painted this rare early work. It depicts a voluptuous model (too stocky to be a ballerina) in a ballet costume posed comfortably on a pink divan before dark gray cushions. The informal position of the "dancer" indicates that the work was created not at the Atelier Cormon, where models held conventional poses, but at one of Lautrec's first studios in Montmartre, which he inhabited from 1884. The same divan also appears in two of Lautrec's paintings of about the same time, *Study of a Nude* (c. 1883), now at the Musée Toulouse-Lautrec, Albi, and *Gustave Lucien Dennery* (1883–84), at the Musée d'Orsay, Paris.

Considered the first in a series of single-figure ballerina pictures the artist produced in the mid-1880s,[1] *Dancer Seated on a Pink Divan* attests to the early influence of Edgar Degas and Jean-Louis Forain, two artists outside the academic fold whose portrayals of ballet dancers were known to the developing young Lautrec. Here, removed from a setting of performance or rehearsal, the model is an individual, not an indistinguishable "type"; her direct pensive gaze suggests an inner life, a humanizing self-absorption characteristic of Lautrec's depiction of women. In color lithography, Lautrec would return to the same seated pose—forearms resting on thighs, hands together, and feet spread apart—in the emphatic frontal view of the performer *The Seated Clowness* (*Mademoiselle Cha-U-Kao*) from the *Elles* series of 1896 (plate 147).

Typical of the small paintings that affluent collectors purchased of subjects alluding to the seedier side of society, this work was first owned by Lautrec's conservative uncle, Count Odon de Toulouse-Lautrec. Outside of the family, the painting changed hands only twice before entering the Sara Lee Collection at the Dixon Gallery and Gardens in Memphis, Tennessee.

—Marnie P. Stark

NOTE

1. Richard Thomson in Richard Thomson et al., *Toulouse-Lautrec* (New Haven, CT: Yale University Press, 1991), 184 n. 1.

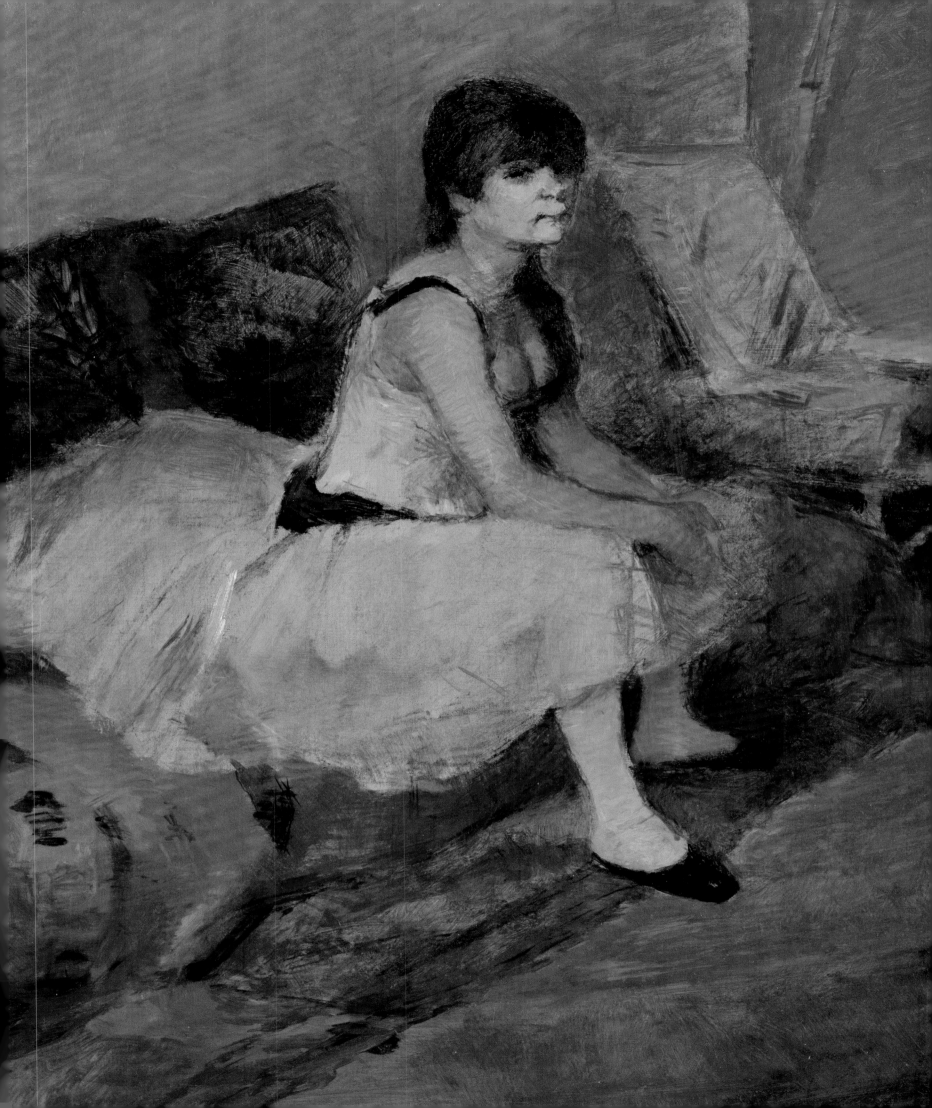

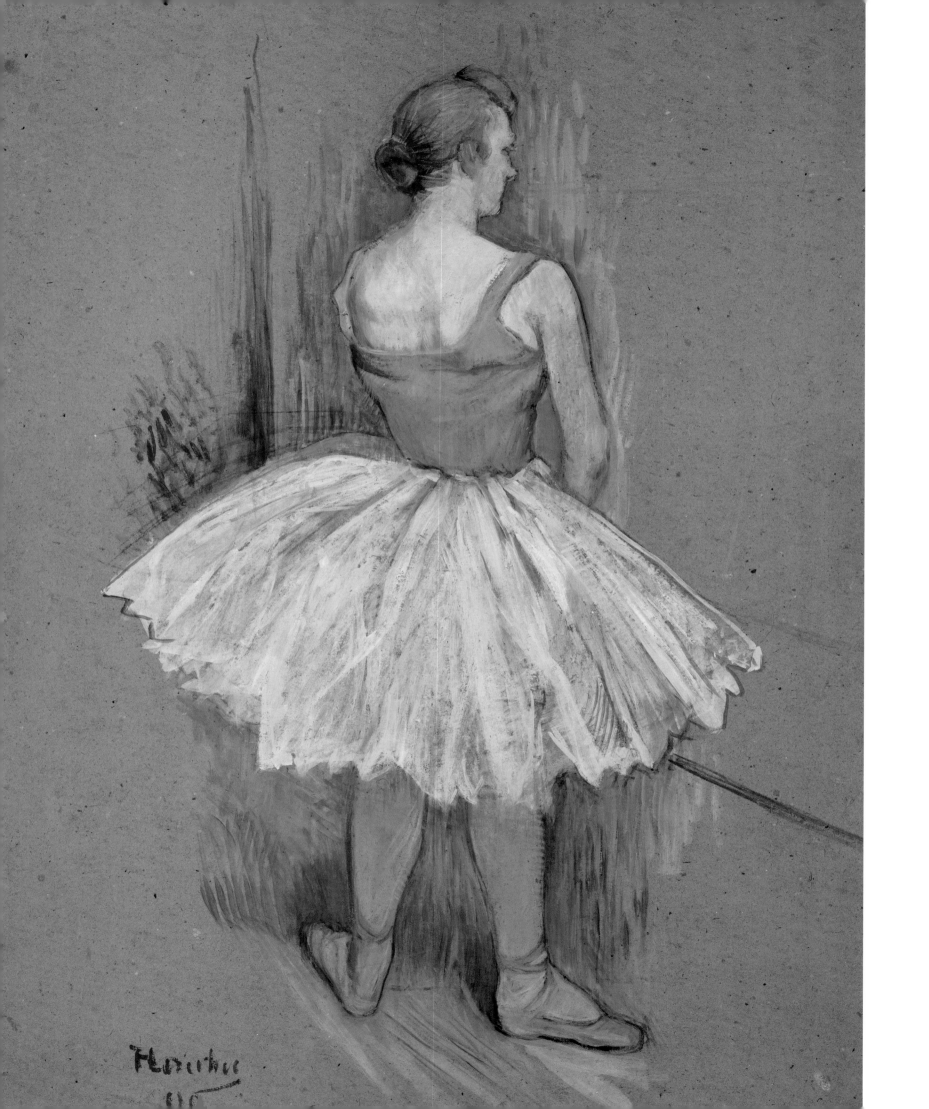

The Dancer, 1890

Throughout the 1880s and early 1890s, Lautrec was increasingly inspired by the world of performers: dancers, acrobats, actors, and singers. In this work, influenced by the oeuvre of Degas, Lautrec depicts a robust ballerina in repose. Emphasizing the strength of the dancer's body, particularly her muscular back, Lautrec contrasts the solidity of the woman's corporality with the airy weightlessness of her billowing, diaphanous tutu, revealing the deception of levity in a ballerina's physique.

Leaving large areas of the support blank, Lautrec barely contextualizes the dancer; brushstrokes of green, brown, and blue only hint at an interior. The centrality of the woman's back is a recurring motif in Lautrec's art. Five years later, when he sat through Marcelle Lender's performance in *Chilpéric* some twenty times, always observing her from the same angle, Lautrec admitted he was interested only in the star's shapely back.

Lautrec often made studies in oil on cardboard, which he signed and dated. The streaks of matte color give the work an effect of drawing more than of painting, recalling Degas's manner of applying pastel to his ballerina subjects. In fact, Lautrec achieved this appearance by removing the oil from his oil paints and thinning them with turpentine (*peinture à l'essence*), a medium that Degas prominently adopted to create a less viscous, dull finish.

The artist gave this work to Rémy Couzinet, editor of the newspaper *La Dépêche de Toulouse*. Couzinet's predecessor, Arthur Huc, was a passionate supporter of Lautrec's art and commissioned several lithographs from him during the early 1890s.

—MPS

Plate 136
Henri de TOULOUSE-LAUTREC
The Dancer
1890
Oil on board
26¾ × 20¼ in. (68 × 51.5 cm)
Private collection

Plate 137
Henri de TOULOUSE-
LAUTREC
*The Englishman at the
Moulin Rouge*
1891
Color lithograph on paper
18½ × 14½ in. (47 × 36.8 cm)
Portland Art Museum, Museum
Purchase, Ella M. Hirsch Fund,
41.11.1

The Englishman at the Moulin Rouge, 1891

The Englishman portrayed here is the painter William Tom Warrener, son of an influential family from Lincoln. Warrener lived in Paris beginning in the mid-1880s, after studying art at the Académie Julian. He exhibited at the Salon and the Royal Academy with modest success. A frequent patron of the Moulin Rouge, Warrener met Lautrec there in the early 1890s, after the Englishman moved to Montmartre.

Warrener is depicted in shadowlike monochrome, broadly outlined but rendered colorless compared to the pair of vibrant women of questionable repute with their billowing frippery and brutish expressions. Donning a top hat and grasping a walking stick and gloves, Warrener is the typical urban dandy who sought out the fashionable pleasures of the Montmartre nightlife. Though the Englishman's lewd, forward bent and the suggestive placement of his glove allude to a sexual advance, the mischievous glances of the squinty-eyed women reveal the mutually predacious nature of the encounter.

Lautrec created the same scene in an oil and gouache on cardboard, once owned by Warrener and now at the Metropolitan Museum of Art. However, in the oil study, the Englishman is fully fleshed out, his skin an array of peach tones, his lips and ears blood red, his shirt bright white, and the top of his cane a gleaming, burnished metal. This time, by contrast, the women are phantomlike, as large areas of the female figures are left for the brown support to finish. The portrait of Warrener, for which a study exists at the Musée Toulouse-Lautrec in Albi, further underscores the masklike visages of the female companions in both the painting and the print. Their theatrical faces, particularly the central figure with extravagant eye makeup, heighten the dramatic nature of the interplay.

—MPS

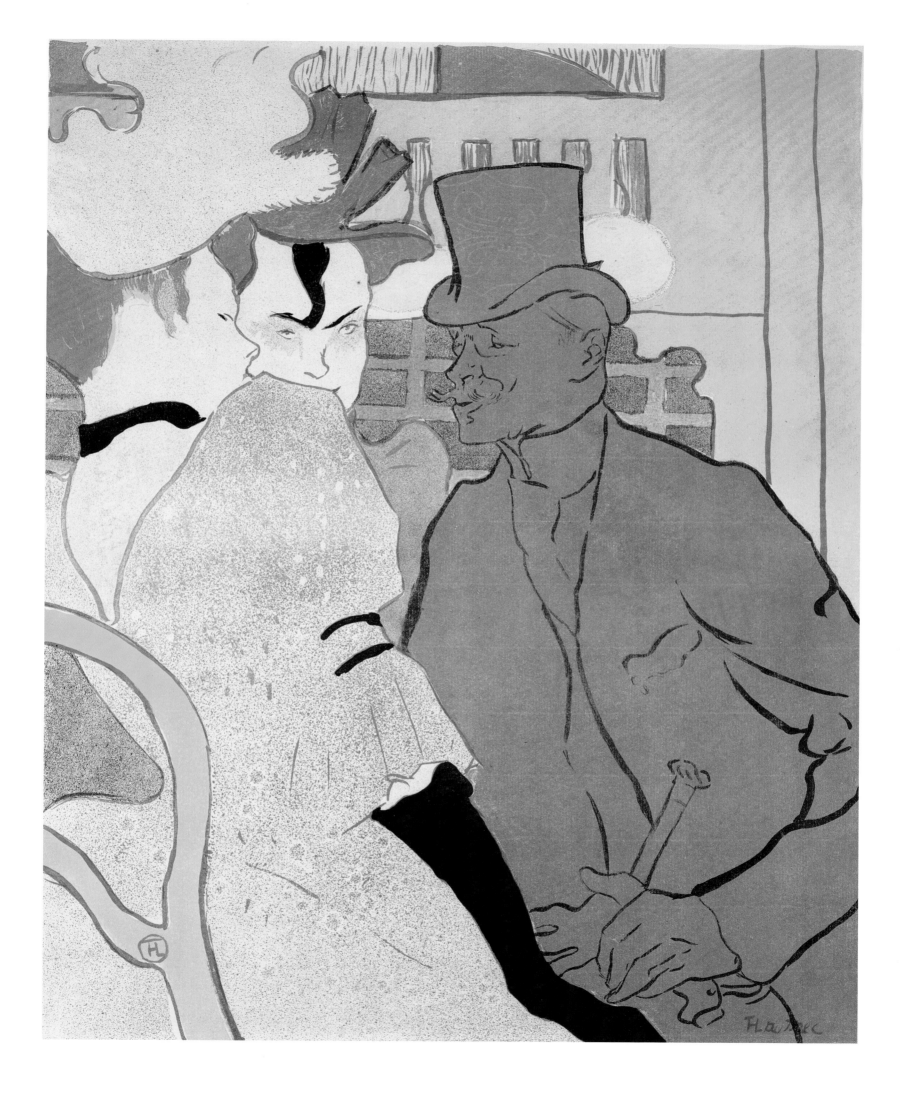

Plate 138
**Henri de TOULOUSE-
LAUTREC**
Moulin Rouge—La Goulue
1891
Color lithograph on paper
75¼ × 45⅞ in. (191 × 116.5 cm)
Krannert Art Museum, Gift of
William S. Kinkead, 1975-11-5

Moulin Rouge—La Goulue, 1891

Revolutionary in the history of printmaking, this work is not only Lautrec's first lithograph but also his first poster. Charles Zidler, the director of the Moulin Rouge, commissioned the artist to create the print to lure customers to the autumn season at the notorious Montmartre dance hall. The image focuses on the dancer Louise Weber, known as La Goulue (The Glutton), a provincial girl from Alsace, who became synonymous with the nightclub. Here, Lautrec depicts her dancing the *chahut,* which enticingly reveals her undergarments. The artist shows her at the most licentious moment of the performance, and the hand gesture of her partner, Valentin le Désossé (Valentin the Boneless), underscores the prurient tone of the act. Encircled by spectators, including us, La Goulue is rendered more riveting against a backdrop of the audience in silhouette. The conceit of the darkened profiles relates to the popular shadow-theater productions of Henri Rivière, staged at the cabaret Le Chat Noir beginning in the 1880s.

Intended to be posted on walls and kiosks, this lithograph, with its groundbreaking employment of a specific star entertainer, launched the popularity of celebrity-driven advertising. Consisting of three adhered sheets[1] and monumental in scale for maximum impact, the image was an overnight sensation. As the architect and painter Francis Jourdain recalled, "I still remember the shock I had when I first saw the Moulin Rouge poster... carried along the Avenue de l'Opéra on a kind of small cart, and I was so enchanted that I walked alongside it on the pavement."[2]

Lautrec was inspired by Jules Chéret, whose inventive production of large-scale color lithographic posters catapulted the use of the medium for advertising in 1866. In fact, Chéret created the inaugural poster for the opening of the Moulin Rouge in 1889. However, whereas Chéret's composition consisted of a montage of generic buxom blondes atop donkeys, Lautrec's work was decidedly modern. Distilled through the influence of Japanese abstraction, the poster design radically blurred the line between mass media and art. Indeed, Lautrec effectively and innovatively transformed popular images of lowbrow culture into an iconic work of high art marked by modernity. Straddling the worlds of the street and the salon, Lautrec contributed the poster to multiple exhibitions, including *Les Vingt* in Brussels in 1892 and the Exposition Internationale d'Affiches in Reims in 1896.

—MPS

NOTES

1. Some works consist of two adhered sheets rather than three. See Wolfgang Wittrock, *Toulouse-Lautrec: The Complete Prints,* 2 vols., ed. and trans. Catherine E. Kuehn (London: Philip Wilson Publishers for Sotheby's Publications, 1985), vol. 2, P 1.
2. Quoted in Julia Frey, *Toulouse-Lautrec: A Life* (New York: Viking, 1994), 296.

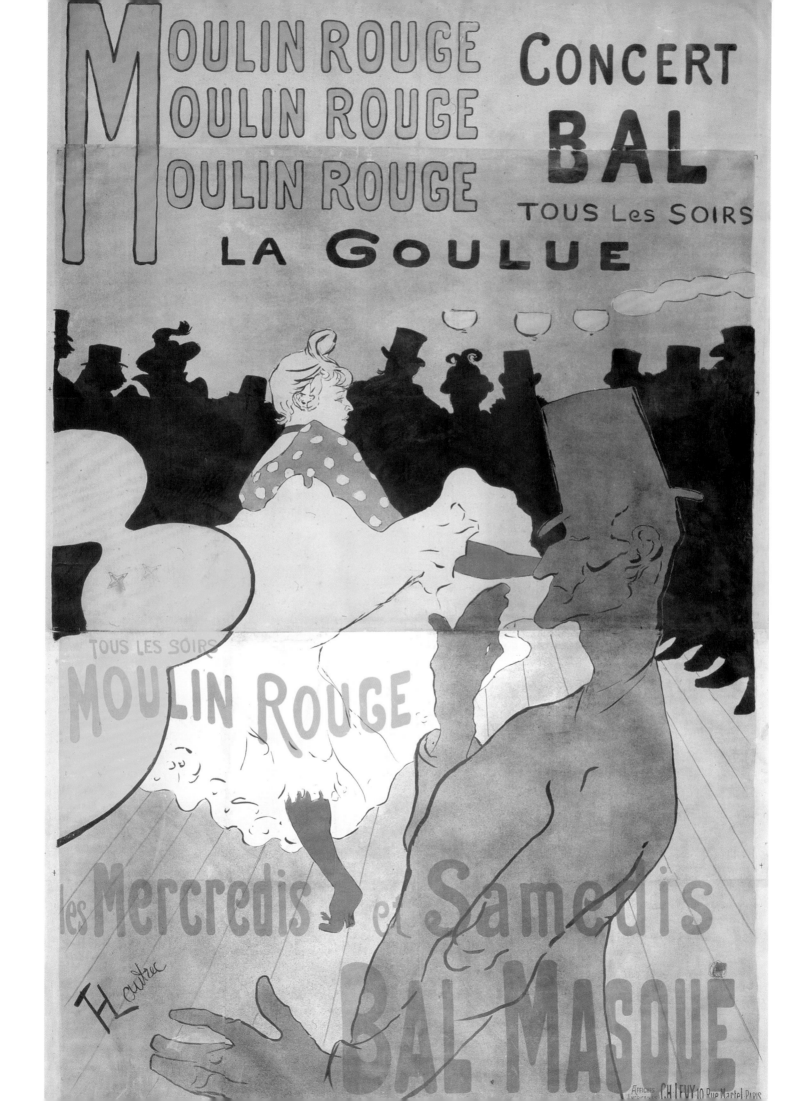

Fig. I
Edgar DEGAS
The Orchestra at the Opéra
c. 1870
Oil on canvas
22¼ × 18¼ in. (56.5 × 46.4 cm)
Musée d'Orsay, Paris, acquis de
Mlle Dihau, soeur de Désiré
Dihau, sous réserve d'usufruit,
1923 (RF 2417)

Plate 139
**Henri de TOULOUSE-
LAUTREC**
Divan Japonais
1893
Color lithograph on paper
31½ × 24⅜ in. (79.9 × 61.9 cm)
Fine Arts Museums of San
Francisco, Gift of Bruno and
Sadie Adriani, 1958.88

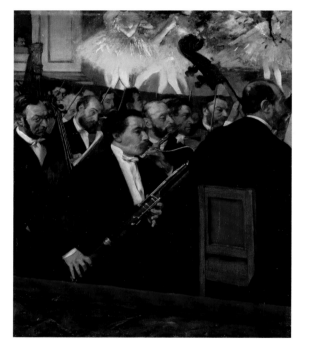

Divan Japonais, 1893

Édouard Fournier, owner of the Divan Japonais, commissioned this poster for the reopening of the small, recently renovated café-concert on the rue des Martyrs. Fashioned in the Japanese mode, the establishment attracted a cultured clientele. In this print, the illustrious patrons are the main attraction: in the center, Jane Avril, the celebrated entertainer with an intellectual bent, and beside her, Édouard Dujardin, a writer, art critic, and proponent of Japanese aesthetics. Relegated to the background and truncated is the star performer, Yvette Guilbert, reduced to her signature black gloves and satin dress.

Divan Japonais illustrates the strong impact that Degas had on Lautrec. The composition quotes an important painting by the master, *The Orchestra at the Opéra*, in which Degas first established the compositional conceit of cropping our view of the stage performance, which is eclipsed by the mediating orchestra in the foreground (fig. I). Here, the spectators replace Degas's orchestra. Dujardin, with his puckered lips and furrowed brow, mirrors Degas's performing contrabassist, the critic's cane echoing the curvilinear instrument. Lautrec supplants the Opéra musician, seated with his back to the viewer on a sturdy rectilinear chair, with Avril, poised on a graceful Thonet bentwood chair, which, like Lautrec's poster, was a symbol of modernity, café culture, and innovative mass-produced design. Twice, Lautrec repeats Degas's motif of the prominent contrabass neck extending into the view of the stage performance.

However, Lautrec filters the influence of Degas through a Japanese aesthetic. The emphasis on sinuous line, the flattening of space, and the use of strong, concise outlines of form filled in with broad monochromatic areas of color are all elements found in Japanese prints. Referencing the Asian atmosphere of the short-lived café-concert, Lautrec's Japanese-inspired design is further underscored by the inclusion of Dujardin, who wrote on the merits of *japonisme* in contemporary French art.

This is the first of four posters Lautrec created of Avril and is the only one of such works in which an image of Guilbert appears.

—MPS

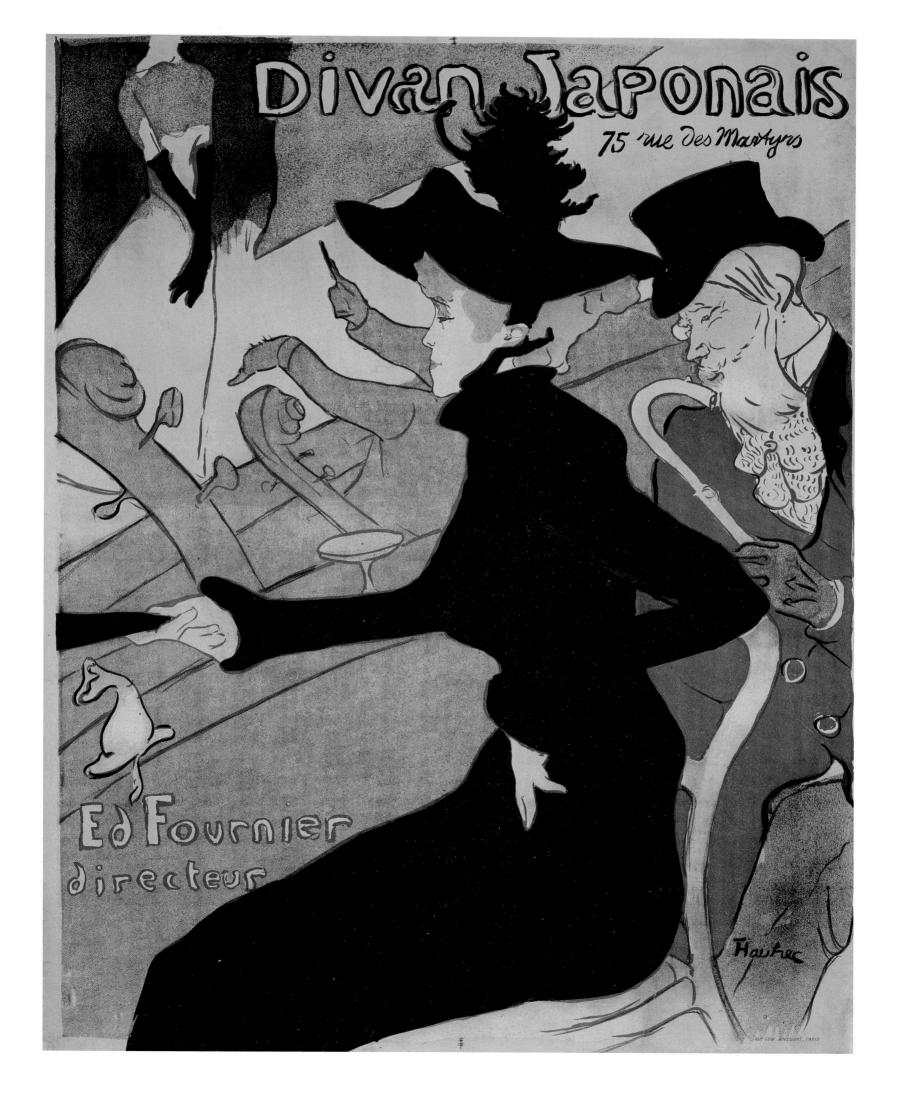

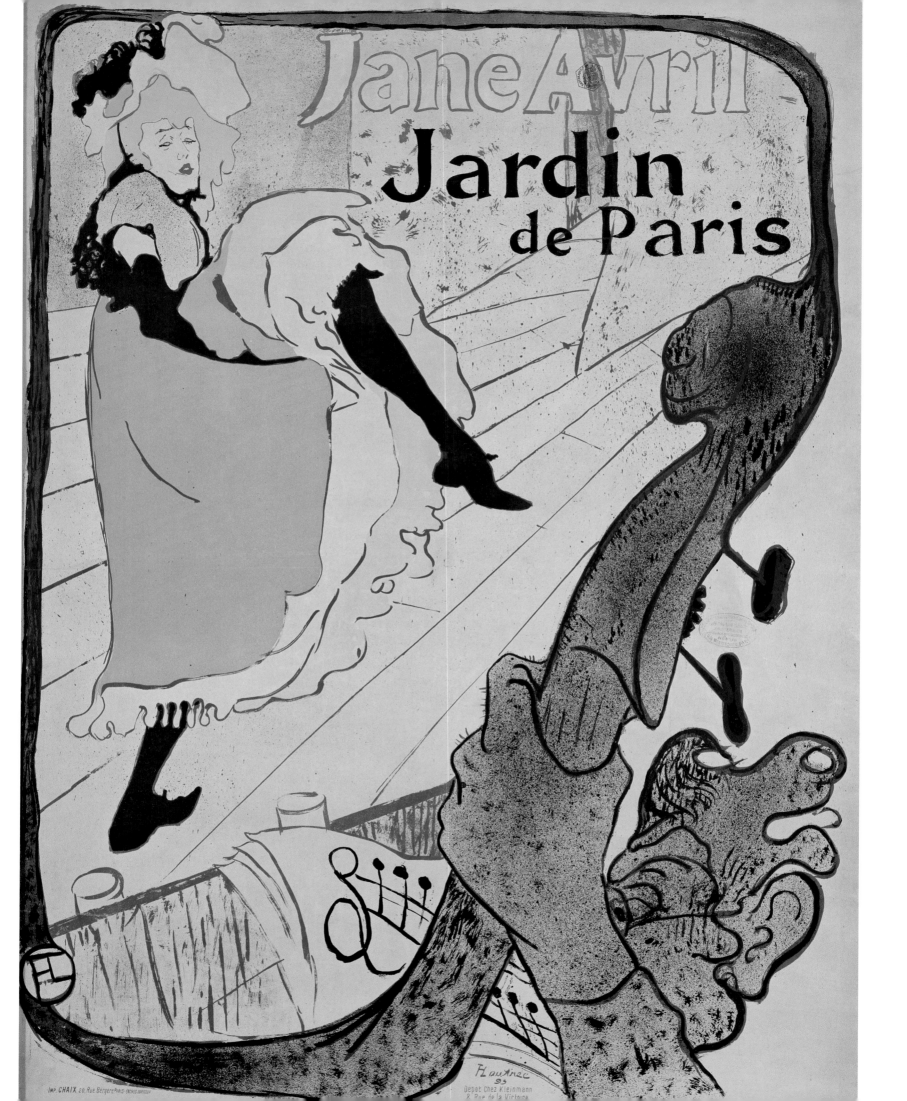

Jane Avril (Jardin de Paris), 1893

Born the illegitimate daughter of an Italian count and a courtesan in 1868, Jane Avril began her career at the Moulin Rouge, where she danced with fellow entertainer La Goulue. Avril's fiery rendition of the *chahut,* a licentious, high-kicking dance, earned her the nickname La Mélinite, a type of explosive used by the French military. Lautrec likely befriended Avril at the Moulin Rouge in the early 1890s. A true believer in the depth of Lautrec's talent, Avril commissioned this poster for her highly anticipated debut at the Jardin de Paris, a new café-concert on the Champs-Élysées.

Probably based on a publicity photograph, the poster shows Avril dancing the *chahut* with characteristic sensual detachment. Lautrec encapsulates the act within an innovative frame that incorporates the silhouetted neck of a contrabass. The motif of the cropped contrabass was used repeatedly by Degas to punctuate the performances onstage, and Lautrec frequently borrowed it. Here, the instrumental element is exalted, tightly linking the dreamlike interplay of the orchestral components with the stage scene.

This image was reproduced in *Le Courrier français* on July 2, 1893, and in *L'Art français* on July 29, 1893. Three years later, it was exhibited at the Exposition Internationale d'Affiches in Reims. A preparatory drawing in oil on cardboard is extant.

Avril received her greatest acclaim at the Jardin de Paris as well as at the Folies-Bergère. Subsequently, she entertained in London at the Palace Theatre and later toured the United States. Impoverished after World War I and estranged from her only son, she died in Paris in 1943.

—MPS

Plate 140
Henri de TOULOUSE-LAUTREC
Jane Avril (Jardin de Paris)
1893
Color lithograph on paper
49 × 35¼ in. (124.5 × 89.5 cm)
Private collection

Plate 141
**Henri de TOULOUSE-
LAUTREC**
Miss Loïe Fuller
1893
Brush and spatter lithograph
with keystone in olive green,
color stone in various colors,
and gold powder on beige
wove paper
14¹⁵⁄₁₆ × 10¼ in. (37.9 × 26 cm)
Smith College Museum of Art,
Northampton, Massachusetts,
Gift of Selma Erving, class
of 1927

Plate 142
**Henri de TOULOUSE-
LAUTREC**
Miss Loïe Fuller
1893
Brush and spatter lithograph
on paper
14⅜ × 10⅜ in. (36.7 × 26.8 cm)
McNay Art Museum, San
Antonio, Gift of Robert L.B.
Tobin, 1974.51

Plate 143
**Henri de TOULOUSE-
LAUTREC**
Miss Loïe Fuller
1893
Lithograph on paper
14⁹⁄₁₆ × 10½ in. (37.0 × 26.6 cm)
Brooklyn Museum, Museum
Collection Fund 39.25

Opposite:
Plate 144 *(detail)*
**Henri de TOULOUSE-
LAUTREC**
Miss Loïe Fuller
1893
Brush and spatter lithograph
printed in black, brown, yellow,
red, and blue with gold powder
added by hand
14⅛ × 10 in. (35.9 × 25.4 cm)
Boston Public Library, Print
Department, Albert H. Wiggin
Collection

Miss Loïe Fuller, 1893

Born in a suburb of Chicago, Loïe Fuller began performing onstage at the age of five. She toured with a Shakespearean acting company and entertained in burlesque shows in Chicago and New York. In November 1892, she debuted in Paris at the Folies-Bergère, astonishing audiences with her world-famous *danse du feu* (fire dance), which she patented in 1894. In her unique performance, she wore billowing voile skirts and manipulated swirling veils of drapery flung high into the air on long poles that she held in each hand. Occurring on a glass floor lit from below and surrounded by mirrors, the movement was heightened by the projection of specially installed multicolored lights onto the veils, creating an electrifying visual sensation.

Fuller's act inspired several artists to capture her performance. Lautrec's lithograph of 1893 shows the entertainer in the throes of her dance. Here, on a stage before a silhouette of a contrabass neck, she is a whirl of undulation. Consisting of various tones of rainbow hues, which simulate the effect of the projected light display, this lithograph is one of Lautrec's most innovative prints. He added dazzle by dusting over the work with gold and silver powder in the Japanese manner. The flattened, highly succinct composition also shows the influence of Japanese printmaking practices on Lautrec's experimental work.

—MPS

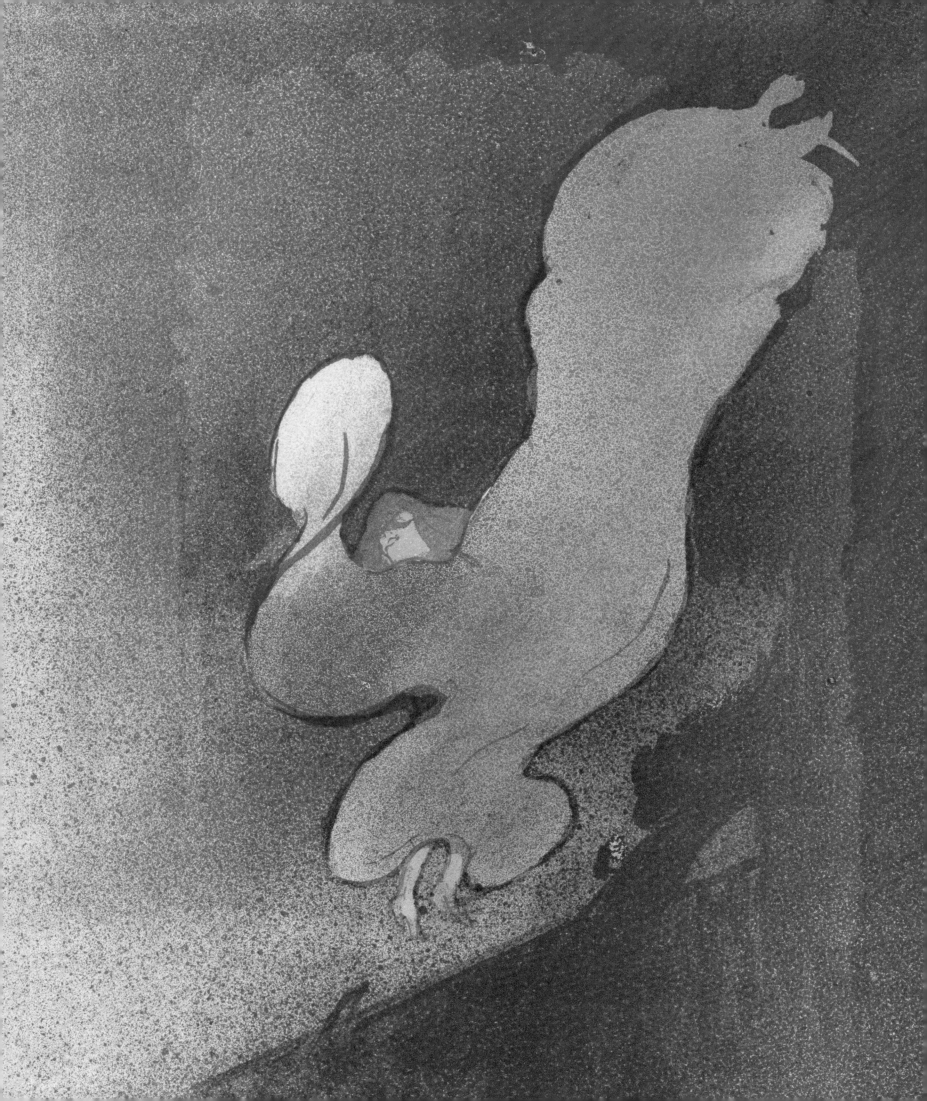

Plate 145
**Henri de TOULOUSE-
LAUTREC**
May Milton
1895
Color lithograph
31⅝ × 24¼ in. (80.3 × 61.5 cm)
Private collection

May Milton, 1895 A minor dancer from England, May Milton is
immortalized solely through Lautrec's work. In Paris, she deserted the English
dance troupe after only a season of performing at the Rue Fontaine and the
Moulin Rouge. Lautrec created this poster of her to publicize her tour of
the United States. Milton was romantically linked to the Irish performer May
Belfort; this poster was likely conceived as a companion to an earlier, striking
red-and-white one of roughly the same size that Lautrec did of Milton's pre-
sumed lover.

Lautrec's art dealer and biographer Maurice Joyant described Milton as
having a "pale, clownlike face, rather like a bulldog."[1] With her pinched face and
protruding lips, Milton in Lautrec's poster is not glossed over by the artist's
touch. Here, as in Lautrec's graphic art in general, the distilled, easily recogniz-
able physical traits of the individual become an iconic testament to the sub-
ject's humanity.

The strong frontal picture plane, the bold, flattened areas of color, and an
economic use of calligraphic line underscore an emphatic two-dimensionality
that reveals the influence of Japanese prints on the composition. The reversal
pattern of Milton's dress, visible around her upturned foot, is also in the Japa-
nese manner. A reproduction of the poster circulated in France in the August 3,
1895, edition of the magazine *Le Rire,* and in 1896, the work was exhibited at
Reims.

A preparatory drawing in blue and black crayon on light brown paper is
extant at the Yale University Art Gallery in New Haven, Connecticut. Two states
and four trial proofs of the poster are known to exist.

—MPS

NOTE

1. Maurice Joyant, *Henri de Toulouse-Lautrec, 1864–1901,* vol. 1, *Peintre* (Paris: H. Floury,
 1926; repr. New York: Arno Press, 1968), 198.

Plate 146
**Henri de TOULOUSE-
LAUTREC**
Mademoiselle Lender
1895
Black crayon, with touches
of blue pencil, on paper
12⁵⁄₁₆ × 7¾ in. (31.2 × 20 cm)
Thaw Collection, The Pierpont
Morgan Library, New York,
EVT 177

Mademoiselle Lender, 1895

Born Anne-Marie-Marcelle Bastien, the performer Marcelle Lender began dancing at the age of sixteen at the Théâtre Montmartre. Her greatest success was in the 1895 production of Hervé's operetta *Chilpéric* at the Théâtre des Variétés. In the starring role of Galswinthe, daughter of the King of Spain, she danced the bolero in a lavish Spanish costume complete with a headdress of enormous pink poppies. She entranced Lautrec; he went to the performance about twenty times, sketching Lender from the audience. He subsequently created nine lithographs, seventeen drawings, and the monumental painting of 1895–96 of the star in performance (see page 171, fig. 16). Lender allegedly refused Lautrec's offer to give her the finished canvas.[1]

This animated work—a quickly drawn flurry of lines—captures Lender's highly expressive face, with the touches of blue on the eyelids underscoring her theatricality. The headdress is similar to the one she wore in *Chilpéric*, indicating that this drawing may be a sketch of her as Galswinthe.

This drawing is one of an ensemble of four works by Lautrec in the exhibition that highlight Lender in her *Chilpéric* role (see plates 132–134 for three related lithographs). The most accomplished of these, the color lithograph *Mademoiselle Marcelle Lender, Bust Length,* of 1895, was a technical feat, printed in eight colors by Henri Stern at the firm of Edward Ancourt, Paris. Attempting to disseminate original French graphic art to German readers, editor Julius Meier-Graefe first published the lithograph in the Berlin magazine *Pan.* Meier-Graefe subsequently resigned owing to the controversy around the image, which critics hailed as a prime example of French decadence.

—MPS

NOTE

1. For an in-depth discussion of this painting, see Florence E. Coman, *Toulouse-Lautrec: "Marcelle Lender in 'Chilperic'"* (Washington, DC: National Gallery of Art, 1994).

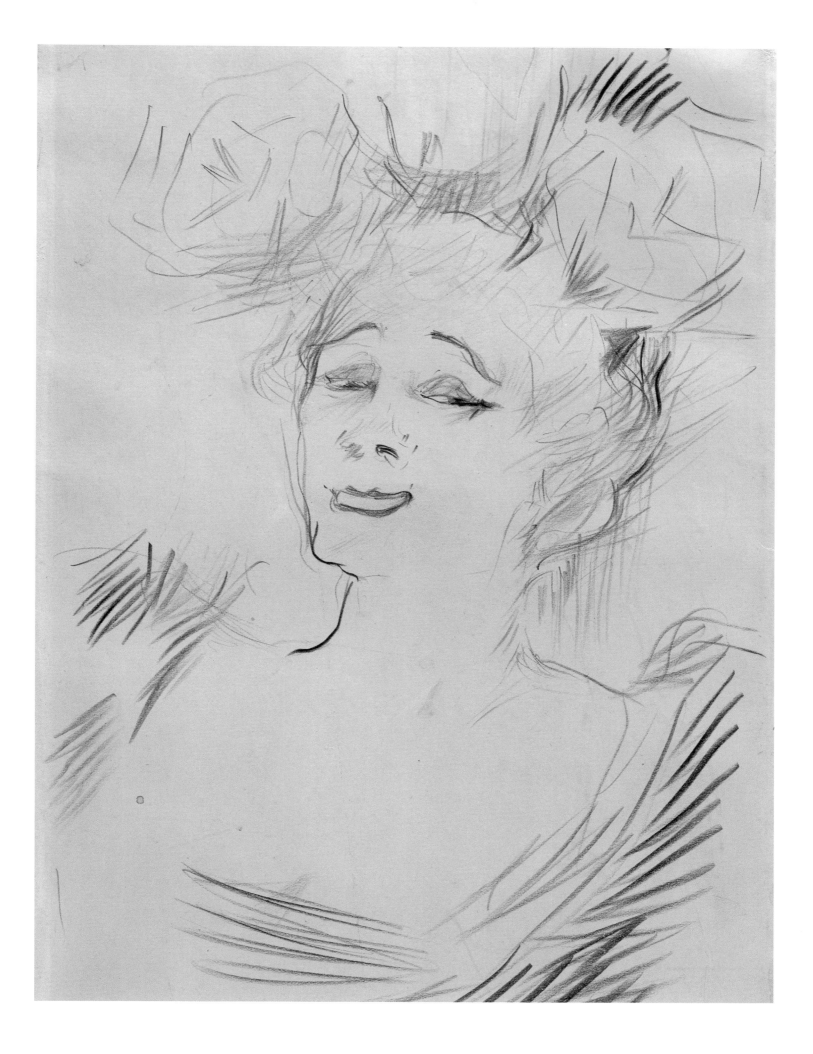

Plate 147
**Henri de TOULOUSE-
LAUTREC**
*The Seated Clowness
(Mademoiselle Cha-U-Kao),*
from the suite *Elles*
1896
Color lithograph on paper
20⅝ × 15⅞ in. (52.4 × 40.3 cm)
Portland Art Museum, Gift
from the Collection of Laura
and Roger Meier, 2004.122.3

The Seated Clowness (Mademoiselle Cha-U-Kao), 1896

From 1892 through 1895, Lautrec intermittently lived in the brothels or *maisons closes* on the rue des Moulins, rue d'Amboise, and rue Joubert in Paris. One result of this experience is his *Elles* series, ten lithographs, plus frontispiece and cover, published by Gustave Pellet in April 1896. The centerpiece of Lautrec's graphic oeuvre, the suite represents the pinnacle of his artistic brilliance and technical virtuosity in lithography.

The Seated Clowness (Mademoiselle Cha-U-Kao) is the first sheet in the series. Cha-U-Kao was a well-known acrobat and performer at the Moulin Rouge and the Nouveau Cirque. Her name derives from a frenzied version of the can-can called the *chahut,* meaning "uproar," or in French, *chaos.* Here, seated on a stoop, she is clad in her signature costume of white wig tied up in a yellow ribbon, matching ruff, and black knickers. As the only work in the *Elles* suite set outside the brothel, it is an anomaly.

Cha-U-Kao was known publicly as a lesbian, but not as a prostitute. However, her pose is more than suggestive. At the center of the composition—and of her emphatically splayed legs—Cha-U-Kao's clasped hands form a dark triangle, evoking the main tool of the female sex trade. Lautrec first used the conceit of the isolated performer seated with arms resting on thighs, legs spread, and hands joined about a decade earlier in *Dancer Seated on a Pink Divan* (plate 135). However, Cha-U-Kao's position is decidedly frontal and confrontational. As she stares directly at us, her look is knowing and humanizing.

As the subject of the first image in the series, she is the gate to a world alluded to by the couple behind her. Privy to the lives of female prostitutes, Lautrec did not idealize them as femmes fatales or as eroticized objects of male fantasy but sympathetically represented them as human beings. As with all of the women in the series, the female clown is presumably between performances. Lautrec was fascinated by Cha-U-Kao; she appears in several of his prints, such as *Dance at the Moulin Rouge* (plate 148) and *Cha-U-Kao at the Moulin Rouge* (plate 125), as well as in four paintings, including the preparatory oil sketch for this work.

Technically, this impression reflects Lautrec's masterful use of *crachis,* or spatter, to create rich atmospheric and coloristic effects that soften and unify forms. The more painterly approach to lithography characterizes Lautrec's graphic art from the *Elles* series onward.

—MPS

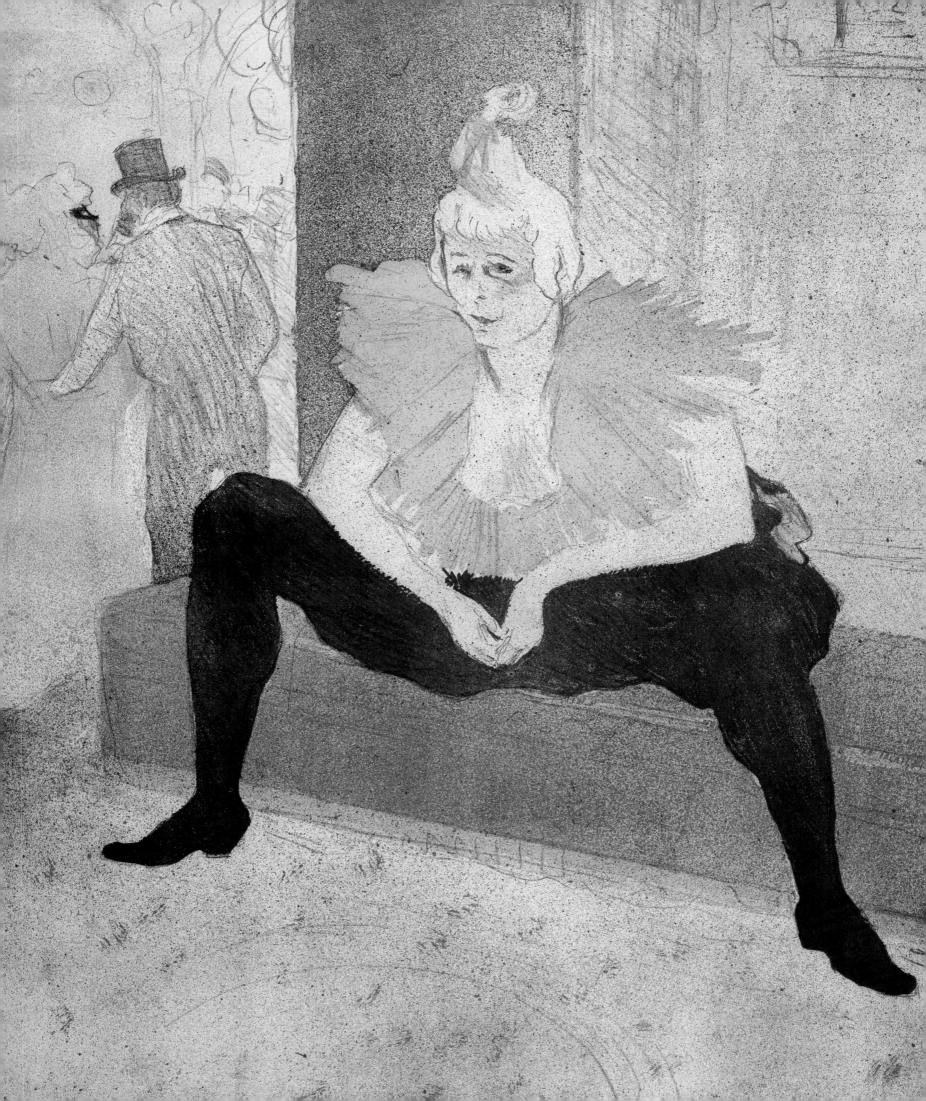

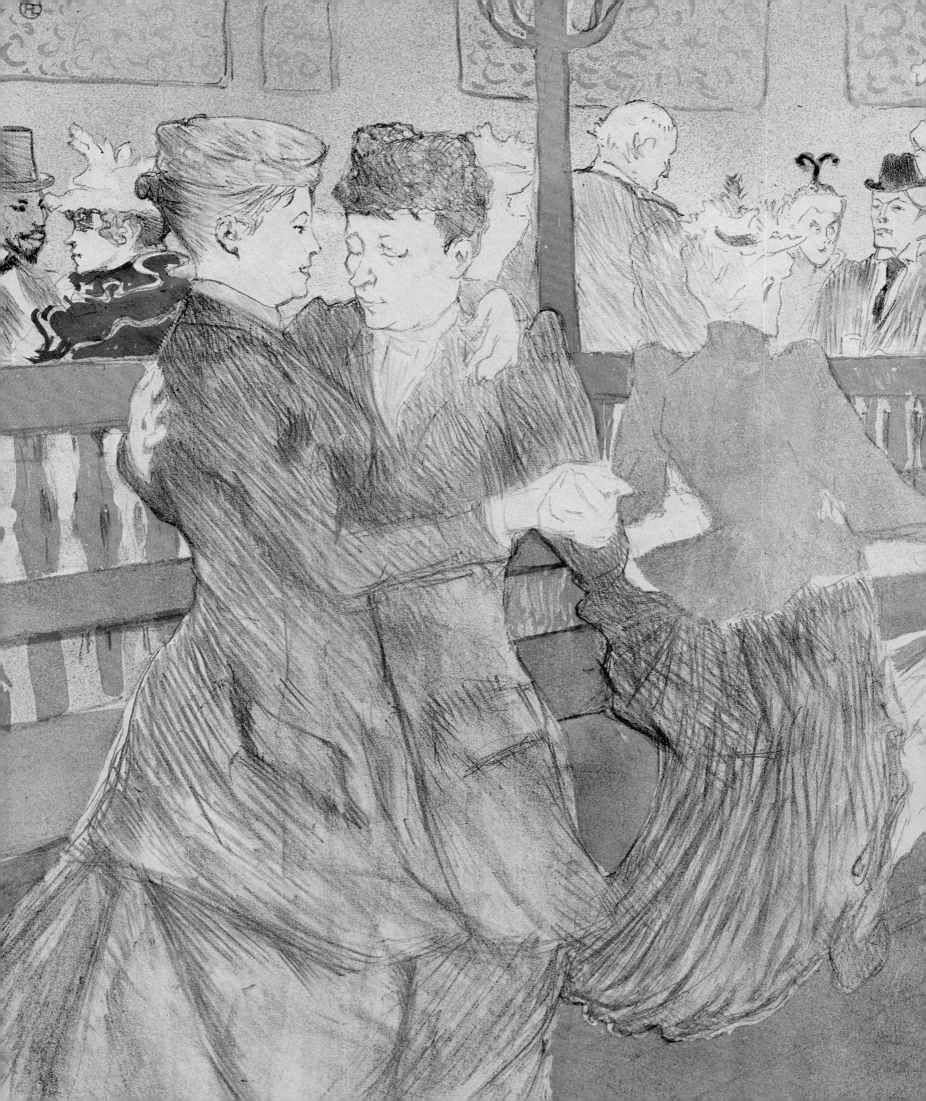

Dance at the Moulin Rouge, 1897

Featuring the dancer, acrobat, and clown Cha-U-Kao dancing with a female companion at the Moulin Rouge, this work is a print after a painting Lautrec created five years earlier. Motivated by the sales of four previous color lithographs, Gustave Pellet published twenty impressions of the image in July 1897.

The Moulin Rouge was a combined dance hall and cabaret with an expansive dance floor and mirrored walls. In the garden, live donkeys labored under ladies who removed their stockings for the ride. A massive papier-mâché elephant was installed near an outdoor stage. With weekly masquerade balls and prurient performances, the Moulin Rouge was the center of decadence in Montmartre. Lesbianism was considered a result of such bohemian extravagance.

Lautrec, drawn to the fringes of society, portrayed lesbians in several works, most notably in the setting of a brothel in his *Elles* series of 1896, in which Cha-U-Kao is prominently, though singly, represented (plate 147). Here, Lautrec underscores the tolerant environment of the club by coupling Cha-U-Kao, a known lesbian, with another woman in an intimate dance. Lautrec portrays the women with characteristic sensitivity, and the tenderness of their embrace is heightened by the synchronized swaying of their matching coats. The famous entertainer Jane Avril, with her back to the pair, shares the dance floor. Among the seated patrons are artists Charles Conder, on the right, and François Gauzi, on the left.

Cha-U-Kao was one of Lautrec's favorite models. The same year as this print, he made a color lithograph (plate 125) based on the oil painting *At the Moulin Rouge: The Clowness Cha-U-Kao* of 1895, which unlike this work, features the performer in costume.

—MPS

Plate 148
Henri de TOULOUSE-LAUTREC
Dance at the Moulin Rouge
1897
Brush and spatter lithograph with scraper, printed in black and four colors on china paper, laid down on mat board
16⁵⁄₁₆ × 13⁵⁄₈ in. (41.4 × 34.6 cm), trimmed
Milwaukee Art Museum, Gift of Mrs. Harry Lynde Bradley, M1964.57

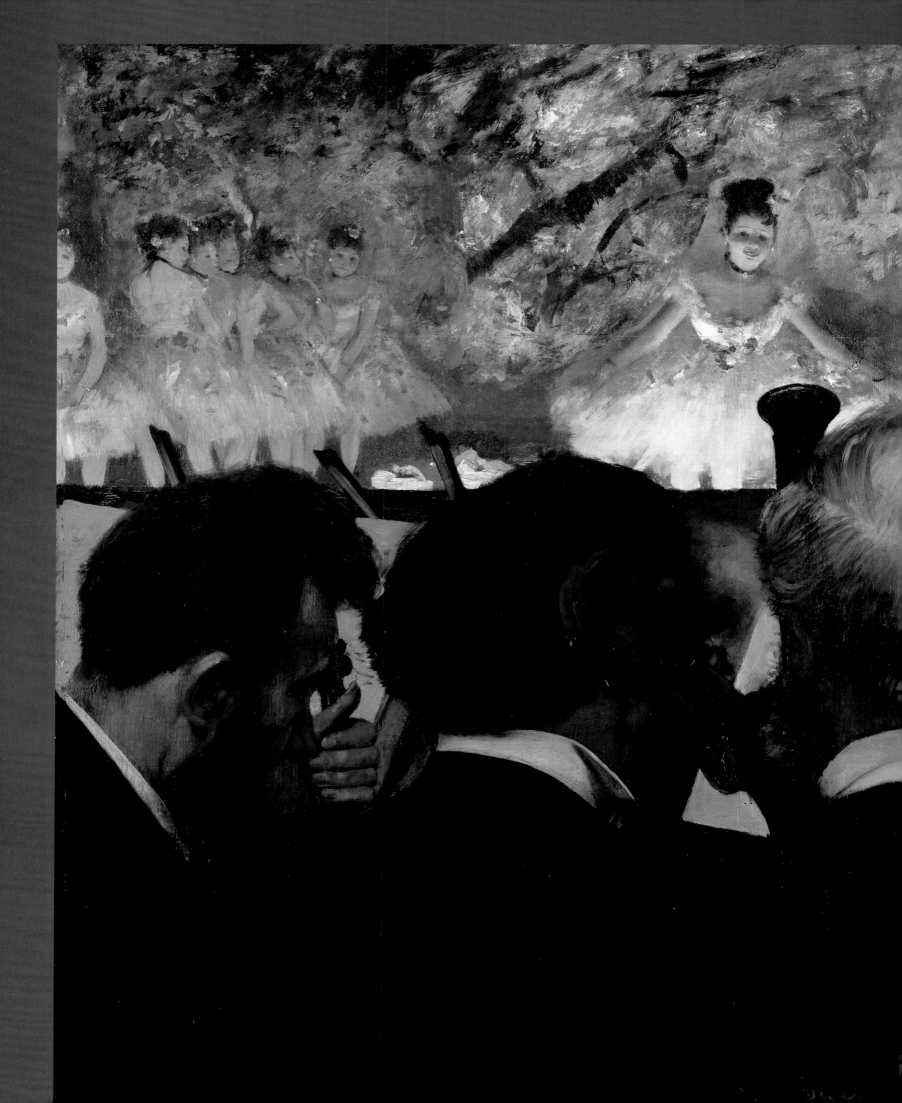

Jill DeVonyar

Re-Presenting *the Dance*
Degas's Inheritance and Legacy

SOME NINETEENTH-CENTURY BALLET IMAGES can seem charmingly naive to those familiar with classical dance today, while others appear strange, even distasteful. At one extreme, the stars of the era are presented as remote and flawless individuals who drift across the stage, sometimes barefoot and airborne like angels, replete with wings. The various characters depicted— peasant girls, impish spirits, and exotic *bayadères,* among others—often look much the same; if it weren't for their detailed costumes, it would be difficult to tell them apart. In contrast to these elusive maidens, a strikingly different image of the dancer proliferated from the mid-1800s onward. In large numbers of prints and a few paintings, the ballerinas are located backstage, where they are seen acting seductively or coyly displaying their feminine charms. They are frequently shown in the company of older gentlemen, chatting in theater foyers (fig. 1, plate 150), fawning over their suitors in dressing rooms (plate 149), and crowded together in the wings during performances (plates 151, 152). Such encounters and behaviors, which are clearly sexual in their implications, have no equivalent in the dance world of our own age, where access backstage is limited to professional staff and unseemly conduct is specifically prohibited. But in the theaters frequented by Edgar Degas, Jean-Louis Forain, and Henri de Toulouse-Lautrec, life beside and beyond the scenes was vastly more complex socially and sexually. It was this potentially charged environment that formed the basis for much of their dance oeuvre, which can be grasped only when the contemporary significance of such divergent images of the ballerina is articulated.

Fig. I
Auguste TRICHON
The Dance Foyer, illustrated
in *Le Nouvel Opéra* by
Alphonse Royer (Paris:
Michel-Lévy, 1875)
Bibliothèque nationale
de France, Paris

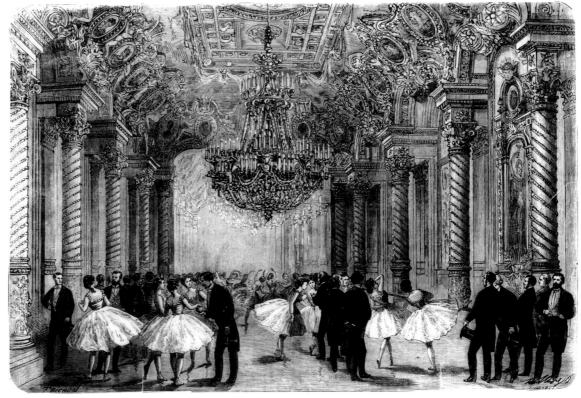

LE NOUVEL OPÉRA. — LE FOYER DE LA DANSE.

Plate 149
Jean-Louis FORAIN
The Dancer and Her Friend
c. 1900
Black crayon and watercolor
on paper
12½ × 14⅝ in. (31.7 × 37 cm)
Musée d'Orsay, Paris,
département des Arts
graphiques du Musée du
Louvre, legs du comte Isaac de
Camondo, 1911 (RF 4055)

Plate 150
Edgar DEGAS
*The Green Room (The Foyer
of the Opéra)*, illustration for
La Famille Cardinal
1876–77
Monotype printed in black
on paper
6⁵⁄₁₆ × 4⁵⁄₈ in. (16 × 11.7 cm)
National Gallery of Art,
Washington, DC, Rosenwald
Collection 1948

68
I

Plate 151
Jean-Louis FORAIN
The Abonné's Choice
c. 1896
Crayon, stumping, and
graphite on paper
16¼ × 11⅝ in. (41.5 × 29.5 cm)
Courtesy of Galerie Schmit,
Paris

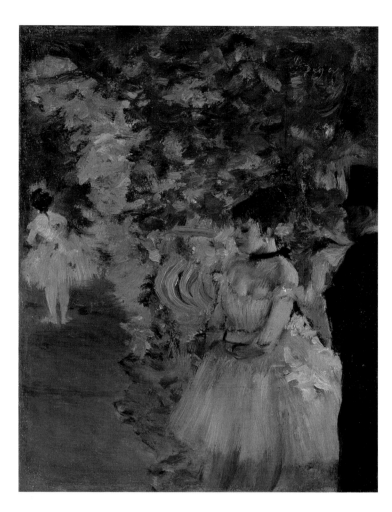

Plate 152
Edgar DEGAS
Dancers Backstage
1876/1883
Oil on canvas
9½ × 7⅜ in. (24.2 × 18.8 cm)
National Gallery of Art,
Washington, DC, Ailsa Mellon
Bruce Collection 1970.17.25

Like the media idols of our own age, certain prominent bal-
lerinas were of sensational interest in fin de siècle France. The
most famous of them performed with the Paris Opéra, home of
the nation's preeminent ballet company and associated school,
with an international reputation reaching back to the Romantic
era. Celebrated for their professional accomplishments and
glamorous appearance, some dancers were almost as renowned
for their extramural lives. Fans collected their photographs, their
love interests were reported in the press, and their activities
were parodied in prints and other media. The allure of these
women was also tainted—and in some quarters enhanced—by
the widespread belief that dancers were morally lax. This percep-
tion was not completely unfounded. Some ballerinas came from
lower-class families that depended on the daughter's earnings,
and this income, though slight at first, held the promise of dra-
matically improved household finances. The salaries of company
members increased as they rose in the ranks of the Opéra hierar-
chy and became considerable once a dancer reached the level of
sujet (soloist).[1] But for those so inclined, fortunes could be fur-
ther enhanced by male patrons—*abonnés*—seeking a romantic
fling, a long-term "arrangement," or, very occasionally, a wife.[2]
Men with the means and connections to secure an *abonnement*
(annual subscription) for three nights a week were permitted to
roam the Opéra premises while productions were under way and
to socialize in the *foyer de la danse,* a huge, ornate room behind
the stage where ballerinas warmed up for performances and
entertained guests.[3] Degas himself secured such an *abonnement*
in the mid-1880s, though by then he was already well acquainted
with the Opéra and its intrigues.[4] Nearly twenty years before, he
had painted two portraits of the much sought-after star Eugénie
Fiocre; about 1870, his brother Achille had an affair—and purport-
edly a child—with Thérèse Malot, a member of the corps de bal-
let; and Degas's friend, Count Ludovic Lepic, was in the midst of
a long and attentive relationship with the *sujet* Marie Sanlaville.[5]

This aspect of the dance world and its depiction, however, coexisted with several others. A stubborn survivor from the Romantic era was the image of the dancer as an unearthly, feminine being. Pictures of winged fairies, ghostly sylphs, and other fanciful creatures first became popular in the 1830s, when the advent of expressive pointe work and other innovations—such as the *ballet blanc*—transformed classical dancing.[6] Alfred-Edward Chalon's conception of Marie Taglioni (fig. 2) is characteristic of this genre: costumed as the goddess of flowers and hovering in arabesque, the lissome Taglioni is as dreamlike as the landscape surrounding her.[7] Other images of this kind portray equally stylized figures, alighting on the tips of their toes or floating through the air, looking more like putti or dolls than dancers. The muscles in their limbs are barely articulated, their bodies conform to types that were currently fashionable, and their ability to defy gravity is pushed to extremes. In later, less prudish years, similarly fanciful representations of dancers could show them as specifically voluptuous: in Alfred Darjou's poster for the 1866 ballet *La Source* (fig. 3), for example, the breasts of several sprightly personalities are revealed.[8] Though the women who danced these roles certainly did not appear half-dressed onstage, Darjou's capricious image, unlike Chalon's, is clearly intended to titillate.[9] These figures are again modeled after fairy-tale archetypes associated with the ballet—in this case, nymphs with identical physiques—and with

Fig. 2
Alfred-Edward CHALON
(after)
Marie Taglioni in "Flore et Zéphire" by Cesare Bossi
1831
Lithograph
Victoria and Albert Museum, London

Fig. 3
Alfred DARJOU
Poster for "La Source"
1866
Lithograph
23⅝ × 18¼ in. (60.1 × 46.4 cm)
Bibliothèque-Musée de l'Opéra, AF tit II no. 494, Bibliothèque nationale de France

current notions of the *féminin éternel.* However quaint such pictures might seem today, they were evidently linked to the fantasy of the performance itself, in marked contrast to images of the seductress waiting in the wings.

Yet another category of dance picture that was popular throughout the mid to late nineteenth century focused on a single, costumed ballerina standing in a nondescript setting and assuming a pedestrian or casual balletic stance.[10] In these types of prints, the figures are somewhat more naturalistically rendered, with much attention lavished on facial features and outfits, whereas the dancers' bodies, once more, are generalized. Viewers are invited to admire the young woman as a star, neither exerting herself nor engaged in questionable behavior behind the scenes. Clearly these works are portraits of a particular kind: not only of the dancer but also of her apparel, which is typically described in extreme, even laborious detail. Such prints could be purchased in sets or individually, while others showing the dressing of the stage—rather than the dancer—appeared in the press. Meticulously executed, these panoramic views of specific sets were conceived to promote upcoming theater productions. When portrayed in this context, performers are usually a minor element, dwarfed by the scenic spectacle around them.[11]

During the 1860s, photographs of classical performers seized the public imagination, introducing a new element of realism into ballet images. In some, the dancers appear in street clothes, looking as dignified and elegant as any *parisienne,* but in the vast majority of *cartes de visite* and other studio shots, they are sporting stage costumes and presented "in character." In this sense, the photographs adhered to the status quo established by their engraved and other printed counterparts, but the very nature of the medium introduced a particularity to the genre that had been previously absent. However contrived the photographs may seem, the dancers represented are inescapably human individuals. Curiously, prior to Degas's revolutionary classroom and rehearsal scenes, no depictions in any medium took the ultimate step of revealing plausible figures of dancers at work, away from the public gaze. In the few instances when such events are shown, artists almost invariably resorted to the stereotypes outlined above. This is clearly the case in an illustration from *La Vie parisienne* of 1864 (fig. 4), based on a dress rehearsal at the Paris Opéra, in which each of the ballerinas conforms to a standard physical type, as if taken from a pattern book. The two figures in tutus standing on a pedestal presumably had an erotic appeal, like the nymphs in Darjou's roughly contemporaneous poster, while their colleagues seem

Fig. 4
"Rehearsal at the Opéra of *Néméa* or 'Love Avenged,'" from *La Vie parisienne,* July 16, 1864
Bibliothèque nationale de France, Paris

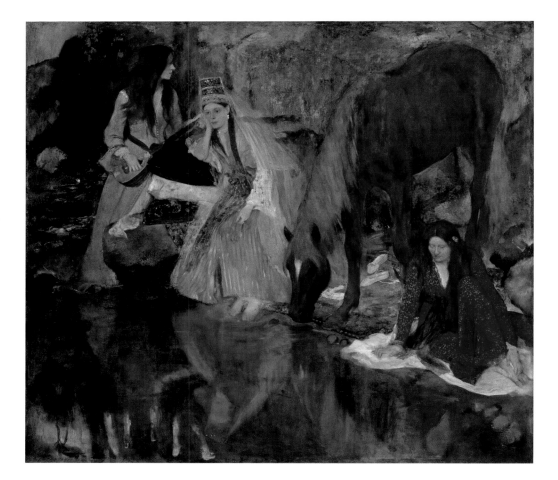

Fig. 5
Edgar DEGAS
*Portrait of Mademoiselle
Fiocre in the Ballet
"La Source"*
c. 1867–68
Oil on canvas
51½ × 57⅛ in.
(130.81 × 145.09 cm)
Brooklyn Museum, 21.111, Gift
of James H. Post, A. Augustus
Healy, and John T. Underwood

largely characterless and ornamental. Though this picturesque gathering was contrived to delight viewers and entice them to the theater, there is little sense of the purpose of the event itself, nor of the hard work and tedium that characterized such practice sessions and, indeed, much of the dancer's life.

Rarely revealed in any pictorial form, the physical exertions of ballerinas were discussed in a succession of contemporary essays and books about backstage life at the Paris Opéra.[12] One of the most comprehensive, *Ces Demoiselles de l'Opéra,* devotes two chapters to the dancers' training and attire as well as to the daily schedule of lessons, rehearsals, and performances.[13] Signing himself "Un vieil abonné" (an old *abonné*), the author concentrates on the period from the early 1860s to the mid-1880s, when he was clearly intimate with the institution. Though his sardonic tone is flippant at times, the "old *abonné*" knew his subject well. Formal exercises, stretches, and other classroom activities are described with some authority, as is the general importance of maintaining "suppleness and agility."[14] The private labors of ballerinas are also referred to on occasion; in one instance, he reveals that the internationally acclaimed and already prosperous *étoile* Rita Sangalli

studied at home for two or three hours every day in a proper "classroom" that consumed the "entire second floor of her Paris residence."[15] Other anecdotes suggest that such determination and discipline were common among Opéra dancers, particularly those who sought to distinguish themselves on the national or international stage.

While generally respectful of the dancers' professional accomplishments, the "old *abonné*" was keen to share his roguish thoughts about their relative prettiness, physical attributes, and personalities. Favorite ballerinas are described as "beautiful . . . with a superb chest" or as "intelligent and agreeable," but others are identified as "thin as a curtain rail" or very "pious" (in other words, too unattractive or virtuous to be alluring).[16] Rife with knavish chatter and sexual innuendo, such passages were written with a particular audience in mind: men with an erotic fascination with ballerinas.[17] As in other examples of "*coulisses* literature" (the *coulisses* are the wings of a theater), readers were indulged in myriad ways and led to believe that ballerinas were more concerned with their romantic affairs than with their professional careers. But toward the

end of this substantial volume, the "old *abonné*" steps back from the clichés and comes clean: he admits that, in reality, the dancer's day is consumed with the demands of her profession, leaving no room for any "foolery" or "tumbles in the hay."[18] "Serious dancers," he bemoans, no longer socialize in the *foyer*: they only appear at the "last moment, to put on their slippers ... before stepping onstage."[19] Such had been the case at least since 1840, when the dance critic Théophile Gautier had made a similar claim, as had others in the intervening years.[20] Those who wanted to rise to the top of their profession had to work hard and dedicate themselves to their craft; "serious dancers" had no time for, or were not interested in, the lecherous men who patronized the Opéra.

The decades surveyed by the "old *abonné*" include the period when Degas painted his first dance subject: *Portrait*

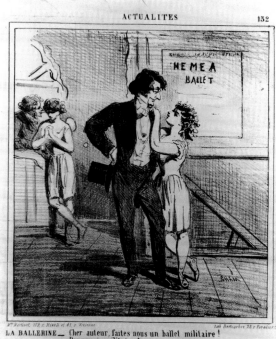

Fig. 6
CHAM (Amédée Charles de Noé)
The Ballerina, plate 132 from *Actualités*
c. 1864
Lithograph on paper
Private collection

of Mademoiselle Fiocre in the Ballet "La Source" (fig. 5). Begun in 1867 and exhibited at the Paris Salon the following year, this "portrait" could be mistaken for an oriental fantasy in the Romantic tradition, rather than a plausible event that transpired at the Opéra. Featured at center is the sensational Fiocre, who had first captivated Parisian audiences when she debuted as Cupid in *Néméa* in 1864.[21] In Degas's painting of *La Source,* she appears dressed as the exotic princess Nouredda, a role created for her by choreographer Arthur Saint-Léon.[22] Accompanied by a live horse and two distracted attendants, Fiocre dangles her feet in a pool of water, her vacant stare and abandoned slippers suggesting a break during a rehearsal.[23] The acclaim that followed *Néméa* and *La Source* thrust Fiocre into the public eye: her beauty and "statuesque" physique were repeatedly extolled by dance critics and admirers; her numerous "charms" were attested to by acquaintances and fans; and several illustrious suitors, including the Duc de Morny, began to compete for her attention.[24] By the time Fiocre sat for Degas's portrait, she was among the most famed Opéra ballerinas, though—crucially—her technical prowess was much debated.[25]

Despite Fiocre's notoriety and much-acclaimed allure, Degas chose not to portray her at her most glamorous.[26] In an 1866 review of *La Source,* for example, Gautier gleefully remarked that Fiocre's "delightful body" could be "glimpsed" through her "gauzy" costume, an aspect that Degas avoided by swamping her seated figure in layers of sumptuous fabric.[27] Her subdued demeanor in Degas's picture is also at odds with her public image; Fiocre hardly appears to be the captivating coquette described in the ballet literature and evoked in the ravishing—and nearly contemporaneous—portrait of her by Franz Xaver Winterhalter.[28] It could be said that popular perceptions of Fiocre are subverted in Degas's canvas, which is a far cry from other images of the ballerina and her colleagues that emphasize their curvaceous figures, flirtatious gestures, and frivolous ways (see figs. 1, 6).[29] But even the dazzling Fiocre, who appears not to have been one of the Opéra's "serious" dancers, is represented with solemnity, a quality that would characterize much of Degas's subsequent ballet oeuvre.[30]

Though Degas's painting of Fiocre was not a critical triumph—only a few Salon reviewers mentioned the picture—it marked the beginning of a dramatically new phase in his artistic career.[31] As he increasingly identified himself with the ballet, Degas forged a succession of entirely new possibilities for the depiction of dancers, both onstage and in their day-to-day existence. Many of these achievements were intricately dependent on his firsthand

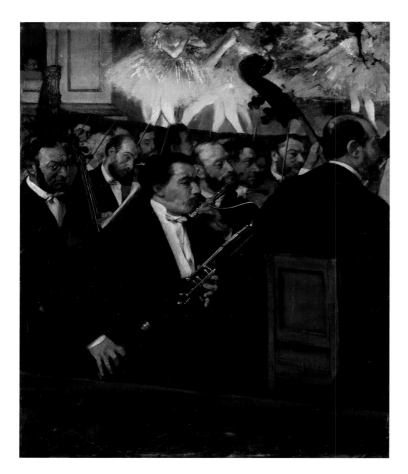

Fig. 7
Edgar DEGAS
The Orchestra at the Opéra
c. 1870
Oil on canvas
22¼ × 18¼ in. (56.5 × 46.4 cm)
Musée d'Orsay, Paris, acquis de Mlle Dihau,
soeur de Désiré Dihau, sous réserve d'usufruit,
1923 (RF 2417)

Fig. 8
Edgar DEGAS
Musicians of the Orchestra
1872
Oil on canvas
27⅛ × 19¼ in. (69 × 49 cm)
Städtische Galerie in Städel Museum,
Frankfurt am Main

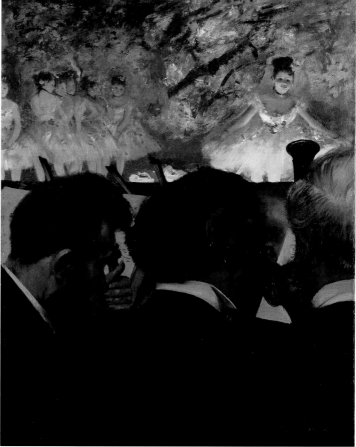

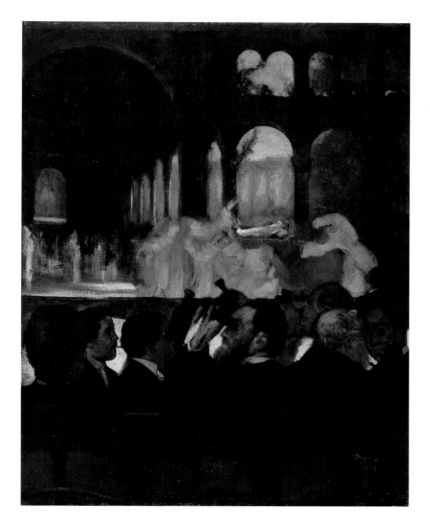

knowledge of classical performers and their training, a process that was already implicit in his numerous preparatory studies of Fiocre.[32] This rootedness in the working lives of Opéra dancers became a defining characteristic of his dance-themed art, but one not always shared or understood by his successors. It is intriguing to note that when Degas began *Portrait of Mademoiselle Fiocre in the Ballet "La Source,"* Forain was still a teenager studying at the École des Beaux-Arts in Paris, and Lautrec was a mere toddler living with his family in Albi. It would be several years before Forain started working professionally, and just over twenty before Lautrec made his artistic debut.[33]

There were no immediate successors to *Portrait of Mademoiselle Fiocre in the Ballet "La Source,"* but Degas would soon expand his dance repertoire. In the early 1870s, he painted a trio

of startling stage images set at the Opéra (figs. 7, 8, 9), all of which show the proscenium above the heads of orchestra musicians. Structurally, these works owe much to Degas's forebears in the world of popular illustration, while taking the utterly original step of translating such topical ballet subjects into the language of oil paint.[34] The last picture in this group, *The Ballet from "Robert le Diable,"* is of particular significance, offering what is arguably the most convincing representation of dancers performing onstage achieved by any artist up to this date. Based on a divertissement (dance interlude) in an opera by Giacomo Meyerbeer, the scene is set in a shadowy ruined cloister where the ghosts of fallen nuns rise from their tombs to engage in a mesmerizing dance.[35] Degas's loosely brushed description of their white habits captures the ebb and flow of the dancers'

Plate 153
Edgar DEGAS
Dancer on Pointe
c. 1877
Oil on canvas
19¾ × 23⅝ in. (50 × 60 cm)
Collection of Diane B. Wilsey

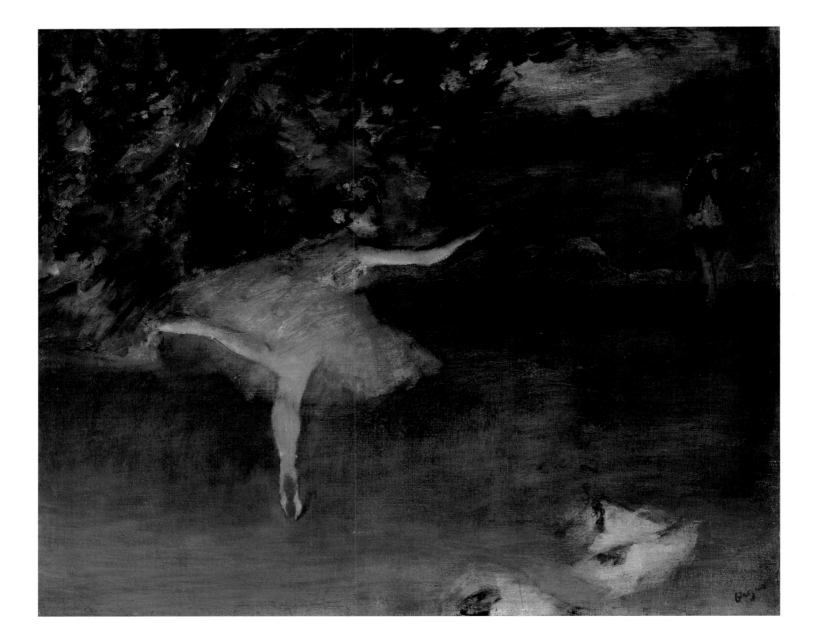

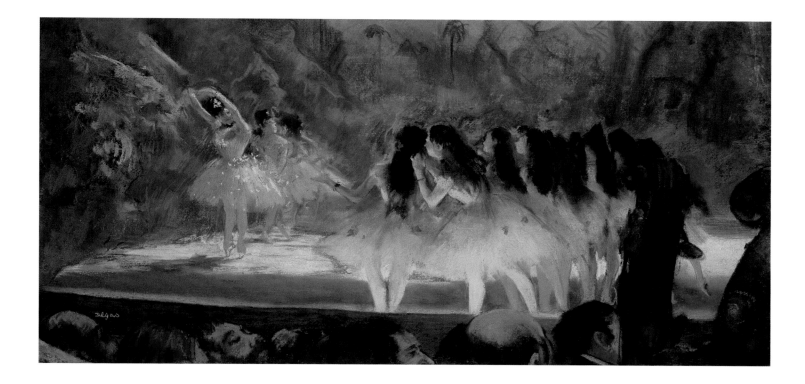

movements, which seem magnified, in turn, by the amplitude of their out-
fits. The barely decipherable mass of figures at center has its own internal
rhythms—punctuated here and there by extended limbs—as the group simul-
taneously responds to the dervishlike character at the far right. Both the con-
sonance of choreographed motion and its transience are vividly evoked; the
blurring of edges and the linking of forms express an uninterrupted flow of
gesture and fabric, as the ghostly assembly moves through the light.

Significantly, the painting of *Robert le Diable* was based on precise draw-
ings of the principal characters, presumably derived from firsthand observa-
tion and perhaps from additional sessions with models in Degas's studio.[36]
In subsequent years, he continued to explore the depiction of dancers' move-
ments, finding strategies to suggest a progression of formal steps or casual
actions and, in certain cases, their inherent lyricism. But in the vast majority
of his performance pictures—most of which date to the 1870s and 1880s—even
ballerinas shown on pointe assume poses held for a moment or longer, such as
an *attitude* (plate 153) or a *cinquième sur les pointes* (see the ballerina at the
far left in fig. 10). Only on rare occasions did Degas attempt to convey the
momentum of performers as they moved from one choreographed position to
another. In this respect, *The Ballet from "Robert le Diable"* is among his great-
est innovations and successes, introducing yet another possibility for repre-
senting dance in the repertoire of the visual arts.[37]

Fig. 10
Edgar DEGAS
Ballet at the Paris Opéra
1877
Pastel over monotype on cream
laid paper
13⅞ × 27¾ in. (35.2 × 70.6 cm)
The Art Institute of Chicago,
Gift of Mary and Leigh Block,
1981.12

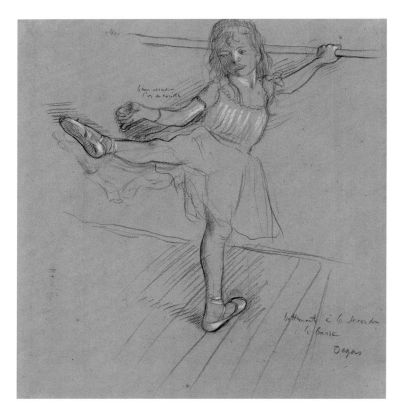

Plate 154
Edgar DEGAS
Little Girl Practicing at the Barre
c. 1878–80
Black chalk and graphite, heightened with white chalk on pink laid paper
12³⁄₁₆ × 11⁹⁄₁₆ in. (31 × 29.3 cm)
The Metropolitan Museum of Art, New York, H. O. Havemeyer Collection, Bequest of Mrs. H. O. Havemeyer, 1929 (29.100.943)

Plate 155
Edgar DEGAS
Arabesque over the Right Leg, Left Arm in Front
1882–95 (cast posthumously, 1919–21)
Bronze
11⁵⁄₈ × 15¾ × 5½ in. (29.5 × 40 × 14 cm)
The Baltimore Museum of Art, Nelson and Juanita Greif Gutman Collection BMA 1963.16.54

Perhaps the most revolutionary of Degas's dance works, however, is the series of classroom and rehearsal scenes that originate in the early 1870s, when he may have first ventured backstage. Access to the instruction rooms at the Opéra was evidently controlled, prohibited even for the otherwise ubiquitous *abonnés,* and achieved by Degas only under exceptional circumstances.[38] Persisting in his rejection of established stereotypes—the flirtatious coryphée or the angelic nymph— Degas now chose to address the physical realities of the ballerinas' daily routine, both in their structured practice sessions and in off-hour applications to their craft. Manifestly based on direct and sustained scrutiny, these works resulted from the study of standard ballet exercises and positions (plates 154, 155), of his subjects' athletic physiques (plates 158, 159), and of their informal labors (see the figures at the barre in figs. 11, 12). By analyzing such activities in the classroom itself and in re-creations in his studio, Degas achieved a sophisticated awareness of the ballerinas' disciplined movements as well as their casual behaviorisms.[39] Hundreds of drawings attest to his persistent and concerted efforts to master the broader principles of classical training and its nuances. Among these are scores of studies that are annotated in the artist's own hand, revealing his understanding of classical technique, his familiarity with the ballet vocabulary, and even an awareness of his models' mistakes and shortcomings (plates 154, 158, 160).[40] Several dance historians and performers of distinction have remarked on Degas's acumen in representing the "mysteries of the ballet," the range and precision of which has never been exceeded.[41] It would be more than a half century before photographers approached the subject so candidly, producing a parallel—though not necessarily superior—catalogue of the dancers' private world.

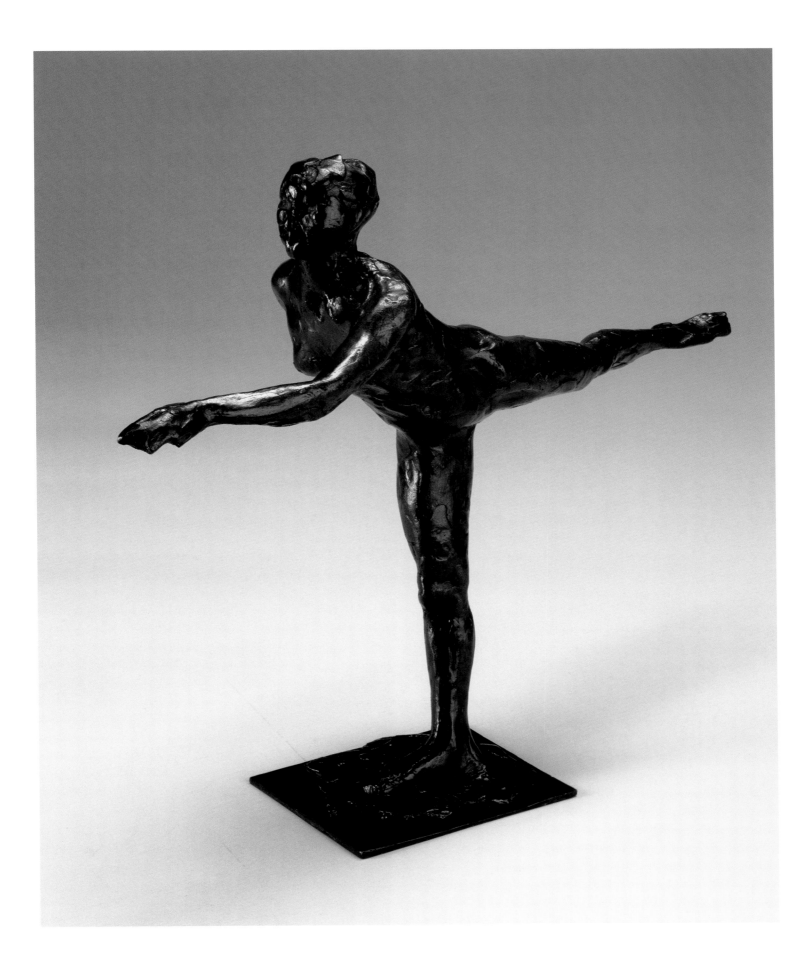

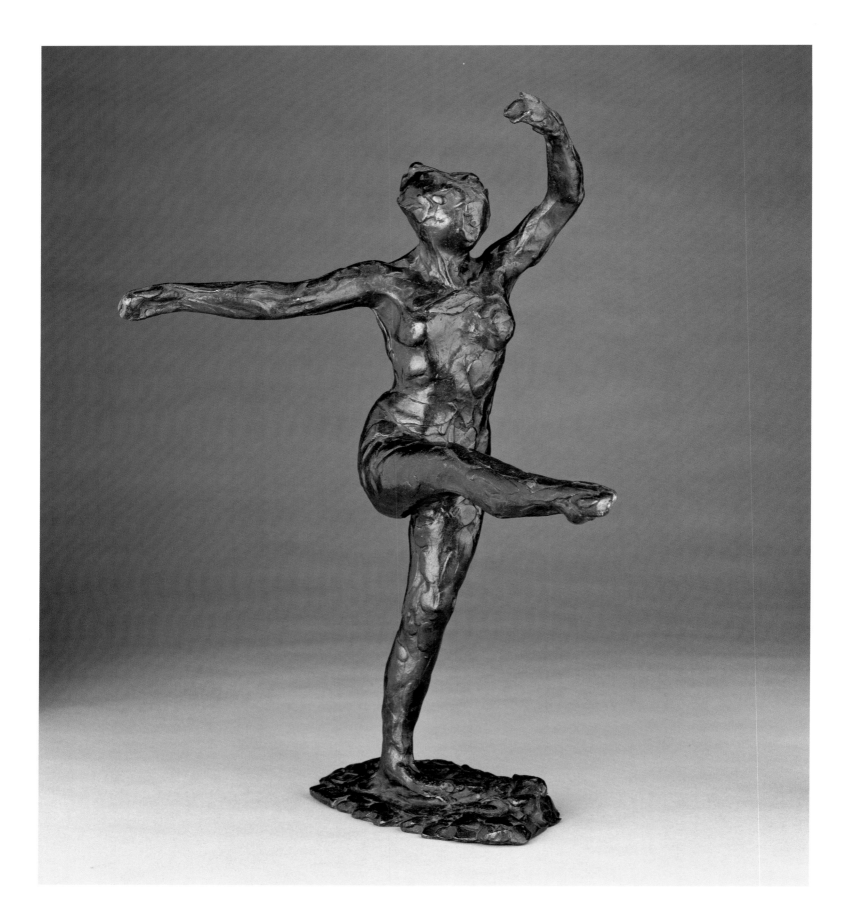

Plate 156
Edgar DEGAS
Dancer, Fourth Position
Front, on Left Leg
c. 1883–88 (cast posthumously,
1919–27)
Bronze
16⅛ × 9¾ × 10¼ in.
(41 × 25 × 26 cm)
Private collection

Plate 157
Edgar DEGAS
Dancer at Rest, Hands on
Her Hips, Right Leg Forward
c. 1882–85 (cast posthumously,
1919–21)
Bronze
17½ × 10⅛ × 5⅜ in.
(44.5 × 25.7 × 13.7 cm)
Tacoma Art Museum, Gift
of Mr. and Mrs. W. Hilding
Lindberg by exchange, 1995.7.1

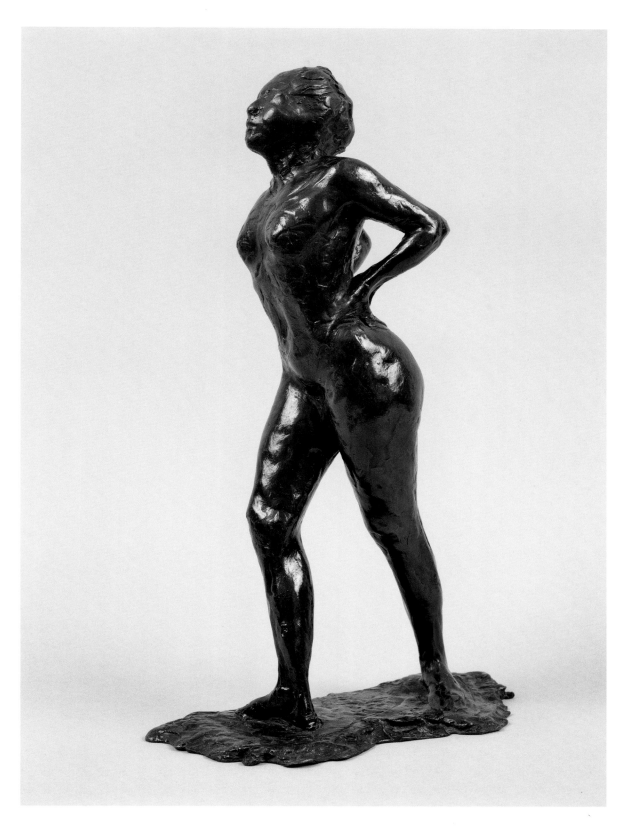

Plate 158
Edgar DEGAS
Dancer at the Barre
c. 1885
Black chalk with touches of
pink and white on paper
12⅜ × 9⅜ in. (31.2 × 23.7 cm)
Cincinnati Art Museum,
Annual Membership Fund

Plate 159
Edgar DEGAS
Ballet Dancer
c. 1883
Colored chalk on gray paper,
squared for transfer
17½ × 12 in. (44.5 × 30.5 cm)
Wadsworth Atheneum Museum
of Art, Hartford, Connecticut,
Purchased through the gift
of Henry and Walter Keney

Plate 160
Edgar DEGAS
*Dancer, Arm Too Far
Behind the Head*
1880
Graphite on paper
13¾ × 9⅛ in. (35 × 23.2 cm)
UCLA Grunwald Center for
the Graphic Arts, Hammer
Museum, Los Angeles, Gift
of Eunice and Hal David,
The Eunice and Hal David
Collection of 19th- and 20th-
Century Works on Paper

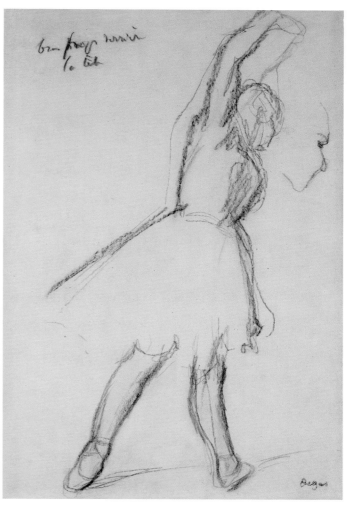

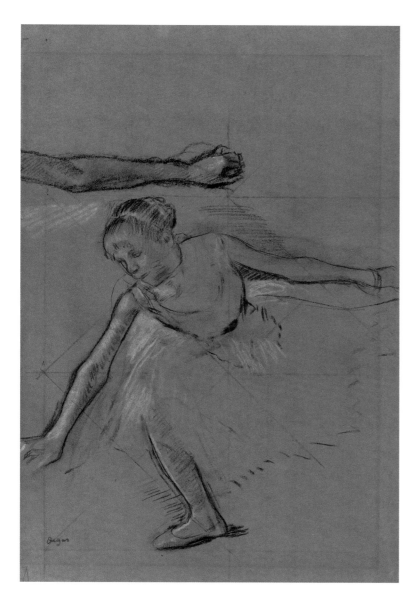

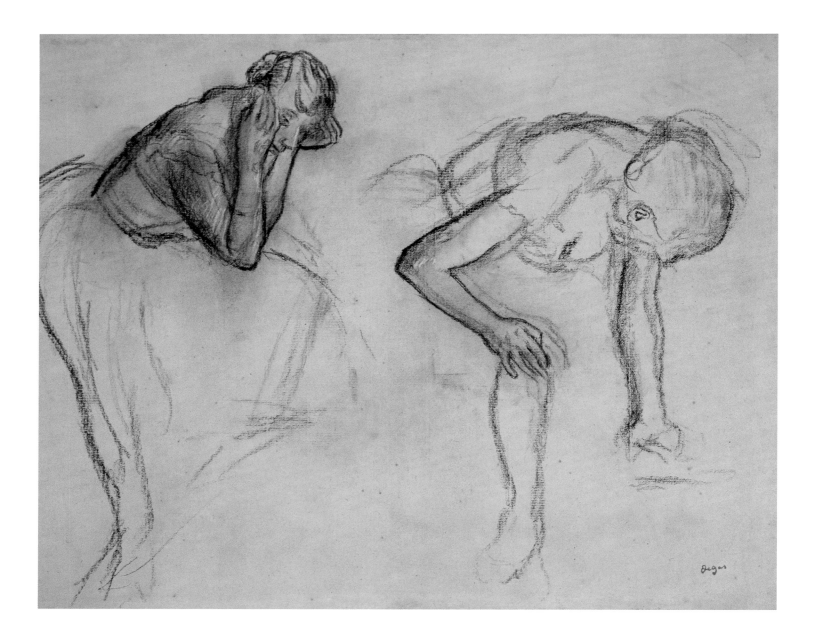

Plate 161
Edgar DEGAS
Study of Two Dancers
c. 1885
Charcoal and chalk on paper
18¼ × 24 in. (46.4 × 61 cm)
High Museum of Art, Atlanta,
Georgia, Anonymous gift,
1979.4

Plate 162
Edgar DEGAS
*Standing Dancer, Seen
from the Back, Hands
on Her Waist*
c. 1873
Essence heightened with
white on pink paper
14½ × 10⅛ in. (36.8 × 25.7 cm)
Musée d'Orsay, Paris,
département des Arts
graphiques du Musée du
Louvre, legs du comte Isaac
de Camondo, 1911 (RF 4038)

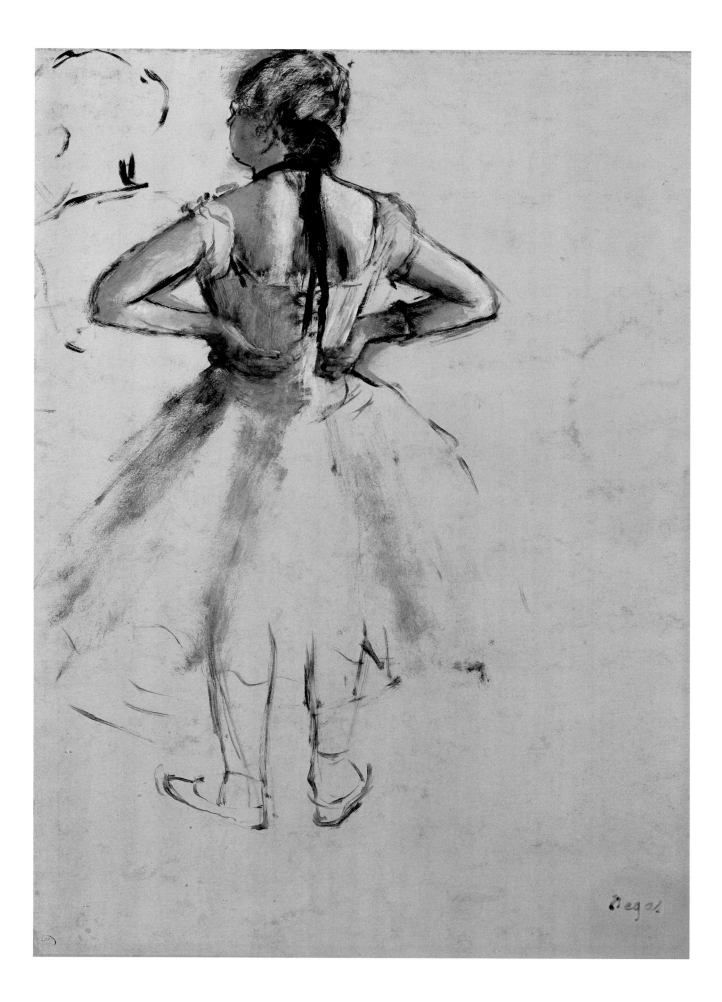

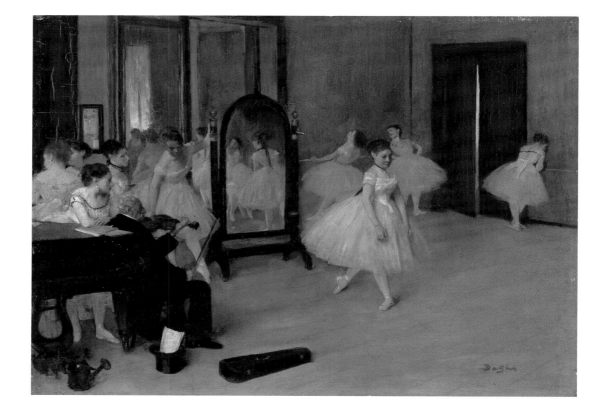

Fig. 11
Edgar DEGAS
The Dancing Class
c. 1870
Oil on wood
7¾ × 10⅜ in. (19.7 × 27 cm)
The Metropolitan Museum of
Art, New York, H.O. Havemeyer
Collection, Bequest of Mrs. H.O.
Havemeyer, 1929 (29.100.184)

The atmosphere in Degas's two earliest dance class paintings (figs. 11, 12) is relatively subdued, with virtually all the figures adopting polite poses and demure attitudes. The action in both cases seems suspended for a moment in time, though it is clear that one ballerina will soon begin to dance. Several attendees watch and wait as their colleague assumes a preparatory position, while others stretch at the barre or engage in their own dance-related occupations. If these activities are widely familiar today from films and photographs of dance practices, they were virtually unknown to the public in Degas's era. The classroom was a secluded domain that few nonprofessionals could enter, where lessons were traditionally divided along gender lines. Girls' and younger women's classes could be observed by female chaperones, with men included only in their capacity as teachers and musical accompanists. Unlike rehearsals and examinations, lessons were not usually open to guests, which had resulted in an extreme scarcity of literary or pictorial descriptions of these events.[42] Especially significant in Degas's paintings are the casually disposed ballerinas, whose idiosyncratic conduct suggests that these early scenes were based on practice sessions witnessed by the artist himself. Such informal postures and exercises are often indulged in by classically trained performers, but depictions of such poses could not have been found in any publications or other sources available to the artist.

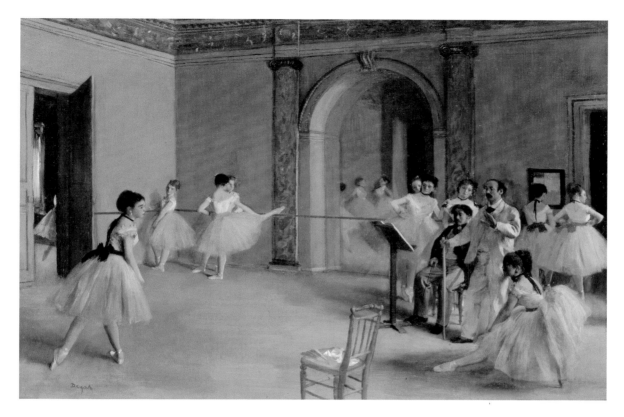

Fig. 12
Edgar DEGAS
*The Opéra Dance Studio
on the Rue Le Peletier*
1872
Oil on canvas
12⅝ × 18⅛ in. (32.1 × 46 cm)
Musée d'Orsay, Paris (RF 1977)

Even though Forain clearly modeled himself on Degas in many respects, there is little evidence that he shared his mentor's interest in the prosaic activities of the ballet classroom. Few pictures by Forain portray dancers engaged in formal exercises, and none represents a lesson in progress. Equally revealing is the absence in Forain's work of a comparable array of dance teachers and accompanists with their instruments or evidence of the austere spaces set aside for instruction. While he studied some standard positions and casual postures in a few sensitive drawings and pastels, such as *Dancer Bowing* (plate 163) and *Ballet Dancer* (plate 164), such works seem to be the exceptions that prove the general rule. Forain's obsessive introduction of *abonnés* into his pictures of ballerinas defined them quite differently, locating them in the wings or *foyer* of the Opéra rather than the classroom. This characteristic clearly resulted from Forain's own preferences, as the work of his close contemporary Paul Renouard demonstrates: the latter chose to make a specialty of behind-the-scenes views at the Opéra, including stairwells crowded with young girls in tutus and even scenes of senior dancers in the celebrated rotunda, where advanced classes took place.[43] Especially vivid evidence of Degas's own engagement with the classroom environment can be found in his *Dance Class* (fig. 13), in which the informality appears to border on chaos. In contrast to Degas's earlier paintings of this daily ritual, in which dancers

Plate 163
Jean-Louis FORAIN
Dancer Bowing
c. 1885
Pastel on brown paper
25¾ × 20½ in. (65.5 × 52 cm)
Private collection

Plate 164
Jean-Louis FORAIN
Ballet Dancer
1887
Pastel on blue wove paper,
laid down
22¼ × 16⅞ in. (56.5 × 43 cm)
National Gallery of Art,
Washington, DC, Gift of
Mrs. Lessing J. Rosenwald 1989

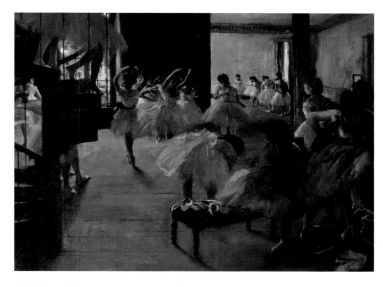

Fig. 13
Edgar DEGAS
Dance Class
1873
Oil on canvas
18¾ × 24½ in. (47.6 × 62.2 cm)
William A. Clark Collection,
The Corcoran Gallery of Art,
Washington, DC, 26.74

behave as if they are being visited by an honored guest, *Dance Class* suggests a hasty, impromptu glimpse through a half-open door. Here, the dancers are caught in the act of adjusting their clothes and relaxing in poses that would have been considered indecent in any other circumstances. Both humor and titillation are implicit in certain details, such as one dancer, shown from behind, who seems to be bending over to adjust a shoe. But in this and other paintings of the period, we are left in no doubt that Degas was reporting from personal observation, attending to both formal activities and lighthearted moments.

A subject that Degas himself would eventually abandon is summarized in *The Rehearsal of the Ballet Onstage* (fig. 14).[44] In this panoramic exploration of the varied personalities who contribute to a rehearsal, we see a *sujet* and her partner in role; the *répétiteur* and his male colleagues; and a cluster of dancers who stand, stretch, and adjust their attire. Compared with the anonymous rehearsal scene of *Néméa*, Degas's later painting seems altogether more plausible and truer to the participants' experience. Especially prominent is the fatigue of several waiting ballerinas at left, who appear bored, restless, or simply exhausted. As with Degas's records of informal positions, these details remind us of his firsthand knowledge of the dancers' professional predicament. Such figures were not arrived at without thought; a study on blue paper (plate 165) is one of many made for this picture.[45] Documents of this kind reveal Degas's technical preparations as well as his ambition to do justice to the full gamut of training and exertion required of these women. Some two decades later, Lautrec would display a marked affinity with this aspect of Degas's oeuvre in *Seated Dancer with Pink Tights* (fig. 15). This poignant image captures the weariness, even the despair, inherent in the ballerina's endless pursuit of perfection. Lautrec pays his model the ultimate compliment by characterizing her features and demeanor with great care, underscoring her frailness as well as her vulnerability. Like Degas, the younger artist seems to have been aware of the effects of a classical

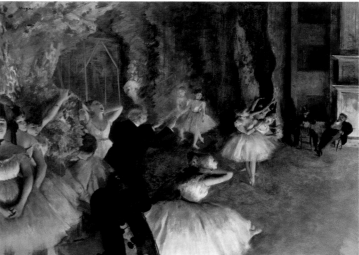

Fig. 14
Edgar DEGAS
The Rehearsal of the Ballet Onstage
probably 1874
Essence with traces of watercolor and pastel over pen-and-ink drawing on paper, mounted on canvas
21⅜ × 28¾ in. (54.3 × 73 cm)
The Metropolitan Museum of Art, New York, H. O. Havemeyer Collection, Gift of Horace Havemeyer, 1929 (29.160.26)

Plate 165
Edgar DEGAS
*Seated Dancer, Profile View,
Turning Toward the Right*
c. 1874
Essence on blue paper
9 × 11¾ in. (22.8 × 29.7 cm)
Musée d'Orsay, Paris,
département des Arts
graphiques du Musée du
Louvre (RF 16723)

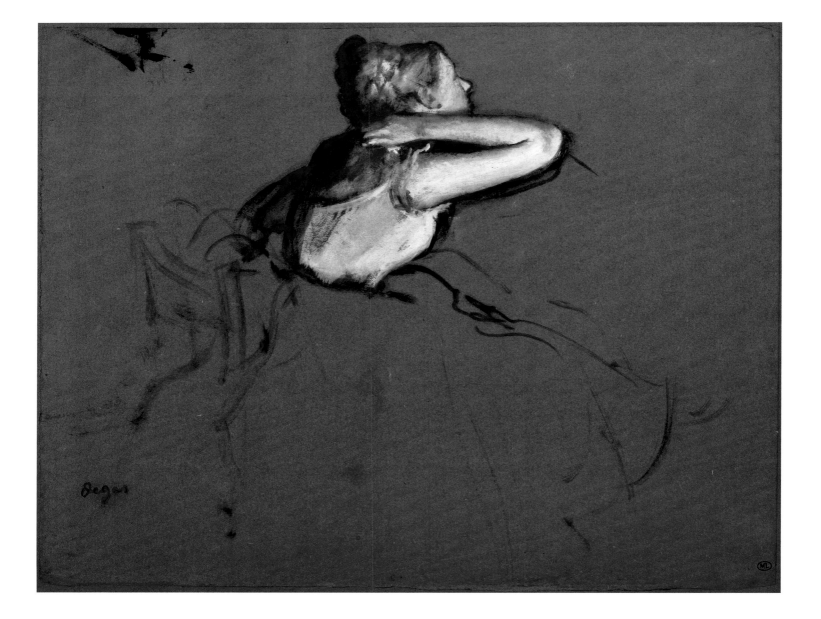

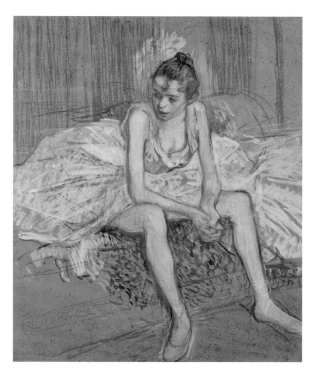

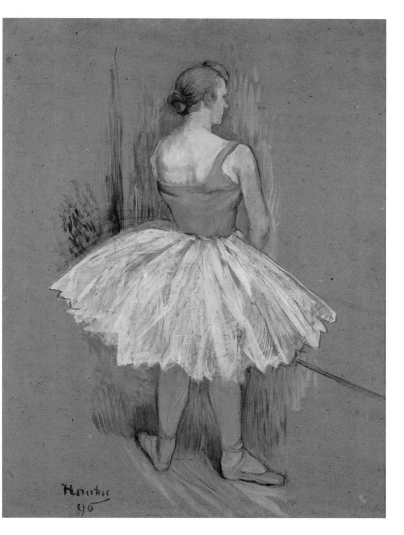

Fig. 15
Henri de TOULOUSE-LAUTREC
Seated Dancer with Pink Tights
1890
Oil and pastel on board
22¾ × 18½ in. (57.5 × 46.7 cm)
Private collection

Plate 166
Henri de TOULOUSE-LAUTREC
The Dancer
1890
Oil on board
26¾ × 20¼ in. (68 × 51.5 cm)
Private collection

regime on the female body, evident to a trained eye in the girl's "pulled-up" calf muscles, the splay of her legs, and the rounded profile of her right ankle that indicates flexibility. The woman who posed for Lautrec's *The Dancer* (plate 166) is less youthful but also respectfully observed; in this casual stance typical of ballerinas, her muscular back and statuesque carriage speak of the arduous training that all corps de ballet members endure.

Seen from the perspective of the younger generation, Degas had clearly set a formidable—even unapproachable—precedent as "the painter of dancers." Indeed, it is hardly surprising that over the next century, no other major artists would dedicate themselves so tenaciously to this subject. In the same way that the *vieil abonné* defined the "serious dancers" at the Paris Opéra, Degas, we might argue, categorized himself as the most "serious" of artists who had ever tackled the dance. But this seriousness was not always solemn. Ballerinas

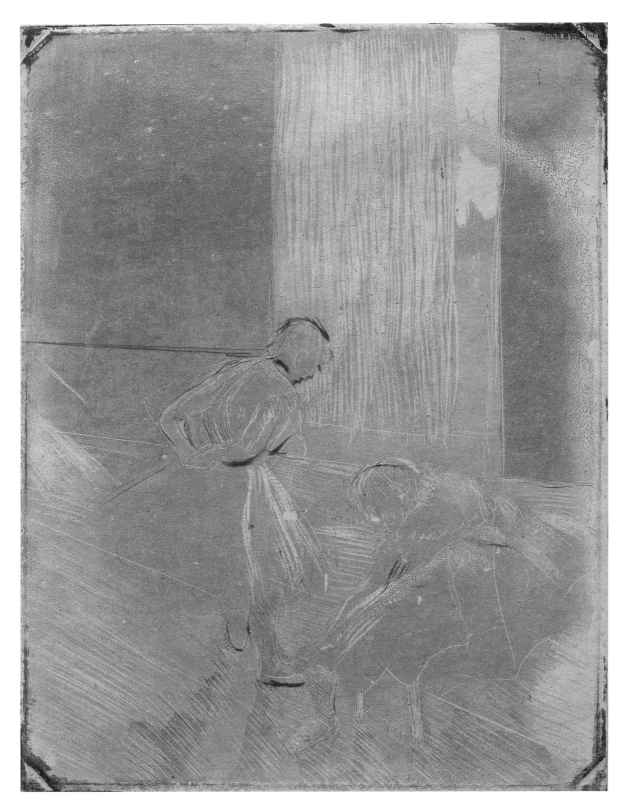

Plate 167
Edgar DEGAS
Two Dancers
c. 1878–79
Aquatint and drypoint
on paper
6¼ × 4⅝ in. (15.9 × 11.8 cm)
Sterling and Francine Clark
Art Institute, Williamstown,
Massachusetts

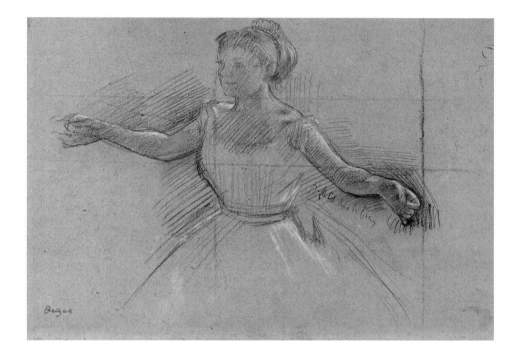

Plate 168
Edgar DEGAS
Ballet Dancer in Repose
c. 1880–82
Charcoal on paper
9⁵⁄₁₆ × 11⁷⁄₁₆ in. (24.3 × 29.1 cm)
The Minneapolis Institute of
Arts, Gift of Julius Boehler

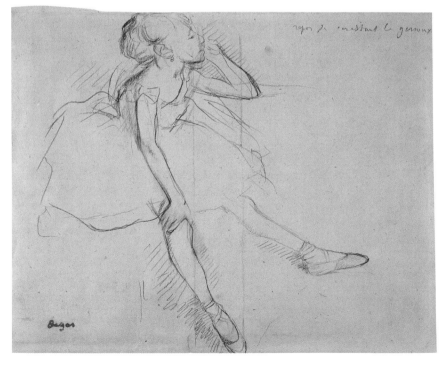

Plate 169
Edgar DEGAS
Dancer
1878–79
Black and white chalk on light
gray paper, darkened, squared
for transfer in black chalk
9¼ × 13⅛ in. (23.5 × 33.3 cm)
Thaw Collection, The Pierpont
Morgan Library, New York,
EVT 278

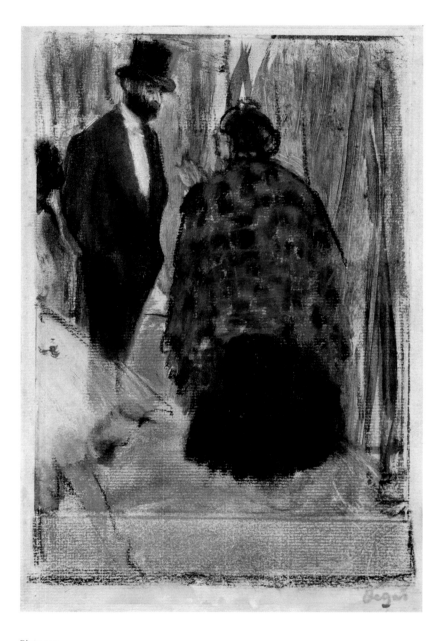

Plate 170
Edgar DEGAS
*Conversation: Ludovic
Halévy Speaking with
Madame Cardinal,*
illustration for *La Famille
Cardinal*
1876–77
Monotype heightened with
pastel on paper
8½ × 6¼ in. (21.6 × 15.9 cm)
Private collection, Minnesota,
courtesy of Ruth Ziegler Fine
Arts, New York

caught off guard (fig. 13) and scenes backstage (plates 150, 170) show that Degas was well aware of the comedic possibilities of the genre. He was also willing to contribute on occasion to the growing pool of caricatures of dancers: in a group of small stage images, for example, the exaggerated gestures and expressions of several nearly identical ballerinas make them look like cartoon figures.[46] He treated *abonnés* in a similar way, showing these well-known characters as tall, shadowy creatures who are largely indistinguishable from one another (plates 152, 171). Among Degas's hundreds of finished oil paintings and pastels of dancers, *abonnés* appear in no more than two dozen, and in the vast majority of these, the ballerinas seem indifferent to—or oblivious of—these lurking presences. Like fixtures in any familiar environment, they are hardly noticed, reduced to pathetic hangers-on rather than engaging, prospective suitors.[47]

For Lautrec, who described the Opéra as "the temple of the arts and of boredom," the depiction of the ballet was never more than an occasional interest.[48] Younger and less socially constrained, he was attracted to more popular dance forms, including those featured at cabarets and music halls. Yet his finest paintings and drawings of classically trained performers have a gravity that is surely not unrelated to his sustained attention to their physiques and dispositions. Lautrec's opposite in many ways, Forain favored mocking anecdote and scenes of sexual frisson, which he endlessly recycled in his commercially successful dance images. Moving easily from illustration to painting and printmaking, Forain had little need to venture into the classroom in order to study his subjects' training and their athletic physiques. In pictures of young women in tutus, who typically are shown in the wings, Forain relied on narrative

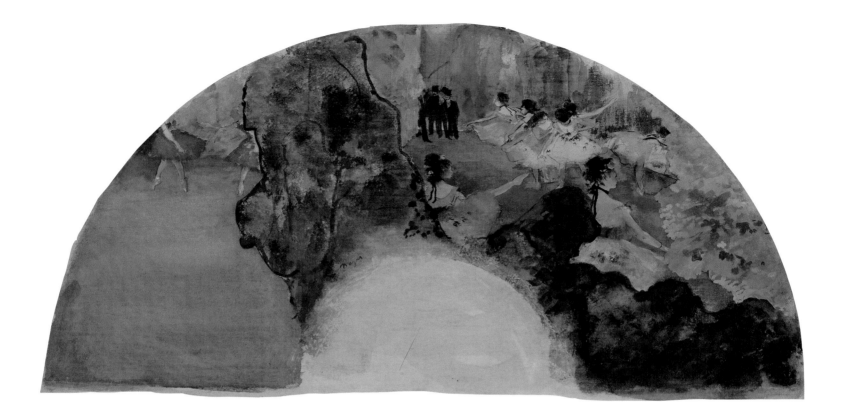

and the manipulation of a stock repertoire of characters. Far from the ideal-ized sylphs or oriental princesses played by identifiable dancers such as Fiocre, Forain's ballerinas belong to the generalized tradition of *coulisse* romances and predatory *abonnés*. Following their respective specializations— the lone, off-duty trainee and the flirtatious coryphée—both Lautrec and Forain tended to steer clear of the modes that Degas had pioneered.

It was Degas's distinction to have established the pictorial possibilities of the ballet and then to stand back with some dignity as admirers, plagiarists, and a few original sensibilities addressed this subtle territory. Yet as Degas himself observed in later life, the stereotypes persisted: "When people speak of dancers, they see them as richly maintained, covered with jewels, living in a fine home, and having a carriage and servants, like in a novel. In reality, most of them are poor girls who have undertaken a very difficult métier."[49] Degas's real achievement was to have taken these dancers and their métier seriously.

Plate 171
Edgar DEGAS
Dancers
1879
Gouache, oil pastel, and oil
paint on silk (fan)
12¹⁄₁₆ × 23¹⁵⁄₁₆ in. (30.6 × 60.8 cm)
Tacoma Art Museum, Gift
of Mr. and Mrs. W. Hilding
Lindberg, 1983.1.8

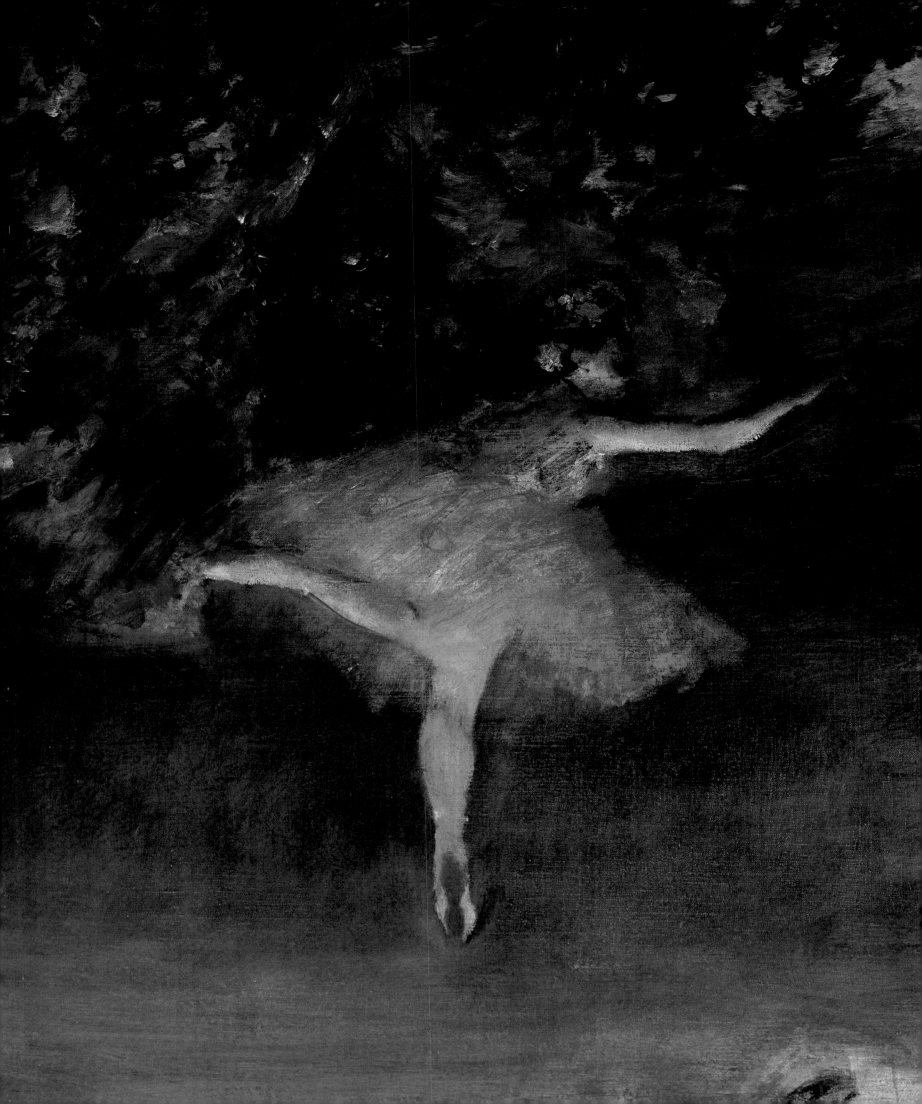

NOTES

In the notes, the following abbreviations for the standard catalogues of Degas's works are used:

L.: Lemoisne, Paul-André. *Degas et son oeuvre*. 5 vols. New York: Garland Publishing, 1984. Reprint, with supplement, of *Degas et son oeuvre*. 4 vols. Les Artistes et leurs oeuvres: Études et documents. Paris: Arts et métiers graphiques, [1947-48, © 1946].

Nb.: Reff, Theodore. *The Notebooks of Edgar Degas*. 2 vols. London: Clarendon Press, 1976. Reprint, New York: Hacker Art Books, 1985.

I, II, III, and IV:

Vente I, *Catalogue des tableaux, pastels et dessins par Edgar Degas et provenant de son atelier . . .*, Galeries Georges Petit, Paris, May 6-8, 1918.

Vente II, *Catalogue des tableaux, pastels et dessins par Edgar Degas et provenant de son atelier . . .*, Galeries Georges Petit, Paris, December 11-13, 1918.

Vente III, *Catalogue des tableaux, pastels et dessins par Edgar Degas et provenant de son atelier . . .*, Galeries Georges Petit, Paris, April 7-9, 1919.

Vente IV, *Catalogue des tableaux, pastels et dessins par Edgar Degas et provenant de son atelier . . .*, Galeries Georges Petit, Paris, July 2-4, 1919.

1. Nineteenth-century sources for dancers' salaries include: Un vieil abonné [Paul Mahalin], *Ces Demoiselles de l'Opéra* (Paris: Tresse et Stock, 1887), 5-7; and Berthe Bernay, *La Danse au théâtre* (Paris: E. Dentu, 1890), 16. Also see Eunice Lipton, *Looking into Degas: Uneasy Images of Women and Modern Life* (Berkeley: University of California Press, 1986), 89-90.

2. See Lipton, *Looking into Degas*, 73-115; Martine Kahane, *Le Foyer de la danse* (Paris: Ministère de la culture et de la communication, Éditions de la Réunion des Musées Nationaux, 1988); and Jill DeVonyar and Richard Kendall, *Degas and the Dance* (New York: Harry N. Abrams, in association with the American Federation of Arts, 2002), 20-23, 35-36, 69-71, and 120-22.

3. For more on the *foyer* and its habitués, see Kahane, *Le Foyer de la danse*.

4. A letter dating from 1882 reveals Degas planning to secure and share such an *abonnement* with a friend; though it is not known exactly when he first obtained one, he certainly had done so by 1885. See Marcel Guérin, ed., *Degas Letters* (Oxford: B. Cassirer, 1947), 68-69; and Henri Loyrette, "Degas à l'Opéra," in *Degas inédit: actes du Colloque Degas, Musée d'Orsay, 18-21 avril 1988* (Paris: Documentation française, 1989), 47-63.

5. For Fiocre's numerous suitors, see Ivor Guest, *The Ballet of the Second Empire, 1858-1870* (London: A. and C. Black, 1953), 70. For the two portraits of Fiocre, see fig. 5 above and L. 129; for another painting that has been tentatively identified as a third portrait of Fiocre (L. 330), see DeVonyar and Kendall, *Degas and the Dance*, 197-98. For Achille Degas's affair with Thérèse Malot, see Roy McMullen, *Degas: His Life, Times, and Work* (Boston: Secker and Warburg, 1984), 250-51, and Henri Loyrette, *Degas* (Paris: Fayard, 1991), 320-23. For Ludovic Lepic's relationship with Marie Sanlaville, see Harvey Buchanon, "Edgar Degas and Ludovic Lepic: An Impressionist Friendship," in *Cleveland Studies in the History of Art* (Cleveland: Cleveland Museum of Art, 1997), vol. 2, 63-64.

6. See Cyril Beaumont, *Five Centuries of Ballet Design* (London: The Studio, 1939), 18-19; Ivor Guest, *Le Ballet de l'Opéra de Paris* (Paris: Théâtre National de l'Opéra, 1976), 81-95; and Martine Kahane, *Le Tutu* (Paris: Opéra National de Paris, 1997), 14-18.

7. Taglioni first appeared in a revival of *Flore et Zéphire* at the Paris Opéra in 1831; the ballet, choreographed by Charles Louis Didelot, was first produced at the King's Theatre in London in 1796.

8. The character here referred to is alternatively identified as the "spirit," "guardian," or "goddess" of the spring; see Cyril Beaumont, *Complete Book of Ballets* (1937; London: Putnam, 1949), 433, 434; and Spire Pitou, *The Paris Opéra: An Encyclopedia of Operas, Ballets, Composers, and Performers. Growth and Grandeur*, 2 vols. (Westport, CT: Greenwood Press, 1990), vol. 2, 1251.

9. The bare-breasted figures presumably represent the dancers who played butterflies and other winged insects in the ballet's first act. Ironically, several critics complained that the costumes for *La Source* covered too much of the performers' bodies, disappointing male audience members. See, for instance, Gustave Bertrand, "Semaine Théâtrale," *Le Ménestrel*, November 18, 1866; Hippolyte Prevost, "Revue Musicale," *La France politique, scientifique et littéraire*, November 18, 1866; and E. della Rocca, "Chronique Musicale," *L'International*, November 18, 1866.

10. For numerous reproductions of these images, see Parmenia Migel, *Great Ballet Reproductions of the Nineteenth Century* (New York: Dover, 1981), esp. figs. 86-88 and 90.

11. See, for example, DeVonyar and Kendall, *Degas and the Dance*, figs. 15 and 185. Scores of such images can also be found in H. Robert Cohen, *Les Gravures musicales dans "L'Illustration," 1843-1899*, 3 vols., in

collaboration with Sylvia L'Ecuyer Lacroix and Jacques Léveillé (Québec: Presses de l'Université Laval; New York: Pendragon Press, 1983).

12. For instance, see Théophile Gautier, "Le Rat" (1840), reproduced in *Paris et les Parisiens: Théophile Gautier, présentation et notes par Claudine Lacoste-Veysseyre* (Paris: Boîte à documents, 1996), 463–73; François-Henri-Joseph Blaze [called Castil-Blaze], *Sur l'Opéra français, vérités dures mais utiles . . .* (Paris: Castil-Blaze, 1856); Charles de Boigne, *Petits mémoires de l'Opéra* (Paris: Librairie Nouvelle, 1857); Albert Vizentini, *Derrière la toile (foyers, coulisses, comédiens)* (Paris: A. Faure, 1868); and Georges d'Heylli, *Foyers et coulisses: Histoire anecdotique de tous les théâtres* (Paris: Tresse, 1875).

13. For these chapters, see Un vieil abonné, *Ces Demoiselles de l'Opéra*, 24–51.

14. Ibid., 26–28; for citation, see p. 26. Unless otherwise noted, translations of quoted materials are by the author.

15. Ibid., 209.

16. Ibid., 205, 234, 196, and 195, respectively.

17. For more on "*coulisses* literature," see Carol Armstrong, *Odd Man Out: Readings of the Work and Reputation of Edgar Degas* (Chicago: University of Chicago Press, 1991), 52–78.

18. Un vieil abonné, *Ces Demoiselles de l'Opéra*, 284.

19. Ibid., 273.

20. See Gautier, "Le Rat," 472–73. Also see Nestor Roqueplan, *Les Coulisses de l'Opéra* (Paris: Librairie Nouvelle, 1855), 35; and Vizentini, *Derrière la toile*, v.

21. Composed by Ludwig (Léon) Minkus and choreographed by Arthur Saint-Léon, *Néméa* premiered at the Paris Opéra on July 11, 1864. Ludovic Halévy, who would later become one of Degas's closest friends, wrote the libretto with Henri Meilhac.

22. *La Source* premiered at the Paris Opéra on November 12, 1866; the choreography was by Arthur Saint-Léon, the libretto written by Charles Nuitter, and the music composed by Ludwig (Léon) Minkus and Léo Delibes.

23. The setting and costumes correspond to the first act of *La Source*.

24. For example, see the following reviews in the *dossier d'oeuvre* for *La Source* at the Bibliothèque de l'Opéra, Paris: Jean Chrysostome, "Les Vérités," *Le Globe artiste*, November 18, 1866; and H. de Pène, *Gazette des Étrangers*, November 14, 1866. Also see Ivor Guest, ed., *Gautier on Dance* (London: Dance Books, 1986), 305 and 323; and Vizentini, *Derrière la toile*, 34. Further

sources include Anne Dumas, *Degas' Mlle Fiocre in Context* (New York: Brooklyn Museum, 1988), 12–14, 18, 20–22; and Guest, *The Ballet of the Second Empire*, 78–79 and 97.

25. This debate is summarized in two contrasting views of Fiocre's performance in *La Source*. One admiring critic described her movements as "natural and rhythmic like the stanzas of poem," adding that she was "delicious to see," while another reviewer likened her dancing to an "insipid, vulgar cancan" that provoked "laughter and shrugs." For the former, see H. de Pène, *Gazette des Étrangers;* for the latter, see G., *Le Monde artiste*, November 17, 1866. (Both articles are available in the *dossier d'oeuvre* for *La Source* at the Bibliothèque de l'Opéra.)

26. As suggested in DeVonyar and Kendall, *Degas and the Dance* (p. 51), Degas's original intention may have been to paint a more traditional portrait of Fiocre.

27. See Gautier in Guest, *Gautier on Dance*, 323.

28. Franz Xaver Winterhalter's 1866 *Portrait of Fiocre* is reproduced in DeVonyar and Kendall, *Degas and the Dance*, fig. 218.

29. For a contemporary caricature emphasizing Fiocre's shapely figure, see Guest, *The Ballet of the Second Empire,* plate opposite p. 114.

30. In addition to her dancing, Fiocre was apparently much absorbed with her equestrian and romantic endeavors. According to contemporary accounts, she frequented the races, was an avid horsewoman herself, and had several affairs before marrying the Marquis de Courtivron in 1888; see Dumas, *Degas' Mlle Fiocre in Context,* 20–22, and Guest, *The Ballet of the Second Empire,* 79–80.

31. Émile Zola was one of the few critics to comment on *Mademoiselle Fiocre in the Ballet "La Source"*; see "Mon Salon VI: Quelques Bonnes Toiles," *L'Événement illustré*, June 9, 1868, reprinted in Jean-Pierre Leduc-Adine, *Émile Zola: Écrits sur l'art* (Paris: Gallimard, 1991), 220–21.

32. These studies include L. 147–49, 1108, and 1109; IV: 18, 77.a/b, 79.a, 107.b, and 247.a; Nb. 20, pp. 20–21; and Nb. 21, p. 12, 12v, 13, and 32v. An uncatalogued pencil drawing of Fiocre in costume is reproduced in Dumas, *Degas' Mlle Fiocre in Context,* 28.

33. Having first published some drawings in the mid-1870s, Forain did not start exhibiting with the Impressionists until 1879. Lautrec's earliest commission, four wall decorations for a country inn near Paris, was executed in 1885 or 1886; one of the murals is now in the Art Institute of Chicago; see page 139, fig. 2.

34. Precedents for certain compositional features—such as the cropping of figures, the perspective from the orchestra, and the juxtaposition of action before and beyond the proscenium—can be found in the works of Honoré Daumier, Cham, and Paul Gavarni. Such prototypes have been much discussed in the Degas literature; see, for example, Theodore Reff, *Degas: The Artist's Mind* (New York: Metropolitan Museum of Art, 1976), 76–78; Joel Isaacson, "Impressionism and Journal Illustration," *Arts Magazine,* June 1982, 95–115; Carol Armstrong, *Odd Man Out,* 140–42; and DeVonyar and Kendall, *Degas and the Dance,* 38–42.

35. Composed by Giacomo Meyerbeer, *Robert le Diable* was first presented at the Paris Opéra in 1831. The divertissements were choreographed by Phillipo Taglioni, and the libretto was written by Eugène Scribe and Germain Delavigne. The nuns' dance was apparently so provocative that the choreographer's prudish daughter, the renowned Marie Taglioni, stopped appearing in the lead role soon after the opera premiered; see Guest, *Le Ballet de L'Opéra de Paris,* 94.

36. The preparatory drawings referred to are III: 363.1, 364.1, and 364.2. Further studies and notes for this painting appear in Nb. 24, pp. 7, 9–11, 13, 15–17, 19–21.

37. Five years later, Degas painted a variant of *The Ballet from "Robert le Diable,"* which is now in the Victoria and Albert Museum; see L. 391.

38. For Degas's access to Opéra classrooms during the early 1870s, see DeVonyar and Kendall, *Degas and the Dance,* 78–79.

39. See ibid., 133–55, for more on this subject.

40. See ibid., 146–47, for the significance of these annotations; also see Jill DeVonyar, "Degas as Documentation: Edgar Degas' Annotated Drawings as Records of Late-Nineteenth-Century Ballet Practice," in *The Proceedings of the Society of Dance History Scholars, Twenty-fifth Conference,* 2002, 25–30.

41. Guest, *Le Ballet de L'Opéra de Paris,* 136–37. See also Lillian Browse, *Degas Dancers* (London: Faber and Faber, 1949), 46 and 59–60; and Toni Bentley, "What's Wrong with Degas," *Art and Antiques,* November 1987, 70–75 and 126.

42. For more on the public's access to classrooms at the Opéra, see DeVonyar and Kendall, *Degas and the Dance,* 77–79.

43. Renouard's print of the rotunda at the Palais Garnier is reproduced in ibid., fig. 117.

44. Degas executed two other variants of this image; see L. 340 and 498.

45. Degas executed numerous preparatory drawings for this work and its two variants; among them is another essence sketch on colored paper, L. 402. Studies in pencil, ink, or charcoal include II: 244 and 327; and III: 83.2, 113.1, 338.1.

46. See, for example, L. 570 and 571.

47. The *abonnés* that appear in the series of *La Famille Cardinal* monotypes are an exception; the unique nature of this project, to illustrate an existing narrative, undoubtedly accounts for this distinction.

48. See Lucien Goldschmidt and Herbert Schimmel, eds., *Unpublished Correspondence of Henri de Toulouse-Lautrec* (New York: Phaidon, 1969), 95.

49. Alice Michel, "Degas et son modèle," *Mercure de France,* February 16, 1919, 476.

1834
Hilaire-Germain-Edgar Degas is born in
Paris.

1852
Second Empire begins under Napoleon III.
Jean-Louis Forain is born in Reims.

*Emperor
Napoleon III*

Time Line

1853
Architect Baron Georges-Eugène Haussmann is
appointed by Napoleon III to "modernize" Paris.

Haussmann orders the demolition
of many old, narrow streets and
dilapidated apartment houses,
replacing them with expansive
boulevards and gardens. The
renovation includes the installation
of 15,000 gaslights throughout
the city.

*The completed
boulevard
Haussmann,
at the crossing
of rues Drouot
and Richelieu,
Paris*

1864
Henri de Toulouse-Lautrec is born in Albi.

1866
Jules Chéret revolutionizes color lithography. He
becomes the first artist to create posters in mass
quantity through lithographic means, giving rise
to the modern advertising poster. His designs
profoundly influence Lautrec.

*Jules Chéret
in his studio,
1908*

1870

Moulin de la Galette is transformed from a mill into a popular cabaret.

Franco-Prussian war breaks out, signaling the rise of German military power and imperialism. Degas joins the National Guard as a volunteer. The French are defeated. The conflict ends with the ratification of the Treaty of Frankfurt on May 10, 1871. With the fall of Napoleon III, the Third Republic is established.

Moulin de la Galette, Paris, c. 1900

1871

Socialist Commune is set up in Paris (March 18–May 29). Gustave Courbet is an active participant in Commune politics and leads a commission for the protection of artistic monuments. After the Commune's overthrow, Courbet is accused of ordering the demolition of the Vendôme column, a symbol of Napoleonic rule; he is imprisoned. Shortly after his release in 1873 and having been declared responsible for the column's restoration, he flees to Switzerland, living there in exile until his death in 1877.

The Vendôme column demolished at the time of the Paris Commune, 1871

1873

Paris Opéra burns down.

1874

The first of eight exhibitions of Impressionist paintings is held in the Paris studio of Nadar (Gaspard-Félix Tournachon), featuring works by Degas, Claude Monet, Pierre-Auguste Renoir, Berthe Morisot, Alfred Sisley, and Camille Pissarro.

Inside the theater after the Paris Opéra fire

American painter Mary Cassatt settles in Paris.

1875

Place de l'Opéra, Paris

The new Paris Opéra, designed by Charles Garnier, opens to the public.

Construction of the basilica of Sacré Coeur begins in Montmartre.

Georges Bizet's opera *Carmen* is performed for the first time in Paris.

1876

The second Impressionist exhibition opens. Degas displays twenty-two works, including *The Dance Class* (1874).

1877

At the third Impressionist exhibition, the term "Impressionist" is used for the first time by the artists to describe themselves as a group. Among the paintings that Degas exhibits is *Dancers Practicing at the Barre* (1876–77).

Late 1870s

Paul Cézanne abandons Impressionism, heralding a new approach to painting, known as Post-Impressionism, which will inspire such major twentieth-century art movements as Cubism.

1879

Forain participates for the first time in the fourth Impressionist exhibition, which Degas dominates with more than twenty-five works, including five fans.

1880

Jules Guesde and Paul Lafargue, Karl Marx's son-in-law, create the French Workers' Party (Parti ouvrier français, or POF), the first Marxist party in France.

The fifth Impressionist exhibition opens. Degas receives high praise from the critics. Forain participates.

1881

Degas exhibits *Little Dancer, Aged Fourteen* (c. 1880–81) at the sixth Impressionist exhibition. The sculpture receives mixed reviews. Forain displays the watercolor *The Actress' Dressing Room* (1880).

1882

Neither Degas nor Forain is represented in the seventh Impressionist exhibition. Renoir exhibits the monumental *The Luncheon of the Boating Party* (1880–81).

1886

Painter Georges Seurat completes *A Sunday on La Grande Jatte* using the technique of divisionism, or pointillism, in which small areas or dots of pure color create a visual unity when viewed from a distance. As a result, Seurat comes to the forefront of the Neo-Impressionist movement.

The eighth Impressionist exhibition opens. Degas is a principal organizer along with Pissarro. Seurat displays his innovative painting *A Sunday on La Grande Jatte.* Odilon Redon contributes for the first time. Forain displays the pastel *Woman Smelling Flowers* (c. 1883).

Émile Zola publishes *The Masterpiece,* a novel rejecting contemporary academic painting in favor of the school of naturalism, appointing Édouard Manet as the leader.

Poet Jean Moréas publishes a Symbolist manifesto in the periodical *Le Figaro,* expounding an art movement that rejects naturalism in favor of the subjective world of the unconscious.

1887

France proclaims the establishment of the Indochinese Union, comprising the French colony Cochin China (southernmost region of Vietnam) and the protectorates of Annam (central Vietnam), Tonkin (northern Vietnam), and Cambodia.

Construction of the Eiffel Tower begins.

Construction of the Eiffel Tower, Paris, July 1888

1888

In Brittany, painters Paul Gauguin and Émile Bernard create Synthetist works of simplified, flattened forms in bold colors infused with Symbolist ideals.

Influenced by Gauguin's Synthetism, a group of young artists form the Nabis, with the aim of promoting decorative painting.

1889

The Exposition Universelle opens in Paris, a centennial celebration of the French Revolution. The completed Eiffel Tower, a 984-foot-high iron structure designed by Gustave Eiffel, stands near the exposition entrance.

Jane Avril debuts as a café dancer at the Moulin Rouge.

Jane Avril

The Eiffel Tower at the Exposition Universelle, Paris, 1889

Moulin Rouge, Paris, c. 1900

1890

Monet, a key proponent of Impressionism, retreats to Giverny, whose landscape deeply influences him.

1891

Lautrec makes his first poster, advertising La Goulue's performance at the Moulin Rouge.

Gauguin makes his first trip to Tahiti, where he will stay until 1893.

1892

American modern dance pioneer Loïe Fuller arrives in Paris. Her performance at the Folies-Bergère inspires Lautrec, Chéret, and Auguste Rodin to produce works based on her act.

Moulin Rouge opens to the public. It ignites the center of nightlife in Montmartre. La Goulue becomes the star performer.

Loïe Fuller in one of her dances

1893

Aristide Bruant first performs in his cabaret, the Mirliton.

Lautrec depicts Jane Avril on the cover of *L'Estampe originale.*

1894

Captain Alfred Dreyfus, an Alsatian Jew and French general staff officer, is tried and wrongly convicted of passing French secret documents to a German military attaché. The resultant controversy, known as the Dreyfus Affair, is largely the result of anti-Semitism in France and will deeply divide the country. Degas, staunchly pro-military and an anti-Semite, takes an anti-Dreyfusard stance, breaking off a fifty-year friendship with Ludovic Halévy, owing to his Jewish roots. Also as a result of the Affair, Degas severs his relationship with Dreyfusards Cassatt

Alfred Dreyfus at the War Council, 1894

and Pissarro. Degas would maintain his anti-Dreyfusard position even after the captain was acquitted. In 1898, Forain will cofound the anti-Dreyfusard publication *Psst . . . !,* regularly contributing virulent anti-Semitic, satirical cartoons.

1894

Claude Debussy composes *Prelude to the Afternoon of a Faun.*

1895

German entrepreneur Siegfried Bing reopens his newly enlarged gallery in Paris as the Maison de l'Art Nouveau. Bing was prominent in promoting *japonisme* and the development of Art Nouveau in France.

Brothers Auguste and Louis Lumière patent the cinematograph, a combined camera and projector operating at 16 frames per second, heralding the

First camera invented by Auguste and Louis Lumière, Paris

beginning of the motion picture. In December, they open the world's first cinema in Paris. Their short documentary *Workers Leaving the Lumière Factory* (1895) is considered the first film.

1896

Oscar Wilde's play *Salomé* is performed in Paris.

1898

The Dreyfus Affair leads to the court martial and nearly immediate acquittal of the actual traitor, Major Marie-Charles-Ferdinand-Walsin Esterhazy. The pro-Dreyfus novelist and critic Émile Zola publishes "J'accuse," an open letter to the president of the French Republic in defense of Dreyfus, accusing the judges of acquitting Esterhazy on orders from the war office. Zola is tried for libel and sentenced to jail but flees to England. Dreyfus is finally exonerated in 1906.

1900

The Exposition Universelle opens in Paris; more than 50 million people visit. The Petit Palais and the Grand Palais survive as venues for art exhibitions.

The Monumental Gate at the Exposition Universelle, Paris, 1900

Art Nouveau dominates design in France, with Paris and Nancy the centers of production. Hector Guimard brings the style to the masses with his design of the Paris Métro gates. The Métro system opens in tandem with the Exposition Universelle.

Métro station on the boulevard Pasteur, designed by Hector Guimard, c. 1900

1901
Lautrec dies at the Château de Malromé, near Bordeaux.

1903
Inauguration of the Salon d'Automne in Paris. The exhibition is organized by André Derain, Henri Matisse, Georges Rouault, and Albert Marquet in reaction to the conservative policies of the official Paris Salon. The Salon d'Automne becomes the bellwether in shocasing developments and innovations in twentieth-century painting and sculpture.

Salon d'Automne, Paris

1905
The first exhibition of the Fauvist artists opens in Paris at the Salon d'Automne. Among the group are Matisse, Derain, and Maurice de Vlaminck.

1907
Pablo Picasso paints the revolutionary *Les Demoiselles d'Avignon*, heralding the advent of Cubism.

The first exhibition of work by Cubist artists is held in Paris.

Pablo Picasso Les Demoiselles d'Avignon *1907 Oil on canvas 8 ft. × 7 ft. 8 in. (243.9 × 233.7 cm) The Museum of Modern Art, New York, acquired through the Lillie P. Bliss Bequest*

1914
World War I begins. Germany invades France. In 1917, the United States enters the fight. World War I concludes in 1918. The Treaty of Versailles is signed in 1919.

1917
Degas dies in Paris.

1918
Swiss-born architect Charles-Édouard Jeanneret, later known as Le Corbusier, and Amédée Ozenfant publish *After Cubism,* a manifesto of the Purist movement.

1919
The first Pan-African Congress, organized by African American activist W. E. B. Du Bois to address problems facing the continent due to European colonization, opens in Paris.

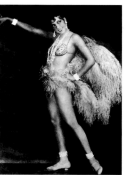

Josephine Baker in the film The Women of Folies-Bergère, *1926*

1925
Josephine Baker debuts in Paris at the Théâtre des Champs-Élysées.

1931
Forain dies in Paris.

Checklist of the Exhibition

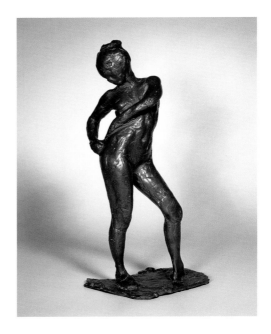

NOTES TO THE READER

Dimensions in most instances have been provided by the lender. They are given in inches followed by centimeters; height precedes width precedes depth.

The checklist is divided by artist; within each part, the works are organized chronologically by medium.

Catalogue raisonné information is given when known. We have relied upon the following catalogues and use the short forms below to designate them.

Czestochowski/Pingeot
Joseph S. Czestochowski and Anne Pingeot. *Degas Sculptures: Catalogue Raisonné of the Bronzes.* Memphis: Torch Press and International Arts, 2002.

Dortu
M. G. Dortu. *Toulouse-Lautrec et son oeuvre.* 6 vols. Les Artistes et leurs oeuvres: Études et documents. New York: Collectors Editions, 1971. Supplement forthcoming. Catalogue numbers preceded by "D." refer to drawings; those preceded by "P." refer to paintings.

Faxon
Alicia Craig Faxon. *Jean-Louis Forain: A Catalogue Raisonné of the Prints.* New York: Garland Publishing, 1982.

Janis
Eugenia Parry Janis. *Degas Monotypes.* Cambridge, MA: Fogg Art Museum, 1968.

Lemoisne
Paul-André Lemoisne. *Degas et son oeuvre.* 5 vols. New York: Garland Publishing, 1984. Reprint, with supplement, of *Degas et son oeuvre.* 4 vols. Les Artistes et leurs oeuvres: Études et documents. Paris: Arts et métiers graphiques, [1947–48, © 1946].

Reed/Shapiro
Sue Welsh Reed and Barbara Stern Shapiro. *Edgar Degas: The Painter as Printmaker.* Boston: Museum of Fine Arts, 1984.

Wittrock
Wolfgang Wittrock. *Toulouse-Lautrec: The Complete Prints.* 2 vols. Edited and translated by Catherine E. Kuehn. London: Philip Wilson Publishers for Sotheby's Publications, 1985. Catalogue numbers preceded by "P" refer to posters.

Above:
Plate 172
Edgar DEGAS
Dancer Fastening the String of Her Tights
c. 1885–90 (cast posthumously, 1919)
Bronze
16¹⁵⁄₁₆ × 8½ × 6⅜ in. (43 × 21.6 × 16.1 cm)
San Diego Museum of Art, Gift of Mr. and Mrs. Norton S. Walbridge

Hilaire-Germain-Edgar Degas
(French, 1834–1917)

PAINTINGS
Dancers Backstage
1876/1883
Oil on canvas
9½ × 7⅜ (24.2 × 18.8)
National Gallery of Art, Washington, DC,
Ailsa Mellon Bruce Collection 1970.17.25
Lemoisne 1024

Dancer on Pointe
c. 1877
Oil on canvas
19¾ × 23⅝ (50 × 60)
Collection of Diane B. Wilsey
Lemoisne 452

Dancers
1879
Gouache, oil pastel, and oil paint on
silk (fan)
12¹⁄₁₆ × 23¹⁵⁄₁₆ (30.6 × 60.8)
Tacoma Art Museum, Gift of Mr. and
Mrs. W. Hilding Lindberg, 1983.1.8
Lemoisne 564

The Ballet Class
c. 1880
Oil on canvas
32⅜ × 30¼ (82.2 × 76.8)
Philadelphia Museum of Art, Purchased
with the W. P. Wilstach Fund, W1937-2-1
Lemoisne 479

SCULPTURE
Study of a Nude Dancer
c. 1878–79 (cast posthumously, 1919–21)
Bronze
28¾ × 13 × 11 (73.02 × 33.02 × 27.94)
Albright-Knox Art Gallery, Buffalo, New
York, Friends of Albright Art Gallery and
Edwin J. Weiss Funds, 1935, 1935:13
Czestochowski/Pingeot 56

Little Dancer, Aged Fourteen
c. 1880–81 (cast posthumously, c. 1919–32)
Bronze and fabric
38½ × 14½ × 14¼ (98 × 36.8 × 36.2)
Virginia Museum of Fine Arts, Richmond,
the State Operating Fund and the Art
Lovers' Society
Czestochowski/Pingeot 73

*Dancer at Rest, Hands on Her Hips,
Right Leg Forward*
c. 1882–85 (cast posthumously, 1919–21)
Bronze
17½ × 10⅛ × 5⅜ (44.5 × 25.7 × 13.7)
Tacoma Art Museum, Gift of Mr. and
Mrs. W. Hilding Lindberg by exchange,
1995.7.1
Czestochowski/Pingeot 63

*Arabesque over the Right Leg, Left Arm
in Front*
1882–95 (cast posthumously, 1919–21)
Bronze
11⅝ × 15¾ × 5½ (29.5 × 40 × 14)
The Baltimore Museum of Art, Nelson
and Juanita Greif Gutman Collection
BMA 1963.16.54
Czestochowski/Pingeot 1

Grande Arabesque, Third Time
1882–95 (cast posthumously, 1919–37)
Bronze
17¼ × 22½ × 10⅜ (43.8 × 57.2 × 26.4)
Denver Art Museum Collection, Edward
and Tullah Hanley Memorial Gift of the
people of Denver and the area, 1974.354
Czestochowski/Pingeot 60

Dancer, Fourth Position Front, on Left Leg
c. 1883–88 (cast posthumously, 1919–27)
Bronze
16⅛ × 9¾ × 10¼ (41 × 25 × 26)
Private collection
Czestochowski/Pingeot 6

Dancer Fastening the String of Her Tights
c. 1885–90 (cast posthumously, 1919)
Bronze
16¹⁵⁄₁₆ × 8½ × 6⅜ (43 × 21.6 × 16.1)
San Diego Museum of Art, Gift of
Mr. and Mrs. Norton S. Walbridge
Czestochowski/Pingeot 33

*Dancer Looking at the Sole of Her
Right Foot*
1890–1900 (cast posthumously, 1919–29)
Bronze
18¼ × 9¾ × 7⅛ (46.2 × 25 × 18)
Private collection
Czestochowski/Pingeot 40

WORKS ON PAPER
Seated Dancer
1872
Essence over graphite on pink paper
10¹⁵⁄₁₆ × 8¹¹⁄₁₆ (27.8 × 22.1)
Thaw Collection, The Pierpont Morgan
Library, New York, EVT 46
Lemoisne 299

*Standing Dancer, Seen from the Back,
Hands on Her Waist*
c. 1873
Essence heightened with white on pink
paper
14½ × 10⅛ (36.8 × 25.7)
Musée d'Orsay, Paris, département des Arts
graphiques du Musée du Louvre, legs du
comte Isaac de Camondo, 1911 (RF 4038)

Study of a Ballet Dancer (recto)
c. 1873
Oil paint heightened with body color
on prepared pink paper
17½ × 12⅜ (44.5 × 31.4)
The Metropolitan Museum of Art, New
York, Robert Lehman Collection, 1975
(1975.1.611)

Seated Dancer, Profile View, Turning Toward the Right
c. 1874
Essence on blue paper
9 × 11¾ (22.8 × 29.7)
Musée d'Orsay, Paris, département des Arts graphiques du Musée du Louvre (RF 16723)
Lemoisne 400

Conversation: Ludovic Halévy and Madame Cardinal, illustration for *La Famille Cardinal*
1876–77
Monotype on paper
8⅜ × 6⅜ (21.3 × 16)
The Cleveland Museum of Art, Gift of the Print Club of Cleveland in honor of Henry Sayles Francis, 1967.167
Janis 198

Conversation: Ludovic Halévy Speaking with Madame Cardinal, illustration for *La Famille Cardinal*
1876–77
Monotype heightened with pastel on paper
8½ × 6¼ (21.6 × 15.9)
Private collection, Minnesota, courtesy of Ruth Ziegler Fine Arts, New York
Janis 199

The Green Room (The Foyer of the Opéra), illustration for *La Famille Cardinal*
1876–77
Monotype printed in black on paper
6⁵⁄₁₆ × 4⅝ (16 × 11.7)
National Gallery of Art, Washington, DC, Rosenwald Collection 1948
Janis 229

On Stage III
1876–77
Etching on paper
3⅞ × 4⅞ (10 × 12.4)
Fine Arts Museums of San Francisco, Museum Purchase, Achenbach Foundation for Graphic Arts Endowment Fund, 1964.142.14
Reed/Shapiro 24

Dancer
1878–79
Black and white chalk on light gray paper, darkened, squared for transfer in black chalk
9¼ × 13⅛ (23.5 × 33.3)
Thaw Collection, The Pierpont Morgan Library, New York, EVT 278

Two Dancers
c. 1878–79
Aquatint and drypoint on paper
6¼ × 4⅝ (15.9 × 11.8)
Sterling and Francine Clark Art Institute, Williamstown, Massachusetts
Reed/Shapiro 33

Little Girl Practicing at the Barre
c. 1878–80
Black chalk and graphite, heightened with white chalk on pink laid paper
12³⁄₁₆ × 11⁹⁄₁₆ (31 × 29.3)
The Metropolitan Museum of Art, New York, H. O. Havemeyer Collection, Bequest of Mrs. H. O. Havemeyer, 1929 (29.100.943)

Dancers in the Wings
1879–80
Etching, aquatint, and drypoint on paper
5½ × 4⅛ (14 × 10.5)
The Baltimore Museum of Art, the George A. Lucas Collection, purchased with funds from the State of Maryland, Laurence and Stella Bendann Fund, and contributions from individuals, foundations, and corporations throughout the Baltimore community BMA 1996.48.1045
Reed/Shapiro 47

Dancer, Arm Too Far Behind the Head
1880
Graphite on paper
13¾ × 9⅛ (35 × 23.2)
UCLA Grunwald Center for the Graphic Arts, Hammer Museum, Los Angeles, Gift of Eunice and Hal David, The Eunice and Hal David Collection of 19th- and 20th-Century Works on Paper

Ballet Dancer in Repose
c. 1880–82
Charcoal on paper
9⁹⁄₁₆ × 11⁷⁄₁₆ (24.3 × 29.1)
The Minneapolis Institute of Arts, Gift of Julius Boehler

Dancer Stretching
c. 1882–85
Pastel on gray paper
18⅜ × 11¾ (46.7 × 29.7)
Kimbell Art Museum, Fort Worth, Texas
Lemoisne 910

Ballet Dancer
c. 1883
Colored chalk on gray paper, squared for transfer
17½ × 12 (44.5 × 30.5)
Wadsworth Atheneum Museum of Art, Hartford, Connecticut, Purchased through the gift of Henry and Walter Keney
Lemoisne 616

Dancer Adjusting Her Shoe
1885
Pastel on paper
19⁷⁄₁₆ × 23¾ (49.4 × 60.3)
The Dixon Gallery and Gardens, Memphis, Tennessee, Bequest of Mr. and Mrs. Hugo N. Dixon, 1975.6
Lemoisne 826

Theater Box
1885
Pastel on paper
35½ × 29½ (90.2 × 74.9)
The Armand Hammer Collection, Gift of the Armand Hammer Foundation, Hammer Museum, Los Angeles
Lemoisne 829

Dancer Adjusting Her Dress
c. 1885
Pastel on paper
24¼ × 18¼ (61.6 × 46.4)
Portland Art Museum, Bequest of Winslow B. Ayer, 35.42
Lemoisne 676

Dancer at the Barre
c.1885
Black chalk with touches of pink and
white on paper
12⅜ × 9⅜ (31.2 × 23.7)
Cincinnati Art Museum, Annual Member-
ship Fund

Study of Two Dancers
c.1885
Charcoal and chalk on paper
18¼ × 24 (46.4 × 61)
High Museum of Art, Atlanta, Georgia,
Anonymous gift, 1979.4

Three Nude Dancers
c.1897–1901
Charcoal on paper
30⅜ × 24⅞ (77.2 × 63.2)
Arkansas Arts Center Foundation Collec-
tion, Purchase, Fred W. Allsopp Memorial
Acquisition Fund, 1983.010.002

Two Seated Dancers
c.1897–1901
Charcoal on tracing paper
24⅜ × 13¾ (62.9 × 34.9)
The Samuel Courtauld Trust, The Courtauld
Gallery, London

Three Dancers in Yellow Skirts
c.1900
Chalk and charcoal on tracing paper
laid down on board
23⅝ × 19⅝ (60 × 49.8)
Cincinnati Art Museum, Gift of
Vladimir Horowitz
Lemoisne 1367

Jean-Louis Forain
(French, 1852–1931)

PAINTINGS
Evening at the Opéra
c.1879
Gouache, some graphite or chalk at left,
on parchment (fan)
6⅝ (stick height) × 23¼ diam. (16.8 × 59)
The Dixon Gallery and Gardens, Memphis,
Tennessee, Museum Purchase, 1993.7.48

Behind the Scenes
c.1880
Oil on canvas
18¼ × 15⅛ (46.4 × 38.4)
National Gallery of Art, Washington, DC,
Rosenwald Collection 1943.11.4

In the Wings
c.1885
Oil on vellum
11¾ diam. (29.7)
Private collection

Dancer with a Rose
c.1885–90
Watercolor on linen (fan)
10⅝ (stick height) × 20 diam. (27 × 51)
The Dixon Gallery and Gardens, Memphis,
Tennessee, Museum Purchase, 1993.7.47

Head of a Young Dancer
c.1885–90
Oil on paper laid down on canvas
16½ × 13⅜ (42 × 34)
Private collection

Dancer in Her Dressing Room
c.1890
Oil on panel
10½ × 13¹³⁄₁₆ (26.6 × 35)
Sterling and Francine Clark Art Institute,
Williamstown, Massachusetts

Le Dialogue
c.1890
Oil on canvas
27½ × 21¾ (69.9 × 55.2)
Courtesy of Mr. and Mrs. Michael Weston

In the Wings
c.1900
Gouache on paper
41½ × 55¾ (105.5 × 141.5)
Petit Palais, Musée des Beaux-Arts
de la Ville de Paris, Inv. PPP00855

Dancers in the Wings
c.1904
Oil on canvas
27⅝ × 21¾ (70 × 55.4)
Manchester City Galleries, 1938.366

Dancer against Stage Decor
1905
Oil on canvas
25⅝ × 31⅞ (65 × 81)
Private collection

Abonnés in the Wings
c.1905
Oil on canvas
35⅜ × 17¾ (90 × 45)
Private collection

Dancers in Pink
c.1905
Oil on canvas
23¾ × 29 (60.3 × 73.6)
Carmen Thyssen-Bornemisza Collection,
on loan to the Museo Thyssen-Bornemisza,
Madrid

On the Stage
1912
Oil on canvas
24 × 19¼ (61 × 49)
Private collection

WORKS ON PAPER
Dancers in Their Dressing Room
c.1876
Etching on paper
6¼ × 4⅝ (15.8 × 11.7)
Print Collection, Miriam and Ira D. Wallach
Division of Art, Prints and Photographs,
The New York Public Library, Astor, Lenox,
and Tilden Foundations
Faxon 7

Intermission. On Stage
1879
Watercolor, gouache, and India ink, with
graphite (traces) on wove rag paper
13⅞ × 10¹¹⁄₁₆ (35.3 × 27.2)
The Dixon Gallery and Gardens, Memphis,
Tennessee, Museum Purchase, 1993.7.3

Dancer at the Barre
c. 1885
Watercolor and ink on paper
10⁵⁄₁₆ × 6½ (26.2 × 16.5)
The Dixon Gallery and Gardens, Memphis,
Tennessee, Museum Purchase, 1993.7.25

Dancer Bowing
c. 1885
Pastel on brown paper
25¾ × 20½ (65.5 × 52)
Private collection

Dancer with a Mirror
c. 1885
Pastel on gray/tan wove paper with blue
fibers
12⅜ × 11⅛ (31.4 × 28.3)
The Dixon Gallery and Gardens, Memphis,
Tennessee, Museum Purchase, 1993.7.27

In the Wings
c. 1885
Pen, brush, and ink on paper
17 × 11½ (43.3 × 29.1)
Petit Palais, Musée des Beaux-Arts
de la Ville de Paris, Inv. PPD00995

Conversation
c. 1885–90
Watercolor on wove heavy card
18¾ × 13⅛ (47.7 × 33.4)
The Dixon Gallery and Gardens, Memphis,
Tennessee, Museum Purchase, 1993.7.36

Conversation with a Ballerina in the Wings
c. 1885–90
Ink and ink wash on paper mounted
on board
13⅜ × 8½ (34 × 21.5)
The Dixon Gallery and Gardens, Memphis,
Tennessee, Museum Purchase, 1993.7.26

Ballet Dancer
1887
Pastel on blue wove paper, laid down
22¼ × 16⅞ (56.5 × 43)
National Gallery of Art, Washington, DC,
Gift of Mrs. Lessing J. Rosenwald 1989

In the Wings
c. 1888
Pastel and black chalk on paper
28 × 23 (71 × 58.5)
Private collection

The Visit
c. 1889
Watercolor with graphite and gouache
on wove paper
11¾ × 8⅞ (29.8 × 22.5)
The Dixon Gallery and Gardens, Memphis,
Tennessee, Museum Purchase, 1993.7.10

In the Wings, No. 3
1890
Graphite, pen and ink, and ink wash
on paper
13¹³⁄₁₆ × 8¾ (33.5 × 22.2)
Boston Public Library, Print Department,
Albert H. Wiggin Collection

Dancer in a Colored Tutu
c. 1890
Black chalk, pastel, and gouache on blue
paper (fan)
12½ (stick height) × 23⅞ diam. (31.7 × 60.7)
The Dixon Gallery and Gardens, Memphis,
Tennessee, Museum Purchase, 1993.7.49

Seated Ballet Dancer, Back View
c. 1890
Charcoal on paper
11¾ × 8¾ (29.8 × 22.2)
The Samuel Courtauld Trust, The Courtauld
Gallery, London

Ballerina in Repose
c. 1890–95
Red chalk on paper
20⅛ × 15¾ (51 × 40)
Private collection

Dancer Refastening Her Shoulder Strap
c. 1890–95
Colored pencil on paper
20⅛ × 15¾ (51 × 40)
Private collection

Dancer Tying Her Slipper
c. 1891
Lithograph on paper
13⅝ × 11¹³⁄₁₆ (34.6 × 30)
National Gallery of Art, Washington, DC,
Rosenwald Collection 1943
Faxon 181

The Consent
1892
Lithograph on dark cream chine collé
mounted on off-white wove paper
10⅝ × 8⁵⁄₁₆ (27.1 × 21.1)
Boston Public Library, Print Department,
Albert H. Wiggin Collection
Faxon 184

Dancer's Dressing Room, Second Plate
1894
Lithograph on off-white paper mounted
on a second sheet
11¾ × 16⁹⁄₁₆ (29.8 × 42.1)
Boston Public Library, Print Department,
Albert H. Wiggin Collection
Faxon 200

Ballet Dancer Seen from the Back
c. 1895
Red, black, and white chalk on light brown
paper
18¹⁵⁄₁₆ × 12¹⁵⁄₁₆ (48.1 × 32.9)
Sterling and Francine Clark Art Institute,
Williamstown, Massachusetts

Dancers at the Barre
c. 1895
Watercolor on paper
16.7 × 22 (42.5 × 56)
Private collection

Dancer Seated in Her Dressing Room
c. 1895
Lithotint on china paper
13¼ × 14 (33.7 × 35.6)
Boston Public Library, Print Department,
Albert H. Wiggin Collection
Faxon 231

*The Presentation: A Dancer, Her Mother,
and a Gentleman*
c. 1895
Black crayon and gray ink wash on paper
16⅜ × 10¾ (41.6 × 27.4)
Musée d'Orsay, Paris, département des
Arts graphiques du Musée du Louvre,
legs du comte Isaac de Camondo, 1911
(RF 4054 recto)

In Front of the Set
c. 1895–1900
Pastel on paper
19½ × 23¾ (49.5 × 60.5)
The Dixon Gallery and Gardens, Memphis,
Tennessee, Museum Purchase, 1993.7.30

The Dancer's Necklace
1896
India ink, blue colored pencil, and graphite
on paper
10⅞ × 13¼ (27.8 × 33.8)
Courtesy of Galerie Schmit, Paris

The Abonné's Choice
c. 1896
Crayon, stumping, and graphite on paper
16¼ × 11⅝ (41.5 × 29.5)
Courtesy of Galerie Schmit, Paris

*Backstage at the Opéra during a
Performance of "Aïda"*
c. 1898
Pastel on paper mounted on canvas
45 × 32 (114.3 × 81.3)
Georgetown University Library, Special
Collections Research Center, Gift of
Leon Fromer, 1957

Negotiations in the Wings
c. 1898
Watercolor and India ink on paper
12⅜ × 11¾ (31.5 × 30)
Courtesy of Galerie Schmit, Paris

The Dancer and Her Friend
c. 1900
Black crayon and watercolor on paper
12½ × 14⅝ (31.7 × 37)
Musée d'Orsay, Paris, département des Arts
graphiques du Musée du Louvre, legs du
comte Isaac de Camondo, 1911 (RF 4055)

Habitués of the Wings
c. 1900
Black ink and brush on wove paper
17⅝ × 22¾ (44.8 × 57.8)
Boston Public Library, Print Department,
Albert H. Wiggin Collection

Fan (For the Gavarni Ball)
1903
Color transfer lithograph printed in
chamois, red, and black on imitation
Japanese paper
10¼ × 19½ (26 × 49.5)
Boston Public Library, Print Department,
Albert H. Wiggin Collection
Faxon 254

In the Wings
c. 1909
Etching on beige laid paper
10½ × 8⅝ (26.7 × 21.9)
Boston Public Library, Print Department,
Albert H. Wiggin Collection
Faxon 72

The Ballet Master and the Dancer
c. 1910
Watercolor and India ink on paper
11 × 15⅞ (28 × 40.5)
Private collection

On Stage
1910–11
Watercolor on paper
20⅛ × 14 (51 × 35.5)
The Samuel Courtauld Trust,
The Courtauld Gallery, London

Two Dancers at Intermission
1919
Watercolor on paper
12⅝ × 8¾ (32 × 22)
Private collection

Dancer and Abonné at the Opéra
c. 1925
Watercolor on paper
21⅞ × 15 (55.5 × 38)
Private collection

Dancer in a Tutu
c. 1925
Watercolor on paper
12 × 8⅞ (30.5 × 22.5)
Private collection

Plate 173
Jean-Louis FORAIN
Seated Ballet Dancer, Back View
c. 1890
Charcoal on paper
11¾ × 8¾ in. (29.8 × 22.2 cm)
The Samuel Courtauld Trust,
The Courtauld Gallery, London

Henri de Toulouse-Lautrec
(French, 1864–1901)

PAINTINGS
Dancer Seated on a Pink Divan
c. 1885–86
Oil on canvas
18¾ × 14¼ (47.6 × 36.2)
The Dixon Gallery and Gardens,
Memphis, Tennessee, Gift of the
Sara Lee Corporation, 2000.3
Dortu P. 248

The Dancer
1890
Oil on board
26¾ × 20¼ (68 × 51.5)
Private collection
Dortu supplement

WORKS ON PAPER
The Englishman at the Moulin Rouge
1891
Color lithograph on paper
18½ × 14½ (47 × 36.8)
Portland Art Museum, Museum Purchase,
Ella M. Hirsch Fund, 41.11.1
Wittrock 2

Moulin Rouge—La Goulue
1891
Color lithograph on paper
75¼ × 45⅞ (191 × 116.5)
Krannert Art Museum, Gift of William S.
Kinkead, 1975-11-5
Wittrock P 1

Divan Japonais
1893
Color lithograph on paper
31½ × 24⅜ (79.9 × 61.9)
Fine Arts Museums of San Francisco,
Gift of Bruno and Sadie Adriani, 1958.88
Wittrock P 11

Edmée Lescot, from *Le Café-concert*
1893
Lithograph on paper
10⅝ × 7½ (27 × 19.1)
Private collection
Wittrock 22

Jane Avril, from *Le Café-concert*
1893
Lithograph on paper
10½ × 8½ (26.7 × 21.6)
Private collection
Wittrock 18

Jane Avril (Jardin de Paris)
1893
Color lithograph on paper
49 × 35¼ (124.5 × 89.5)
Private collection
Wittrock P 6

Miss Loïe Fuller
1893
Brush and spatter lithograph printed in
black, brown, yellow, red, and blue with gold
powder added by hand
14⅛ × 10 (35.9 × 25.4)
Boston Public Library, Print Department,
Albert H. Wiggin Collection
Wittrock 17

Miss Loïe Fuller
1893
Brush and spatter lithograph with key-
stone in olive green, color stone in various
colors, and gold powder on beige wove
paper
14¹⁵⁄₁₆ × 10¼ (37.9 × 26)
Smith College Museum of Art, Northamp-
ton, Massachusetts, Gift of Selma Erving,
class of 1927
Wittrock 17

Miss Loïe Fuller
1893
Brush and spatter lithograph on paper
14⅜ × 10⅜ (36.7 × 26.8)
McNay Art Museum, San Antonio,
Gift of Robert L. B. Tobin, 1974.51
Wittrock 17

Miss Loïe Fuller
1893
Lithograph on paper
14⁹⁄₁₆ × 10½ (37.0 × 26.6)
Brooklyn Museum, Museum Collection
Fund 39.25
Wittrock 17

La Goulue
1894
Lithograph printed in black on paper
11¹⁵⁄₁₆ × 9¹⁵⁄₁₆ (30.3 × 25.2)
The Museum of Modern Art, New York,
Gift of Abby Aldrich Rockefeller, 147.1946
Wittrock 65

Miss Ida Heath, English Dancer
1894
Lithograph printed in green on paper
14¼ × 10⅝ (36.2 × 27)
Fine Arts Museums of San Francisco,
Bequest of Bruno Adriani, 1971.28.23
Wittrock 64

*Lender Dancing the Bolero Step in
"Chilpéric"*
1895
Lithograph printed in olive green on ivory
wove paper
14½ × 11 (36.8 × 27.9)
Mount Holyoke College Art Museum,
South Hadley, Massachusetts, Gift of
Mrs. Myron Black
Wittrock 103

*Lender from the Back Dancing the Bolero
in "Chilpéric"*
1895
Crayon and spatter lithograph printed
in olive green on wove paper
14¹³⁄₁₆ × 10⁹⁄₁₆ (37.6 × 26.8)
Boston Public Library, Print Department,
Albert H. Wiggin Collection
Wittrock 105

Mademoiselle Lender
1895
Black crayon, with touches of blue pencil, on paper
12⁵⁄₁₆ × 7¾ (31.2 × 20)
Thaw Collection, The Pierpont Morgan Library, New York, EVT 177
Dortu D. 3.765

Mademoiselle Marcelle Lender, Bust Length
1895
Color lithograph on paper
12⅞ × 9⅝ (32.7 × 24.4)
Portland Art Museum, The Vivian and Gordon Gilkey Graphic Arts Collection, 80.122.22
Wittrock 99

May Milton
1895
Color lithograph
31⅝ × 24¼ (80.3 × 61.5)
Private collection
Wittrock P 17

Mademoiselle Églantine's Troupe
1895–96
Color lithograph on paper
24¼ × 31⅝ (61.6 × 80.3)
Private collection
Wittrock P 21

The Seated Clowness (Mademoiselle Cha-U-Kao), from the suite Elles
1896
Color lithograph on paper
20⅝ × 15⅞ (52.4 × 40.3)
Portland Art Museum, Gift from the Collection of Laura and Roger Meier, 2004.122.3
Wittrock 156

Cha-U-Kao at the Moulin Rouge
1897
Crayon, brush, and spatter lithograph printed in dark brown, gray-brown, orange-yellow, yellow, red, and blue on paper
15¹⁵⁄₁₆ × 12¹¹⁄₁₆ (40.5 × 32.2)
Boston Public Library, Print Department, Albert H. Wiggin Collection
Wittrock 178

Dance at the Moulin Rouge
1897
Brush and spatter lithograph with scraper, printed in black and four colors on china paper, laid down on mat board
16⁵⁄₁₆ × 13⅝ (41.4 × 34.6), trimmed
Milwaukee Art Museum, Gift of Mrs. Harry Lynde Bradley, M1964.57
Wittrock 181

In the Wings
c. 1898–1900
Essence and colored crayon over lithograph on paper
22 × 19¼ (56 × 49)
Private collection, Minnesota, courtesy of Ruth Ziegler Fine Arts, New York
Wittrock 330
Dortu supplement

Jane Avril
1899
Color lithograph on paper
21⅞ × 13⅝ (55.6 × 34.6)
Private collection
Wittrock P 29

Plate 174
Henri de TOULOUSE-LAUTREC
Edmée Lescot, from *Le Café-concert*
1893
Lithograph on paper
10⅝ × 7½ in. (27 × 19.1 cm)
Private collection

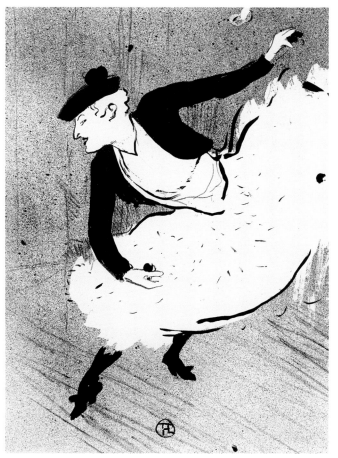

Plate 175
Jean-Louis FORAIN
Conversation
c. 1885–90
Watercolor on wove
heavy card
18¾ × 13⅛ in.
(47.7 × 33.4 cm)
The Dixon Gallery and
Gardens, Memphis,
Tennessee, Museum
Purchase, 1993.7.36

Selected Bibliography

Adriani, Götz. *Toulouse-Lautrec. Das gesamte graphische Werk. Bildstudien und Gemälde.* Cologne: Dumont, 2005.

——. *Toulouse-Lautrec: The Complete Graphic Works.* Translated by Eileen Martin. New York: Thames and Hudson, 1988.

Armstrong, Carol. *Odd Man Out: Readings of the Work and Reputation of Edgar Degas.* Chicago: University of Chicago Press, 1991.

Beaumont, Cyril. *Five Centuries of Ballet Design.* London: The Studio, 1939.

Bentley, Toni. "What's Wrong with Degas." *Art and Antiques,* November 1987, 70–75, 126.

Bernay, Berthe. *La Danse au théâtre.* Paris: E. Dentu, 1890.

Berson, Ruth, ed. *The New Painting: Impressionism, 1874–1886, Documentation.* 2 vols. San Francisco: Fine Arts Museums of San Francisco, 1996.

Blaze, François-Henri-Joseph [called Castil-Blaze]. *Sur l'Opéra français, vérités dures mais utiles. . . .* Paris: Castil-Blaze, 1856.

Boggs, Jean Sutherland, Henri Loyrette, Michael Pantazzi, and Gary Tinterow. *Degas.* New York: Metropolitan Museum of Art; Ottawa: National Gallery of Canada, 1988.

Bonduelle, Michel, and Toby Gelfand. "Hysteria Behind the Scenes: Jane Avril at the Salpêtrière." *Journal of the History of the Neurosciences* 7, no. 1 (1998): 35–42.

Brettell, Richard R. *Monet to Moore: The Millennium Gift of Sara Lee Corporation.* With Natalie H. Lee. New Haven, CT: Yale University Press, 1999.

Brettell, Richard R., and Suzanne Folds McCullagh. *Degas in the Art Institute of Chicago.* Chicago: Art Institute of Chicago; New York: Harry N. Abrams, 1984.

Browse, Lillian. *Degas Dancers.* London: Faber and Faber, 1949.

——. *Forain the Painter, 1852–1931.* London: P. Elek, 1978.

Buchanon, Harvey. "Edgar Degas and Ludovic Lepic: An Impressionist Friendship." In *Cleveland Studies in the History of Art,* vol. 2, 63–64. Cleveland: Cleveland Museum of Art, 1997.

Caradec, François. *Jane Avril au Moulin Rouge avec Toulouse-Lautrec.* Paris: Fayard, 2001.

Catalogue des tableaux, pastels et dessins par Edgar Degas et provenant de son atelier. . . . Galeries Georges Petit, Paris. Vente I: May 6–8, 1918; Vente II: December 11–13, 1918; Vente III: April 7–9, 1919; Vente IV: July 2–4, 1919.

Cate, Phillip Dennis, and Sinclair Hamilton Hitchings. *The Color Revolution: Color Lithography in France, 1890–1900.* Santa Barbara, CA: Peregrine Smith, 1978.

Chapin, Mary Weaver. "Henri de Toulouse-Lautrec and the Café-Concert: Printmaking, Publicity, and Celebrity in Fin-de-Siècle Paris." PhD diss., Institute of Fine Arts, New York University, 2002.

Cohen, H. Robert. *Les Gravures musicales dans "L'Illustration," 1843–1899.* 3 vols. In collaboration with Sylvia L'Ecuyer

Lacroix and Jacques Léveillé. Québec: Presses de l'Université Laval; New York: Pendragon Press, 1983.

Coman, Florence E. *Toulouse-Lautrec: "Marcelle Lender in 'Chilpéric.'"* Washington, DC: National Gallery of Art, 1994.

Condemi, Concetta. *Les Cafés-concerts. Histoire d'un divertissement (1849-1914).* Paris: Quai Voltaire, 1992.

Coolus, Romain. "Souvenirs sur Toulouse-Lautrec." *L'Amour de l'art* 12, no. 4 (April 1931): 137-39.

Coquiot, Gustave. *Lautrec, ou quinze ans de moeurs parisiennes, 1885-1900.* Paris: Ollendorff, 1921.

———. *Des Peintres maudits.* Paris: André Delpeuch, 1924.

Czestochowski, Joseph S., and Anne Pingeot. *Degas Sculptures: Catalogue Raisonné of the Bronzes.* Memphis: Torch Press and International Arts, 2002.

Daniel, Malcolm. *Edgar Degas: Photographer.* New York: Metropolitan Museum of Art, 1998.

Danker, Jo-Anne Birnie, ed. *Loïe Fuller—Getanzter Jugendstil.* Munich: Museum Villa Stuck, 1995.

de Boigne, Charles. *Petits mémoires de l'Opéra.* Paris: Librairie Nouvelle, 1857.

Delsol, Maurice. *Paris-Cythère: Étude de moeurs parisiennes.* Paris: Imprimerie de la France artistique et industrielle, n.d. [c. 1891/94].

Denvir, Bernard. *Toulouse-Lautrec.* London: Thames and Hudson, 1991.

DeVonyar, Jill. "Degas as Documentation: Edgar Degas' Annotated Drawings as Records of Late-Nineteenth-Century Ballet Practice." In *The Proceedings of the Society of Dance History Scholars, Twenty-fifth Conference,* 2002, 25-30.

DeVonyar, Jill, and Richard Kendall. *Degas and the Dance.* New York: Harry N. Abrams, in association with the American Federation of Arts, 2002.

d'Heylli, Georges. *Foyers et coulisses: Histoire anecdotique de tous les théâtres.* Paris: Tresse, 1875.

Dortu, M. G. *Toulouse-Lautrec et son oeuvre.* 6 vols. Les Artistes et leurs oeuvres: Études et documents. New York: Collectors Editions, 1971.

Dumas, Anne. *Degas' Mlle Fiocre in Context.* New York: Brooklyn Museum, 1988.

Faxon, Alicia Craig. *Jean-Louis Forain: A Catalogue Raisonné of the Prints.* New York: Garland Publishing, 1982.

———. *Jean-Louis Forain: Artist, Realist, Humanist.* Washington, DC: International Exhibitions Foundation, 1982.

Freher, Christina. "Die Clownesse Cha-U-Kao." In *Sammlung Oskar Reinhart "Am Römerholz," Winterthur. Gesamtkatalog,* edited by Mariantonia Reinhard-Felice, 542-45. Basel: Schwabe, 2003.

Frey, Julia. *Toulouse-Lautrec: A Life.* New York: Viking, 1994.

Gautier, Théophile. "Le Rat" (1840). Reproduced in *Paris et les Parisiens: Théophile Gautier, présentation et notes par Claudine Lacoste-Veysseyre.* Paris: Boîte à documents, 1996.

Gauzi, François. *Lautrec et son temps.* Paris: David Perret, 1954.

———. *Lautrec mon ami.* Paris: La Bibliothèque des Arts, 1992.

Gerstein, Marc. "Degas's Fans." *Art Bulletin* 64, no. 1 (March 1982): 105-18.

Gillet, Louis. "Forain, son exposition aux Arts Décoratifs." *La Revue hebdomadaire,* January 25, 1913, 481-505.

Goldschmidt, Lucien, and Herbert Schimmel, eds. *Unpublished Correspondence of Henri de Toulouse-Lautrec.* New York: Phaidon, 1969.

Guérin, Marcel. *J.-L. Forain, aquafortiste. Catalogue raisonné de l'oeuvre gravé de l'artiste.* Paris: H. Floury, 1912.

———. *J.-L. Forain, lithographe. Catalogue raisonné de l'oeuvre lithographié de l'artiste.* Paris: H. Floury, 1910.

Guérin, Marcel, ed. *Degas Letters.* Oxford: B. Cassirer, 1947.

Guest, Ivor. *Le Ballet de l'Opéra de Paris.* Paris: Théâtre National de l'Opéra, 1976.

———. *The Ballet of the Second Empire, 1847-1858.* London: A. and C. Black, 1955.

———. *The Ballet of the Second Empire, 1858-1870.* London: A. and C. Black, 1953.

———. "The Heyday of the *Cancan.*" In *Second Empire Medley,* edited by W. H. Holden, 10-23. London: British Technical and General Press, 1952.

———. *The Romantic Ballet in Paris.* 2nd revised edition. London: Dance Books, 1980. First published 1966.

Guest, Ivor, ed. *Gautier on Dance.* London: Dance Books, 1986.

Guilbert, Yvette. *La Chanson de ma vie: Mes Mémoires.* Paris: B. Grasset, 1927.

Halévy, Daniel. *Degas parle.* Paris: La Palatine, 1960.

Halévy, Ludovic. *La Famille Cardinal.* Paris: Calmann Lévy, 1883.

Hamel, Abel. "Chronique parisienne." *La Vie moderne,* January 23, 1886, 903.

Harris, Margaret Haile. *Loïe Fuller: Magician of Light.* Richmond: Virginia Museum of Fine Arts, 1979.

Herbert, Robert L. *Impressionism: Art, Leisure, and Parisian Society.* New Haven, CT: Yale University Press, 1988.

Huisman, Philippe, and M. G. Dortu. *Lautrec par Lautrec.* Paris: La Bibliothèque des Arts, 1964. English edition: *Lautrec by Lautrec.* Edited and translated by Corine Bellow. New York: Viking Press, 1968.

Huysmans, Joris-Karl. *Écrits sur l'art, 1867-1905.* Edited by Patrice Locmant. Paris: Bartillat, 2006.

Impressionist and Modern Art (Part I). Sales catalogue. Sotheby's, London, June 26, 2001, lot 4.

Impressionist and Modern Paintings, Drawings and Sculpture (Part I). Sales catalogue. Christie's, New York, November 9, 1994, lot 17.

Impressionist Paintings and Drawings from the Estate of Florence J. Gould. Sales catalogue. Sotheby's, New York, April 24, 1985, lot 50.

Isaacson, Joel. "Impressionism and Journal Illustration." *Arts Magazine,* June 1982, 95–115.

Ives, Colta, Susan Alyson Stein, and Julie A. Steiner. *The Private Collection of Edgar Degas: A Summary Catalogue.* New York: Metropolitan Museum of Art, 1997.

Janis, Eugenia Parry. *Degas Monotypes.* Cambridge, MA: Fogg Art Museum, 1968.

The John and Frances L. Loeb Collection. Sales catalogue. Christie's, New York, May 12, 1997, lot 111.

Joyant, Maurice. *Henri de Toulouse-Lautrec, 1864–1901.* Vol. 1, *Peintre.* Paris: H. Floury, 1926. Vol. 2, *Dessins, estampes, affiches.* Paris: H. Floury, 1927. Reprint, New York: Arno Press, 1968.

Kahane, Martine. "Enquête sur la *Petite Danseuse de quatorze ans* de Degas—Le modèle." *La Revue du Musée d'Orsay,* Fall 1998, 48–62.

———. *Le Foyer de la danse.* Paris: Ministère de la culture et de la communication, Éditions de la Réunion des Musées Nationaux, 1988.

———. *Le Tutu.* Paris: Opéra National de Paris, 1997.

Kendall, Richard. *Degas and the Little Dancer.* New Haven, CT: Yale University Press; Omaha: Joslyn Art Museum, 1998.

———. *Degas: Beyond Impressionism.* London: National Gallery Publications; Chicago: Art Institute of Chicago, 1996.

Kendall, Richard, Anthea Callen, and Dillian Gordon. *Degas: Images of Women.* Millbank, London: Tate Gallery Publications, 1989.

Kendall, Richard, and Griselda Pollock, eds. *Dealing with Degas: Representations of Women and the Politics of Vision.* New York: Universe, 1991.

Koutsomallis, Kyriakos, Bertrand du Vignaud de Villefort, Danièle Devynck, and Götz Adriani. *Toulouse-Lautrec: Woman as Myth.* Hora Andros, Greece: Basil and Elise Goulandris Foundation; Turin: Umberto Allemandi, 2001.

Lemoisne, Paul-André. *Degas et son oeuvre.* 5 vols. New York: Garland Publishing, 1984. Reprint, with supplement, of *Degas et son oeuvre.* 4 vols. Les Artistes et leurs oeuvres: Études et documents. Paris: Arts et métiers graphiques, [1947–48, © 1946].

Léon, Paul. "Forain 1852–1931." *L'Art,* no. 16 (November–December 1913), 117–18.

Lipton, Eunice. *Looking into Degas: Uneasy Images of Women and Modern Life.* Berkeley: University of California Press, 1986.

Loyrette, Henri. *Degas.* Paris: Fayard, 1991.

———. "Degas à l'Opéra." In *Degas inédit: actes du Colloque Degas, Musée d'Orsay, 18–21 avril 1988.* Paris: Documentation française, 1989.

Maindron, Ernest. *Les Affiches illustrées.* Paris: G. Boudet, 1896.

McMullen, Roy. *Degas: His Life, Times, and Work.* Boston: Secker and Warburg, 1984.

Meller, Mari Kálmán. "Exercises in and around Degas's Classrooms." Pts. 1–3. *Burlington Magazine,* March 1988, 198–215; March 1990, 253–65; July 1993, 452–62.

Michel, Alice. "Degas et son modèle." *Mercure de France,* February 16, 1919, 457–78, 623–39.

Migel, Parmenia. *Great Ballet Reproductions of the Nineteenth Century.* New York: Dover, 1981.

Millard, Charles. *The Sculpture of Edgar Degas.* Princeton, NJ: Princeton University Press, 1976.

Moffett, Charles S. *The New Painting: Impressionism, 1874–1886.* Geneva, Switzerland: R. Burton, in association with the Fine Arts Museums of San Francisco and the National Gallery of Art, Washington, DC, 1986.

Muehlig, Linda D. *Degas and the Dance.* Northampton, MA: Smith College Museum of Art, 1979.

Murray, Gale B. "The Theme of the Naturalist Quadrille in the Art of Toulouse-Lautrec: Its Origins, Meaning, Evolution, and Relationship to Later Realism." *Arts Magazine,* December 1980, 68–75.

———. *Toulouse-Lautrec: The Formative Years, 1878–1891.* Oxford: Clarendon Press; New York: Oxford University Press, 1991.

Murray, Gale B., ed. *Toulouse-Lautrec: A Retrospective.* New York: Hugh Lauter Levin Associates, 1992.

Natanson, Thadée. *Un Henri de Toulouse-Lautrec.* Geneva, Switzerland: Pierre Cailler, 1951.

Pedley-Hindson, Catherine. "Jane Avril and the Entertainment Lithograph: The Female Celebrity and *fin-de-siècle* Questions of Corporeality and Performance." *Theater Research International* 30, no. 2 (2005): 107–23.

Potts, Alex. "Dance, Politics and Sculpture." *Art History* 10, no. 1 (March 1987): 91–109.

Price, David. *Cancan.* Cransbury, NJ: Fairleigh Dickinson University Press, 1998.

Reed, Sue Welsh, and Barbara Stern Shapiro. *Edgar Degas: The Painter as Printmaker.* Boston: Museum of Fine Arts, 1984.

Reff, Theodore. *Degas: The Artist's Mind.* New York: Metropolitan Museum of Art, 1976.

———. "Edgar Degas and the Dance." *Arts Magazine,* November 1978, 145–49.

———. *The Notebooks of Edgar Degas.* 2 vols. London: Clarendon Press, 1976. Reprint, New York: Hacker Art Books, 1985.

Reff, Theodore, and Florence Valdès-Forain. *Jean-Louis Forain: Les Années impressionnistes et post-impressionnistes.* Lausanne: Fondation de l'Hermitage; Paris, Bibliothèque des Arts, 1995.

———. *Jean-Louis Forain, the Impressionist Years: The Dixon Gallery and Gardens Collection.* Memphis: Dixon Gallery and Gardens, 1995.

Rewald, John. *Post-Impressionism: From Van Gogh to Gauguin.* New York: Museum of Modern Art, 1956.

Rewald, John, Sacha Guitry, and Jean Nepveu-Degas. *Edgar Degas, 1834–1917: Original Wax Sculptures.* New York: M. Knoedler, 1955.

Roqueplan, Nestor. *Les Coulisses de l'Opéra.* Paris: Librairie Nouvelle, 1855.

Sautman, Francesca Canadé. "Invisible Women: Lesbian Working-Class Culture in France, 1880–1930." In *Homosexuality in Modern France,* edited by Jeffrey Merrick and Bryant T. Ragan Jr., 177–201. New York: Oxford University Press, 1996.

Schimmel, Herbert D., ed. *The Letters of Henri de Toulouse-Lautrec.* Oxford and New York: Oxford University Press, 1991.

Shackelford, George. *Degas: The Dancers.* Washington, DC: National Gallery of Art, 1984.

Shercliff, Jose. *Jane Avril of the Moulin Rouge.* London: Jerrolds Publishers, 1953.

Sickert, Walter. "Degas." *Burlington Magazine,* November 1917, 183–91.

Stuckey, Charles F. *Toulouse-Lautrec: Paintings.* Chicago: Art Institute of Chicago, 1979.

Symons, Arthur. *From Toulouse-Lautrec to Rodin, with Some Personal Impressions.* New York: Alfred H. King, 1930.

Thomson, Richard. *The Private Degas.* New York: Thames and Hudson, 1987.

———. *Toulouse-Lautrec.* London: Oresko Books, 1977.

Thomson, Richard, Claire Frèches-Thory, Anne Roquebert, and Danièle Devynck. *Toulouse-Lautrec.* New Haven, CT: Yale University Press, 1991.

Thomson, Richard, Phillip Dennis Cate, and Mary Weaver Chapin. *Toulouse-Lautrec and Montmartre.* Washington, DC: National Gallery of Art and the Art Institute of Chicago, in association with Princeton University Press, 2005.

Valéry, Paul. "Degas, Dance, Drawing." Reprinted in Paul Valéry, *Degas, Manet, Morisot.* Translated by David Paul. Princeton, NJ: Princeton University Press, 1989.

Un vieil abonné [Paul Mahalin]. *Ces Demoiselles de l'Opéra.* Paris: Tresse et Stock, 1887.

Vizentini, Albert. *Derrière la toile (foyers, coulisses, comédiens).* Paris: A. Faure, 1868.

Wittrock, Wolfgang. *Toulouse-Lautrec: The Complete Prints.* 2 vols. Edited and translated by Catherine E. Kuehn. London: Philip Wilson Publishers for Sotheby's Publications, 1985.

Wrubel, Faye, and Francesca Casadio. "Conservation/Revelation: Henri de Toulouse-Lautrec's *Ballet Dancers* Finds Renewed Harmony." *Conservation at the Art Institute of Chicago* (Museum Studies/Art Institute of Chicago) 31, no. 2 (2005): 46–53.

Plate 176
Jean-Louis FORAIN
Dancer Tying Her Slipper
c. 1891
Lithograph on paper
13⅜ × 11¹³⁄₁₆ in. (34.6 × 30 cm)
National Gallery of Art, Washington, DC, Rosenwald Collection 1943

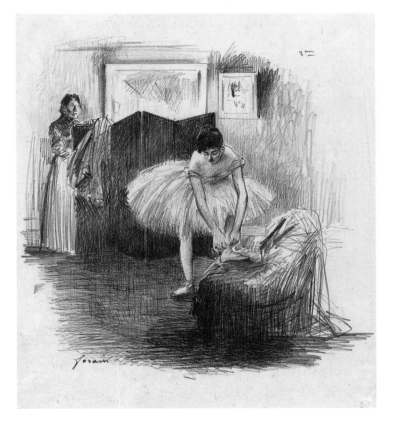

Notes on the Contributors

Paris (18th district). The ball of the Moulin Rouge, 1900

Annette Dixon, curator of prints and drawings at the Portland Art Museum, holds a PhD in the history of art from Yale University. She has organized exhibitions on a range of Old Master to contemporary topics. She coauthored *Monet at Vétheuil: The Turning Point* and edited and contributed to *Women Who Ruled: Queens, Goddesses, Amazons in Renaissance and Baroque Art* and *Kara Walker: Pictures from Another Time,* the first book on the artist's work.

Richard Kendall, curator-at-large at the Clark Art Institute, has written extensively on Impressionism, including books on Cézanne, Monet, and van Gogh. Among the exhibitions he has organized are *Degas: Images of Women, Degas Landscapes, Degas: Beyond Impressionism, Degas and the Little Dancer,* and, with Jill DeVonyar, *Degas and the Dance.* Most recently, he cocurated *The Unknown Monet.*

Florence Valdès-Forain is preparing the catalogue raisonné of the work of Jean-Louis Forain, her great-grandfather. A graduate of the Institut d'Études Politiques, Paris, she holds a master's degree in art history from the Sorbonne. She has served as a consultant to and collaborated on catalogues for several museums, including the Dixon Gallery and Gardens (Memphis), Fondation de l'Hermitage (Lausanne), and Museo Thyssen-Bornemisza (Madrid). She has contributed articles to publications such as *La Revue du Musée d'Orsay, L'Oeil,* and *Le Monde d'Hermès.* She serves as an expert appointed by the Court of Appeals of Versailles.

Mary Weaver Chapin is assistant curator of prints and drawings at the Milwaukee Art Museum. A graduate of Wellesley College, Chapin received her doctorate from the Institute of Fine Arts, New York University. She held an Andrew W. Mellon Curatorial Fellowship from 2002 to 2004 at the Art Institute of Chicago, where she was one of the cocurators and coauthors of the major exhibition and catalogue *Toulouse-Lautrec and Montmartre.*

After teaching ballet for twenty years, **Jill DeVonyar** worked as a corporate curator and, subsequently, as an independent scholar. She has written numerous essays, articles, and books on Degas's ballet oeuvre and was joint curator, with Richard Kendall, of *Degas and the Dance.* Her other projects have included a PBS film on Degas, for which she won a Peabody award, and the forthcoming exhibition *Degas and the Art of Japan.*

Marnie P. Stark is assistant curator of prints and drawings at the Portland Art Museum, where her exhibitions include *Speaking Ruins: Piranesi and the Legacy of Ancient Rome, From Anxiety to Ecstasy: Themes in German Expressionist Prints,* and *Graphic Force, Humanist Vision: Leonard Baskin Works on Paper.* She received her MA in the history of decorative arts and design from the Cooper-Hewitt, National Design Museum/Parsons School of Design. Her articles have appeared in publications such as *Studies in the Decorative Arts.*

Ingrid Berger is curatorial assistant at the Portland Art Museum. She received her BA in art history from Barnard College, Columbia University, and has also studied at the Sorbonne and Jussieu Universities, Paris. Her first exhibition at the Portland Art Museum, on the Oregon artist Charles E. Heaney, will be mounted in winter 2008.

Lenders to the Exhibition